MEDIEVALIA ET HUMANISTICA

MEDIEVALIA ET HUMANISTICA

New Series
Edited by Paul Maurice Clogan

MEDIEVALIA ET HUMANISTICA

STUDIES IN MEDIEVAL & RENAISSANCE CULTURE

NEW SERIES: NUMBER 8

Transformation and Continuity

EDITED BY

PAUL MAURICE CLOGAN

1977

CAMBRIDGE UNIVERSITY PRESS

CAMBRIDGE

LONDON · NEW YORK · MELBOURNE

Published by the Syndics of the Cambridge University Press
The Pitt Building, Trumpington Street, Cambridge CB2 1RP
Bentley House, 200 Euston Road, London NW1 2DB
32 East 57th Street, New York, NY 10022, USA
296 Beaconsfield Parade, Middle Park, Melbourne 3206, Australia

Library of Congress Catalogue Card Number: 75–16872

ISBN 0 521 21783 0
ISSN 0076 6127

First published 1977

Printed in the United States of America
Typeset, printed, and bound by
Vail-Ballou Press, Inc, Binghamton, New York

Contents

Editorial Note

Since 1970, this new series has sought to promote significant scholarship, criticism, and reviews in the several fields of medieval and Renaissance studies. It has published articles drawn from a wide variety of disciplines and has given attention to new directions in humanistic scholarship and to significant topics of general interest. This series has been particularly concerned with exchange between specializations, and scholars of diverse approaches have complemented each other's efforts on questions of common interest.

Medievalia et Humanistica is sponsored by the Modern Language Association of America, and publication in the series is open to contributions from all sources. The Editorial Board welcomes scholarly, critical, or interdisciplinary articles of significant interest on relevant material and urges contributors to communicate in a clear and concise style the larger implications, in addition to the material of their research, with documentation held to a minimum. Texts, maps, illustrations, diagrams, and musical examples will be published when they are essential to the argument of the article. In preparing and submitting manuscripts for consideration, potential contributors are advised to follow carefully the instructions given on page xiv. Articles in English may be submitted to any of the editors. Books for review and inquiries concerning *Fasciculi* I-XVII in the original series should be addressed to the Editor, *Medievalia et Humanistica*, P.O. Box 13348, North Texas Station, Denton, Texas 76203.

Inquiries concerning subscriptions should be addressed to the publisher, Cambridge University Press, 32 East 57th Street, New York, New York 10022, or at Bentley House, 200 Euston Road, London NW1 2DB.

Preface

"To the world when it was half a thousand years younger," wrote Johan Huizinga at the beginning of *The Waning of the Middle Ages* (1924), "the outline of all things seemed more clearly marked than to us." Huizinga's great book, dealing with "the history of the fourteenth and fifteenth centuries regarded as a period of termination, as the close of the Middle Ages," turned historians away from problems of origins of modern culture to those of decline and fall, finding new life under the apparent ruins. The Dutch historian's eloquent account and interpretation of the significance of chivalry at that crucial moment in history when the Middle Ages gave way to the Renaissance has indeed come to be accepted as the classic treatment of the subject. Huizinga did his best for France and Burgundy to illuminate the style of a whole culture at the extreme limit of its development, yet his emphasis on decay and the very title of his book has contributed a negative and oppressive tone. Although much has been written about Valois Burgundy since Huizinga wrote, there has been no major reinterpretation of the subject.

The present age, as Erich Auerbach predicted, is one of reevaluation, and the watershed was World War II. This volume on Transformation and Continuity contains several essays of reevaluation. The lead article by Maurice Keen, author of *The Laws of War*, assesses the work of Huizinga – more than a half-century after the appearance of *The Waning of the Middle Ages* – and that of R. L. Kilgour, in terms of their interpretation of the significance of the cult of chivalry in late medieval civilization. Keen's well-documented reevaluation stresses the continuities between the ideals of early and late medieval chivalry, pointing both to early criticism of its ideals and simultaneously to later (sixteenth-century) flowering and vigor of those ideals. Keen continues the game theory of culture proposed by Huizinga, which took steps toward breaking down periodizations. Reevaluation is also the object of J. R. Hale's article on Renaissance Venice. One member of the Editorial Board described this article as "fascinating, distinctive, ground-breaking material on a hitherto little-studied but important aspect of Venetian culture; hence this article is a major contribution to Renaissance studies, and Venetian history in particular; the discussion of Arms and Letters from this angle, the emphasis on land rather than sea partly because classical models were

lacking for the latter, and all this and more are brilliant insights into Venetian culture, opening a whole new dimension to our appreciation of Renaissance Venice." Keen's and Hale's essays should contribute both to those studies themselves and to the understanding of them by those in other specializations.

The next two essays are grouped together because each involves reevaluation of literary theory and literary history. During the past twenty-five years, present-day, ancient, medieval, European, Asian and African cultures have been investigated in the light of the theory of oral formulaic composition. In this connection Michael Curschmann's article examines the way in which this theory has been used for the study of Germanic poetry, with original contributions. Stephen G. Nichols's essay is a perceptive and informative examination of recent trends in the criticism of medieval poetry; he asks some important questions of significant interest to many readers and suggests the possibility of a poetics of historicism.

The following two articles concern reevaluations of well-known plays. Commenting on Thomas Jambeck's essay on *Everyman*, one Board member writes: "This essay is, I think, the finest study of *Everyman* I have read, and I recommend it with rare enthusiasm. It has every virtue I can think of. It deals with a well-known and beautiful play that has been written about a lot and yet manages to say something vitally new that amounts to a new reading of the entire play." The essay by Jeanne S. Martin also contains much that is remarkably perceived and stated, as she examines typological and archetypal history as determinants of form and structure in the Towneley Cycle. Both essays should prove useful to those directly concerned and to those in related fields.

At first glance, the next four articles might appear to have little in common, yet each concerns reinterpretation, although in quite different ways and on quite different authors. Rodney M. Thomson, treating William of Malmesbury and the letters of Alcuin, contributes new information and insight regarding the literary tradition of Alcuin and throws revealing light not only on William of Malmesbury but also on the way in which medieval historians transformed their sources. The same is true of the engaging essay by Robert Hollander, who makes a welcomed contribution to our knowledge of Boccaccio and reveals the advantages as well as the literary implications of having a major writer provide his own glosses. Kurt Olsson's essay on John Gower and the tradition of the *exemplum* should be of special interest to Middle English readers and to those concerned with rhetoric and preaching. Similarly, Lawrence V. Ryan's readable essay on the Banquet Colloquies of Erasmus examines the characteristics of the ancient literary type that was esteemed and practiced during the Renaissance and discerns their important Erasmian religious and humanistic themes.

A special feature of the new series has been the appearance of review

articles and progress reports. In this volume, M. L. Colker reviews recent advances in palaeography and discusses recent volumes in the *Manuscrits datés* series and in De La Mare's series on humanistic script. Colker's review article should be of significant interest to scholars and serious students, and especially to those concerned with palaeography. Robert Levine's review essay contributes a useful correction and reply to a Jungian explanation of four characteristics of the pearl-maiden in the well-known Middle English poem. The volume concludes with a review article on Chaucer Criticism, by D. W. Robertson, Jr.

As usual, I am grateful to my fellow editors and the Cambridge University Press for their ready cooperation.

P. M. C.

February 1977

Articles for Future Volumes Are Invited

Articles in English may be submitted to any of the editors, but it would be advisable to submit to the nearest or most appropriate editor for consideration. A prospective author is encouraged to contact his editor at the earliest opportunity to receive any necessary advice and a copy of the style sheet. The length of the article depends upon the material, but brief articles or notes are normally not considered. The entire manuscript should be typed, double-spaced, on standard 8½″ x 11″ bond paper with ample margins and documentation should be held to a minimum. Endnotes, prepared according to *A Manual of Style*, twelfth edition (University of Chicago Press), should be double-spaced and numbered consecutively and appear at the end of the article. All quotations and references should be carefully verified before submission. The completed article should be in finished form, appropriate for printing. Only the original manuscript (not photocopy or carbon) should be submitted, accompanied by a stamped, self-addressed manuscript envelope.

The addresses of the American editors can be determined by their academic affiliations. The addresses of the editors outside the United States are:

Professor Giuseppe Billanovich, Foro Buonaparte 55, Milano 20121, Italia (Medieval and Humanistic Philology)

Dr. Derek Brewer, Emmanuel College, Cambridge CB2 3AP, England (Medieval Literature)

Mr. Peter Dronke, Clare Hall, Cambridge CB3 9DA, England (Medieval Latin Poetry and Thought)

Professor J. R. Hale, Department of Italian, University College London, Gower Street, London WC1E 6BT, England (Renaissance History)

Professor Denys Hay, Department of History, University of Edinburgh, William Robertson Building, George Square, Edinburgh EH8 9JY, Scotland (Renaissance History)

Professor Ian D. McFarlane, Wadham College, Oxford OX1 3NA, England (Renaissance French and Neo-Latin Literature)

Professor Jean-Claude Margolin, 75 Bld Richard-Lenoir, 75011 Paris, France (Humanism, Renaissance Philosophy and Neo-Latin)

Professor Dr. Paul G. Schmidt, Seminar für Klassische Philologie der Universität, 34 Göttingen, Nikolausberger Weg 9c, West Germany (Medieval Latin Philology)

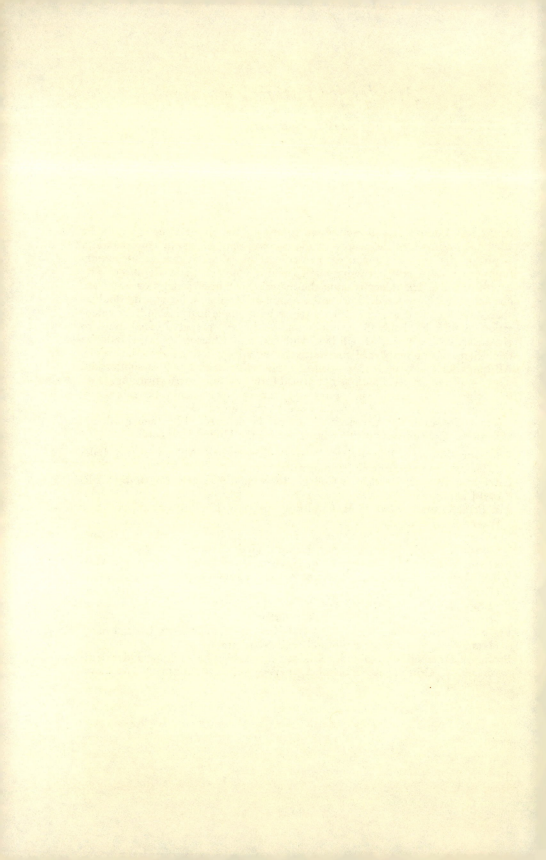

Huizinga, Kilgour and the Decline of Chivalry

MAURICE KEEN

Johan Huizinga's great book, *The Waning of the Middle Ages,* contains what is still the most illuminating and eloquent account of chivalry in the last centuries of the medieval period, one which has deservedly come to be accepted as the classic treatment of the subject. It is not just an account: It is an interpretation of the significance of the cult of chivalry in the context of late medieval civilization, and a very subtle and perceptive one. Since Huizinga wrote, no major re-interpretation of the subject has been attempted. R. L. Kilgour's book, *The Decline of Chivalry,* offers the most important full-scale treatment that has since appeared, and Kilgour, in whose interpretation the influence of Huizinga is very plain, accepted the great Dutch master's views on most significant aspects.[1] Much has indeed been written since about subjects that Huizinga touched on, and in particular about Valois Burgundy, whose court occupies much of the foreground, both in his delineation of the late medieval cult of chivalry and in Kilgour's. Much, too, has been written about the social and economic position of the secular nobility in the fourteenth and fifteenth centuries that is germane to the love of display and the cult of honour, which are what entitle one to call their culture chivalrous. But chivalry, as such, has not been the central preoccupation of those who have written on these subjects.[2] Here is the excuse for a brief attempt to re-examine Huizinga's views. It is only honest, at the outset, to state clearly that it is an attempt to do so which has been largely inspired by what Huizinga himself wrote.

Chivalry – the word itself demands definition, but at the same time eludes it. It is a vague word, with tonal, rather than precise, implications, and perhaps that is why Huizinga himself did not offer any succinct definition. It could and did mean different things to different people at different times. Always, however, it has in the Middle Ages a martial connotation, as the complaints of those who lamented the decline of chivalry attest: Both in the twelfth and the fifteenth centuries they identified lack of martial vigour and discipline as the definitive symptom of its decadence. Indeed, the word *chevalier,* from which chivalry derives, means basically a mounted warrior, no more. But *miles,* its Latin equiva-

lent, was from an early period closely associated with another idea, that of noble status. In the light of recent research it seems to be clear that many of those who, about the year 1100, would in France have called themselves *milites* came of old noble stock; and a sharp distinction between *milites*, on the one hand, and the *plebs* or *rustici*, on the other, was already drawn in eleventh-century texts.[3] So it is clear that from the first period of its general currency the abstract noun *chevalerie* (or *militia*) carried social overtones over and beyond a purely military connotation. A third aspect of chivalry was the consciously Christian ideology of knighthood, of which the crusade was the clearest expression. Perhaps, therefore, chivalry can be broadly defined as the ethos of a Christian and martial nobility, together with the mystique associated with that ethos. It was this mystique, and its elaboration in the late medieval period, that principally focussed Huizinga's attention; and it will be with his contention, that this period saw a progressive separation and ultimate divorce between this mystique and the ideology in which it was founded, that this article will be primarily concerned.

Huizinga's book does not treat of chivalry in isolation: His view of it is integrated into his overall view of late medieval culture. Here, a central theme in his interpretation is what he describes as "the marked tendency of medieval thought to embody itself in images," the desire of the medieval spirit to "give concrete shape to every conception." [4] In religion, this tendency led to an immense proliferation of the cults of the saints in the late Middle Ages, to the point where, ultimately, over-familiarity with an ever-extending range of stylised images debased veneration of God's work in his saints into profanity and superstition, a new idolatry. The tendency, in literature and iconography, to personify virtues, vices and sentiments was equally strong, and the consequence similar: The effort to express abstractions, feelings and values in concrete terms led inevitably not only to a profuse multiplication of personification but also, in the process, to confusion or conflation of the image with reality. In the end, the image, bereft of inner meaning, came to be valued for its own sake – or feared for its own sake, as in the case of the obscene material horrors of the medieval picture of judgement and hell. Here is the essence of Huizinga's "waning" of the Middle Ages: There was no way forward for significant new ideas and conceptions when imagination had lost touch with the ideas and ideals that its imagery had once been intended to convey.

The case was the same, according to Huizinga, with secular ideals as with religious ones. In romance and in the pseudo-history first recounted in the old *chansons de geste*, values and ideals were incapsulated in the actions and lives of their heroes. The chivalrous chronicles of the late Middle Ages adopted the tone of romance and turned their history, in the end, into pseudo-history. Though the stories that were recorded by such

writers as Froissart, Monstrelet, and Chastellain were full of cruelty, calculation and diplomatic subtlety, these authors still professed to be telling of "the noble enterprises, conquests, feats of arms and heroism" of their times. By this "traditional fiction," Huizinga explains, "they succeeded in explaining to themselves, as well as they could, the motives and the course of history, which was thus reduced to an edifying spectacle of the honour of princes and the virtue of knights, to a noble game with edifying and heroic rules." [5] Chivalrous biographies, such as those of Jean de Bouçicaut and Jacques de Lalaing, similarly recounted the doings of their heroes in the terms of romance.

These biographies bring out with peculiar clarity the imitative tendency of late medieval chivalry: "The essence of chivalry is the imitation of the ideal hero." [6] This overflowed far beyond the bounds of literature and historical writing, for "literature did not suffice for the almost insatiable needs of the romantic imagination of the age." [7] The great tournaments and feasts organized by such princes as Philip the Good and René of Anjou carried the imitation into real life and were staged, without thought to expense, in the fairy-tale worlds of Arthur or Charlemagne. There is a fountain, maybe, with a pavilion, the residence of a lady holding a unicorn which bears three shields: Each knight who wishes to take up the challenge to joust must touch one of the shields with his lance. Any knight who is unhorsed must wear for a year a gold bracelet, until he finds the lady who holds the key to it that will free him.[8] Hollow imagery, a make-believe drawing its dynamism from a heady compound of imaginary heroism with eroticism, has here made a "fantastic ornament" of what had once been a "serious element in earlier civilisation."

The process that Huizinga describes reaches its apogee, in his account, in the elaborate staging of the Vows of the Pheasant at Philip the Good's great banquet at Lille in 1454, a "last manifestation of a dying usage." The old ritual, "as chivalrous tradition and romance taught it," is carefully observed: The vows of those who pledge themselves to follow Philip on the crusade that never set out run wild: One knight swears to take the journey with his arm bared, another to drink no wine on one day each week, another to wear a hair shirt – each until his vow be fulfilled in some spectacular encounter with the infidel.[9] Yet a vein of mockery betrays the consciousness of illusion, as in the oath of Jean de Rebreviettes, who swore that unless he won the favour of his lady before departing he would on his return marry the first willing girl that he should meet who could offer a dowry of twenty thousand gold pieces. This vein of mockery is one re-encountered continually and, according to Huizinga, is a symptom of the strain of maintaining an illusion whose loss of contact with reality had become painfully obvious. "The crying falsehood of it can only be borne by treating it with a certain amount of raillery."[10] The "blasé aristocracy" laughs at its own ideal. By overloading its dream

of heroism with all the available resources of fantasy, art and wealth, it has transmuted an ethical ideal into a merely aesthetic one, and the point has come where hard reality begins to open the eyes of the nobility to the uselessness of what has been created. The value of the thing signified, the heroic ideal of the earlier romances, has been lost to sight in a quest for imitative decoration, and the cult of chivalry has become purposeless and outworn.

Huizinga thus offers an analysis of chivalry in its last phase, in which picturesque efflorescence can no longer successfully conceal the gap between illusion and reality, in terms that are psychological and anthropological. The primitive instinct that seeks to incapsulate values in images has, as it were, run to seed. Kilgour's picture of late medieval chivalry is in its essentials a similar one. "In its first heroic age," he writes, "chivalry achieved the amazing fusion of military glory with religion. . . . The final period shows us a chivalry bent on mad, exaggerated display, as if to hide its impotence and its sordid vices under gilded armour and flowered silk."[11] Fifteenth-century Burgundian imitation of romantic antiquity wears, he says, "the appearance of a child's game, where costume and speech are imitated, but where no real sincerity is possible."[12] The popularity among the nobles of the *Cent Nouvelles Nouvelles* shows that "knights were no longer ashamed to put themselves on record as being scornful of women, a thing they would scarcely have dared to do a century before."[13] A host of critics, such as Eustace Deschamps, Honoré Bonet,[14] Jean Gerson and Alain Chartier, bear witness to chivalry's decline as they harp on the same themes: The new knighthood has forgotten how to endure the rigours demanded by true chivalry and has given itself over to the quest for luxury and pillage. Eloquently comparing Jacques de Lalaing's expensive exploits in the lists with Jean de Bueil's *Jouvencel*, a semi-autobiographical romance based on the author's military experiences of the real encounters of the Hundred Years' War,[15] Kilgour finds in the latter the type of a new kind of soldier, who had seen through the old illusion and "had not time for knightly games."[16] Chivalry, with its extravagant effort to maintain the illusion of significance by means of lavish display, could not stand the cold eye that Commynes cast upon the doings of knights and princes.[17] At the end of the fifteenth century it stood revealed for what it had become, at best a fragile dream: The painful contrast with reality was too sharp, and the effort to keep up the appearance was no longer attractive.

Kilgour draws rather harder outlines to his picture than Huizinga did. In consequence, he brings out more clearly the assumption, which is, in fact, implicit in what Huizinga wrote also, that the decadence of chivalry in the last two centuries of the Middle Ages is to be contrasted with an earlier period of vigour, a period of greater simplicity when reality approached more closely to an ascetic ideal. Huizinga speaks of the

"seriousness" of an "earlier civilisation." "Chivalry in its first bloom," he says, "was bound to blend with monachism."[18] That was in the age of the first crusades and of the founding of the Templars, who in their early days offered a pattern of true knight-errantry. This is the same period that Kilgour identifies as chivalry's "first heroic age," when it achieved the "fusion of military glory with religion." J. Rychner, writing much more recently, speaks in the same vein: What the Burgundian court succeeded in aping was only the "esprit chevaleresque, c'est à dire une morale aristocratique et chrétienne du douzième siècle."[19] But neither Huizinga nor Kilgour nor Rychner justifies the assumption with any substantial treatment of chivalry in its first bloom, at a time before it had degenerated into an "aesthetic game." Thus, a first question is forced on us: Was the chivalry of the earlier Middle Ages quite as different in spirit from its autumnal mood in the golden age of the Dukes of Burgundy as these authors have suggested? The question is a vital one, because it is on the assumption of a profound contrast that the notion is based – that is, that the extravagance of late medieval chivalry is the witness to its decline.

One point that raises an initial disquiet about this assumption is that if one looks back to see what the critics of chivalry were saying in the twelfth century, one finds that, although the evidence is, of course, less plentiful, some of it was remarkably similar to what was being said two or three hundred years later. As Kilgour rightly emphasises, the writing of men like Deschamps, Bonet and Alain Chartier makes it abundantly clear that to them the gap between the reality of fashionable knightly life and the ideal of knightly conduct was painfully obvious.[20]

Bonet's *L'Apparicion Maistre Jehan de Meun* is a good example of this kind of criticism of late medieval chivalry.[21] Jehan, the sage author of the continuation of the *Roman de la Rose,* appears to Bonet in his sleep, in order to introduce him to four other figures – a doctor, a Jew, a Saracen and a Dominican friar – and they discourse. The Saracen (who is the principal speaker) has been sent by the Sultan to investigate the ways of French knighthood. What he has found has given him, as an infidel, much comfort: The knighthood of the West have forgotten the true ways and have become soft and comfort-loving. That is why the Turks have triumphed over them, for *they* still maintain the rigorous discipline of chivalry that trains men from childhood for the hardships of war.

Deschamps, Gerson and Chartier attribute the disasters of France and French knighthood to the same cause as Bonet's Saracen does and con-trast, likewise, the decadence of the contemporary nobility with the hardy vigour of their ancestors. But if we look back to William of Tyre, seeking in the 1180s to explain the repeated reverses suffered by the Franks of Outremer, how much difference is there in what he has to say? One who would seek to portray in full the monstrous vices of the knights of his time would succumb under the weight of material, seeming to write

satire, rather than history, he declares. How different from their fore-fathers, who were "led by divine zeal and aflame with spiritual enthusiasm for the faith, and were accustomed to military discipline, trained in battle and familiar with the use of weapons."[22] Peter of Blois has the same story to tell: The knights of his day have lost their vigour; to see them setting out for war you would think they were bound for a picnic.[23] Earlier, St. Bernard was harping on a similar theme, contrasting secular knight-hood, with its gold spears, its gaily painted shields and extravagant attire – better calculated to dazzle the eyes of women than to strike fear into the foe – with the chaste idealism of the Templars.[24] Earlier still, Orderic and William of Malmesbury lament knighthood's loss of ancestral vigour in a new generation obsessed with effete fashions.[25]

The criticisms of early medieval knighthood are indeed sometimes so similar to those levelled by later generations as to make one wonder how seriously the latter should be taken. Though it is clear that in the later period there was genuine and widely felt disquiet about the degree to which contemporary chivalry fell short of ideal standards, the contrast between the degeneracy of modern knighthood and its antique vigor came to be repeated so often as to suggest that it became a *topos* – a theme for elegant literacy or poetical exercise which did not necessarily reflect real unease about contemporary mores.

Turning from historical to literary sources, and from the critics of chivalry to those who sought to extol its ideal in literature, one again finds that though there naturally are differences, the contrast between the spirit of the twelfth century and that of the late Middle Ages is not as sharp as one might expect it to be. Huizinga and Kilgour both stress the eagerness of the late Middle Ages to recapture what was, by then, re-garded as the glamour of the earlier, heroic age of chivalry, which they knew largely through literature. And it is quite clear that Burgundian chivalry did look back to the literature of the twelfth century. G. Doutre-pont, in his magisterial work on French literature at the court of Bur-gundy, traced the steps in the "revival," under the personal patronage of the Valois dukes, of the themes of the twelfth-century *chansons*, which were worked over by writers like Jean Wauquelin and reshaped into prose versions for readers at the ducal court.[26]

The direct influence of this literature upon chivalrous feasts and exercises in Valois Burgundy is also very clear. It can be seen, for instance, that many of Jacques de Lalaing's chivalrous conceits owed their inspira-tion to literary works that had been re-written in the Valois period, notably the stories of *Gilles de Chin* and *Gilles de Trazegnies*.[27] Similarly, we find that at the feast of the Pheasant, Toison d'Or King of Arms directly invoked the ancient custom of presenting "a peacock or other noble bird at great feasts before the illustrious princes, lords and nobles, to the end that they might swear expedient and binding oaths."[28] The

Vows of the Peacock had been first described by John de Longuyon in the early fourteenth century, in the romance of Alexander.[29] The ducal library contained a number of accounts of this and no less than three copies of the *Vows of the Heron,* which Edward III of England and his knights were supposed to have taken at the beginning of the Hundred Years' War.[30]

But although it is thus clear that Burgundian chivalry did look to literature and to the past for its models, it is not quite fair to imply a sharp contrast, in this respect, with the age of the first crusades. The twelfth-century authors of the original chansons of the Carolingian cycle, whose stories writers like Jean Wauquelin revived in prose versions for the Burgundian court, were already writing about a period that was distant from their own and holding up its heroes as models of the true chivalry of antique times. The authors of the earliest Arthurian romances were looking back to a period even more remote. From the very first, it would seem, true chivalry was always presented in antique dress. Even the twelfth-century *Chanson d'Antioch,* which worked into a verse epic the events of the first crusade, is only an apparent and partial exception to this rule. Before the end of the twelfth century that story had already proved to have insufficient glamour for the taste of the chivalrous; the slightly later *Chanson de Jerusalem* and the story of the *chétifs* were added to it, introducing new dimensions of fiction and myth, and finally all these stories were woven into the framework of a much longer epic, the *Chevalier de Cygne.* In this epic the marvellous ancestry of Godfrey de Bouillon is traced back to the Swan Knight who married Beatrice of Boulogne in the time of the emperor Otto – a tale that takes the reader back behind the events of the first crusade into a world of faery and an age just beyond the fringes of authentic memory. Thus, the epic cycle of the crusade proves no exception to the rule that chivalry always looks to the past for its models.[31] It also illustrates an important point that Doutrepont makes, that marvels were – and from a very early moment – an ingredient of chivalrous literature almost as essential as the Christian military ideal.[32] The instinct to look back to antique times, to a world peopled with heroes whose adventures were larger and stranger than life, was there from the outset.

The early vogue of the Arthurian stories, whose popularity so quickly eclipsed that of the Carolingian epics, is here significant, for they are the great repertories of the marvellous in medieval secular literature. There are also other aspects of their matter which are instructive. Even in the very early versions of the Arthurian stories we find their heroes moving in a world that simply will not tally with Huizinga's claim that the ideal knight errant, "fantastic and useless, will always be poor and without ties, as the first Templars had been."[33] This is not at all the tone of the Arthurian world. *Largesse* was the virtue that Cligès's parents urged upon

him, in the opening passages of Chrétien's romance, as they heaped him with riches, in preparation for his journey to Arthur's court.[34] It was not empty-handed that Gahamuret set out to find adventures at the beginning of Wolfram's *Parzival*, but loaded with treasure, "with many a gold vessel and many a bar of gold" and four chests brim-full of jewels.[35] Neither he nor his son Parzival took long to forge for themselves the ties of a wife and a kingdom. Riches and lineage are here assumed to be the concomitants of a noble and knightly life. In the Arthurian romances, moreover, secular adventure very clearly displaces the struggle against the infidel from priority of interest. (It might, I think, be rash to maintain that that struggle had ever really been the dominant theme, even in the Carolingian romances.) There are fights with the infidel in Arthurian stories, but much more often it is for the rights and honour of lord or kin or lady that the knights of the Round Table draw their swords. Very often, indeed, it is not in war at all, but in the tournament, that we meet Lancelot or Percival or Gawain excelling all others; in that very secular sport, that is to say, which in the twelfth century lay very firmly under the ban of the church.

One reason that the tournament plays such an important part in the Arthurian romances is clearly that it was the ideal vehicle for the introduction of the theme of courtly love into chivalrous stories of martial adventure. Here was the perfect opportunity to display the hero, fired by his pure passion for his lady, excelling himself under her eyes; here, too, the opportunity for all sorts of intriguing mystification – as, perhaps, he enters the lists disguised, and she can find no trace of him. He can flaunt his devotion by wearing her token in the thick of the fight, or he can offer an example of true *Frauendienst* by his obedience to her every whim, even to deliberately holding back from the fray, and so standing dishonoured, simply because she wills him to – as Lancelot does in Chrétien's story.[36] This erotic motif, which thus appears early in literature, was clearly a very powerful impulse towards the elaboration of the theatrical element in the real-life tourney, as well as in romance. But there is no question here, it must be pointed out, of decline from an original and austere sincerity. From its first appearance, the erotic theme that is woven into the Arthurian romances presents us with something that is exaggerated and extravagant. Through the tournament, which offered the opportunity to dramatize the theme of courtly love that the romances offered, eroticism had a powerful effect on chivalrous manners. The rapidity with which men seized on its potential in this regard suggests very powerfully that the instinct towards extravagance and decoration was from the beginning a stronger and more basic element in chivalry as an aristocratic ethos than was martial and Christian austerity.

Indeed, it is at least arguable that the tournament, in which the later chivalry of Valois Burgundy was to take such delight, was from the out-

set quite as important an influence on the development of chivalry as the crusade.[37] As it happens, we begin to find evidence of the popularity of tournaments at just about the same time that the idea of the crusade was developing: Geoffrey de Preuilly, their reputed "inventor," was killed at his favourite sport in 1064.[38] Their immense popularity in the twelfth century is well attested. Many were quite small affairs, but, as the biography of William Marshal witnesses, great tournaments could already draw knights from far afield – as, for instance, in the accounts of the men who came to the great tournament at Pleurs near Epernay in 1177 and of the Count of Champagne's tournament at Lagny in 1179, which was attended by the young King Henry of England, the Duke of Burgundy and no less than nineteen counts and their followers. The Marshal began his career as a landless knight and made a fortune out of the ransoms that he won at tourneys, but it is clear from his story that already in his day there was much more to tourneying than the mere quest for booty. Tournaments were becoming great occasions, gatherings of the aristocracy, where heralds and minstrels celebrated the prowess of knights past and present and where there was much talk of the rules of good knighthood.[39] In an atmosphere such as the tournaments thus created, the attempt to capture dramatically in their staging something of the glamour of romance was really a natural development.

The first record of a deliberate attempt to give a tournament an Arthurian flavour comes from the Holy Land, in Philip of Novara's account of the celebrations on the occasion of the knighting of Jean d'Ibelin's sons in 1223: *"moult i ot doune e despendu et behourde et contrefait les aventures de Bretaigne et de la Table ronde."*[40] Ulrich von Lichtenstein's extravagant *Artursfahrt* (1240), when he and his companions appeared to joust in elaborate Arthurian dress, is only a little later and is well-known. By the end of the thirteenth century we find in Lodwiyk van Veltheim's account of the great tournament and feast in Arthurian guise that Edward I held, probably in 1299, a scene of lavish pageantry that already anticipates the staging of the later Burgundian feasts and *pas des armes*. There was even a Loathly Damsel with a nose a foot long, ass's ears and fangs worthy of Dracula (she was in fact a young squire dressed up for the occasion).[41] In the same manner, the accounts of Edward I's feast of the Swans in 1306 and of the vows that were taken[42] there anticipate the pageantry and the induced atmosphere of Philip the Good's feast of the Pheasant.

Thus, it seems clear that lavish display was a feature of the cult of chivalry a long time before the age of the Valois Dukes of Burgundy. The imitative tendency so marked in the chivalrous ritual of the fifteenth century was also a feature obvious at a very early stage. Let us note, though, that it was not simply a matter of imitation – in the earlier period, at any rate. Tournaments were not antique in the twelfth century: They

found their way into literature from real life. Romance refined and decorated the model that life offered, elaborating, above all, its erotic potentialities (as Huizinga so rightly stressed), and so offered a new model to those who took part in real tourneys. There is a genuine interplay here between art and the facts of life. Imitation, moreover, did not make of the tournament a mode by which aristocratic life was reduced to an "all-round game," though no doubt it did heighten the attraction of the element of game that was involved. Drawing together the powerful and their followers, tournaments were often very directly related to most serious purposes, to schemes of revolt or of political protest, maybe, or to plans for a crusade, as was the case at Ecry in 1199[43] and at the Round Table tournament held at Hesdin in 1235, after which all the participants pledged themselves to take the cross.[44] Edward I's Round Table tournament at Nefyn was staged to celebrate the conquest of Wales, and his feast of the Swans was directly connected with his plans for a new offensive in Scotland to put down the upstart Robert Bruce.

From one very important point of view, the theatrical element in the display of these occasions is simply a reminder that we are in an age when display was necessary to make power meaningful. Competition, and the need to make friend and foe alike conscious of the power of a prince, has quite as much to do with the elaboration of ceremony as the desire to create a heroic illusion, and probably more. There is nothing new, moreover, about this need to make power tangibly evident: It is not the attempt of an age softened by luxury to conceal from itself the loss of ancient vigour. Hrothgar in *Beowulf* was bent about the same purpose as Edward I when he ordered the building of Heorot, to be a mead-dwelling greater than ever the children of men had heard of, at once a feast hall and a symbol of power. But Edward I was richer than a Germanic war lord, and new and more elaborate modes of display had come into fashion which his money, the ultimate sinew of power, enabled him to pay for.

As in Edward's England, so in the later Burgundian world we find that there was more to chivalrous culture and pageantry than the mere desire to create an heroic illusion. When, for instance, we are looking at the revival of interest in Carolingian history and epic in Valois Burgundy, we must not miss in it the element of subtle propaganda in favour of a measure of Burgundian separatism.[45] The early history of the Carolingian Middle Kingdom and the still-earlier history of the kingdom of Gundobad, which the Franks overran in the fifth century, had a real contemporary relevance in the age when the Valois dukes were edging their way towards the constitution of a kingdom of Burgundy in lands in which Gundobad and, later, Lothar I and his descendants had once held royal sway. Readers of David Aubert's account, in his *Croniques et Conquestes de Charlemagne*, of the deeds of Girart de Viane would not have missed the point that it concerned a hero who was a native of the Burgundian

lands and who fought many times with the King of the West Franks. The author of the prose version of *Gilles de Chin* took care to introduce into his story, sited in Hainault, connections with important families in the contemporary country, such as those of Lalaing and Condé. Wauquelin's prose version of *Girart de Rousillon* brought out the fact that this early Burgundian hero had territorial claims, both in the southern Burgundian territories (in the duchy proper) and in the Low Countries (Brabant and Flanders) – in the two principal areas of Valois Burgundian dominion, that is to say. The well-patronized revival of old stories and the staging of jousts and feasts in mythical dress has thus to be seen in a political frame of reference: It was not just the cultivation of the antique for the sake of maintaining an illusion of grandeur and idealism. Indeed, what seems here to be fragile is not chivalrous tradition but the newly acquired lordship of the Valois dukes in territories geographically separate from one another: The dukes and the court *littérateurs* hoped that by playing on the genuine respect for chivalrous values and traditions they could solidify respect for the rather shaky ducal authority. Illusion and reality are here in almost the opposite relation to that usually proposed for them.

In their prefaces, the authors of the new prose versions of the old epics spoke frequently of their ambition to revive and uphold by example the noble traditions of chivalry.[46] The preamble to the statutes of the Order of the Toison d'Or proclaimed the same object,[47] and their detailed regulations were full of echoes of the ideals that were more amply portrayed in literature. But, once again, we soon find that we cannot for this reason write off the foundation of the order, and the elaborate rituals laid down for the meetings of its members, as mere posturing. Some of the regulations in the Statutes did have a purely ceremonial significance, but others were more serious, such as the rule that no knight of the order should accept or bear the insignia of any other lord or sovereign but the Duke of Burgundy.[48] The Burgundian territories had been brought together by careful exploitation of dynastic claims and marriages and had no recent traditions of unity; there was only the personal lordship of the Duke to bind them together, and he himself was not the ultimate sovereign in any of them. The order had a political function to perform, in promoting a sense of unity among noblemen drawn from the various provinces and in their pledged loyalty to the duke as sovereign of the order.[49] The great feasts of the court and the elaborately staged tournaments served towards the same end and could reach a wider circle of the nobility. Public demonstration of wealth and power was particularly necessary to princes like the Valois Dukes of Burgundy whose authority was fragile because it was new. Significantly, other princes of the same age whose territorial authority was fragile, like King René of Anjou, also sought to make their courts glamorous through the same cult of chivalry. Edward IV of England took the Burgundian court as his model, in order to bolster the newly won monarchy of the Yorkists with a fitting display of magnifi-

cence.[50] Because their lands were rich, and because their neutrality, after 1435, in the Hundred Years' War gave them a golden opportunity to consolidate their authority in their very diverse territories, the Dukes of Burgundy became past masters at using chivalrous propaganda for their own ends. Other rulers did not see this as the pursuit of an extravagant illusion: Rather, they sought to imitate them.

The French courts of Charles VII and Louis XI do, it is true, provide something of a contrast. But the reason in the former case was partly poverty and early misfortune, partly the need to concentrate all efforts on the struggle to the death with the Lancastrian. (And we should note that as soon as the war began to slacken, Charles took the opportunity to show himself a patron of tournaments in the extravagant mode, as at Nancy in 1445, where he entered the lists in person and at the *pas des armes du rocher perilleux* at Chinon next year.)[51] In the latter case, the personal predilections of a particular, and rather peculiar, monarch have to be taken into account. After the final triumph over Burgundy, and after Louis XI was dead, we find French chivalry enjoying an Indian summer, not unlike that which Ferguson has revealed for us in Tudor England[52] and excelling it in magnificence. The "feat of arms" of the Field of the Cloth of Gold in 1520 revived all the extravagance of the Burgundian *pas des armes*.[53] Louis XII's great tournaments showed that he knew how to seek to recapture, as they had done, the glamour of an Arthurian setting.[54] The challengers of the tournament at Blois in 1554 were simply keeping up with literary fashion when they appeared in the guise of figures drawn from Ariosto and Boiardo.[55] And when the guns begin to roll in the war of Lisuard and Perion in the fourth book of the romance of Amadis of Gaul, the new darling of sixteenth-century chivalrous literature, we are reminded that chivalrous romance has not yet degenerated, even at this late stage, to the point where there is no room left for the interplay of real life with romance.[56] This late flowering of French chivalry is a warning that we need to be very restrained about exploiting the contrast, which both Huizinga and Kilgour stress, between the tone of the biography of the Burgundian courtier Lalaing and the autobiography of his contemporary, Jean de Bueil, who was Charles VII's captain. The Chevalier de Bayart, in the sixteenth century, was a greater captain than Jean and fought in wars quite as fierce, but he did not share his predecessor's distrust of chivalrous feats. He first caught attention in the martial world when, in youth, he took up the challenge in the *pas des armes* of the Burgundian veteran, Claude de Vauldray.[57] We have to go well beyond the middle of the sixteenth century before the things that recall the world of the Dukes of Burgundy and their style begin to be only echoes.

Those who have castigated Burgundian chivalry as an effort to sustain an outworn illusion have nearly always cited the Vows of the Pheasant, at

the banquet held at Lille in 1454, as the prime example of both its extravagance and its emptiness. But even here we must beware of diagnosing insincerity too readily. Philip the Good was genuinely concerned about the affairs of the eastern Mediterranean and with the crusade.[58] His house had long-standing crusading traditions: His father had led the disastrous expedition which was overwhelmed by the Turks at Nicopolis in 1396, and it was to his grandfather that Philippe de Mézières dedicated his *Epistre lamentable et Consolatoire,* in which he explained how he believed that even after that disaster the Christian crusading cause could be revived by French arms.[59] The nobility of Philip's dominions had a long tradition of involvement in the crusades against the pagan Slavs in and beyond Prussia.[60] Philip's own personal interest in the crusade was evinced at the very outset of his ducal reign, when he sent Guillebert de Lannoy to the east to obtain information about the military situation there.[61] Throughout the 1440s Burgundian flotillas were operating in the eastern Mediterranean, and there was a series of serious exchanges between the Duke and King Alfonso of Naples, with a view to a combined crusading venture.

The feast of the Pheasant was thus no isolated *coup de théatre.* It was, rather, a carefully thought-out attempt to launch an enterprise that was seriously intended with a maximum *éclat,* so as to ensure adequate support.[62] It was not the end of the recruiting effort either: After the feast there were meetings of the nobility elsewhere in the Burgundian dominions to gather more pledges of service in the forthcoming expedition.[63] Serious plans for the crusade, which by then had been postponed, following the death of Pope Nicholas V, were still under review at the beginning of 1456.[64] The sudden deterioration of Franco-Burgundian relations, following the quarrel of Charles VII with the Dauphin Louis later that year and the latter's flight to Burgundy, was what finally dashed all remaining hopes that the vows made on the Pheasant at Lille would be fulfilled. The Burgundian crusading projects of Philip the Good's reign may not have been witness to his political astuteness, but they were not make-believe. He was still making plans for a Burgundian crusade against the Turk when he died. His use of chivalrous propaganda for an end specially in keeping with the chivalrous ideal was very far from an empty gesture.

There is, of course, no denying that there was in Burgundian chivalry an element of conscious cultivation of illusion, of fantasy running wild. But there is an almost insuperable difficulty in the way of distinguishing, in the elaboration of its ceremony and ritual, between that which is inspired by an illusory dream of heroism and that which has serious purpose: They are too often two sides of the same coin. This is true not only of Burgundian chivalry, but of late medieval chivalrous culture, generally.

One particular aspect of this culture which brings out with special clarity the difficulty of making sharp distinctions in this matter is the heraldic,

and it is also one to which Huizinga and Kilgour, most remarkably, give very little attention. Most remarkably, because by the early fourteenth century (at the latest) the heralds had made of their office what was almost a secular priesthood of chivalry. Indeed, without their advice and their activities as masters of ceremony, the elaborate Arthurian and other legendary recreations of the fifteenth century would have been infinitely more difficult to stage on such a grand scale.

Heraldic books are easily the most replete repertory of the antique fictions that the autumnal chivalry of the age so relished. Here, one will find *soi-disant* authoritative accounts of the foundations of the order of heralds by Julius Caesar;[65] of the invention of blazonry by the heroes at the siege of Troy;[66] of the rules of the tournament as laid down by King Uther Pendragon; and of the blazonry of the arms of the Knights of the Round Table.[67] These last occur in a series of manuscripts which record the arms of all the one hundred fifty knights of Arthur's order. (This was thought in the fifteenth century to have been the number of his company.)

The agreement between the names of the Knights and the order in which they occur in many of the rolls suggests an established tradition[68] and offers a glimpse of the way in which heraldry and heraldic learning were powerful influences towards establishing norms of ritual and usage in chivalry. When for instance, the Burgundian heralds – Toison d'Or, Artois, Namur and Chasteaubelin – were despatched around the courts of Europe in 1448 to announce the passage of arms of *La Belle Pélérine*, carrying representations of the arms of Lancelot and Palamades which those who wished to take up the challenge should touch,[69] everyone would have appreciated whose arms they were and what overtones they were intended to give to the occasion.

The duties of the late medieval herald were, however, very far from being confined to the world of ceremony. Their knowledge of armoury could be of real importance in the field, as well as at the tourney. Because they were recognised as enjoying safe conduct in war, they were constantly employed in diplomatic activity. Lefèvre de St. Rémy, Toison d'Or King of Arms, recalled that he had served his master, the Duke of Burgundy,

alike in his wars and in his embassies, in whose behalf I was sent both to the popes Eugenius and Nicholas, and to the courts of the princes of many lands: as to the King of Aragon, and to the Kingdoms of Sicily and Naples, to Spain to the Kings of Castile and Portugal and Navarre and Granada, as well as many times into Germany and to England and Scotland.[70]

Antis's records of the journeys of Garter King of Arms over the decade 1435–45 tell a similar story of almost unremitting travel;[71] and we know that he wrote an important report on the state of the English possessions in northern France for the council – a useful reminder that the sort of business that a trusted herald might find himself concerned with was very

far from purely ceremonial. The serious business of war proves not to be separable from ceremony, however:

and it is the business [of heralds] to inquire in the day of battle who has shown *prouesse* and courage, in act or in council, and to record the names of the dead and the wounded, and whether they were in the van or the rear. . . . that there may be honour to him to whom it is due.[72]

So runs the text of one anonymous fifteenth-century treatise on the herald's office. From Anjou King of Arms we learn that even the erotic element in chivalry was not outside the herald's purview: A herald should be ready to act as a messenger for lovers, he says, and must keep their secrets, provided their love is lawful and honourable.[73] There was no aspect of chivalry, ceremonious or serious, which was not the concern of the heralds in some way or other at the end of the Middle Ages.

The heralds of the fifteenth century believed that their office was originally instituted in order to carry messages between belligerents; that is to say, for a practical and serious military and diplomatic purpose. In fact, they were almost certainly wrong. All the earliest evidence suggests that heralds first acquired a definite function in connection with the staging and organisation of tournaments and that their role as messengers in time of war was a development of the role that they had acquired in publicizing tournaments and jousts to the courts of their employers' aristocratic neighbours.[74] Here, it appears, is a reversal of the process we have been taught to expect: A role to play at the fringes of the mock war of the tournament paves the way to a serious role in the business of war and diplomacy, not vice-versa. The truth is, of course, that once again this sort of contrast is inappropriate. Armorial bearings, the special subject of heraldic learning, were granted so that they might be borne in battle, joust *and* tournament, *et in omni exercitio militari,* as a German *Wappenbrief* put it.[75] War was the special business of the nobility, which was conceived to be a martial class essentially, a warriors' estate, and the tournament was their special recreation. Jean de Bouçicaut, the champion of the jousts of St. Inglevert and the founder, in honour of womankind, of the order of the *Dame Blanche à l'Escu Vert,* was also Bouçicaut the veteran of Nicopolis and Agincourt. Jacques de Lalaing, the young hero of the elaborate Burgundian *pas des armes* was just entering, with greater maturity, on a more serious stage of his career when he met his death in the real, bloody business of war. Who knows whether he might not, had he lived, have risen to be a great captain, in the mould of a Bouçicaut, perhaps even of a Bayart? Had he done so, the heralds would have regarded his feats in the tourney and on the field as alike contributory to the chivalrous traditions that they associated with the house and arms of Lalaing: It would not have occurred to them that they belonged to separate compartments of life. Bayart's biographer made no such distinction.

Mock battle and ceremony are things almost inseparable from martial

life in any age. And in every age they will find their critics, as in modern times some are distrustful that the full glory of cavalry mess dress is no more, really, than a cover for effete snobbery. The decorative aspect of late medieval chivalrous ceremonial was, it is true, peculiarly elaborate, and the entwining of the themes of courtly love with that of martial heroism made possible an extra dimension of elaboration. But it can be misleading to concentrate too much attention on the decorative and ceremonial aspects of this chivalry. To do so almost inevitably promotes overstatement of the differences between the late Middle Ages and the times that went before. The Valois Dukes of Burgundy could indulge the aristocracy's taste for spectacle more lavishly than earlier patrons of chivalry because they were richer than most of these had been. But ceremony and mock battle and the desire to model things on the manner of the heroes of old had been vital ingredients of chivalrous culture from the beginning. The contrast with earlier times is a contrast in amplitude of style, rather than in spirit. Crusading, admittedly, had a less important relation to chivalry in the late Middle Ages than it once had, and the idea of the service of a secular sovereign, a rather more important one, but that only reflects changing political conditions. Crusading had become more difficult and materially much less attractive; princely patronage had become more vital to the nobility. Huizinga himself came very near to making this point when he remarked that "chivalry at the end of the middle ages, far from being completely disavowed, drops its affectation of quasi-religious perfection, and will be henceforth only a model of the social life." But even in this statement the implied contrast between the late Middle Ages and an earlier time, when what became affectation was serious, is probably too strong. From the very first, chivalry had been very largely what he calls a model for the social life, and important for that very reason.

Throughout Huizinga's treatment the contrast between affectation and genuine feeling, between illusion founded in mere imitation and the genuine thing, runs as a continuous theme. The reiteration makes the contrast appear too sharply in other respects besides that already mentioned. It can mislead us into underrating, in the case of chivalry, the continuous interplay that always runs between life and literature and also to underrate the seriousness of the purpose with which pageantry, imitative, in that it looked to literary models, but not solely imitative, may be associated. Perhaps my point is best put in a figure. Because Huizinga's eye is always on the westering sun and the lengthening shadow, those who gaze with him can almost forget that there cannot be a shadow without a substance. The Dukes of Burgundy and René of Anjou were skilled masters of theatre, but their political ambitions were not frivolous. They understood how to make a marriage between the ostentatious cultivation

of chivalry and the service of their own ends. Chivalry was something that they as secular princes could exploit, not because it was an enjoyable game, but because it was an ideal with largely secular foundations and which was still taken seriously by a very important sector of people. That there was a very considerable element of game in it is not to be denied, but the games that people play can be very serious indeed.[76]

NOTES

I am very grateful to Mr. P. S. Lewis of All Soul's College, Oxford, who read this paper in MS and offered a number of useful criticisms. I am also indebted to the Revd. H. E. J. Cowdrey and to Mr. M. Brett for helpful guidance on twelfth-century sources and to the editorial board of *Medievalia et Humanistica* for their helpful suggestions regarding this article.

1. J. Huizinga, *The Waning of the Middle Ages* (London, 1927); R. L. Kilgour, *The Decline of Chivalry* (Cambridge, Mass., 1937).
2. G. Cohen, *Histoire de Chevalerie* (Paris, 1948) and Richard Barber, *The Knight and Chivalry* (London, 1970) are excellent surveys, but do not offer radically new interpretations. To my mind, the most original recent discussion of the subject is A. Borst, "Rittertum im Hochmittelalter. Idee und Wirklichkeit," *Saeculum* Band 10 (1959), pp. 213–31.
3. See G. Duby 'Lignage, noblesse et chevalerie au XIIme siècle dans la région maconnaise,' *Annales* Tome 27 (1972), pp. 803–23; and 'La diffusion du titre chevalersque' in *La Noblesse au Moyen Age*, ed. P. Contamine (Paris, 1976). See also H. van Luyn 'Les *milites* dans la France au XIme siècle' *Moyen Age* Tome 77 (1971).
4. Huizinga *cit. sup.*, p. 136: Compare pp. 182, 201.
5. *Ibid.*, p. 56.
6. *Ibid.*, p. 29.
7. *Ibid.*, p. 68.
8. For details of the *pas des armes de la Fontaine des Pleurs*, see *Chronique de Mathieu d'Esouchy*, ed. G. Du Fresne de Beaucourt (Paris, 1863), Tome I, p. 264ff.
9. Huizinga, *cit. sup.*, p. 80–1; *Chronique de M. d'Escouchy*, Tome II, pp. 116–237.
10. Huizinga, *cit. sup.*, p. 69.
11. Kilgour, *cit. sup.*, p. 3.
12. *Ibid.*, p. 226.
13. *Ibid.*, p. 269.
14. I have retained the spelling given by Huizinga and Kilgour, but the name should be Bouvet: see G. Ouy, "Honoré Bouvet (appelé à tort Bonet) Prieur de Selonnet," *Romania* Vol. 80 (1959) p. 255–9.
15. *Livre des Faicts du bon chevalier Messire Jacques de Lalaing*, ed. Kervyn de Lettenhove in G. Chastellain, *Oeuvres*, Tome VIII (Brussels, 1866); *Le Jouvencel*, ed. L. Lécestre and G. Favre (Paris, 1887–9).
16. Kilgour, *cit. sup.*, p. 317.
17. *Ibid.*, p. 423; see also J. Dufournet, *La Destruction des Mythes dans les Mémoires de Ph. de Commynes* (Geneva, 1966), pp. 428–38, 609. As Dufournet explains, Commynes's systematic omission of chivalrous material

may not so much denote a change of fashion, as be connected with his twin aims of justifying himself and denigrating Charles the Bold.

18. Huizinga, *cit. sup.*, pp. 66, 80.
19. J. Rychner, *La Littérature et les moeurs chevaleresques à la cour de Bourgogne* (Neuchâtel, 1950), p. 25.
20. Kilgour, *cit. sup.*, chs. 3, 5, 6.
21. *L'Apparicion Maistre Jehan de Meun d'H. Bonet*, ed. I. Arnold (Paris, 1926).
22. William of Tyre, *A History of Deeds done beyond the Sea*, trans. E. Babcock and A. C. Krey Book XXI, ch. 7 (New York, 1943), pp. 406–7.
23. Kilgour, *cit. sup.*, p. 6.
24. St. Bernard, *De Laude Novae Militiae*, in *Opera*, ed. J. Leclercq and M. Rochais, Vol. III (Rome, 1963), p. 216.
25. Orderic Vitalis, *Historiae Ecclesiasticae*, ed. M. Chibnall (Oxford, 1969), Vol. IV, pp. 186–90; William of Malmesbury, *Gesta Regum*, ed. W. Stubbs (Rolls Series),Vol. II, London, 1889, pp. 369–70.
26. G. Doutrepont, *La Littérature Française à la Cour des Ducs de Bourgogne* (Paris, 1909), ch. 1, especially pp. 17–19; and see also his "Les Mises en prose des épopées et des romans chevaleresques" *Mémoires de L'Academie Royale de Belgique*, Lettres, Tome 40 (Brussels, 1939).
27. Rychner, *cit. sup.*, p. 18 ff.; and Doutrepont, *cit. sup.*, pp. 99–101. *Gilles de Chin* and the biography of Lalaing are almost certainly by the same author.
28. *Chronique de M. d'Escouchy*, Tome II, p. 160.
29. See *The Buik of Alexander*, ed. R. L. Graeme Ritchie (Edinburgh, 1925), p. xxxvi ff.
30. Doutrepont, *cit. sup.*, p. 113. On the vows of the Heron, see B. J. Whiting, "The Vows of the Heron," *Speculum*, Vol. 20 (1945), pp. 261–78. I am not entirely happy about the view that the poem has a burlesque intention.
31. On the crusade cycle see H. Pigeonneau, *Le Cycle de la Croisade et de la famille de Bouillon* (St. Cloud, 1877), and S. Durparc-Quioc, *Le Cycle de la Croisade* (Paris, 1955). The earliest reference to the story of Godfrey's ancestry seems to be that in William of Tyre, Lib. IX, ch. 6.
32. G. Doutrepont, "Les Mises prose des Épopées," p. 407.
33. Huizinga, *cit. sup.*, p. 66.
34. Chrétien de Troyes, *Cligès*, vv. 169–234.
35. Wolfram von Eschenbach, *Parzival*, I, vv. 91–10.
36. Chrétien de Troyes, *Lancelot du Lac*, vv. 5641–6104.
37. On tournaments, generally, see F. H. Cripps Day, *The History of the Tournament in England and France* (London, 1918); R. C. Clephan, *The Tournament: its periods and phases* (London, 1919); F. Niedner, *Das Deutsche Turnier im XII and XIII Jahrhundert* (Berlin, 1881); and R. Harvey, *Moriz von Craun and the Chivalric World* (London, 1961), ch. III, which is probably the most useful recent contribution to the subject.
38. C. Du Cange, *Dissertations sur l'histoire de St. Louys*, No. VI, in *Glossarium*, ed. Henschel (Niort, 1887), Tome X, p. 20.
39. *L'Histoire de Guillaume le Maréchal*, ed. P. Meyer (Paris, 1891), vv. 2773–2874, 2909–2940, 3428–3520, 4457–5044.
40. Philippe de Novare, *Mémoires*, ed. C. Kohler (Paris, 1913), pp. 7, 134, quoted by R. S. Loomis, "Chivalric and dramatic imitations of Arthurian romance," *Medieval Studies in Memory of A. K. Porter* (Cambridge, Mass., 1939), Vol. I, p. 79.
41. R. S. Loomis, "Edward I, Arthurian enthusiast," *Speculum*, Vol. 28 (1953),

pp. 114–127. Loomis explains in detail why Lodewijk's account is to be given some credence, in spite of a number of manifest errors of fact.

42. N. *Triveti Annales*, ed. T. Hog (London, 1845), pp. 408–9; *Flores Historiarum*, ed. H. R. Luard (Rolls Series), Vol III, London, 1890, pp. 131–2; and see N. Denholm-Young, "The Song of Carlarerock and the Parliamentary Rolls of Arms," *Proc. British Acad.*, Vol. 47 (1961), pp. 251–62.

43. G. Villehardouin, *La Conquête de Constantinople*, ed. E. Faral (Paris, 1938), Tome I, p. 4; and see E. H. McNeal, "Fulk of Neuilly and the tournament of Ecry," *Speculum*, Vol. 28 (1953), p. 371ff.

44. R. Cline, "The influence of romances on tournaments of the Middle Ages," *Speculum*, Vol. 20 (1945), p. 205.

45. On what follows in this paragraph, see further Doutrepont, *La Littérature Française*, ch. 1, and Y. Lacaze, "Le Role des Traditions dans la Genèse d'un sentiment national . . . la Bourgogne de Philippe le Bon," *Bibliothèque de l-École de Chartes*, Tome 129 (1971), pp. 303–385.

46. Doutrepont, "Les Mises en prose des épopées," pp. 403–5.

47. *Chronique de Jean Le Fèvre*, ed. F. Morand (Paris, 1881), Tome II, p. 211.

48. *Ibid.*, p. 212.

49. See C. A. J. Armstrong, "Had the Burgundian government a policy for the nobility?" *Britain and the Netherlands*, ed. J. S. Bromley and E. H. Kossman (Groningen, 1964), Vol. II, pp. 25–7; also M. le Vicomte Terlinden, "Les origines réligieuses et politiques de la Toison d'Or," *Publications du Centre Européen d'Études Burgundo-Médianes*, No. 5 (1963), pp. 41–3.

50. A. R. Myers, *The Household of Edward IV* (Manchester, 1959), pp. 3–4, 18–19, 33–4; and C. Ross, *Edward IV* (London, 1974), ch. 11.

51. G. Du Fresne de Beaucourt, *Histoire de Charles VII* (Paris, 1888), Tome IV, pp. 92–3, 183–4.

52. A. B. Ferguson, *The Indian Summer of English Chivalry* (Durham, N.C., 1960); and see also S. Anglo, *Spectacle, Pageantry and early Tudor Politics* (Oxford, 1969), ch. 3.

53. J. G. Russell, *The Field of the Cloth of Gold* (London, 1969), ch. 5.

54. M. Vulson de la Colombière *Le Vray Théatre d'Honneur et de Chevalerie* (Paris, 1648), Tome I, pp. 147–216. The Arthurian motif is most marked at the tournament that Louis held in 1493 at Sandicourt, while he was still Duke of Orleans.

55. E. Bourçiez, *Les Moeurs Polies et la Littérature de Cour sous Henri II* (Paris, 1886), p. 20.

56. *Ibid.*, p. 81.

57. *Histoire du Gentil Seigneur de Bayart*, ed. M. J. Roman (Paris, 1878), p. 24ff.

58. On Philip's crusading projects, see further N. Jorga, *Les Aventures sarrazines des Français de Bourgogne au XVme siècle* (Cluj, 1926); A. Grunzweig, "Philippe le Bon et Constantinople," *Byzantion*, Vol. 24 (1954), pp. 47–61, and "Le Grand Duc de Ponant," *Moyen Age*, Tome 62 (1956), pp. 119–65; C. Marinesco, "Philippe le Bon, duc de Bourgogne, et la croisade 1419–1453," *Actes du VIme Congrès international des études byzantines* (Paris, 1950), pp. 149–68.

59. P. de Mézières's *Epistre*, printed by K. de Lettenhove in *Oeuvres de Froissart* (Brussels, 1872), Tome XVI, p. 444ff. At Philip the Good's own court, Jean Germain, Bishop of Nevers and chancellor of the Toison d'Or, was a noted literary propagandist for the crusade.

60. See E. Maschke, "Burgund und der preussische Ordenstaat. Ein Beitrag

zur Einheit der ritterlichen Kultur Europas im späteren Mittelalter," *Syntagma Friburgense* (Constance, 1956), pp. 147–72: a very interesting and suggestive article.

61. R. Vaughan, *Philip the Good* (London, 1970), p. 268ff. Prof. Vaughan's footnotes provide a very full bibliography on Philip's crusading project.
62. Oliver de la Marche, who had an important role in planning the *tableaux* for the feast at Lille, explicitly states that this was Philip's object. See his *Mémoires*, ed. H. Beaune and J. d'Arbaumont (Paris, 1884), Tome II, pp. 338–9.
63. G. Doutrepont, "La croisade projetée par Philippe le Bon contre les Turcs," *Notes et Extraits des MSS de la Bibliothèque Nationale*, Tome 41 (1923), pp. 1–28.
64. Vaughan, *cit. sup.*, p. 360ff.
65. British Library, Cotton MS Nero D II fo. 254; see also Phillip's MS 10396 (property of the late Prof. G. W. Coopland) fo. 18.
66. B. L., Harleian MS 2259 fo. 11f.
67. A. de Blangy, ed., *La Forme des Tournois au temps du Roy Uter et du Roy Artus* (Caen, 1887); and E. Sandoz, "Tourneys in the Arthurian Tradition," *Speculum*, Vol. 19 (1944), pp. 389–420.
68. Mr. M. Maclagan has pointed this out in an unpublished paper on "Arthurian Heraldry," which he very kindly allowed me to see.
69. *Chronique de M. d'Escouchy*, Tome I, pp. 244–263.
70. B. L., Add MS 9017 fo. 32v.
71. J. Anstis, *Officers of Arms* (Coll. of Arms MS), pp. 170–2.
72. B. L., Stowe MS 668 fo. 79v.
73. A. R. Wagner, *Heralds and Heraldry in the Middle Ages* (Oxford, 1956), p. 42.
74. *Ibid.*, pp. 25, 32–3.
75. *Ibid.*, p. 123, note 10.
76. E. Berne, *Games people play* (New York, 1964); and, of course, see also J. Huizinga, *Homo Ludens* (London, 1949), and the interesting paper by D. A. Bullough, "Games people played: drama and ritual as propaganda in medieval Europe," *T. R. H. S.*, 5th Series, Vol. 24 (1974), pp. 97–122.

Printing and Military Culture of Renaissance Venice

J. R. HALE

Between 1492 and 1570 there were printed in Venice 145 works devoted to military affairs or dealing with them to a significant degree (see Appendix 1). Of these, 53 were titles (by 46 different authors) originally printed in Venice, 32 were editions of works first printed elsewhere, 48 were new editions or issues of works first published in Venice, 4 were translations of books already first published in Venice, 4 were works originally published elsewhere, and 4 were new editions of translated works. If we disregard new editions and reissues, Venetian printers produced 67 titles that were fresh to the local public (Table 1).

Comparing this number, 67, with similarly but less thoroughly based figures for whole *countries*, we get Italy (excluding Venice), 22-plus; England, 14-plus; France, 10-plus; Spain, 3-plus. Thus, not only did the production of military books in Venice vastly exceed that of any other individual printing centre, but Venice's 67 was close to the comparable

Table 1. *Books of military interest printed in Venice*

Category	Original titles	Titles first published elsewhere	Translations of works first published elsewhere	Total
Art of war	13	3	1	17
The military character	2	0	0	2
Laws of war and chivalry	15	1	1	17
Horses and riding	5	2	2	9
Fencing and gymnastics	2	2	0	4
Fortification	9	0	0	9
Artillery	4	0	0	4
Military medicine	0	2	0	2
Miscellaneous	3	0	0	3
Total	53	10	4	67

figure for the rest of Europe as a whole: 64-plus. Imperfect as these figures must be,[1] Venice's leadership in this field is startlingly apparent. It is too startling to be explained simply by remembering that Venetian printers accounted for something like half the total number of books produced in Italy during this period.[2] As Table 2 shows, only 1 author was himself a Venetian, and only 5 lived in the Veneto. Did the other 40 choose Venice because its printing industry offered authors better conditions than they could find elsewhere, or because they could anticipate a wider readership in the republic's dominions than elsewhere in Italy? If the latter reason predominated, as this article will suggest, then the maritime and commercial image that Renaissance Venice is commonly made to present will have to be revised to take account of the evidence of Table 1: that is, the absence of any work dealing with war at sea and the presence of many dealing with chivalrous interests.

Certainly the uniquely high proportion of military books did not reflect the presence of any dominating student of the subject – as the presence of Regiomontanus made Nuremberg the European centre for the publication of original contributions to mathematics. Nor was there any single publisher or printer (a not unmeaningful but uneasy distinction at this period) who built up a demand, as Aldo Manuzio did for reasonably priced classical texts. The 145 military books were produced over no fewer than 66 imprints; thirty-one different printers were responsible for the first editions of the 53 original titles. Again, works dealing with fortification, artillery and tactics, as well as a number of those concerned more generally with the art of war, required illustrations and diagrams, as, indeed, did those on fencing and one or two of the riding manuals. But taking all the books together, the level of production is competent, rather than distinguished or even particularly attractive. Only two deserve to be called "fine": the 1493 folio edition by Cristoforo da Mandello of Antonio Cornazano's *Opera belissima del arte militar* and the anonymous 1570 edition of Galasso Alghisi's *Delle fortificationi*, also a folio. Between these dates, which almost define our period, lie a mass of workmanlike, readable quarto and octavo volumes distinguishable from other Italian products by neither the aesthetic quality of the type-faces and the quality of the paper, nor the accuracy of type-setting.

The comparative (if sometimes exaggerated) indulgence of the Venetian censorship may have encouraged authors whose political or religious views or whose general scurrility might have intimidated printers elsewhere, but military books were uncontroversial. They dealt with tactics and weapons, siegecraft and fortification: Methods of warfare were broadly uniform throughout Western Europe, and the mercenary system, together with the employment of foreign engineers and artillerists, kept them so.

If censorship is irrelevant to our subject, a glance at another aspect of

Table 2. *Place of origin of authors* (*chronological order of publication*)

Author	Place of origin	Author	Place of origin
Ruffo	Calabria	Attendolo	Bagnacavallo
Cornazano	Piacenza	Ferretti (Giulio)	Ravenna
Brucioli	Florence	Centorio	Milan
Columbre	Santo Severo	Belli	Asti
Porcia	Pordenone	Memmo	Venice
Tortaglia	Brescia	Maggi	Anghiari
Biringuccio	Siena	Castriotto	Milan
Alciatus	Milan	Montemellino	Perugia
Socinus	Siena	Coniano	Coniano
Rusius	?	Rocca	Piacenza
Muzio	Padua	Caracciolo	?
Fausto	Longiano Forlivese	Cicuta (recte for Adriano)	?
Possevino	Mantua	Urrea	Spain
Zanchi	Pesaro	Sansovino	Rome
Cataneo	Siena	Mora	Bologna
Pigna	Ferrara	Cicogna	Verona
Garimberto	Parma	Ferretti (Francesco)	Ancona
Farra	? Pavia	Ruscelli	Viterbo
Lanteri	Brescia	Mercurialis	Forlì or Bologna
Nannini	Florence	Ballino	Unknown. In Venice from c.1530 on.
Susio	Mirandola	Grassi	Modena
Cyllenius	? Greece	Alghisi	Carpi

governmental contact with the book trade, the granting of exclusive sales privileges to authors, printers and publishers, might seem more promising. Yet, out of the fifty-three first editions of the original titles, only sixteen carried Venetian privileges. Twenty-five bore the unspecific formulae "con gratia e privilegio" or "con privilegio," and nine mentioned none at all. The use of the general formula increased over the years, a tendency reflected in later editions of the earlier works: Venetian privileges become general, and general ones are dropped altogether. Of the twenty-eight titles published between 1560 and 1570 only three carry Venetian privileges. Moreover, half of the works bearing Venetian privileges support them with privileges granted by other governments. But without knowing more about the enforcement of privileges it is safest to see them as conveying an aura of protection generally considered more useful than not. What can be concluded with some confidence is that there is no indication that the nature of the Venetian privilege was a factor inclining our authors to send their works for publication there.

Not enough is known about the comparative sizes of print orders for it to be guessed whether Venetian printers promised a wider numerical distribution than their rivals elsewhere. The 1,000 copies which were printed in 1547 of Niccolò Tartaglia's first pamphlet answer to criticisms of his *Quesiti, e inventioni diverse* (1546) possibly reflected a norm. Still less is known about the profitability to authors of the sale of books. Probably, it was small everywhere. Certainly, the frail (because self-interested) evidence contained in petitions to the Senate for grants of sole publication rights, which stress the heavy labour that goes into writing and printing a book, the difficulty of realizing even the capital investment, does not point to Venice as offering the inducement of greater profits than did other printing centres.

Authors, in any case, were only interested in privileges if they were underwriting the costs of printing themselves. There were, after all, no royalties, and the notion of purely literary copyright did not exist. It is doubtful whether authors received even an outright fee for the use of their manuscripts unless they were *poligrafi* writing to publishers' demands and providing editorial services for vocational reasons. What the great majority of military authors wanted from the press was fame, a reputation for expertise and support in the form of a job, a stipend or a present of cash. The printer thought in terms of the market, the author in terms of a patron. It was important, therefore, for an author to feel free to dedicate his work to the individual most likely to help him or, at least, to add lustre to his name by association.

Only two of the original titles carried no dedication, the anonymous *Libro della natura delli cavalli* . . . (1537) and *Libro de' marchi de cavalli* . . . (1569). Only four are addressed to Venetians, only two to men who were natives of the Venetian *terra ferma*. Six were dedi-

cated to condottieri or members of well known military families outside the Veneto. Most aimed higher still: Three works were dedicated to the Grand Duke of Tuscany, Cosimo I; two were dedicated to Alfonso, the heir of Duke Ercole II of Ferrara. Giacomo Lanteri, in his *Del modo di fare le fortificationi di terra* . . . of 1559, said that he wanted to have his name associated with so famous and warlike a prince as Alfonso, and he wished him all the children he could possibly want from his Medici bride. He dedicated the Latin translation of 1563, however, to Maximilian II of Hapsburg. Of the ducal family of Mantua, only one member, Ferrando Gonzaga, received a dedication.

The Farnese were more popular. In 1556 Girolamo Garimberto, himself a native of Parma, addressed his *Il capitano generale* to its duke, Ottavio Farnese, with the hope that it would help his son Alessandro match the degree of military glory attained by his ancestors. Ottavio also received dedications from the Bolognese Domenico Mora, a professional soldier who wrote that he was sending the book, *Il soldato*, "accioche vedutolo, posse giudicare quello, che io voglio per servirla," and from Giovan Mattheo Cicogna, the Veronese author of *Il primo libro del trattato militare* . . . (1567), who described him as the "idea et vero essempio di capitano perfettissima" and expressed the wish "di tutto core servirla . . . come da Signor mio unico, et singolare." In addition, Bernardino Rocca dedicated the third part (1570) of his *Del governo della militia* . . . , and Ascanio Centorio the second discourse (1558) of his *Sopra l'ufficio d'un capitano generale di essercito*, to him. The second part of Rocca's work was addressed to Alessandro Farnese, who had already, in 1568, been the dedicatee of Girolamo Ruscelli's *Precetti della militia moderna*. . . . Girolamo Muzio dedicated his *Il duello* . . . in 1550 to Emanuele Filiberto of Savoy, as did Domenicus Cyllenius his *De vetere et recentiore scientia militari* . . . in 1559. Lesser Italian princes included Jacopo Appiano, Lord of Piombino, to whom Sebastiano Fausto dedicated the *Duello* . . . (1552), which he had finished while "sotto gli honoratissimi tetti di V.S.," but they were outnumbered by monarchs.

It was natural enough for Lorenzo Suarez de Figueroa, the Spanish translator of Cornazano in 1558 to dedicate the work to Philip II, and Pietrino Belli, who addressed his *De re militari et bello tractatus* to him in 1563 had acted as a military auditor under Charles V and had been promoted by Philip to the Spanish war council. Girolamo Maggi, however, simply gave as his reason for dedicating his *Della fortificatione delle citta* . . . to him in 1564, that Philip, being "il più potente Re che sia fra Christiani," was concerned about fortifications "massimamente per essere alla sacra corona di V. Maiestà sottoposti molti di quei paesi, che hoggi sono come una trincea contra e' potentissimi nemici del nome Christiano." Maximilian II also had works on fortification dedicated to him, Giovanni

Battista Zanchi's *Del Modo di fortificar le città* . . . in 1556 and Alghisi's splendid *Delle fortificationi* . . . of 1570, while the brothers Giovanni Battista and Giulio Fontana dedicated both their newly illustrated editions of Marozzo's fencing manual and the first Venetian edition of Camillo Agrippa's *Trattato di scientia d'arme* (both 1568) to a prominent member of Maximilian's court, Don Giovanni Manriche. An earlier Hapsburg dedication had been Jacopo di Porcia's offering of his *De re militari* to the Archduke Ferdinand in 1530.

In contrast, only two works were dedicated to the Valois, Andreas Alciatus's *De singulari certamene* of 1544, which was addressed to Francis I, and Giovanni Battista Susio's *I tre libri della ingiustitia del duello* . . . offered in 1558 to Henry II; and only one was dedicated to a King of England, Tartaglia's *Quesiti e inventioni diverse* of 1546, a dedication to Henry VIII prompted by his friend and pupil in Venice, Richard Wentworth.

Dedications may, indeed, reveal more about the attractiveness of Venice to our authors than colophons. The republic's relations with its Hapsburg neighbours, and with the papacy and its satellite families and states, were often strained. Yet the dedications reveal a complete indifference to the reputation of foreign rulers and military leaders in the government's eyes. Ironically, it looks as though one factor that made Venice the leading producer of military books was her proclaimed intention of remaining neutral, with ill-will towards no-one, save the infidel.

A few authors, it is true, might be styled honorary Venetians. As a lecturer and teacher, Tartaglia, though from Brescia (which had a fairly lively printing industry of its own) was a frequent visitor and occasional resident: His *Nova scientia* . . . was published "Ad instantia di Nicolò Tartalea brisciano il qual habita a San Salvador." There were a few others who, from circumstance, visited the city for long enough, or regularly enough, to make them turn naturally to its printers. There were yet others, again few, who were honorary Venetians in a second sense: As writers on other subjects they had already associated themselves with the city's presses, had become "Venetian" authors. Before Muzio's *Il duello* appeared in 1551, Giolito had already published his edition of Tullia d'Aragona's *Dialogo della infinita di amore*, his *Operette morali* and *Egloghe*. The year 1551 also saw the publication by Giolito of his *Rime diverse*, *Lettere* and *Le mentite ochiniane*. Fausto was another author whose support from Venice's printers made it natural that his *Duello* . . . should appear there. Before its publication in 1552 he had already produced works on geography, meteorology and the art of translation, and editions of Petrarch, Erasmus, Dioscorides, Marcus Aurelius and Cicero through at least four (some works have no printer's name) different firms. Two other authors who had been drawn to Venice before writing on military affairs were Garimberto, who started authorship with

a concern for religious and moral issues, and Maggi, the classical scholar whose lively interest in warfare exemplified an attitude we shall have to examine in some detail. In the same year, 1564, that Rutilio Borgominiero printed his *Della fortificatione* . . . , Giordano Ziletti issued his *Variarum lectionum seu miscellaneorum libri IIII*, a patchwork of mainly classical materials which, nevertheless, included the most thorough account yet printed of the origin and development of gunpowder.

All the same, the "Venetian" authors were but a small minority of those who sent works to be published in Venice, many of them authors of only one book. Some sent their manuscripts because they were in contact with the *poligrafi* who, in addition to writing and editing, acted in a role which in some respects anticipated that of the literary agent. It was Ruscelli who persuaded Zanchi, during a visit to Venice, to leave his manuscript with him when he left and who arranged its publication. It was Dolce who urged Susio to send his treatise on the duel to Giolito. And it was the presence in Venice of the Spanish *poligrafo* Alfonso de Ulloa that led Ximenez de Urrea, who had previously used the presses of Antwerp, to send the manuscript of his *Dialogo* (1566) from Naples. Contacts could be fortuitous. In a letter dated from Venice on 15 July, 1566, Captain Giovanni Spinelli urged Cicogna to publish the manuscript of *Il primo libro del trattato militare* . . . (1567) which he had shown him and not "far torto di tenirla come intatta verginella più lungamente appo voi celata, et custodita."

There are other references to contacts in Venice that encouraged publishers and authors alike to believe that there was a market for their wares. Among the interlocutors of Tartaglia's *Quesiti* . . . the author names the Venetian commander-in-chief, the Duke of Urbino, and two members of the outstanding military families of the *terra ferma*, Gabriel Martinengo and Giulio Savorgnan, men whose employment by the Republic brought them frequently to Venice. He names the patricians Bernardo Sagredo, Giovanni Battista Memmo and Marc'Antonio Moro; the famous gunfounder, Alberghetto de' Alberghetti, member of a clan who had for generations been identified with the cannon cast in the Arsenal; and the Spanish ambassador, Don Diego Hurtado di Mendoza.

Another ambassador who acted as a focus for the discussion of military affairs was Giangiacopo Leonardi, the Duke of Urbino's resident representative and author of a much talked-about manuscript treatise on fortification. Lanteri, indeed, warned his readers that his own book might not treat the subject as it deserved, but "vi goderete questo fin tanto che lo Ill. S. Gio. Giacomo Leonardi vi farà vedere in questa materia un volume . . . piu tosto miracoloso che altrimenti." It was thanks to Leonardi that Daniele Barbaro inserted a section on modern fortifications in his superb Venetian edition (F. Marcolini, 1556) of Vitruvius, which also contained the chapter headings of Leonardi's own work – still un-

printed. Something of the tone in which warfare was discussed in patrician circles can be caught in a letter appended to Zanchi's book by Ruscelli. We have been bewailing the fact, he told his correspondent, Nicola Manuali, that Roberto Valturio "in quel belissimo libro" (the, indeed, most beautiful 1472 Verona edition of the *De re militari*) had not dealt with fortification. He went on to describe a conversation with Domenico Venier, who was ill in bed, and his doctor Fedele Fedeli (who was to write an unpublished history of the War of Cyprus) about the extent to which civilians knew more about the theory of fortification than did many professional soldiers. If only a true balance could be struck, he went on, between the experience of captains and the knowledge of scholars, the controversy over the precedence of Arms or Letters would be at an end. Ruscelli's own discussion about fortification in his *Precetti* . . . of 1568 contains, he acknowledges, "cose narrate da M. Gio. Tomasso da Venetia, ingegniero eccellentissimo."

In this atmosphere, where patricians, foreign ambassadors, educated non-patrician Venetians, *poligrafi* and publishers, professional soldiers and engineers discussed military affairs, there was, as the interests of Maggi have already suggested, a common ground: the relevance of the experience of classical antiquity. "Letters" stressed it, "Arms" admitted it, the press capitalized on it.

Brucioli's dedication to the Duke of Urbino referred to "lo alto valore della peritia militare, non essendo stato mai alcuna antica, o nuova arte di guerra incognita à vostra eccelenza." In 1555 Muzio wrote a prefatory letter to Lauro Gorgieri's *Trattato della guerra* . . . , which was published at Pesaro and was entirely based on classical sources. The letter was addressed to the ducal secretary of Urbino, Paolo Mario. "Veramente ha bisogno il nostro secolo di un libro tale," Muzio claimed,

Percioche tanto è guasta la militia, che ella ha mestieri di una totale riformatione. Hoggi senza haver consideratione alla qualità, et alla conditione delle persone, si danno danari à quelli che prima corrono al suono del tamburo: i gradi si distribuiscono non à chi piu ne è degno, ma à chi piu è caro, o à chi piu ha da spendere. . . . I tradamenti si procurano: le fedi delle trègue non si mantengono: et in somma nella militia di vera militia non ci rimane altro che il nome. [To correct these abuses it is necessary to study] la forma della antica vera, et regolata militar disciplina.

The need for the reform of the Italian military system had been stressed by another of our authors, Jacopo di Porcia, as early as 1492, in his *De liberorum educatione* (Gerardus de Flandria, Treviso). He recommended that boys should prepare themselves for a military career by hunting and learning to handle weapons before serving their apprenticeship under some famous commander. But when he came to deal with such men in his chapter "De militum ducibus" his tone was one of deep bitterness.

Nam in Italia omnes iam artis bellicae peritia penitus extincta est, tum ob Italorum principum avariciā, qui militiae pecuniā anteponunt, tum etiam quia ad plebeios tantum et agricolas (heu dedecus ingēs) res militaris deducta est, nobiles autem qui haereditario quodam iure in strenuissimos quodem milites, optimosque imperatores evadere possent, sine gratia, sine auctoritate, sine ulla denicque existimatione, apud principes suos hebescunt, hinc nostrae culpae ascribendum est, si a barbaris quottidie vincimur, quottidie in servitutem redigimur.

This reformist zeal, anticipating by two years the invasion of Italy by Charles VIII of France, was developed in his *De reipublicae Venetae administratione* (Gerardus de Lisa, Treviso, 1495?), a short work entirely devoted to Venice's need to prepare in peace for war, to choose good leaders and to be willing to pay them and their men enough, and in time.

Accusations and advice on these lines remained constant in the following generations, but gradually, and after the virtual adoption by Venice of Machiavelli's heavily classicizing *Arte della Guerra* (six editions between 1537 and 1554), with increasing consistency, the discussion of military reform became identified with the example of "la antica vera et regolata militar disciplina." It was conceded, for example, by Ruscelli in his letter accompanying Zanchi's *Del modo di fortificar* . . . , that gunpowder had necessitated such changes in fortifications that "si vede di gran lunga avanzar l'antiche de' Romani, de' Greci et d'ogn' altra famosissima natione." It was not accepted, however, that gunpowder weapons had destroyed the relevance of ancient tactical procedures. Indeed, the superiority of Roman and Macedonian battle formations became so familiar a theme that in 1562 Cicogna could take it for granted that "si loda la triplice ordinanza de' Romani . . . , si conosce la utilità della Falange Macedonica." Garimberto coupled a defence of ancient formations with another popular theme, the superior morale of those days; "i soldati Romani attendevano solamente à vincere, dove pel contrario i nostri attendono più al predare, spogliar, et far prigioni, che all' acquisto della vittoria." He saw this as increasing the need for modern commanders to be well read,

perchè con nissun altro mezzo più facilmente, che con quel dell' eloquenza si possono regolar le passioni dell'anima: lequali, per l'ordinario sogliono abondar nella moltitudine, massimamente quando ella è composta d'huomini per natura incontinenti, come si potrebbe dir de i soldati.

It was a belief which had already led Nannini to urge the relevance of his *Orationi militari* (1557), a collection of (mainly classical) harangues whose largest section was headed "Per esortar soldati a combattere."

The relevance of ancient to modern warfare became axiomatic. It was *the* bridge between Arms and Letters. Four of our military authors were primarily concerned with classical warfare and military training: Cyllenius,

Rocca (in his *Imprese . . .*), Cicuta and Mercurialis. One of the arches of the bridge was Porcia's insistence on preparation in peace for war, a preparation seen increasingly in terms of study, of reading. The Machiavelli, not only of the *Arte della guerra* but of *Il Principe*, chapter XIV, helped to support this arch: "Non si dovria per tanto non solo mai levare il pensiero dall' essercitio delle armi, ma nella pace non meno essercitarle che nella guerra." The soldier should hunt, for exercise and in order to imagine how to fight over different terrains; but

Si aggiunge anchora à cotali essercitij la diligente et assidue lettione de gli scittori dell' arte militare, et dell' historie, et in quelle considerare i gloriosi et degni fatti di gli huomini grandi et eccellenti, et vedere come si sono governati nelle guerre . . . et parimente fare come han fatto per l'adietro molti huomini rari et singolari, che han preso ad imitare se alcuno è stato innanzi à loro lodato et valoroso.

Up to now we have been examining almost exclusively the Venetian books dealing overtly with military matters. This quotation, however, prompts us to take notice of another category of works: editions, especially in translation, of classical historians and tactical authors, which also demonstrate a concern for the subject of war. It comes from the translation by Nicolo Mutoni of Polyaenus' *Strategemi dell' arte della guerra* (V. Valgrisi, 1552). Another translation of Polyaenus, by Lelio Carani, was published in the same year, by Giolito, and the same point is made briefly in its title: *Gli stratagemi di Polieno, di grandissimo utile a i capitani nelle diverse occasioni della guerra.*

Mutoni emphasized that his Polyaenus, based on manuscripts "delle più honorate librarie di Venetia," should be read in conjunction with the works "de' tempi nostri" of Valturio, Machiavelli and Jacopo di Porcia, of Alciato, Soncino, Fausto and Muzio. And he, too, referred to Giovan Giacopo Leonardi "il qual fra non molto tempo si spera che arrichirà il mondo con un miracoloso trattato suo." Among the ancients he cited "Heliano anchora novellamente ridotto al l'antico suo splendore con le vive et miracolose figure del raro et dottissimo nell' una e l'altra lingua il S. Francesco Robortello."

Robortello, whose works as a scholar included the first commentary on the *Poetics* of Aristotle, and who was a friend of Girolamo Maggi, had, in fact, published his Greek and Latin editions of Aelianus Tacticus, carefully illustrated with diagrams, earlier in that same year, 1552. They were printed in the same volume by Andrea and Jacopo Spinello, a small firm which took great pains over its appearance. Robortello based the Greek text on a manuscript (c. 1330) which was part of the collection left to the city by Cardinal Bessarion, and he dedicated it to one of Venice's most trusted *condottieri* and military advisers, Mario Savorgnan – "qui artis militandi veterum tum Graecorum, tum Romanorum peritissimus es" – in a letter saying how important it was for modern armies to understand

the practice of ancient ones and to adopt those that could improve their efficacy. The Latin text was addressed to another *condottiere*, the Istrian cavalry captain Antonio Sergio, with a message to the same effect. And, lest this emphasis on the relevance of what is, after all, a somewhat obscure and confused work seem due solely to Robortello's personal enthusiasm for it, it may be noted that Francesco Ferrosi had made the same point in his Italian translation of Aelian, which had been printed in the previous year – and again in Venice – by Giolito. In his dedication "Al valoroso capitano Nicolo Passerini" Ferrosi wrote of Greek formations:

et quantunque generalmente elle sieno differenti da quelle, c'hoggi di s' usano dei moderni soldati italiani, nondimeno egli non è dubbio alcuno, che s'uno esperto et giudicioso spirto consideratamente le vorra leggere, ne potrà trarre un grandissimo frutto, scegliendone tutte quelle miglior parti, che sono piu accommodate al moderno uso.

The relevance of Polybius to the contemporary military reformer had been clear from Machiavelli's use of the Greek historian. The anonymous translator of *Libro della militia de Romani et del modo dell' accampare tratto dell' historia di Polibio* (s.l., 1536) dedicated it to the Duke of Urbino. Translating the *Undici libri di Polibio nuovamente trovati* (Giolito, 1553), Lodovico Domenichi, who dedicated his work to another soldier, Captain Camillo Caula, wrote that Polybius was an historian "di quella grandezza, che voi stesso sapete, et piu volte ancho havete udito celebrare da qual rarissimo et perfetto giudicio che Sig. Giovan Iacopo Lionardi . . . ch'è da me nominato qui per cagion d'honore." In 1546 Giolito himself had dedicated Fabio Cotta's translation, *Onosandro Platonico dell'ottimo capitano generale*, to Leonardi in terms which suggest, more clearly than we have yet been able to see, the almost salon-like liaison between scholars, soldiers and publishers which helps to explain Venice's prominence as a centre for the printing of military books. I have dedicated it to you, Giolito wrote, because

Tiene V.S. tale notitia dell' arte della guerra, cosi intorno a i costumi de gli antichi, come alle usanze dei nostri tempi; che di piu non se ne potrebbe desiderare a volersi chiamare perfetto in si fatta disciplina. Della qual cosa non pure a tutto 'l mondo ne fa chiarissimo testimonio l'universal concorso, che ogni di si fa a lei da gli huomini piu intendenti, ed piu valorosi; ma si spera anco, che i celebratissimi scritti suoi in cotal materia, quand' appariranno in publico, ne debbano dare intiera contezza, et por silentio a tutti gli altri, che dopo voi vorranno.

These last were words which, had Giolito obtained the manuscript, he would have had to swallow, for military books, and classical translations aimed at an audience interested in military affairs, played a growing part in his list of publications.

Giolito's belief in the audience for translations of classical works with military applications can be seen from the first full translation of the *Guerre esterne* and the *Guerre civili* of Appian (1554–9). Lodovico Dolce,

the editor and partial translator, dedicated the first part "al chiarissimo e valoroso S. Christoforo Canale" perhaps the most imaginative and pugnacious of contemporary Venetian naval commanders; like Leonardi, he had written a treatise (but on naval warfare) which was widely admired but never given to the press. The third and last part was addressed to the Marquis of Pescara, the great Spanish soldier-administrator.

It would be wearisome to continue demonstrating the relevance felt to exist between ancient and modern military experience. In the range of authors and the numbers of editions, especially of translations, Venice led not only Italy but the rest of Europe, and the number of military dedicatees, and the theme of relevance, establish Venice as – from this point of view – the centre of the utilitarian humanism of the Cinquecento.

The connection between an interest in classical history, on the one hand, and, on the other, in the art of war was most strikingly illustrated by a hitherto unprecedented publishing venture: the issuing, in uniform format, of a series comprising translations of thirteen Greek historians, together with a parallel library of military books. The publisher was Gabriel Giolito, his editor the Tuscan *poligrafo* Tomaso Porcacchi, and the component volumes spanned the years 1557–70, though the idea of the series, as such, only took hold from 1564.[3] From that date Porcacchi and Giolito deliberately planned the continuation of some previous Giolito titles into a *Collana Historica*, a collection of translations, each called on its title page an *Anello*, to be decorated with *Gioie*, interpretative compendia and original works supporting the assumption that ancient history was chiefly important to those who plotted, organized and waged wars in the present.

The Greek historians were, in chronological order: Dictys Cretensis and Dares Phrygius (in one volume), Herodotus, Thucydides, Xenophon, Polybius, Diodorus Siculus, Dionysus of Halicarnassus, Josephus, Plutarch, Appian, Arrian and Dion Cassius. Some of the translations were reprints; others were, in whole or in part, the work of Porcacchi and his fellow *poligrafi* Nannini, Lodovico Dolce and Lodovico Domenichi. A comparable *Collana* of Latin historians was envisaged briefly but was dropped – probably for copyright, or, at least, inter-press reasons. The *Collana* had a message:

Deve principalmente avertire di tutte l'operationi che si leggono nell' historie i qual sia maggiore, et di piu importanza: et essendo senza dubbio la guerra, perche da essa dependono gli stati et gli imperi, ha da considerare il giudicioso lettore, in che modo sono stato da gli antichi maneggiati le guerre, et paragonatele con le moderne, valersi a tempo [the military lessons that could be learned from the past.]

But the lessons were buried in the flow of narrative. It was necessary to extract and collect them in a series of supplementary volumes: This, affirmed Porcacchi, "è la mia concatenatione, che in effetto desidero fare

all'historia." No-one, moreover, could remember everything an historian said. For the busy, practical man what was needed was "una raccolta di quasi tutte l'historie, fruttuosamente ordinata per beneficio di chi essercita la militia." Hence, the *Gioie*.

Before looking briefly at the items in this remarkably methodical prospectus (Appendix 2), it is worth emphasizing that the collection – the *Collana* and its *Gioie* – was conceived as a whole, as a complete library for the student of warfare, lacking only works on the duel and on fortification which were already freely available. Title pages carried the announcement that the volume constituted such and such an *anello* or *gioia*, and there were frequent prefatory references from Giolito or Porcacchi to the scope of the collection as it grew. The last volume of the historians contained a biographical appendix relating to the authors as a whole. Each book was indexed with unusual fullness, though, as was common in the period, the haphazard use of keywords reduced their practicability: "Errori de Carthaginesi," or "Guerra sanguinosa," for example. All the volumes were printed in italic and in the same quarto format – "tutti in una giusta et convenevol forma, et con equali, ma però sempre belli et sempre vaghi ornamenti," as Porcacchi put it in one prefatory letter. In another, Giolito reminded his readers that with this collection "potrete poi adornare le vostre stanze." And that readers did build up the complete collection is confirmed by the sale of one in 1773 from the library of Joseph Smith, the famous British Consul in Venice.

The first of the military *Gioie* referred to was *Le cagioni delle guerre antiche* (1564), in which Porcacchi produced an anthology of (mostly condensed) passages from the Greek historians which dealt primarily with the causes of war. Against these he noted the moral, or general principle, each appeared to illustrate, so that the reader could consider not only why wars came to be waged but under what circumstances they had the greatest likelihood of success. It was, in fact, a thematic key to the *Collana*: "A beneficio," or, as the title put it, "di chi vol' adornarsi l'animo delle Gioie dell' historie." Porcacchi did not produce, as the prospectus implies, a companion volume.

The second was Centorio's *Il primo discorso . . . sopra l' ufficio d' un capitano generale di essertio* (1558), the first part of the five-part work we have treated as one volume in our list of Venetian military books, as they appear to have been issued together in 1568, although each has a separate title page. The third was Centorio's *Il terzo discorso di guerra . . . nel qual si tratta della qualità, ufficio, et autorità d' un mastro di campo generale* (also 1558). The fourth was another on our list, Mora's *Il soldato . . . nel qual si tratta di tutto quello, che ad un vero soldato, et nobil cavalliere si conviene sapere ad essercitare nel mestiere dell' arme,* first printed by Giovanni Griffo in 1569 but taken over by Giolito in 1570. The fifth was Centorio's *Il quinto et ultimo discorso* (1562), the sixth,

another on our list, was Rocca's *La seconda parte del governo della militia . . . nella qual si tratta con discorsi e con essempi de' più eccellenti historici, come s'ha da provedere ne' fatti d'arme, ne gli assalti delle fortezze, ne' ripari di tutti i pericoli di guerra, e nella conservatione de gli stati* (1570). This is normally bound with *La terza parte . . .* (also Giolito, 1570; separate pagination and title page), though there is no reference to its status as a *Gioia*.

The seventh was another of Porcacchi's "keys" to the *Collana, Paralleli o essempi simili . . . cavati da gl' historici, accioche si vegga, come in ogni tempo le cose del mondo hanno riscontro, o fra loro, o con quelli de' tempi antichi* (1567). On its title page it was denominated "la seconda Gioia," but this was before the publishing team had decided to intersperse the theme of the military relevance of antiquity with works concentrating on contemporary warfare. In the dedication to the patrician cleric Luigi Diedo, Porcacchi pays tribute "al Magnifico S. Gabriel Giolito de' Ferrari, primo padre et fautor di cosi honorato assunto" and describes his own role as the provider of reference works that will extract the military pith from the historians and cut down the time which the reader might otherwise have spent, in spite of the indices, locating passages which would bring light from the ancient world to bear upon the military problems of the present. The work lives up to its title: It quotes illustrations from the past, along with comparable actions and consequences in modern times; it is based on the assumption that the present can learn from the past.

The eighth work, the treatise on castrametation, was not published. The ninth was Bernardino Rocca's *Imprese, stratagemi et errori militari . . . ne' quali discorrendosi con esempi, tratti dall' historie de' Greci, et de' Romani, s'ha piena cognition de' termini, che si possono usar nelle guerre, cosi di terra, come di mare,* announced as "la quarto gioia" when it was published in 1566. This is another work that may be considered to be a military book, though its general resemblance to Porcacchi's *Paralleli . . .* is a warning as to how indeterminate the definition of a "military book" can be. Rocca does, at least, draw on personal experience in his comments on the feints and other devices employed by commanders in antiquity. The tenth work was another of our titles, Nannini's *Orationi militari. Raccolte . . . da tutti gli historici greci e latini, antichi e moderni . . .*, published by Giolito in 1557, two years before Porcacchi's arrival in Venice, and not improbably the work that suggested the premise of the whole collection. The publisher had been encouraged enough by its reception to bring out a second, enlarged edition in 1560. The demand, however, was not sufficiently great to call for an edition which would identify the book as a *Gioia*.

Giolito did publish Rusconi's edition of Vitruvius, but not until 1590, and with no reference then to the *Collana* and its *Gioie*. On the other

hand, another *Gioia* was published but then dropped from the prospectus: Oratio Toscanella's *Gioie historiche, aggiunte alla prima parte della vite di Plutarco* . . . , which Giunta published in 1567; a companion volume to the "seconda parte" appeared in 1568. This was planned as a "key" to a new edition of a translation by various hands of Plutarch's *Lives*. In a letter to his readers prefaced to the 1566 edition of Dion Cassius, Giolito announced this, "ch' è un Anello nella nostra Collana Historica de' Greci; con l'aggiunta di tutte le Gioie piu preciose, che vi son dentro, scelte da M. Horatio Toscanello, per dimostrar l' utilità che si trahe da quella lettione." The *Vite di Plutarco Cheroneo* duly appeared in two parts in 1567 (part two) and 1568 (part one), and a letter to the reader drew attention to Toscanello's *Gioia*, which gathered together, as in a vast subject index, "tutti i frutti che si possono cavar dalla lettion di questo famoso auttore." The work itself, however, carried no reference to the *Collana* or to the other *Gioie*, which suggests that the decision had already been taken not to include it in the collection. Whatever the reason, it was not, in thematic terms, a logical one, for among the *Gioie historiche* was a rich assortment of articles, resembling those in an encyclopedia, dealing with the history and development of weapons and armour, with warfare in general and, in particular, with the ranks, training and tactics of the infantry and cavalry of the Romans.

Among contemporary architects, Palladio showed an unusual lack of interest in fortifications, neither designing them nor writing about them. He explained this in the Introduction to his richly illustrated edition of *I commentari di C. Giulio Cesare*, pointing out that no fortification can be made strong enough to resist a really determined enemy in the long run: Not walls and bastions but properly organized armies were a country's best defence. Though its publication (Pietro de' Franceschi, 1575) lies beyond the chronological scope of this survey, the edition splendidly sums up the connection between the study of ancient history and that of modern warfare. Moreover, its Introduction allows us to see how the literary culture of Venice and its *terra ferma* encouraged authors to write about war, and the book trade to print their works with confidence in the buoyancy of the home market. For, however good a printing house's colportage system was, an estimated profit margin depended in the first instance on the probability of local sales.[4]

Palladio's interest in the training and organization of ancient armies and the lessons to be derived from studying them had, he said, been aroused by his early patron and intellectual guide, Count Giangiorgio Trissino. Trissino's long epic poem, *Italia liberata da Gotthi* (3 vols., Rome and Venice, 1547–8) had been written to underline this lesson, as the author pointed out in his dedication of the work to Charles V. Encouraged by Trissino, Palladio set himself to read widely (in translation) in the historical and technological literature of antiquity. He was encouraged by

other contacts he made through his patron with Mario Savorgnano, Robortello, Filippo Pigafetta, author of an unpublished translation of the Emperor Leo VI's treatise on tactics, Francesco Patrizi, author of two works comparing ancient and modern military practice, and, perhaps above all, the Vicentine professional soldier Valerio Chieregato, who wrote an original treatise (again, unpublished) on Roman and Macedonian troop formations. Palladio dismissed the argument that firearms had negated the relevance of classical battles; method and discipline were more important than any weapons. He rebutted, as well, the suggestion that modern soldiers were too clumsy and ignorant to be tought the drills and formations that had brought victory to ancient armies. Patrizi and Chieregato were both present when Palladio proved his point by actually putting an ad hoc collection of pioneers and galley oarsmen recruits through a training session *all 'antico*. That an architect of villas and churches could take to barking orders on an impromptu parade ground is an index, just as suggestive as is the presence of erudite soldiers like Savorgnan and Chieregato, of a fairly calculable body of readers for military books; the Venetian press, and the authors who used it, could reckon on an audience comprising both practising and armchair students of the art of war.

For a wider appraisal of that audience it is necessary to take some note of the military system of the Venetian republic. Though based on the employment of mercenary troops it was not merely peripheral to the consciousness and experience of the reading public in Venice itself or the *terra ferma*. Among the permanent army, garrisoned among Venice's subject towns and cities, of from four thousand to eight thousand men, depending on the international situation, were many representatives of families who served the republic generation after generation. While never anything like in a majority, there was an increasing tendency to employ natives of the Veneto as officers in the army's permanent core and to rely on native volunteers in time of peace. And, while the presence of troops in garrison was a familiar feature of citizen life, a peasant militia of some twenty thousand men was organised among the villages and hamlets of the countryside and assembled for regular training periods on a regional basis. Every large town had its locally-recruited, part-time *scuola* of bombardiers and was the scene of periodic marksmanship contests where it was open to all who could handle an arquebus to compete for prizes. Finally, the Veneto was the seat of an important arms industry; from heavy cannon to bits and bridles, it was a net exporter of military equipment.

Nor was Venice itself isolated from the sights and sounds of military life. As street names like Spaderia and Frezzaria suggest, it was a centre for the production of small arms, and the whole of the republic's bronze guns were cast in the Arsenal. The armoury in the Arsenal was supposed to be

capable of outfitting ten thousand soldiers and, together with the smaller but more select armoury of the Council of Ten in the Ducal Palace, was a coveted attraction for important visitors. The shooting competitions on the Lido could attract over eight hundred entrants from all classes. Suggesting the reorganization of a civic militia of six thousand in Venice, Adriano met the argument that it could be dangerous to arm the *popolo minuto* by saying "che ad ogni modo il popolo di Venetia ha l'arme in mano: percioche non vi è artista, nè piu minimo meccanico, che non habbia in bottega, et in case arme d'asta, di fuoco et di ferro, per offendere et difendere." And, in fact, throughout its domains, Venice was probably of all governments the one most willing to trust its subjects to possess arms. It was an attitude supported by the lack of mutinies on vessels in which every man, from oarsman to patrician commander, was armed against the possibility of combat at sea or while watering and taking in stores.

Few patricians fought as professional soldiers – about thirty in 1509–30, perhaps a dozen thereafter. Several hundreds went as temporary volunteers to Padua and Treviso in the years immediately following the disaster of Agnadello. Thereafter, small numbers were sent, again for short periods, to raise morale and command the companies defending city gates. The practice was revived in the Turkish war of 1537–40 and in 1570 twenty-two patricians were sent for gate duty at Zara, Sibenico, Traù, Spalato and Cattaro. From 1509 and 1515 to 1542 there were sporadic moves to pass legislation encouraging young patricians to train as army officers, but all evaporated in debate.

Yet it is probably not an exaggeration to suggest that no other governing class had so informed an interest in military affairs as did the Venetian patriciate. Experience at sea accounted for much, but at any given time more patricians were occupying posts involving some military duties by land than on shipboard. Patricians acted as *castellani* of forts; *rettori*, primarily the *capitano*, but also the *podestà*, were responsible for town garrisons and the country militia in their jurisdiction. In wartime special military *proveditori* were appointed to command key cities and to accompany the army and its chief detachments, and these were men whose opinions on military planning were taken seriously by professional officers and who frequently rode into action with them; the image of the military proveditor as simply a political watchdog is a quite misleading one.

Moreover, thanks to the principle of rotation, men with military experience by sea and land were constantly drawn into the chief councils and magistracies where military policies were discussed and implemented: the Senate, the Council of Ten and the College. Add to these the permanent magistracies responsible for artillery, the arming of galleys and the planning and construction of fortifications, the responsibility of itinerant *inquisitori* to report on garrisons and fortresses, the constant coming and

going of professional commanders to discuss army affairs with the doge and College, plus the hundreds of secretaries and accountants from the citizen class who accompanied *rettori* and proveditors and sat on councils and magistracies – and the resultant picture is of a large group of men likely to be interested in military books. Add, again, the military families of the *terra ferma* and their retainers, and the home market may be imagined as a potentially broad one. And this is without taking into account the more scholarly or purely recreational or predominantly legal interest in the subject.

This interest, as far as the somewhat loose category (see Table 3), the Art of War, is concerned, was satisfied chiefly in the fifties and sixties; that is, after the conclusion of the war period 1494–1529 and the Turkish War of 1537–40. Partly, this reflects the increasing productivity of the printing industry as a whole, but it also reflects the common experience that more military books are written and printed in periods of peace than when fighting is imminent or actually going on. The tag, "in peace prepare for war," was much bandied about. Reformers urged that changes be made before the outbreak of hostilities meant that there was time to do nothing but reimplement the old methods, faults and all. In 1542, in a confidential *Discorso sopra la sicurezza di Venetia*[5] (one of many such pieces

Table 3. *Works by category (numbers refer to Appendix I)*

Category	Original titles	Title first printed elsewhere	Translations of works first printed elsewhere
Art of War	2,14,66,68,85,100, 109,116,118,125, 128,134,140.	3,7,24	48
The military character	9,102		
Laws of war and chivalry	31,32,42,49,52,54, 62,72,87,88,89,97, 101,119,120	5	65
Horses and riding	1,18,19,117,138	51,96	35,36
Fencing and gymnastics	135,141	44,132	
Fortification	58,61,69,86,106,107, 108,124,142.		
Artillery	22,26,39,129		
Military medicine		114,123	
Miscellaneous	70,136,143		

of advice), Alvise Gritti, illegitimate son of the great wartime doge Andrea Gritti, stressed that "è tempo che questa Republica si faccia più gelosa assai del solito a questo poco stato che gli è rimasto," that the militia should be improved, defences strengthened, control over the permanent army tightened; and he made another unsuccessful plea that young patricians should be trained for war on land. It was among the first of a flood of memoranda submitted to the government by *rettori, proveditori* and commanders-in-chief, all appealing for changes to be made before it was too late. These arose from tours of inspection, from parades, from discussions between *rettori* and municipal councils, all of which served to sustain public interest in the role of the military among them.

Before 1550, the only original publications in this category were the books of Cornazano (1493) and di Porcia (1530), both strong on exhortation and weak on information. More solid fare was provided by works reprinted in Venice. First printed in Augsburg in 1473, Egidio Colonna's *De regimine principum* was brought out in 1498 and 1502. Though written around 1285, the last twenty-three chapters, which dealt with war, provided the clearest summary of classical thinking about the subject then available. More specific in the practical advice they had to offer were two imports which Venetian printers made practically their own. First published in Naples in 1521, Battista della Valle's *Vallo: libro continente appertenentie ad capitani . . .* appeared in Venetian editions or reissues no fewer than thirteen times between 1524 and 1569 (elsewhere, only in French, at Lyons in 1529 and 1554). Also first published in 1521 (in Florence; second edition 1529), Machiavelli's *Arte della guerra* became "Venetian" with editions in 1537, 1540, 1541, 1546, 1550 and 1554. For all their discursiveness and lack, at times, of a sense of practicability, these two works nevertheless set new standards for Europe as a whole, new with regard to their relevance to current practice and with respect to the use of elaborate and accurate diagrams. The quality and popularity of these "imports" may well have encouraged the publication of original works in the fifties and sixties.

That the first work published in these decades (within the same category) was a translation is none the less appropriate, for Raimond de Fourquevaux's *Instructions sur le faict de la guerre* (Paris, 1548) drew heavily on Machiavelli. Translated by Mambrino Roseo as *Tre libri della disciplina militare* (1550), it was ascribed in the privilege to "Monsignor di Lange"; that is, to Guillaume de Bellay, Sieur de Langey, with whom the work was regularly associated in all its sixteenth-century editions and translations. The works originally printed in Venice then appeared in a cluster: Garimberto and Farra (1556), Cyllenius (1559), Centorio (1558–62), Giovacchino da Coniano (1564), Rocca (1566), Adriano (1566), Cicogna (1567), Ferretti (1568), Moro (1568), Rocca again (1570).

Most of these works touch with more or less emphasis on the qualities

required of the soldier, especially of senior officers. It is appropriate, then, to associate with the Art of War category the works by Brucioli (1526) and Memmo (1563), which, though not treatises on war, contain sustained discussions of the military character. It was, of course, a topic of deep concern to the civilian employers of mercenary captains and to the natives of the *terra ferma* who suffered from the indiscipline of their men. The Venetian literary tradition hardly encouraged a trust in the military: Ruzzante's cowardly peasant volunteer, Aretino's young officers, "schiave da la desperazione e figliastre di quella porca fortuna che non si stracca mai di crocifiggerci per tutti i versi," the braggart of classical comedy brought back to the stage in such works as Lodovico Dolce's *Il capitano* of 1545 (new editions, 1547, 1560). The cowardly (partly because ill-trained) peasant was a cause of concern to those who ran or wished to reform the militia, but, while his inefficiency was deplored, he was not seen as a potential danger to the state. The long-service troops who formed the peacetime garrisons were, again, often licentious and idle, but this was, in the main, shrugged off as inevitable. The real tensions arose when debating the potential loyalty of commanders-in-chief – debates which could drag on for months – and when considering the dangers to be anticipated when recruiting in time of war very large numbers of men who had had no previous connection with Venice: tensions, painfully irresolvable, between need and trust.

In theory, wrote Memmo in his *Dialogo nel quale . . . si forma un perfetto principe ed una perfetta republica, e parimente un senatore, un cittadino, un soldato e un mercatante*, war was an "illustre et eccellente arte . . . senza la quale . . . niuna Republica si può conservare et illustrare." But this is not demonstrated by men who serve "solo per un vil stipendio et mercede. Divenuti lupi sitibondi del sangue humano, non attendono ad altro, che a rubbare et far ogni male, abbrucciando insino le case de i poveri contadini . . . et in vece di esser forti contra gli inimici questi sono crudeli et superbi contra gli amici." The patrician class has always served at sea. "Ma all' incontro nella Terra ferma, dove sempre ha adoperato le arme mercenarie et forestiere ha fatto poco progresso, et il tutto con suo grandissimo disavantaggio et ruina. Che se havessero i nostri padri adoperato le arme proprie cosi in terra, come in mare havevano fatto essercitando in quelle i suoi Cittadini, havrebbono superato lo Imperio Romano." He then fends off the suggestion that such arms might be turned against the state (could not naval commanders have done that if they wished?) and proceeds to advocate military training for "tutti i giovani della Città . . . et de' luoghi soggetti a quella." The interest of this discussion does not lie in its originality, for it has none, but in the evidence it provides for the long-prevailing nervousness about the republic's military system, a nervousness that provided another incentive to read about the conduct of wars, actual or ideal.

Given the popular image of Venice as a marine and mercantile capital, it may seem strange that the second largest category is that of books dealing with the laws or war and of chivalry, backed up by subordinate categories dealing with horsemanship and personal combat. Does the argument that printers first considered the home market apply here too?

To give an added resonance to the question it may be asked why one Venetian printer, Domenico Nicolini, was so quick to publish, in a translation from the French, the herald Sicile's *Trattato de i colori nelle arme, nelle livree, et nelle divise* (1565) or why another, Giordano Ziletti, produced an edition of Paolo Giovio's *Ragionamenti sopra i motti et disegni d'arme et d'amore* only a year after its appearance in 1555 in Rome. (Giolito printed a Spanish translation, by Alfonso de Ulloa, in 1558.) Indeed, why was it Venice which took over such authors as Pulci, Boiardo and Ariosto and became *the* publishing centre for those who wished to read about the chivalric adventures of (among others) Amadis, Altobello, Mambriano, Sir Bevis, Il Cavallier del Sole, Drusiano dal Leone, Falchonetto, Fioravante, Ganelon, Il Cavaliere de l'Orsa, Palmerin, Perceforest, Platir, Primaleon of Greece and Rinaldo de Montalbano?

The connection between the Art and the Law of War had always been close, because writers on the former were seldom able to resist justifying the existence of warfare and defining the just use of it, while writers on the latter were forced to specify the situations to which the laws applied. In Venetian experience the laws were particularly relevant in their applicability to capitulation terms (the campaigns of 1509–29 had come to centre on the siege and defence of towns) and to declarations of war and truces. Adequate defence and instantly mobilizable military self-sufficiency were all the more necessary, "non procedendo più la maggior parte dei principi con l'antiqua e buon costume solito di mandar li araldi a nuntiar la guerra", as Alvise Gritti wrote. "Taccio che si fanno le guerre non per giustitia, ma per appetito," Muzio wrote deploringly in his introduction to Gorgieri's *Trattato della guerra* . . . in 1555, "nelle taglie et ne' prigioni le giuste regole non si servano: i tradimenti si procurano: le fedi delle tregue non si mantengono: et in somma nella militia di vera militia non si rimane altro che il nome."

There was, similarly, a connection between the law of war and the conventions of the duel; the lawyers saw war as a duel between nations, and writers on the honour code applied to the motives and conduct of the duel something like the concept of the just war. The mixture can be seen in the reprint which stands earliest in the category Laws of War and Chivalry. First published about 1471 in Naples, the Venetian titlepage (1521) of the work by "il generoso misser Paris de Puteo" reads: *Duello, libro de re, imperatori, principi, signori, gentil' homini, et de tutte armigeri, continente disfide, concordie, pace, casi accadenti, et iudicii con ragione, exempli, et authoritate de poeti, hystoriographi, philosofi, legisti, canonisti*

et ecclesiastici. Five editions followed, each produced by a different firm, in 1523, 1525, 1530, 1536, and 1540. Elsewhere, the work appeared in collections which now stressed the duel, now the general law of war; in Venice it was printed together with Belli's *De re militari et bello* (Venice, 1563) in the collection *Tractatus universi juris* of 1584. The editions of original works dealing more or less exclusively with the duel and the honour code start with Alciatus and Socinus (printed together in 1544 and translated together in the following year in two separate editions by Vincenzo Vaugris and by Alvise de Tortis). In the 1550s came an impressive cluster: Muzio, two different works in 1550 and 1551; Fausto da Longiano in 1552; Possevino in 1553; Pigna in 1554; Susio in 1558; another work by Muzio in 1559; Attendolo and new works by Fausto in 1560. The two works that conclude this category deal with more general chivalric themes: the *Dialogo de la verdadera honrra militar, que tracta como se ha de conformar la honrra con la conscientia* (the nub of the duelling issue!) of Geronymo Ximenez de Urrea and Francesco Sansovino's *Origine de cavalieri*, both of which appeared in 1566.

The only "cavalieri" created by Venice were those of San Marco. It was a non-hereditary title, and though it was granted to soldiers, especially to stradiot captains from the empire *da mar*, it was not primarily a military one, nor were its members (as with the Tuscan Knights of San Stefano, for instance) part of a formally constituted order. On the face of it, indeed, a purely legally defined upper class, as was that of Venice, was difficult to accommodate to the chivalrous overtones of other aristocracies, though the legal definition gave ample scope for genealogists and heralds. Muzio himself faced the question of what sort of nobility was represented by the patriciate in *Il gentilhuomo* (1571). Venice, he wrote, is "città nobilissima per antichità, per Signoria, et per gloria d'arme, et di lettere, piene di Signori, et di cavalieri. . . . Oltra che essi sono Signori del mare. . . . Si che se per nascimento, et virtù sono nobili, per istato etiando sono Signori. Di che ne seguita, che dir si dee di loro, che sono nobilissimi."

Muzio's *Lettere* (Giolito, 1551), containing an epistle to the Marchese del Vasto in which he sums up his attitude to knighthood and the duel, was dedicated to the patrician military proveditor and ambassador Vicenzo Fedeli, whom he represents as "tra gli armati eserciti . . . sostenendo la persona della Eccellentissima Vinitiana Republica." But references to Venetians in a chivalrous context are rare. Susio, exceptional as an opponent of the duel, said in his *I tre libri della ingiustitia del duello . . .* (1558) that "io gia più di dieci anni sono, tenni, et difesi il mio parere in Venetia." Together with Porcacchi's remark in a letter to Mario Cardoini, prefacing Rocco's *Imprese . . .* of 1566, to the effect that in a discussion he had had about "un perfetto Cavaliero" with Pietro Bizarro and the diplomat and Knight of Malta Sir Richard Shelley, Cardoini had been named

as an ideal example, this suggests that chivalrous topics were not uninteresting to Venetians and their friends, though it was doubtless among readers outside the lagoon that the market envisaged by the printers lay.

That this market was wide is shown by Sir Christopher Hatton's copy of the second edition (Giolito, 1558) of Possevino's *Dialogo dell' honore* in the Bodleian Library at Oxford; but, as with works on the art of war, the chivalrous category was probably aimed in the first place at Venice's aristocratic subjects in the castles and cities of the *terra ferma*, cities like Vicenza, "la qual è stata sempre florida per studio di lettere, e d'arme," as Fausto put it in the dedication to the "Signori Academici Costanti, nobilissimi Vicentini" of his *Dialogo del modo de la tradurre* . . . (Giovanni Griffio, 1556), or Brescia, where Porcacchi was entertained with "giostre e torneamenti" by Count Alfonso Cavriolo, according to a letter in one of his *Gioie*, Rocca's *La seconda parte del governo della militia* (1570). Apart from absorbing the values of the influential military dynasties, Avogaro, Martinengo, Collalto, da Porto, Savorgnan and many others, and of the "foreign" captains in garrison, the *terra ferma* remained open to the example of knightly pastimes and the cult of duelling in its neighbour states, Milan, Austria and the Tyrol, Ferrara and Mantua. Venice also recognized the value of the honour code, and the skills in riding and fencing it called for, as a means of keeping the energies and ambitions of the young nobles of the *terra ferma* within reasonable bounds. The deliberate encouragement of these potentially useful occupations came later, with the formal creation of military academies between 1608 and 1610 in Padua, Verona, Udine and Treviso. In our period only one attempt was made to harness the energies associated with "honour," the setting-up in 1566 of a riding academy in Verona. Among its regulations was one requiring members to serve the government for four months, at their own expense, in time of war. It lasted until 1607, and it was the example of its beneficial effect on formalising violence that might otherwise have been politically dangerous, that prompted the Senate to support the more formal institutions that took its place.

The social habits of the *terra ferma*, then, provide ample explanation for the publication of books in this "aristocratic" category and in the more technical categories that depend on it: Horses and Riding, Fencing and Gymnastics. Some of these, it should be acknowledged, have but a tenuous connection with the actual practice of war. The *Libro de marchi de cavalli* . . . of 1569, for instance, is simply a guide to the identification of thoroughbreds through their brands. Fieschi has illustrations of numerous types of bits and horseshoes, and his illustrations of riding techniques (some with bars of music for the rider to hum as a guide to the rhythm of the exercise) are aimed at the *manège*, not the battlefield. Ruffo wrote for the *marescalco*, rather than his employer. Only one chapter in Mercurialis's *Artis gymnasticae libri sex* . . . refers directly to the military

relevance of physical exercise. The fencing manuals are often coy about the applicability of their art to combat in the field. Yet at a time when horsemanship and swordsmanship were virtually the only attainments required of a potential army officer it is perhaps pedantic to omit the books which illustrate the degree of interest taken in these skills, especially when they underline the extent to which the Venetian printing industry was conditioned by the taste of the *terra ferma*. For, at least as far as military culture is concerned, it is artificial to think of the lagoon as a sealed world – a point every *rettore*, proveditor, inquisitor or ambassador, forced to spend much of his time in the saddle, with a sword at his side, would have taken for granted.

The most impressive category among Venetian military books was the group devoted to fortification. Among the earlier works reprinted there were some (those by Colonna, della Valle, Machiavelli) which treated the subject as an ingredient of the Art of War, in general. But with the publication in 1554 of *Del modo di fortificar le città* . . . , by Giovanni Battista Zanchi, a military engineer in the republic's employ, there began a series of specialized works, all printed for the first time in Venice. The only book devoted to fortification which had appeared in Europe before Zanchi's treatise was Albrecht Dürer's *Etliche underricht, zu befestigung der Stett, Schloss, und flecken* (Nuremberg, 1527). Between 1554 and 1570 only two other works on fortification were published anywhere else than in Venice: Girolamo Cataneo's *Opera nuova di fortificare* . . . (Brescia, 1564) and the *Discorsi di fortificationi* of Carlo Theti (Rome, 1569). Zanchi's book was published in French as *La manière de fortifier villes, chasteaux, et faire autres lieux forts* (Lyons, 1556) by a translator, François de la Treille, who posed as the author. Three years later, via what was basically a translation of la Treille's text, it passed into English as Robert Corneweyle's *The maner of fortification*. . . . This version remained unpublished, but when the first printed English work dealing with fortification, Peter Whitehorne's *Certain waies* . . . (London, 1562), appeared, much of it was translated more or less exactly from the Italian edition of Zanchi.

That this sort of diffusion through piracy should have happened to Zanchi, rather than to Pietro Cateneo, whose *I quattro primi libri di architettura* was also published in 1554, is understandable; the latter was much longer, and only one of its four books dealt principally with fortification. It was, indeed, the last treatise to deal with both civil and military architecture, for, as fortifications became more complex, their design was increasingly seen as the province of specialists. Giacomo Lanteri's *Due dialoghi* . . . (1553) are rigorously concerned with the geometrical basis of fortress design and with surveying and model-making – that essential means of communication between engineers on the site and the government and their advisers in the capital. Equally technical is his treatise

on earthen fortifications of 1559 (translated into Latin in 1563). Girolamo Maggi's *Della fortificatione delle citta* of 1564 was, for all the author's humanistic and literary bent, a practical work made all the more useful by the clearest illustrations of fortification methods yet produced and by his including edited versions of two supporting texts: the posthumous treatise of Jacopo Castriotto on the fortifications he had come to know when working as Superintendent of Fortresses in France and Francesco Montemellino's *Discorso sopra la fortificatione del Borgo di Roma*. Fortification occupied only one of the *Tre quesiti . . .* (1567) of Domenio Mora, but our period ends with the thoroughly technical and splendidly illustrated *Delle fortificationi libri tre*, by Galasso Alghisi. So specialized, indeed, had military engineering become that Alghisi, or his anonymous publisher, commissioned an engraved title-page showing a Roman triumphal arch peopled with statues representing the Quadrivium and the Virtues associated with a sturdily defended polity: fortitude, prudence, justice and temperance. It was to provide a model for a host of later title-pages whose imagery was devoted to pleading that, though military engineering relied on brute strength, it was nevertheless a liberal art and required the exercise of *ingegno*.

That Venetian printers should have produced a near-monopoly of works dealing with the new art of fortification that had been forced into being by the use of effective siege artillery is not surprising if we think, again, in terms of the potential market. Other states, in Italy and beyond, were building new fortresses and bringing town *enceintes* up to date, replacing walls and tall towers with squat curtains and pointed bastions. It is doubtful that any state, however, had a larger re-building programme in this period than Venice, nor one that was so widely discussed. In 1517 Andrea Gritti, the most respected military proveditor of his time, and a future doge, recommended what was to remain the republic's defence strategy. It was unwise, he wrote, to trust to frontier fortresses, for, once broken through, they left the republic's armies nowhere to shelter. Certain places should be strengthened because of their strategic value, such as Asola, Peschiera and Legnago, but the chief care should be to refortify the large centres of population, not only so that they could resist siege but also to turn them into cities of refuge for retreating or assembling armies. Brescia, Bergamo, Crema, Verona, Padua, Treviso, Udine: The fortification of all were to undergo changes which were the subject of intense interest to their populations – if only because they had to bear one-third of the costs. On these grounds, indeed, coupled with an outcry against the losses to property that followed the modification of walls and the clearing of a deep glacis, Vicenza managed to defeat a whole series of proposals and remained the only city on the *terra ferma* whose walls were more or less unaltered from pre-gunpowder days.

The need for up-to-date fortifications was not only a strategic but a

political necessity, to give credibility to the policy of armed neutrality adopted by the republic after 1529. And the constant menace of raids by, and the possibility of war with, the Turks meant that the process of modernization had to be carried on in the ports down the Dalmatian coast and in Cyprus and Crete. The patriciate thus came to contain a large number of men who, as rectors, proveditors, inquisitors and castellans, had been forced to acquaint themselves with the principles of modern military engineering. In addition, there were constant interviews in the College with engineers, Senate debates during which models and plans were explained, the appointment of special proveditors to supervise changes once they had been decided on or to confer with experts on the spot and report back to Venice. From 1542 the pressure of building-work was so great that a new magistracy was created, that of the *proveditori alle fortezze*. When we add the arm-chair experts in Venice, like Leonardi and the men Ruscelli mentions in his letter accompanying Zanchi's book, the senior officers of the permanent army who were concerned in every new project, and the self-constituted experts in the *terra ferma* who showered gratuitous advice on the government, we can assume that printers could think reasonably safely of an adequate market within Venice and its own dominions.

To connect books on artillery with those on fortification is an obvious step. Here, too, Venice took the lead and remained without the need to reprint works first published elsewhere. The *Nova scientia* of Niccolò Tartaglia (1537) was aptly named. It was the first work devoted to the subject of artillery to be printed and the pioneer contribution to the new science of ballistics. Biringuccio's *Pirotechnia* (1540) was the first printed book on metallurgy, the casting of cannon and the manufacture of explosives and incendiary compounds. Gabriello Busca's *Istrutione de' bombardieri* . . . (1545), the next work on artillery to be published in Europe, was the first practical guide to the handling of guns. In 1546 Tartaglia published his *Quesiti, et inventioni diverse,* a work which extended his ballistic theories, as well as containing important sections on fortification, surveying and troop formations. Between this work and the publication in 1568 of Ruscelli's posthumous *Precetti . . . ne' quali si contiene tutta l'arte del bombardiero* only two works dealing with artillery had appeared outside Venice, Walter Ryff's *Der furnembsten, notwendigsten der ganzen Architectur angehörigen mathematischen und mechanischen kunst* . . . (Nuremberg, 1547) and Girolamo Cataneo's *Un trattato de gli esamini de' bombardieri* . . . (Brescia, 1564). The subject had also been touched on in a few works on the art of war published elsewhere, but for books exclusively or weightily concerned with artillery Venice's lead was as striking as in the field of fortification.

To describe the gunfounding industry, the organisation of the *scuole di bombardieri*, the duties of munitioneers and the responsibility of patri-

cian councillors and office-holders to keep abreast of changes in the making and use of artillery by land and at sea would serve only to labour a now-familiar point, that Venetian leadership in the production of military books depended on a capacious and widely recognized industry which could reckon on an interested local market. There is, all the same, one further point to make about that market. Fortification, ballistics, troop evolutions and formations: All came to assume a knowledge of mathematics. Tartaglia had lectured on Euclid in Venice before the publication of his *Nova scientia*. On its title-page the author is shown standing between maidens labelled "Aritmetica" and "Geometria" while he watches the trajectories of a cannon and a mortar; in the background philosophy sits enthroned in an enclosure, the entrance to which is guarded by Plato, who flourishes a scroll inscribed "Nemo huc geometrie expers ingrediatur." Zanchi pointed out that "son necessarie la geometria, l'aritmetica, per numerare et dividere le misure delle fortezze." Pietro Cataneo's *Le pratiche delle due prime matematiche* . . . was published in Venice in 1559. One of Lanteri's *Due dialoghi* was "del modo di disegnare le piante delle fortezze secondo Euclide," and in his treatise on earthen fortifications he emphasized the prime importance of "la cognitione delle forme, la quale non si puo in vero perfettamente possedere, senza la geometria," and in 1569 Mora told his readers that nowadays the Sargente Generale, the officer responsible for brigading an army, "deve essere buon arithmetico et abbachista."

An interest in mathematics was widespread in Italy, but it is particularly appropriate that it was in Venice that science in this form came to affect the nature of books about the art of war. The foundation had been laid, well before the setting up there of a public lectureship in mathematics in 1530, by the instruction given at the Scuola di Rialto in the mid-fifteenth century and in the first publication of works like Fra Luca Pacioli's *Summa* . . . (1494) and the first Latin translation of Euclid (1505). The original holder of that lectureship was the patrician Giovanni-Battista Memmo, a friend of Tartaglia's. When the latter was attacked in a pamphlet of 1547 by a rival mathematician, Ludovico Ferrari, fifty copies were addressed personally to influential men in different parts of Italy; by far, the largest group, twenty, were natives or residents of Venice. The activities of the Accademia Venetiana, set up in 1557, were to have a strongly mathematical bias. When Curtio Troiano published Tartaglia's formidable posthumous work, *Il general tratato di numeri et misure* in six parts in 1556, three of the parts were dedicated to military men: Camillo Martinengo, not only a soldier but a man drawn to learning "et massime alla divina scienza di Matematica"; Venice's commander-in-chief, Sforza Pallavicino; and the influential condottiere Girolamo Martinengo, "essendo Ella un de' primi lumi, che in questi nostri tempi si trovino, della militia, et dilettandosi sommamente delle cose delle fortificationi, et

delle ordinanze, le quali cose non si possono perfettamente intendere, senza l'aiuto delle Mathematiche."

Of the nine European works printed in this period that dealt specifically with military medicine, especially with the treatment of gunshot wounds, four were reprinted at Venice, though only two of these had not already been reprinted elsewhere: Leonardo Botallo's *De curandis vulneribus sclopettiorum* (1564; original edition, Lyons, 1560) and Giovanni Rota's *De tormentariorum vulnerum natura* (1566; original edition, Bologna, 1555). More initiative was shown in the two works, first published in Venice, that comprise (in addition to Nannini's *Orationi militari* . . .) the admittedly vague and subjective category "Miscellaneous." Giulio Ballino's *De' disegni delle piu illustre città et fortezze del mondo*, which Bolognino Zaltieri produced in two separate editions in 1565, was the first topographical work aimed at an audience primarily interested in war, with its engraved views of forts and battle sites in Italy, France, Hungary and Transylvania. The *Informatione a soldati christiani et a tutti coloro che sono su la potentissima armata* . . . of 1570 was the shrewdest piece of propaganda that had yet been issued to a military force. Francesco Sansovino opened it in the traditional vein of the eve-of-battle harangue that had been represented in Nannini's *Orationi militari*. "La Maestà di Dio, o soldati, vi apparecchia una bella et honorata vittoria, la quale continouando voi nell'ardente dispositione dell'animo vostro, vi sarà facile ad ottenere." God will humble the pride of the Turks. What is more, "il nemico si trova per mare inferiore alle nostre forze, tanto per legni, quanto per capitani et soldati." The Turks are legally in the wrong, for they, not the Venetians, have broken the truce. Their morale has been sapped by years of peace. Their vessels are outmoded, over-weighted with rigging, their oarsmen are not trusted to carry arms. Sansovino then breaks with tradition by introducing a series of woodcuts illustrating the various types of troops the Venetians are about to encounter. All of them, including the dreaded Janissaries, are made to look remarkably harmless. Here they are, he emphasizes, men of flesh and blood, no nobler nor more valourous than other men; indeed, easier to defeat because they are "infami et privi d'ogni ordine di militia." And he ends with a reassuring reminder of the Turkish failure in Malta in 1565.

The vast proportion of writings about war in this period that exist in Venice were not, of course, intended for publication: reports, surveys, projects and suggestions submitted to or requested by the government. The majority were, in any case, too topical, or too narrow in subject matter to have repaid publication. A very few were too confidential, an example being Maggi's compilation of fortification devices and secret weapons (including poisons) designed to help Famagusta, were it to be besieged by the Turks; "il qual libro," as the endorsement to the Council of Ten's minute of 23 February, 1570, reads, "fo salvato, dal mg.co con-

cellier grande nel suo leto."[6] But while it is hazardous to generalize about military culture on the evidence of published works alone (even in a century when the press was so active), two things can be said with some confidence: the archival material supports the interest in military affairs already claimed for the Venetian patriciate and the citizens of the *terra ferma*, and the manuscript treatises that remain in libraries would not, had they been printed, affect the impression given by the published works, either in range or quality – with one most notable exception.

The first book printed anywhere in Italy that dealt exclusively, or even at length, with naval warfare was Pantero Pantera's *L'armata navale* (Rome, 1614), a fact that makes the silence of the Venetian presses less surprising. Yet some surprise must remain, given the numbers of Venetians who had had ship-board experience, the continuity of combat or anti-corsair activity, the experimentation with new craft and the means of arming and manning them and the recognition of naval warfare as a subject: Underneath the armoured busts of Alessandro Contarini and Girolamo Michiel in the church of San Antonio in Padua the inscriptions read "totius maritimae disciplinae simulacrum" and "rei navali scientia . . . praestanti." In 1558 Vincenzo Valgrisi printed the *Elogia venetorum navali pugna illustrium* of the Venetian cleric Antonio Stella, a collection of forty-seven brief biographies of patrician sea captains designed to stimulate a patriotic ardour among the young. But no battles are described, no interest in naval warfare evinced. The materials for Mario Savorgnan's *Arte militare terrestre e maritima* . . . (1599) were accumulated, as we have seen, before his death in 1574; yet, in spite of the title, naval affairs amount to little more than a description of Lepanto.

The silence is not to be explained in terms of secrecy. Huge numbers of men were constantly being recruited from the *terra ferma* and the empire *da mar* and then being redistributed there. The trials of new warships were conducted publicly. Naval tactics were more or less common to all the Mediterranean naval powers. Continual piracy meant that the vessels of one state were constantly falling into the hands of others. Three reasons explain the silence. One is familiarity; naval powers are less interested in writing or reading about navies than about armies. Another is sameness; naval tactics were extremely simple and changed very little during the period we are considering. The last and possibly most important reason is that there was no classical precedent for the independent, or even reasonably detailed, treatment of naval warfare. Cyllenius's title (1559) recalls that of Savorgnan, *De vetere et recentiore scientia militari, omnium bellorum genera, terrestria perinde ac navalia . . . complectente,* and its treatment of war at sea, which is exclusivly classical, is just as brief as his. What is surprising, then, is not that no work on naval warfare was published but that one – Cristoforo da Canal's *Della milizia marittima* – was actually intended for the press.

Da Canal was born in 1510 and died of wounds received in combat at sea in 1562. He exemplified those poor patricians whose lives were entirely dedicated to government service. In his case, apart from a term of office as proveditor of Marano, this was spent entirely at sea: "I quali tutti carichi, et honori non sarebbono stati a vostra Magnificenza," wrote Lodovico Dolce, dedicating his edition of Appian to him in 1559 (though the colophon has 1554), "cosi spesso, e con tanto favore conceduti, se non si fosse in lei veduto trovarsi tutte o la maggior parte di quelli conditioni, che convengono a vero e perfetto capitano." He continued,

Taccio che come che'l suo proprio e principale esercitio, sia stato sempre quello delle arme, in quello della penna riesce lodevolissimamente: come ne rende chiara fede il Dialogo da lei gia gran tempo fatto della militia maritima; ove tratta pienamente e leggiadramente di tutto quello, che appartiene a condurre un' armata, alle battaglie, et alle cose di mare, formando un legno, et un capitano a perfettione.

That this manuscript had a status comparable to that of Leonardi's is suggested by a reference in Porcacchi's *L'isole piu famose* . . . (1572) to

Christoforo Canale, oltra che in mare fece molte prove; fu ancho tanto prattico in quei governi, che pare c' hoggi tutti gli altri siano per imitar la disciplina di lui, trovandosi per le mani de' nobili un libro, ch' io ho veduto, composto da esso Canale: il quale insegna con giudicio et con ordine tutta la disciplina navale.

The manuscript is not dated, nor, on internal evidence, is it easy to date. Influenced by Dolce's "gia gran tempo," M. Nani Mocenigo, who first printed it (Rome, 1930), put its composition at around 1540. Alberto Tenenti, whose *Cristoforo da Canal: la marine Vénitienne avant Lépante* (Paris, 1962) renders prolonged description of the work here superfluous, prefers a later date, 1553–4. It is not uninteresting, however, that P. A. Zeno, whose *Memoria di scrittori veneti patritii* (Venice, 1662) cites Canal's work as the first of a military nature to be produced by a Venetian patrician before Pietro Maria Contarini's work on land war, *Corso di guerra* . . . (Venice, 1601), dates it 1538.

The dialogue form (one of the interlocutors is the Alessandro Contarini whose tomb commemorates him as "totius maritimae disciplinae simulacrum"), the references to Rome and Carthage, the emphasis on the usefulness of writing about, as well as practising military affairs, are aspects of the work, as well as a strong if cumbrous attempt at a literary style, which make it clear that Canal had publication in mind. He was, moreover, a friend of Dolce, one of the most prolific writers of the age, and da Canal took it upon himself to get the work of another friend ("anchora che senza il consentimento di lui") into print: Antonio Pellegrini's *I segni de la natura ne l' huomo* (Giovanni Farri for J. Gryphius, 1545) – a topic interesting to Canal for its bearing on the choice of men to crew galleys. *Della milizia marittima* is a mine, indeed *the* mine, of detailed information about the design, armament, crewing and handling of war galleys and

their deployment on patrol or in war. Yet that the writer was also a reader is made clear, time after time. Discussing the theme that "l'arte della guerra non si aprende nei libri," one of his characters goes on to say:

ricordomi haver udito raccontare [the story was told by Bandello] che Nicolò Macchiavelli, il quale così ben ragionò et scrisse delle cose che appartengono a un capitano et soldato da terra, essendo messo dal sig. Giovanni de' Medici alla cura delle genti delle quali esso era capitano pose ogni cosa in disordine.

It is certainly not unlikely that Canal, at the end of a life increasingly heavily committed to naval service, left the manuscript unfinished and unprinted because of his conscious rivalry with the literary form (also a dialogue) of such a work as Machiavelli's *Arte della guerra*.

The work also suggests a more general reason for the lack of books on naval warfare – the degree to which the subject overlapped that of war on land. Naval tactical formations for the highly manoeuvrable, fore-and-aft firing galleys comprised little more than variations on the advance guard, main body and rearguard of contemporary armies. Battle at sea was avoided as much as possible; apart from convoy escort, coastal patrol and deterrent shows of strength, the warship's characteristic function was that of a troop-carrier supporting amphibious or purely terrestrial operations. With its *scapoli* and *soldati*, a galley carried a company of infantrymen whose armament, training and organization are treated by Canal with frequent reference to the companies garrisoning the fortresses of the *terra ferma*. Whether it concerned the character of a commander or the preliminary bombardment followed by grappling and boarding which made naval engagements resemble sieges, the *arte militare maritima* – especially in the absence of an independent, classically based tradition – was difficult to imagine as a subject in its own right, and Canal was able to make it one only by reconsidering naval affairs, from ship design to strategy, with the verve of an anecdotalist and the zeal of a reformer.

What, then, can be concluded from this survey? Hopefully, it suggests that neither what is known about the functioning of the printing industry nor what might be conjectural about the existence of an international market can explain Venice's unique role in the production of books dealing with military, or quasi-military subjects. The explanation lies mainly in the existence of an informed and interested local market for such works, both in Venice and its territories. If this is so, then a larger place than has hitherto been acknowledged must be accorded to the role of military culture in the *forma mentis* of Renaissance Venetians and their subjects.

NOTES

This article is a revised version of a study which is to appear in the volume devoted to Renaissance Venice in the *Storia della Cultura Veneta*, to be published by Neri Pozza of Vicenza. I am most grateful to Signor Pozza for

permission to publish in this form. I am indebted to Dr. Dennis E. Rhodes, and Professor Conor Fahy, whose scrupulous reading of the draft of this study saved me from many errors. It has also benefited from the vigilance of the editorial board of *Medievalia et Humanistica*.

1. In the absence of a short-title catalogue of Italian books printed in the fifteenth and sixteenth centuries, they are based on: Maurice J. D. Cockle, *A Bibliography of English Military Books up to 1642 and of Contemporary Foreign Works* (London, 1900; reprinted 1957); M. d'Ayala, *Bibliografia militare italiana* (Torino, 1954); *Short-title catalogue of books printed in Italian and of Italian books printed in other countries from 1465 to 1600 now in the British Museum* (London, 1958). *Short-title catalog of books printed in Italy . . . 1501–1600 held in selected North American Libraries* 3 vols. (Boston, Mass., 1970). Also useful were: Horst de la Croix "The literature on fortification in Renaissance Italy," *Technology and Culture* (1963), 30–50; T. M. Spaulding, "Early military books in the Folger Library," *Journal of the American Military History Foundation* (1937), 91–100; J. R. Hale, "A Newberry Library Supplement to 'Cockle,'" *Papers of the Bibliographical Society of America* (1961), 137–9; T. M. Spaulding and L. C. Karpinski, *Early Military Books in the University of Michigan Library* (Michigan, 1941).

2. Horatio Brown, *The Venetian Printing Press* (London, 1891) is still useful. Apart from Salvatore Bongi's *Annali di Gabriel Giolito de' Ferrari*, 2 vols. (Roma, 1890–5), there is very little discussion of post-Aldine Venetian printing; see the excellent bibliography in Ruth Mortimer, *Italian Sixteenth century books* (Cambridge, Mass., 1974), vol. 1.

3. See Paul F. Grendler, "Francesco Sansovino and Italian popular history," *Italian Renaissance Studies* XVI (1969), 158–61.

4. Rudolf Hirsch surely exaggerates the effectiveness of Venice's distribution system north of the Alps, especially for works in Italian in his *Printing, selling and reading, 1450–1500* (Wiesbaden, 1967), 58–9.

5. Marciana Library, Venice, Mss. Misc. c.3504.

6. Archivio di Stato, Venice, Consiglio dei dieci, Secreta Deliberationi, Registro 9.f.57.

APPENDIX 1

A check list of books of military interest printed in Venice, 1492–1570

Check no.	Year	Status	Author	Short title[a]	Printer[b]
1	[1492]	A	Ruffo, Giordano	. . . arte del congnoscere la natura de cavael . . .	Piero Bergamasco
2	1493	A	Cornazano, Antonio	Opera belissima delarte militar . . .	Christophorus de Pensis [Mädello] for Piero Benalio
3	1498	C	Colonna, Egidio	De regimine principum (orig. Augsburg, 1473)	Simon Bevilaqua
4	1502 1517°	C		New ed. of no. 3.	Bernardinus Vercellensis
5	1521	C	Puteo, Paris de [= Pozzo, Paride dal]	Duello . . . (orig. Naples, 1471)	[Gregorio de Gregoriis for Melchiorre Sessa and Pietro dei Ravani]
6	1523	C		New ed. of no. 5	Gregorio de Gregoriis
7	1524	C	Della Valle, Battista	Vallo . . . (orig. Naples, 1521)	[Gregorio de Gregoriis]
8	1525	C		New ed. of no. 5	[Gregorio de Gregoriis] for M. Sessa and P. dela Serena
9	1526	A	Brucioli, Antonio	Dialogi	Gregorio de Gregoriis
10		B[a]		New ed. of no. 2	Melchiorre Sessa
11		C		New ed. of no. 7	?
12	1528	C		New ed. of no. 7	Pietro dei Ravani
13	1529	C		New ed. of no. 7	Nicolò d'Aristotile Zoppino
14	1530	A	Porcia, Jacopo di	. . . de re militari . . .	Joannes Tacuinus
15		C		New ed. of no. 5	Aurelio Pincio
16	1531	C		New ed. of no. 7	Vittore dei Ravani & Co.
17	1535	C		New ed. of no. 7	Vittore dei Ravani & Co.

53

APPENDIX 1. *Continued*

Check no.	Year	Status	Author	Short title[a]	Printer[b]
18	1536[e]	A	Columbre [or Colombre], Agostino	Libro . . . dedicato al . . . re Ferdinando . . .	Piero dei Nicolini da Sabbio for Piero Facolo
19		A	Anon	. . . natura delli cavalli . . .	Francesco Bindoni and Mapheo Pasini
20		B		New ed of no. 2	Piero dei Nicolini da Sabbio
21		C		New ed. of no. 5	Piero dei Nicolini da Sabbio
22	1537	A	Tartaglia, Niccolò	Nova scientia . . .	Stefano dei Nicolini da Sabbio for N. Tartaglia
23		B		New ed. of no. 9	Bartholomeo Zanetti
24		C	Machiavelli, Niccolò	Arte della guerra (orig. Florence, 1521)	No printer.
25	1539	C		New ed. of no. 7	Vittore dei Ravani & Co.
26	1540	A	Biringuccio, Vanuccio	De la pirotechnia	Venturino Ruffinelli for Curtio Navò
27		C		New ed. of no. 24	Sons of Aldus
28	1541	C		New ed. of no. 5	Comin da Trino
29		C		New ed. of no. 24	Comin da Trino
30	1543	C		New ed. of no. 7	Heirs of Pietro dei Ravani
31[f]	1544	A	Alciatus, Andreas	. . . de singulare certamine	Vincenzo Valgrisi
32[f]		A	Socinus, Mariano	Consilia . . . in materia duelli	Vincenzo Valgrisi
33		B		New ed. of no. 19	Francesco Bindoni and Mapheo Pasini
34		B		New ed. of no. 9	Francesco Brucioli & Bros.
35		D	Rusius, Laurentius	. . . de l'arte del malscalcio (orig. Latin, s.n.)	?
36		D	Vegetius Renatus, Publius	. . . dell'arte di manescalchi . . . (orig. Latin, Basel, 1528)	Michele Tramezzino
37	1545[g]	D		Duello, Italian tr. of no. 31	Vincenzo Valgrisi
38		D		Another setting of no. 37	Alvise de Tortis
39	1546	A	Tartaglia, Niccolò	Quesiti et inventioni . . .	Venturino Ruffinello for N. Tartaglia
40		C		New ed. of no. 24	Aldus

No.	Year		Author	Title	Printer
41	1548	D	Muzio, Girolamo	New ed. of no. 35	Michele Tramezzino
42	1550	A		Il duello . . .	Gabriel Giolito & Bros.
43		B	Marozzo, Achille	New ed. of no. 22	No printer, for N. Tartaglia
44		C		Opera nova . . . (orig. Modena,1536)	Giovanni Padovano for Melchiorre Sessa
45		B		New ed. of no. 26	Giovanni Padovano for Curtio Navò
46		C	Fourquevaux, Raymond de[h]	New ed. of no. 24	Gabriel Giolito & Bros.
47		C		New ed. of no. 7	Heirs of Pietro dei Ravani & Co.
48		D		. . . della disciplina militare . . . (orig. Paris, 1548)	Michele Tramezzino
49	1551	A	Muzio, Girolamo	Le risposte cavalleresche	Gabriel Giolito & Bros.
50		B		New ed. of no. 42	Gabriel Giolito & Bros.
51		C	Grisone, Federigo	Gli ordini di cavalcare (orig. Naples, 1550)	?
52	1552	A	Fausto da Longiano, Sebastiano	Duello . . .	Vincenzo Valgrisi
53		D		New ed. of no. 37	Comin da Trino
54	1553	A	Possevino, Giovanni Battista	Dialogo dell'honore . . .[i]	Gabriel Giolito & Bros.
55		B		New ed. of no. 42	Gabriel Giolito & Bros.
56		B		New ed. of no. 49	Gabriel Giolito & Bros.
57		C	Zanchi, Giovanni Battista	New ed. of no. 51	?
58	1554	A		Del modo di fortificar le citta	Plinio Pietrasanta
59		B	Cataneo, Pietro	New ed. of no. 39	Niccolò de Bascarini for N. Tartaglia
60		C		New ed. of no. 24	Domenico Giglio
61		A		. . . libri di architettura . . .	Sons of Aldus
62		A	Pigna, Giovanni Battista	Il duello	Vincenzo Valgrisi
63		B		New ed. of no. 1	Heirs of Giovanni Padovano
64		B		New ed. of no. 42	Gabriel Giolito [and Bros.?]

Check no.	Year	Status	Author	Short title[a]	Printer[b]
65	1555	D	Massa, Antonio	Contra l'uso del duello (orig. Latin, Rome, 1556)	Michele Tramezzino
66	1556	A	Garimberto, Girolamo	Il capitano generale . . .[j]	Giordano Ziletti
67		B		New ed. of no. 58	?
68		A	Farra, Alessandro	. . . dell'ufficio del capitano[k]	A. della Paglia
69	1557	A	Lanteri, Giacomo	Due dialoghi . . .	Vincenzo Valgrisi and Baldassar Costantini
70		A	Nannini, Remigio	Orationi militari . . .	Gabriel Giolito
71		B		New ed. of no. 66	Giordano Ziletti
72	1558	A	Susio, Giovanni Battista	. . . della ingiustitia del duello . . .	Gabriel Giolito
73		B		New ed. of no. 22	No printer
74		B		New ed. of no. 42[l]	Gabriel Giolito
75		B		New ed. of no. 49[l]	Gabriel Giolito
76		B		New ed. of no. 54	Gabriel Giolito
77		B		New ed. of no. 26[m]	Comin da Trino for Curtio Navò
78		C		New ed. of no. 7	Giovanni Guarisco & Co.
79		D		Las reglas militares. . . . Spanish tr. of no. 2	Giovanni Rossi
80	1559	B		New ed. of no. 26	Girolamo Giglio & Co.
81		D		New ed. of no. 35	Girolamo Cavalcalupo
82		B		New ed. of no. 52	Rutilio Borgominieri
83		B		New ed. of no. 26	Girolamo Giglio & Co.
84		B		New ed. of no. 54	Gabriel Giolito
85		A	Cyllenius, Domenicus	. . . de vetere et recentiore scientia militari . . .	Comin da Trino for F. da Portonari
86		A	Lanteri, Giacomo	. . . fare le fortificationi di terra . . .	Bolognino Zaltieri for Francesco Marcolini
87	1560	A	Muzio, Girolamo	Le faustina . . . delle arme . . .	Vincenzo Valgrisi

No.	Type	Author	Title	Date	Publisher
88	A	Attendolo, Dario	Il duello . . .		Francesco Lorenzini
89	A	Fausto da Longiano, Sebastiano	Duello . . . con un discorso . . . e con due risposte . . .n		Rutilio Borgominieri
90	B		New ed. of no. 58		D. and C. de' Nicolini da Sabio
91	B		New ed. of no. 42		Gabriel Giolito
92	B		New ed. of no. 62		?
93	B		New ed. of no. 52		Rutilio Borgominieri
94	B		New ed. of no. 1	1561	Rutilio Borgominieri
95	B		New ed. of no. 18		Francesco Fasani
96	C	Fiaschi, Cesare	. . . del modo dell'imbrigliare . . . (orig. Bologna, 1556)		Domenico Nicolini
97	A	Ferretti, Giulio	Consilia et tractatus . . .	1562	Lodovico degli Avanzi
98	B		New ed. of no. 22o		Curtio Navò
99	B		New ed. of no. 39o		Curtio Navò
100	A	Centorio, Ascanio de Hortensii	. . . sopra l'ufficio d'un capitano generale . . .	1558–62	Gabriel Giolitop
101	A	Belli, Pietrino	De re militari . . .	1563	Francesco Portonari
102	A	Memmo, Giovanni Maria	Dialogo . . .		Gabriel Giolito
103	B		New ed. of no. 42q		Gabriel Giolito
104	B		New ed. of no. 49q		Gabriel Giolito
105	D		De modo substriendi terrena . . . (Latin tr. of no. 86)		Vincenzo Valgrisi
106	A	Maggi, Girolamo	Della fortificatione delle citta . .r	1564	Rutilio Borgominieri
107	A	Castriotto, Giacomo Fusto	Della fortificatione delle cittar		Rutilio Borgominieri
108	A	Montemellino, Francesco	La fortificatione del Borgo di Romar		Rutilio Borgominieri
109	A	Coniano, Giovacchino da	Trattato dell'ordinanze . .r		Rutilio Borgominieri
110	B		New ed. of no. 42s		Gabriel Giolito
111	B		New ed. of no. 49s		Gabriel Giolito
112	B		New ed. of no. 54		Gabriel Giolito

APPENDIX 1. *Continued*

Check no.	Year	Status	Author	Short title[a]	Printer[b]
113		B		New ed. of no. 88	Gabriel Giolito
114		C	Botallus, Leonardo	De curandis vulneribus scloppetorum (orig. Lyon, 1560)	Francesco Rampazetto
115	1565	B		New ed. of no. 88	Gabriel Giolito
116	1566	A	Rocca, Bernardino	Imprese, stratagemi et errori . . .	Gabriel Giolito
117		A	Caracciolo, Pasquale	La gloria del cavallo	Gabriel Giolito
118		A	Adriano, Alfonso[t]	Della disciplina militare . . .	Lodovico degli Avanzi
119		A	Ximenez de Urrea, Geronymo	. . . de la verdadera honrra militar . . .	Giovanni Griffio
120		A	Sansovino, Francesco	Origine de cavalieri	C. and R. Borgominieri
121		B		New ed. of no. 66	Giordano Ziletti
122		B		New ed. of no. 42	Gabriel Giolito
123		C	Maggius, Bartholomeus	De vulnerum sclopetorum (orig. Bologna, 1552)	Gratioso Perchacino[u]
124	1567	A	Mora, Domenico	Tre quesiti . . .	Giovanni Varisco & co.
125		A	Cicogna, Giovan Mattheo	Il primo libro del trattato militare . . .	Giovanni Bariletto
126		B		New ed. of no. 100	Gabriel Giolito
127		B		New ed. of no. 61	Paolo Manuzio
128	1568	A	Ferretti, Francesco	Della osservanza militare . . .	C. and R. Borgominieri
129		A	Ruscelli, Girolamo	Precetti della militia . . .	Heirs of Melchiorre Sessa
130		B		New ed. of no. 54	Francesco Sansovino
131		C		New ed. of no. 44	Antonio Pinargenti
132		C	Agrippa, Camillo	Trattato di scientia d'arme . . . (orig. Rome, 1553)	Antonio Pinargenti
133		B		New ed. of no. 100	Gabriel Giolitto
134	1569	A	Mora, Domenico	Il soldato . . .	Giovanni Griffio
135		A	Mercurialis, Hieronymus	Artis gymnasticae . . .	Giunta[v]

No.	Type	Author	Date	Title	Printer
136	A	Ballino, M. Giulio		De disegni delle . . . citta et fortezze . . .	Bolognino Zaltieri
137	B			New ed. of no. 136	Bolognino Zaltieri
138	A	Anon.		Libro de marchi de cavalli	Niccolò Nelli
139	D			Del vero honore militare (Italian tr. of no. 119)	Heirs of Melchiorre Sessa
140	A	Rocca, Bernardino	1570	La seconda [e terza] parte del governo della militia . . .	Gabriel Giolito
141	A	Grassi, Giacomo di		Ragione di adoprar . . . l'arme . . .	Giordano Ziletti & Co.
142	A	Alghisi, Galasso		Delle fortificationi	No printer
143	A	Sansovino, Francesco		Informatione a soldati . . .	No printer
144	B			New ed. of no. 134	Gabriel Giolito[w]
145	B			New ed. of no. 120	Heirs of Melchiorre Sessa

Key: A = Work first printed in Venice.
B = Later edition of works first printed in Venice.
C = Venetian editions of works printed elsewhere.
D = Translation.
? = Unseen by compiler.

[a] Excluding classical works, histories, campaign reports and biographies of military figures.
[b] Printer's names given as in British Library *Catalogue of Italian books . . . 1465–1600.*
[c] Cockle follows Ayala (see text note 1) in attributing a misdated copy of no. 44 (ed. of 1568) to this year, thus making it a work first printed in Venice. See Mortimer (see text note 2) Vol. II, p. 423.
[d] As the interest of this Appendix is primarily statistical, no distinction is made between new editions and new issues; some of the latter, for example, nos. 71, 115 and 133, are issues of existing page stock redated on the old title page.
[e] Doubtful, but earliest edition known to me.
[f] Published together.
[g] Cockle follows Ayala in attributing the first edition of Gabriel Busca, *Instruttione de' bombardieri* to this year. As Busca was born around 1540 and refers to a work of Domenico Mora's which must be our no. 124 of 1567, this cannot be right, nor can Ayala's Venetian editions of 1554 and 1559. The first is almost certainly Carmagnola, 1584.
[h] Attributed in 1548 and 1550 to Guillaume du Bellay. The common attribution since the last century to Fourquevaux is still unproven.

i "Di nuovo stampato" on title page; but in sense of "for the first time."

j "Nuovamente mandato in luce" on title page; but again in sense of "for the first time."

k Date from, Ayala, followed by Cockle, who nevertheless gives Pavia, 1564, as the *princeps*. I have not found a copy of the 1556 edition. The dedication of the Pavia edition to Hestorre Visconte" is dated Pavia, April 1, 1564, which casts further doubt on the 1556 edition.

l Published together.

m Colophon 1559.

n Treated as an original work because of the amount of new material.

o Published together.

p Five parts, separate title pages, published together.

q Published together.

r Published together.

s Published together.

t Actually by Cicuta, Aurelio.

u T.p.: "Venetiis Apud Gulielmum Valgrisum et Io. Alexium Socios et bibliopolas Bononie." Colophon: "Venetiis apud Gratiosum Perchacinum."

v T.p.: "Venetiis, apud Iuntas"; colophon: "Venetiis in officina Iuntarum."

w Re-issue retains colophon "Per Giovan Griffio."

APPENDIX 2

It is printed in the last of the Greek historians to appear, *Ditte Candiotto et Darete Frigio della guerra troiana* . . . (1570).

Essendo la guerra la piu importante attion, che si legga nell'historie, poiche da essa dependono gli stati; et essendo certo che la guerra non si fa senza cagione esplicita, o implicita; però la prima Gioia congiunta all'Annello della mia Collana historica; sarà

Il libro delle cagioni delle Guerre, diviso in piu volumi, che tutti sono sotto Il prima Gioia. Et di queste fin' hora Thomaso Porcacchi da Castiglione Arretino n' ha publicato il primo volume. Et perche trovata la Cagion della Guerra; è necessario volendola fare; proveder primieramente d'un buon Capitano; però sarà

Il libro del Capitan Generale dell'essercito. Et questo è stato fin' hora composto, et descritto dal S. Ascanio Centorio de gli Hortensij nel suo primo Discorso. Et perche il Capitano Generale, subito ch' è creato, deve proveder d'altri ministri, et particolarmente del Maestro di campo: però sarà

Il libro che tratta della qualità del Maestro di Campo. Di che s'ha pienamente nel terzo discorso di detto S. Ascanio Centorio. Et perche trovato et eletto il Maestro di Campo, è necessario proveder soldati per poter far la guerra; però sarà

Il libro del Soldato: nel quale si tratta di quanto è necessario a un vero soldato, et a un nobil Cavalliero. Et questo fin hora è stato publicato dal S. Domenico Mora Bolognese, et gentil' huomo Grigione. Et perche trovato il soldato; si discorre del modo di far la guerra, però sarà

Il libro dell'arte della militia, che è il quinto discorso del S. Ascanio Centorio. Et perche trovato il modo del far la guerra; bisogna ancho saperla governare, et maneggiare, però sarà

Il libro del governo della Militia: il quale essendo stato composto dal S. Bernardino Rocca Piacentino; fra pochi giorni sarà posto in luce. Et perche in questo discorso del maneggiar l'imprese della guerra, molto utili son quelli argomenti che si deducono da' casi seguiti, o da gli Essempi simili, però sarà

Il libro de' Paralleli, o Essempi simili di Thomaso Porcacchi, gia publicato. Et perche trovato il modo di maneggiar dette imprese, si tratta del modo dell'accampare; però sarà

Il libro della Castrametatione: nel qual saranno posti insieme tutti quelli Auttori antichi et moderni, che del modo dell'accampare habbiano scritto. Et perche dopo questo debbe venirsi al far l'impresa della guerra: nella quale succedono stratagemi et Errori: però sarà

Il libro dell' imprese, de gli stratagemi, et de gli Errori militari;che fin' hora è stato descritto dal S. Bernardino Rocca Piacentino, et dato in luce. Et perche nell' Imprese intervengono spesse volte parlamenti di Capitani a' soldati; però sarà

Il libro dell' Orationi militari, raccolte et publicate da M. Remigio Fiorentino. Et cosi con queste considerationi puo accrescersi quest'ordine di nuovi concetti, et pensieri: i quali secondo che alla giornata soverranno, o saran publicati; cosi vi saranno inserti, avisando che in questo ordine medesimo vanno inclusi i libri scritti in materia di Duello: ma non se n'ha fatto mentione; percioche sono stati molti gli scrittori di questo soggetto, et per esser l'opere loro state stampate da diversi; non s'ha voluto co'l nominare i SS. Girolamo Mutio, Gio. Battista Possevino, et Dario Attendolo; far pregiudicio a gli altri. Havremmo anchora adornata questa Collana di quella preciosa Gioia et

traduttione, che fa il S. Gio. Antonio Rusconi del Vitruvio; in modo che tosto si spera con molte belle et utili figure darlo alla stampa; se quest' opera non appartenesso piu all' Architettura et elegantia del fabricare, che alla fortificatione de' luoghi, necessaria nelle guerre; et se da molti altri non fusse stato scritto in questo soggetto di fortificar terre et luoghi abbondantemente.

The Concept of the Oral Formula as an Impediment to Our Understanding of Medieval Oral Poetry

MICHAEL CURSCHMANN

Over the past quarter-century or so, the Theory of Oral-Formulaic Composition has exerted the most profound influence in several disciplines that have to do with epic literature and related genres – living, ancient, medieval, European, Asian, African.[1] It has set in motion and continues to inform a truly international and interdisciplinary process of re-evaluation of traditional critical norms. In view of this it may seem odd at first that Germanic – more specifically, German – studies have been rather slow to respond. Or, to put it differently and a little more precisely, why is it that, while a fair number of Germanists from this side of the Atlantic have done their best to promote the cause of this theory, there has, until recently, been only the faintest echo from the other side?

Up to a point, American scholars are justified in chastising their German counterparts for a certain lack of past comprehension and present interest. But the situation is not quite as simple as Ruth Hartzell Firestone makes it sound when she says that "German scholarship could neither understand nor accept the implications of [John] Meier's observations [on the nature of oral traditions] at that time [1909]" or that even Theodor Frings and Maximilian Braun, his Slavist colleague, failed "to comprehend fully the nature of oral composition."[2] Notions such as Meier's have, at least in some areas (e.g., the ballad, and folksong in general), played an important role in twentieth-century German scholarship; the work of Frings and Braun, practically contemporaneous with Parry's, resulted in a different, not less valid, theory of oral composition;[3] at least in one case, which will be discussed later, the concept of multiple authorship of a traditional text was arrived at without recourse to any particular theory; and as a result of all this, German Germanists might, in turn, be justified in regarding as an exercise in single-minded quantification much of what goes on in the relentless pursuit of the Theory of Oral-Formulaic Composition.

Useful as it is, *The Haymes Bibliography of the Oral Theory* (1973) also raises a clear warning signal. Undertakings of this type are a sure sign that their subject is becoming academic, frozen in its own original premises. The Oral Theory, or, for short, the Theory, deserves a better fate, and it is particularly in this context of critical discussion of some funda-

mental questions that recent developments in medieval German studies merit attention and comment.

For medieval studies, in general, the most fundamental of these questions has, of course, always been whether it is legitimate at all to apply a theory developed pragmatically in the field of a living tradition to medieval literary production. Before turning to the text that was bound to become the *pièce de résistance* in any systematic discussion of basic issues, the *Nibelungenlied*, I should therefore like to illustrate, with three concrete examples, the general spectrum of attitudes that have been taken in this regard. (1) Armin Wishard's call for a "revaluation of the *Spielmannsepen*" provides an example of unquestioning acceptance, including the acceptance of Milman Parry's original definition of the formula which quite a few recent studies in other fields have found in need of modification.[4] (2) Ruth Hartzell Firestone has investigated a different *corpus*, texts from the thirteenth-century Dietrich cycle. Tempered by several reservations regarding the direct applicability of the Theory in such cases, for example, the question of end rhyme versus assonance, her initial research produced statistics which she judged to be inconclusive, although three of the five poems revealed a formula density exceeding the accepted minimum requirement for orally composed texts (p. 3). Submitting to this verdict, she attempts to clarify the picture through an application of Vladimir Propp's descriptive method of folktale analysis, thereby replacing one extraneous theory by another, rather than meeting the texts on their own ground. (3) Lars Lönnroth, on the other hand, to quote an example from Scandinavian studies, has taken full account of the special living conditions of his sources, that is, the specifically North-Germanic combination of poetry and prose in the Sagas. In this context the Eddic lays appear to him as "carefully polished products of poetic craftsmanship, as rhetorical and dramatic showpieces meticulously preserved from one performance to the next, where they would be the especially esteemed highlights of a legendary and, presumably highly variable prose story." That does not exclude the possibility "that a certain *element* of oral-formulaic improvisation sometimes entered the performance when the performer's memorization was less than perfect" (Lönnroth's emphasis).[5] The Theory has provided the incentive to take another close look at specifically medieval conditions of delivery and transmission, and it remains extremely useful in matters of detail as well, precisely because it is being introduced with critical restraint.

For anyone who is at all inclined to consider certain medieval texts in terms of oral traditions that produce them, the *Nibelungenlied* is probably the most interesting (and challenging) German text, and, conversely, it is also the text which stands to gain most from such attention. The main point at issue is, naturally, the mode of composition of that work which has been preserved in over thirty manuscripts and manuscript fragments representing, basically, three versions, which are, in turn, represented by

three thirteenth-century manuscripts, A, B, and C. However, this question is inextricably bound up with two other considerations: How and in what form did the material develop from the late Migration Period to the time around 1200, and how do we explain the considerable textual diversity which exists between A, B, and C, as well as within each of these groups? Several recent studies have attempted to clarify this picture in one way or another and from different points of view.[6]

The first of these, by Helmut Brackert, looks primarily at the history of the text after its codification, without advancing any firm conclusions as to what exactly accounts for this diversity. Brackert's meticulous investigation of manuscript readings directly challenges the basic assumption underlying the classical stemma established by Wilhelm Braune: that the three main branches of the tradition can be subsumed under one archetype and, beyond that, one original. One must assume some form of oral interference throughout the thirteenth century, second injections of "genuine" Nibelungen material, and at the beginning of the written tradition known to us stand several oral versions. The existence of one poet who "was greater than all the others" (Brackert, p. 170) and to whom the text owes its high degree of internal cohesiveness can be acknowledged, but his version has no higher claim to authenticity than any of the other oral productions that were in use concurrently during, as well as after, the period of incipient codification of the material.

Based as it is on simple, if highly imaginative and trenchant, textual criticism, and not on any particular theory of poetic diction, Brackert's analysis has indeed yielded the most persuasive evidence so far of the presence of a strong oral element in the *Nibelungenlied* tradition well into the thirteenth century. It is in the area of manuscript diffusion and all its aspects, the specifically medieval condition of distribution, that any further explication of the *Nibelungenlied* in terms of its oral past and present should have begun or, at the very least, looked for support or corrective evidence.

But that would have meant giving up the criterion of formulaic usage as the chief, if not sole, determinant and characteristic of oral tradition, and in this respect advocates of the Theory in the context of medieval literature are entirely dogmatic. It never even occurred to Edward Haymes, who of course knew Brackert's study, to weave this notion of multiple authorship at least into his overall conclusion, which consistently speaks of "the" *Nibelungenlied* (p. 107). Haymes's own approach is essentially synchronic, and he simply gives statistics based on the vulgate – statistics for two formulaic systems, with a view not only to demonstrating formulaic content but also to relating formulaic usage to metrical structure.[7] Comparing these to similar statistics obtained from a contemporary example of highly literate narrative, Gotfrid's *Tristan*, he concludes that the *Nibelungenlied* is an orally composed work.

Franz Baeuml's approach is more explicitly past-oriented, at least in his

first paper, written in collaboration with Donald Ward. He has analysed some fifty stanzas from various segments of the poem, which show a particularly high degree of formulaic density, and which he uses to counter the methodological premises underlying Andreas Heusler's classical reconstruction of the poem's genesis. This verse material is, Baeuml and Ward say, obviously of an oral tradition, and this, in turn, means that a) many details that Heusler attributed to the last master are, in fact, much older and b) no precise description of earlier stages in the development of the material can be given, since oral traditions do not produce fixed texts.

In general terms, at least, Haymes and Baeuml are in agreement by viewing the *Nibelungenlied* as a poem with an exclusively oral past. This may be conceded as a matter of heuristic principle, despite the fact that, as I shall discuss later, the formulaic diction of the extant text is no doubt multiple in origin.

Regarding the manner in which the extant text was *composed*, Baeuml and Haymes are in agreement only insofar as they, unlike Brackert, recognize only one text, which must, by definition, have been written. Beyond that, their views differ substantially. For Haymes, the *Nibelungenlied*, as we have it, is a dictated (or self-dictated) oral composition (p. 104), in line with his *dictum* that "as long as a text displays all the characteristics of traditional language, it is, if only in the technical sense, an 'oral' text" (p. 37). For Baeuml, the transposition of the narrative from oral into written form was "not the work of an oral but that of an educated, courtly poet" (p. 362).

In the context of his first article this statement came as an abrupt aside open to misunderstanding, but Baeuml has since clarified his position in a paper written in collaboration with Agnes Bruno. In the earlier instance stanzas were selected for their value in the argument against Heusler. Taken as a whole, the poem is actually very uneven in formulaic density per stanza (from 85 to 25 percent), and this means that we have here a learned, literate poet who, in turn, worked from a dictated text.[8] Of the latter, Baeuml and Bruno say that, as long as we have the technique (means) of composition in mind and the text is predominantly formulaic, "it belongs to the oral tradition, even if it was composed on the typewriter" (p. 485).

Two comments are in order at this point. It is remarkable – and revealing – that two studies for which formulaic usage is the common critical denominator can come to such different conclusions regarding the status of the work under examination. Moreover, the formulations used by both scholars to characterize as oral the dictated text assumed by both in effect dispose of the Theory as a meaningful tool of literary criticism, for they actually blur the theoretical distinction between written and oral without realizing its critical potential.

While Baeuml and Bruno concede, in fact, that the formulation quoted above might be taken as an exaggeration "of the concepts of 'oral' and 'written' to the point of meaninglessness" (p. 485, n. 17), they already construct a new dichotomy. The new argument in this second paper fulfills a dual function. It is meant to support the application of the Theory on socio-anthropological grounds and to illuminate further the categorical difference between written and oral in the light of yet another parallel between twentieth-century Yugoslavia and late twelfth-century Germany. According to Baeuml and Bruno, the parallel consists in the fact that an analphabetic, and therefore oral, culture exists within (or below) a dominant literate, written culture. What once was the prevalent mode of literary communication also among the members of the upper class has now become the hallmark of the literature of the disadvantaged, and the step from oral to written therefore entails a drastic "change of perception" of the same narrative material (p. 481). The man who re-worked the dictated text of the *Nibelungenlied* worked for a literate society with a new "perceptual orientation," as Baeuml and his collaborator Edda Spielmann say in the latest published continuation of the argument. It is beginning to look as though the chief purpose of these investigations into the oral character of the *Nibelungenlied* has been, after all, to stress the literary character of the extant text, where this literate perception permits oral formulas to be used (and appreciated) as "ironic" statements reflecting conscious distance from the tradition (see especially p. 254 ff.). All this seems to be based on the unevenness in formula density discovered by the computer.

Few would deny that the *Nibelungenlied* frequently reflects upon itself, that is, its traditional subject matter – the same could be said of *Beowulf*. But does this presuppose an absolute juxtaposition of analphabetic and literate cultures? Brackert's findings completely undermine this view as far as the *Nibelungenlied* is concerned, and Hans Fromm calls it anachronistic on general grounds. The analphabetic lay culture of the late twelfth century, he says, occupied a position that was, if anything, above that of the school-educated clergy and its (few) lay pupils: Literacy did not confer social status (Fromm, p. 58ff.). Although this broadside misses a couple of fine points in Baeuml's argument and could not take into account the elaborations advanced in his latest paper, it is essentially on target. One might, in fact, add that for centuries the literate culture of the monasteries and, later, the episcopal courts seems to have been quite happily – if mischievously and, for the most part, unproductively – wedded to the "subculture" of indigenous oral tradition. Indirect testimony abounds: from the Fulda monks who slipped the text of the *Hildebrandslied* into a Latin theological codex to one of the most conspicuous church dignitaries of his time, Bishop Gunther of Bamberg, who preferred listening to stories about Attila and Theodoric to reading

Augustin and Gregory. *Fabulas curiales* his irate friend Meinhard calls them![9] And let us not forget the British scribe Lucas who, in 1170, revived the spirits of a defeated Danish army with recitals of *memoratis ueterum uirtutibus,* a semi-learned man who behaves in a way highly reminiscent of the earliest accounts of how (oral) heroic lays were used (and composed).[10] As opposed to the recording of a text that would never have been written down, had not the modern scholar been on the spot and brought about an abrupt media transfer, medieval written traditions of originally oral material are the eventual outcome of a process of gradual cultural amalgamation.

Fromm himself has described the situation of around 1200 in terms of a symbiotic relationship between written and oral and attempted, on this basis, to reconcile Brackert's findings with the positive results of the debate on the oral composition of the *Nibelungenlied.* A "symbiotic culture" in which the institution of public oral recitation before aristocratic lay audiences constantly mediates between oral and written (p. 60) creates "intermediate types" of epic composition (not to be confused with "transitional texts"!) (p. 60). Even the courtly romance becomes part of this concept: In subject matter it looks towards the aristocratic, illiterate lay culture, but it has no oral past and depends on literacy for its existence.

Another of these intermediate types is represented by the *Nibelungenlied* and its branches. Here, Fromm, in addition to recalling Parry's and Lord's experiences, draw on his own extensive experience with the Finnokarelian material and his field work in the Faroes. His conclusion is that the textual congruity among the *Nibelungenlied* manuscripts is much too extensive not to reflect a written original. This written version existed side by side with oral ones but was separated from them by the "higher degree of linguistic and compositional consciousness" of one particularly gifted individual. At the same time, this individual was prevented from excessive innovation by his audience's knowledge of these concurrent oral versions. In the process of further transmission of his text this "symbiotic competition" makes itself felt in two ways: the continuing influence of the oral tradition and the demands of modern taste that bring about amelioration and refinement (pp. 61–63).

One need not agree with every detail of this analysis to accept the principle that, rather than exclude each other – be it as a matter of technical procedure in composition or of a radical perceptual change – the oral and the literary are closely intertwined in a case such as this. Beyond that, and along with the discussion that preceded it, the idea of a symbiotic culture leads to several general conclusions regarding the applicability of the Theory to medieval situations.

The first is elementary but bears re-stating: Any such attempt must be preceded by careful study of the living conditions and cultural ambience

of the document in question. Only in this way can we learn whether, where, and how to apply.

Second, the chief obstacle in the path of this seemingly self-evident approach is the concept of the poetic formula itself and the way in which it is linked to the concept of "oral." That is to say, whether we are "for" or "against" application, we have become obsessed with a definition of formulaic usage that is bound to be at variance with what is formulaic in medieval poetic usage. This conclusion is re-enforced by the work of Hans Dieter Lutz, who has addressed himself to this problem with a brief (and rather abstract) critique of the Theory and its application by Baeuml and his collaborators and with a book which seeks to develop a method of describing (medieval) formulaic usage in precise quantitative terms.[11]

In spite of the counterarguments advanced by Haymes in the new foreword to his dissertation (p. VII ff.), Lutz seems to me to be essentially correct in stating that the Theory provides a descriptive, not an explanatory or analytical model: It "knows" that what it describes is oral narrative, and hence it cannot be used, except with a great deal of reservation and caution, to answer such questions as "Why is a medieval text formulaic or non-formulaic?" Nevertheless, Lutz's proposals for a future "Ersatztheorie" seem to me more to the point. Among the things that this new theory would have to take into account, according to Lutz, is the fact that in German epic verse the relation between metre and formula is not as one-sided as it is in Serbocroatian verse, according to Lord. In view of Haymes's remark that the example from *Dukus Horant* used by Lutz ("Zur Formelhaftigkeit," p. 444) is an isolated aberration on the part of the author or the scribe (p. IX), I should like to state quite emphatically what everyone with some experience in the thirteenth-century heroic epic and similar epic forms knows only too well: Formulas, formula systems, and stereotyped diction can at any time supersede metrical regularity as the ordering principle of the text.[12] At least as high on my own list of major factors to be considered is the use of end rhyme, or, more specifically, the conventional use of a small number of trivial rhymes which creates its own "system" of formulaic response, producing equivalences that are indistinguishable from what the Theory would designate as correspondences resulting from the process of oral composition.

Of course, beneath all this still lurk two questions which have bothered critics, as well as thoughtful adherents, of the Theory almost from the beginning: Given the assumption that a certain formula density denotes an orally composed text, how can this density be established in exact statistical terms; and how can formulaic usage be defined in a way which makes it susceptible to such scientific analysis? The methods and procedures which Lutz has used to provide at least a preliminary answer

derive from information and communication theory, and for this first test of their applicability he has confined himself to one, the most simple, type of formula, the noun-adjective combination. The analysis is based on four carefully chosen epic texts representing different literary backgrounds and trends between 1150 and 1250.

To describe Lutz's computer-aided operation in sufficient detail to do justice to its complexity would fill several pages. I shall confine myself to a few general observations. In line with Lutz's overall position, his "operational definition" of the formula seeks to ascertain the presence or absence of formulaic diction, not to interpret the results. The immediate goal is to identify formulas, irrespective of their provenance and function, and the resulting concept of the formula is bound to be at variance with all definitions advanced within the general framework of the Theory. It allows not only for varying relative position of article, adjective, and noun in what amounts to six phenotypes of the basic model but also for the injection of various kinds of lexical qualifiers into this basic model. Thus *der haiden werc vil spaehe* can, if other conditions are met, be considered a formulaic variant of *daz spaehe werc*.

The operation itself is relational and seems to work – at least in the sense that the statistical results take into account every factor that could conceivably be of significance, for example, the total numbers of adjectives, nouns, and noun-adjective combinations in the text under investigation, the length of that text, and the relation between the absolute frequency of a given noun-adjective combination and the average frequency of the respective adjective in combination with other nouns. This system also permits comparison between different texts and distinguishes between word sequence whose formulaic character is evident from the text which is the primary target of the investigation ("Formel qua Text") and phrases which turn out to be formulaic only after consideration of other texts, as well ("Formel qua Tradition"). Finally, it opens up the prospect of a general typology of formulaic language in quantitative, functional, sociogeographic, as well as socio-literary terms (diagram on p. 131), recognizing that a theory which seeks to explain the phenomenon of formulaic usage for this period cannot possibly exclude the notion of multiple origin and purpose.

It remains to be seen whether Lutz or anyone else will ever find the time and muster the energy required to expand this model and advance the investigation to a point where the results become sufficiently clear to warrant a systematic re-appraisal of the relationship between formulaic diction and orality in Middle High German or other medieval texts.

This brings me to my third conclusion. We have become so mesmerized by the specificity of the claim made by the Theory – absolute distinction between written and oral creation – that we have forgotten all the other aspects of oral culture which pertain to the production and dissemination

of vernacular literature in the Middle Ages – aspects that in many cases are just as or more important than that of how, exactly, the text was composed. We have forgotten, in other words, that in a culture which is still predominantly oral, in the general sense, there is no room for an absolute juxtaposition of oral and written, in a specific sense, and that when we use the term "oral" in speaking about the Middle Ages we are of necessity speaking of a cultural phenomenon that is infinitely more varied and complex than that from which the Theory derives.

How does the institution of oral performance influence the external proportions (and internal cohesion) of written texts? Examples and questions range from the major works of Wolfram and their subdivision into "books" to a fifteenth-century redaction of the thirteenth-century *Wolfdietrich* which concludes with the statement that the narrative has been condensed from 700 to 333 stanzas so that it can be presented in one session (*auf einem sitzen*). Oral proportions are not the concern of oral singers alone. What are the sources and what is the ultimate purpose behind the directness of address and repartee with which a poet like Wolfram communicates with his audience? He is the only one among the German writers of courtly romance working around 1200 who makes direct reference to the traditional heroic poetry current at the same time and in the same circles. It is quite possible that his own stance of public oral communication has something to do with his predilection for or, at least, close acquaintance with this genre. However this may be, his style reflects the same symbiotic culture in which the *Nibelungenlied* surfaced as a written document, only this time we are looking at it from the viewpoint of a literate poet who reacts to an oral environment.

But I want to return to the *Nibelungenlied* for a concrete example that may show in which direction the more relaxed attitude advocated by Fromm and implicit in Brackert's analysis may develop new perspectives (although it may at the same time revive old issues). Chapters six through eleven, some four hundred stanzas in the vulgate version, relate Gunther's courtship of Brünhild, an episode which is firmly intertwined with Sigfrid's courtship of Krimhild: Krimhild's hand is the price for Sigfrid's assistance in the matter; the whole affair culminates in a double wedding; and the manner in which Sigfrid assists Gunther becomes the root cause of the following quarrel of the queens and Sigfrid's death. Hence, when modern scholars speak of a hypothetical *Lay of Brünhild* as one, if not the chief, source of the first part of the poem, they usually mean a poem which went considerably beyond the limited narrative framework of Gunther's courtship. If one looks at the manuscript tradition with heightened awareness of the potential presence of oral "interference," one detects something else as well: the existence and continuous influence of a (probably oral) lay of Brünhild which told the story of Gunther's courtship more or less on its own and which I shall call *The Short Lay of Brünhild*.

Branches A, B, and C disagree as to where exactly chapter six begins, and they do so in a way which rather isolates the stanza which appears as no. 325 in the Bartsch-de Boor edition. Here are the three versions of this text (from Batt's synoptic, diplomatic reprint):

Iteniwiv maere sich hůben vber Rin.
man seite daz da were manich magedin.
der dahte imeine werben des kunich Gvnthers mv̊t
daz dvhte sine rechen vñ die heeren alle gůt.

<div align="right">A(324)</div>

Itniwe̊ maere sich hv̊ben vber Rin.
man sagte daz da waere manech sco̊ne magedin.
der gedaht im eine erwerben Gvnther der kvnech gv̊t.
da von begvnde dem rechen vil sere hohen der mv̊t.

<div align="right">B(323)</div>

Iteniwe maere sich hvben vmben vmben Rin.
ez sprachen zv dem kunige die hosten mage sin,
warvmbe er niht ennaeme ein wip zv siner ê.
da sprach der chunic riche: "ine wil niht langer biten me."

<div align="right">C(327)</div>

In A this stanza opens the sixth chapter, in B it concludes the fifth, and in C it forms a different kind of conclusion to chapter five, with the help of an additional stanza, C 328. The editors of the standard text have in this case followed A, instead of B, and stanza 324 of the Bartsch-de Boor edition does indeed provide the most logical conclusion for chapter five, at least as far as A and B are concerned: It foreshadows things to come, as do many stanzas in this position, and, along with 323, it responds quite pointedly to the end of chapter three (137; 138). On the other hand, stanza 326, rather than 325, is the logical opening for chapter six in all three versions: The phrase *ez was ein küneginne gesezzen über se* (326,1) marks the beginning of a new story or major episode in highly typical, stereotyped fashion (echoing, by the way, the introductions of Krimhild and Sigfrid in chapters one and two, respectively), and what follows immediately – description of Brünhild's activities and re-introduction of Gunther as *ein riter wolgetan* and *vogt von Rine*, her potential suitor (326–329) – is completely in keeping with this style.

With its announcement of "tidings never heard before" that prompt Gunther to think of winning one of the many lovely maidens across the Rhine – the reading of AB – stanza 325 is not only redundant but completely undermines the effect of the following introduction. Indeed, all three branches of the manuscript tradition seem to treat it as a kind of foreign body that has to be neutralized somehow. Does it represent an

attempt, made at the stage of a common archetype, and not very success-fully as it turns out, to provide a smoother transition after the "master" had opened chapter six rather abruptly by adhering closely to another, independent version of the episode? Or is it this stanza 325 which records or paraphrases the beginning of another popular version? The redactor may have wanted to provide the reciter with an alternative introduction closer to the way in which the audience was accustomed to hearing the story told, and it may even have been a marginal entry at first.

Version C gives a substantially different context, including a substan-tially different wording of stanza 325 which is elaborated in C 328 and, early in chapter six, C 332. This arrangement in C leads into chapter six in a way which parallels most closely the standard introduction to such courtship tales: The "tidings never heard before" are that Gunther's rela-tives urge him to take a wife, he agrees to take counsel in the matter, and his choice of Brünhild is indeed made during such a meeting. This different narrative patterning is not entirely confined to C, though. In essential agreement with the spirit of C and in contrast to B, which at this point comments on Gunther's elation at the thought of marriage, version A says in 325,4 (A 324,4) that his intentions were welcomed by his men.[13] It seems highly likely, then, that A and C reflect, in different degrees and independently, the motivation for Gunther's courtship as *The Short Lay of Brünhild* conceived it, in line with one of the standard variants of the popular courtship pattern.

Unlike C, which is not only longer but also gives a fairly consistent alternative interpretation of the material, A as a whole is quite close to B. However, there is one important exception which, when seen in con-junction with what has just been discussed, provides the most telling clue to *The Short Lay of Brünhild*: It is 61 stanzas shorter. In this connection it has often been noted, but I know of no attempt to interpret the fact, that no less than 55 of these stanzas concern the Brünhild episode, from chapter six to the end of chapter eleven.[14] Moreover, this tendency toward a more concise rendering is most evident, by far, in chapters six and seven, the core of the Brünhild story, if it is viewed mainly as a story of (successful) courtship. It is hard to believe that this two-fold concen-tration is pure coincidence: A is, in this case, closer than B or C, at least in format, to a type of narrative which told the story in sketchier fashion, with primary emphasis on the theme of courtship, as such, and less (probably much less) attention to the wider context.

This hypothetical *Short Lay of Brünhild* probably fit the description of a poem which Wolfgang Mohr, as early as 1942, postulated as one of the sources of the *Nibelungenlied* on purely stylistic grounds, that is, the close stylistic affinity between the Brünhild episode and the so-called "Spielmannsepen." He called it a poem which had taken as its subject "one sector of the well-known Sigfrid legend and given it colour and a life of

its own in an independent poetic production."[15] Beyond that, we can now say that the relationship between this lay and the *Nibelungenlied* was not confined to one moment of contact. The *Short Lay of Brünhild* and the evolving written versions of the great epic are very likely to have crossed paths more than once. We may never understand the details fully, but in general the picture is reasonably clear: What we observe here is part of a constant debate between competing versions and even types of narrative dealing with the same material in either written or oral form. I have little doubt that the *Nibelungenklage*, the poem which, purporting to be the authentic conclusion of the story of the Nibelungen, follows the *Lied* from the beginning of the known manuscript tradition but is now generally regarded as a secondary commentary on one or the other of the written versions, is, in fact, the record of the situation in which a written tradition begins serious competition with oral ones.[16] The *Klage* "quotes" from a tradition that is still very much in flux: This is apparent in its rendering of individual incidents, such as the murder of young Ortlieb, as well as in the way in which its anonymous author toys continuously (and inconsistently) with questions of source, transmission, and previous knowledge on the part of the audience. A closer re-examination may well show that this poem, which accommodates much of the substance of the story in indirect presentation, as it were, is an early literary experiment that actually paves the way for the process of poeticization and codification that produces the *Lied* as a text through which poet and audience finally face the old tales on their own generic terms. At any rate, it is this phenomenon of active interdependence of the two cultures that we must make part of the critical apparatus we use to interpret the *Nibelungenlied* as a work of art.

NOTES

1. For a recent survey see A. B. Lord, "Perspectives on Recent Work on Oral Literature," *FMLS*, 10 (1974), 187–210. A first version of my article served, along with others, as the basis for discussion at a seminar on oral poetry at the eighty-ninth Annual Meeting of the MLA in 1974 in New York; it has been thoroughly revised and updated.

2. Ruth R. Hartzell Firestone, *Elements of Traditional Structure in the Couplet Epics of the Late MHG Dietrich Cycle*, Göppinger Arbeiten zur Germanistik, No. 170 (Göppingen: A. Kümmerle, 1975), p. 26, and ibid., note 9. Cf. John Meier, *Werden und Wesen des Volksepos*, 1909; rpt. in *Das deutsche Versepos*, ed. Walter J. Schröder (Darmstadt: Wissenschaftliche Buchgesellschaft, 1969), pp. 143–181.

3. See my article, "Oral Poetry in Medieval English, French, and German Literature: Some Notes on Recent Research," *Speculum*, 42 (1967), pp. 36–52. An important study of traditional composition following in Th. Frings's footsteps is by Hinrich Siefken, *Überindividuelle Formen und der Aufbau des Kudrunepos*, *Medium Aevum*, No. 11 (München: Fink, 1967). Manfred Caliebe has made an attempt to combine the two approaches in his study,

Dukus Horant: Studien zu seiner literarischen Tradition, Philologische
Studien und Quellen, No. 70 (Berlin: Schmidt, 1973), esp. p. 87ff. (cf. my
review, *Speculum,* 51 [1976], pp. 715–717).

4. A. Wishard, "Formulaic Composition in the *Spielmannsepik,*" PLL, 8
(1972), 243–251, esp. 251: The article is based on the author's unpublished
dissertation, "Composition by Formula and Theme in the Middle High
German *Spielmannsepik,*" University of Oregon 1970.

5. Lars Lönnroth, "Hjalmar's Death-Song and the Delivery of Eddic Poetry,"
Speculum, 46 (1971), 1–20, pp. 10 and 18, respectively. Regarding the
compositional technique behind the sagas as such, Carol J. Clover has
written an astute analysis of narration in "tripartite scenes arranged
paratactically in sequence" as "a fundamental point of contact with oral
tale-telling." "Scene in Saga Composition," *ANF,* 89 (1974), 57–83, esp.
p. 82.

6. Helmut Brackert, *Beiträge zur Handschriftenkritik des Nibelungenliedes,*
Quellen und Forschungen, N.S. No. 11 (Berlin: de Gruyter, 1963).
Franz H. Baeuml and Donald J. Ward, "Zur mündlichen Überlieferung
des Nibelungenliedes," *DVLG,* 41 (1967), 351–390. Edward Haymes,
Mündliches Epos in mittelhochdeustcher Zeit, Dissertation, Erlangen, 1969;
re-issued, with a new foreword, as Göppinger Arbeiten zur Germanistik,
No 164 (Göppingen: A. Kümmerle, 1975). Franz H. Baeuml and
Agnes M. Bruno, "Weiteres zur mündlichen Überlieferung des Nibelungen-
liedes," *DVLG,* 46 (1972), 479–493. Hans Fromm, *Der oder die Dichter
des Nibelungenliedes?* in *Acta: IV. Congresso Latino-Americano de
Estudos Germanisticos* (São Paulo, 1974), 51–66. Franz H. Baeuml and
Edda Spielmann, "From Illiteracy to Literacy: Prolegomena to a Study
of the *Nibelungenlied,*" *FMLS,* 10 (1974), 248–259. See also my comments
in "*Spielmannsepik,*" *Wege und Ergebnisse der Forschung von 1907–1965.
Mit Ergänzungen und Nachträgen bis 1967* (Stuttgart: Metzler, 1968), esp.
pp. 102–108. A voluminous study of Germanic formulicity, which devotes
some 250 of its over 600 pages specifically to the *Nibelungenlied,* unfortun-
ately appeared too late to be incorporated into the following discussion:
Teresa Pàroli, *Sull' elemento formulare nella poesia Germanica antica,*
Biblioteca di ricerche linguistiche e filologiche, No. 4 (Rome: Istituto di
Glottologia, 1975). Unless otherwise stated, *Nibelungenlied* references are
to the critical edition of B, closest to the so-called vulgate text: *Das
Nibelungenlied,* ed. Karl Bartsch – Helmut de Boor (Wiesbaden: F. A.
Brockhaus, 1972). A synoptic view of all three versions is provided by
Michael S. Batts (ed.), *Das Nibelungenlied* (Tübingen: M. Niemeyer,
1971).

7. From a purely methodological point of view this approach seems superior
to that followed by Franz Baeuml, although it did apparently prevent
Haymes from spotting substantial variations in formulaic density.

8. Baeuml–Bruno, p. 487, n. 20, and Baeuml–Spielmann, p. 249. It is in this
methodological context, although not with the aim of proving this particular
theory, that Agnes M. Bruno has carried out her computer analysis of the
style of the *Nibelungenlied* (*Toward a Quantitative Methodology for
Stylistic Analyses,* University of California Publications in Modern Philol-
ogy, No. 109 [Berkeley: University of California Press, 1974]), and the
great concordance published more recently by Baeuml in association with
Eva-Maria Fallone (Compendia, No. 7. Leeds: W. S. Maney and Son,
1976) also contains indices designed especially "to serve research in the area
of formulaic composition" (p. IX). For a voice against these kinds of

quantification cf. Otto Holzapfel, "Homer – Nibelungenlied – Novalis: zur Diskussion um die Formelhaftigkeit epischer Dichtung," *Fabula*, 15 (1974), 34–46; a more positive survey is by N.T.J. Voorwinden, "De dichter van het Nibelungenlied: zanger of schrijver?" in *Literatuur en samenleving in de middeleeuwen* (1976) 63–81.

9. On the overall significance of Meinhard's remarks, see Carl Erdmann, "Fabulae Curiales," *ZfdA*, 73 (1936), 87–98.

10. *Saxonis Grammatici "Gesta Danorum,"* ed. Alfred Holder (Strassburg: Karl J. Trübner, 1886), p. 583.

11. H. D. Lutz, "Zur Formelhaftigkeit mittelhochdeutscher Texte und zur 'theory of oral-formulaic composition,' " *DVLG*, 48 (1974), 432–447; *Zur Formelhaftigkeit der Adjektiv-Substantiv-Verbindung im Mittelhochdeutschen: Struktur-Statistik-Semantik* Münchener Texte und Untersuchungen zur deutschen Literatur des Mittelalters, No. 52 (Munich: C. H. Beck, 1975).

12. Lutz's example is, in turn, taken from the article by Werner Schwarz, which constitutes the first full-scale attempt at applying the Theory to a German (in this case Judeo-German) text: "Die weltliche Volksliteratur der Juden im Mittelalter," in *Judentum im Mittelalter*, ed. P. Wilpert (Berlin: de Gruyter, 1965), pp. 72–91.

13. On the difference between the readings of A and B, with regard to the relative courtliness of the response, see Brackert.

14. For a general discussion of this material, see Brackert, p. 55ff. and 155ff.

15. W. Mohr, Review of Dietrich von Kralik, *Die Sigfridtrilogie im Nibelungenlied und in der Thidrekssaga*, in *Dichtung und Volkstum*, 42 (1942), 83–123, esp. p. 122.

16. See Karl Bertau, *Deutsche Literatur im europäischen Mittelalter*, I: 800–1197 (München: C. H. Beck, 1972), esp. p. 744ff. Bertau's aphoristic comments on the problem point in the right direction, but a good deal of further investigation is needed, which I hope to carry out in the not-too-distant future.

A Poetics of Historicism?

Recent Trends in Medieval Literary Study

STEPHEN G. NICHOLS, JR.

The past two decades have witnessed a series of developments in medieval literary theory and history which, in their increasing divergence from one another, have reduced literary study – normally an activity serving to link theory and history – to the status of an ancillary appendage of each of the master disciplines. The "crisis" has now reached a point where students of medieval literature, once the most privileged of literary fields in its catholicity, find it all but impossible to converse meaningfully with colleagues not of their own theoretical party. Calling attention to the problem several years ago, Brian Stock proposed to resolve the difficulty by a return to the comparative method of which the archetypal practitioner, for Stock, was Erich Auerbach.[1]

As sympathetic as one might be to Stock's plea, it is based upon a nostalgia for a simpler era of literary study which had not witnessed the impact of the pretension to a literary science which linguistically-based models of structuralist poetics have generated, particularly during the last twenty years. A glance at the work of scholars such as Paul Zumthor suffices to show that before one can hope to rehabilitate a comparative approach to medieval literature, one must somehow resolve the fundamental opposition between literary history, on the one hand, and literary theory, particularly as represented by structuralist poetics, on the other. This opposition has been recognized by Hans Robert Jauss, whose recent work has been directed towards a rejuvenation of literary history as applied to medieval literature, and Zumthor, who speaks openly against historicism as an obsolete model for the study of medieval literature.[2]

Unquestionably, structuralist poetics is the most prolific and fertile movement to have emerged in literary study in the last two decades. Nevertheless, its bias against those concerns which historicism took for granted as paramount for the study of literature effectively abstracts the medieval literary tradition from the idea of "history," which even the progressively more formalistic studies of the last half century – by scholars on the order of Erich Auerbach, Ernst Robert Curtius, Leo Spitzer, Robert Guiette, Eugene Vinaver, Peter Dronke, D. W. Robertson, Daniel Poirion, Karl Uitti and Peter Dembowski – did not challenge.

While admitting some validity to Zumthor's charge that medieval literary study had fallen into an *ornière descriptive et historiciste*,[3] one cannot fail to heed Jean Starobinski's reminder that historical distance plays an important role in demonstrating the literariness of historical literary works:

Were [indifference to history] to spread, the texts of the past would – without disappearing from our horizon – cease to bear the mark of specifically historical distance; they would float around in a state of historical weightlessness. The temporal "course" of history, so clearly linked to the notion of "direction" and "meaning," would become nothing more than an outdated illusion, and would make way for the image of a special field open to the whole register of variations and divergences of human discourse; in such a view – a view which would go so far as to attribute to the historistic vision itself an arbitrary, ephemeral status – history would appear as but a presumption of meaning, as only one of many types of narrative or discourse.[4]

Before attempting to examine more closely the nature of the current opposition between literary theory and history, as represented in the works of Zumthor and Jauss, it may be helpful to review briefly the work of a few of the shapers of the modern critical tradition, in order to understand the extent to which their concept of medieval literary form was determined by their attitude towards historicism.

In reviewing the various methodological statements by Auerbach, Curtius and even Spitzer – more modest than the other two, as regards the scope of his vision – one finds a three-fold assumption underlying their orientation: namely, that history is dynamic and dialectical, a subjective process of creation which can therefore be recovered by means of another subjective, dialectical process, and finally, that the process of creation is always guided by a prevailing set of ideals or concepts which each artistic monument of the period in question seeks to express in part. The total creative oeuvre of a given period may therefore be perceived as constituting a synthesis of the prevailing world view of that period. It is a metaphoric projection of the mind of man.

This obviously implies the existence of a synthetic philosophy, recoverable today by a reconstruction of the synthesis through the monuments which have come down to us. It presupposes a mentalist view of literary language as the outward form of an inner life. This premise could be worked out from the microscopic level of text and author, all the way along the continuum of literary relations, for example, genre, audience, community and so on, to the macroscopic level of the whole historical context.[5] In each instance, the kind of dialectical process of recovery utilized was determined by the binary oppositions selected for study and by their place on the continuum. Leo Spitzer chose the microscopic level of text and author, while Auerbach and Curtius preferred the more comprehensive level in which author, text and genres would be linked to the entire context of a period or age.

Calling the dialectical process of recovery "a to-and-fro movement basic to all humanistic studies,"[6] Spitzer founded his method on an adaptation of the "philological circle," used by Dietz and his followers to reconstruct the concept of Romance, as in Romance Languages. Romance is a theoretical postulate, a unifying whole without which the individual, constituent Romance Languages cannot be conceived in their relational totality, a totality which can be known only in its parts. The principle was refined for interpretive purposes by Dilthey, who was continuing the work of Schleiermacher, in a concept which he called the *Zirkel im Verstehen*. This postulates that "cognizance in philosophy is reached not only by the gradual progression from one detail to another detail but by the anticipation or divination of the whole—because the detail can be understood only by the whole, and any explanation of the detail presupposes the understanding of the whole."[7]

Form, for Spitzer, is metonymic, a figure representing the particular subjective life of the writer-in-the-work (the contained), but only as encoded in the literary form, which also connotes the external referent. This referent is at least two-fold: the world of the historical moment when the work was produced and the aesthetic tradition in which the writer participated. That external referent which informs the "inner soul"[8] is, he says, the intellectual spirit of the time, the network of intellectual, spiritual, political and social ideas which constitute the physiognomy of the period. The form of the work, a metonymic metaphor, is conceived by Spitzer to be explicable only in terms of these centripetal and centrifugal references radiating from the text, as identified and interpreted by the critic.

The circularity inherent in this concept is necessary for the placing of the work on what Spitzer calls the "historical line." In effect, the "inner soul" discovered by reading through the text is seen to have been generated by the transcending system which embraced the author and those "around, before and after him."[9] That transcending system is intuited during the reading process from the critic's experience with other texts; it is the result of a continual, unconscious comparison of the unfolding text with others previously experienced, which, naturally, create associations by contrast and complement during the reading of the text under consideration.

Spitzer thus postulates a Gestalt-like accretion of the awareness of textual relationships as part of the reading process. Unfortunately, he never really explains how the internal structure of the literary object contains within itself the objective basis for intertextual and intersubjective relationships, even though he recognizes that these exist. Accordingly, it is left to the critic's intuition to assert the relationships on the basis of his "to-and-fro dialectical movement of critical reading." Later, we shall have occasion to examine how the basis for intertextuality and intersubjectivity may be internalized in the poetic structure.

It is not "structure," as we understand it, that appeals to Spitzer but the "form" of the literary work, apprehended as the point of departure for a dialectic between the empirical and the ideal, between individual manifestation (text) and universal (historical context). Rather than the discontinuous relationships of empirical phenomena, it is the recreation of the idealist, genetic process that fascinates him. Or, as he states with forthright simplicity, he is gripped by the "relationship between the poem and us."[10]

In his insistence on the primacy of empirical experience as a starting point, as well as in his refusal to systemize critical methodology along "scientific" lines, Spitzer betrays his neo-Kantian principles. As René Wellek long since pointed out, criticism, for Kant, "is personal, but aims to discover a structure of determination in the object itself. . . . Criticism is always judging by examples from the concrete."[11] It is thus "historical in the sense of being individual, while science . . . is general, abstract, aiming at a systematic doctrine."[12] Art can never simply be – that is, it cannot exist as appearance, as object alone. It is act, as well as appearance, and that quality of action, of moral freedom accessible only in action, must be recovered along with the objectness.

While accepting the general outlines of this position, Auerbach pushes even further the situational dialectic by recalling Vico's dictum that "there is no knowledge without creation." The creative act, the created object are less important for themselves than for what they reveal of the creating mind and its view of the world. What interests Auerbach, as a literary historian, is the recoverability of the poet's intention of the world. The feasibility of this task rests on his belief that "all possible forms of human life and thinking, as created and experienced by men, must be found in the potentialities of the human mind . . . [and] therefore we are capable of reevoking human history from the depths of our own consciousness."[13]

Even more explicitly than with Spitzer, we find here the notion of identification with and immersion in the artifacts of a period as a prerequisite for acquiring the "inner experience" which will permit the discovery of a structure of determination of the object itself. But whereas Spitzer was prudently content to let the object be the concrete manifestation (the text), Auerbach situates the object to be recovered beyond the text, even though he repeatedly asserts that he adheres rigorously to the evidence of the text. It is obviously the universal, rather than the particular, which interests him.

For this reason, Auerbach does not limit himself to the strictly literary in his exegesis. The past may be recovered through any authentic linguistic text of the period to be studied: " . . . whatever is taken as a starting point," he writes, "must be strictly applicable to the historical material under consideration."[14] Although from a strictly neo-Kantian viewpoint Auerbach's failure to discriminate between the disinterested works of art

and functional linguistic texts may be bothersome, it is comprehensible when one recalls that, like Spitzer, Auerbach uses a hermeneutic approach adapted from philology. It is also explicable in terms of his goal: to constitute "a lucid and coherent picture of this disintegrating civilization and its unity."[15]

What Auerbach wanted was to develop a process of cultural description, based upon the study of linguistic texts, which would lead ultimately to a total picture of a given age. This total picture, he realized, could never be achieved by means of a detail-by-detail description, so he, too, adopted Dilthey's approach, with its notion of the "intuitive leap."

The interpretive instruments permitting Auerbach to practice the "intuitive leap" were the concepts of figural interpretation and mimesis for which he is best known. Figural interpretation is the more relevant of the two for our purposes, because it is strictly a late classical and medieval phenomenon which grew out of the awareness of the differences between Christian and classical world views and the attempt to bring them both into a unified structure.

Figural interpretation incorporates an historical viewpoint in a twofold manner: by its genesis – having been created as a means to differentiate and then unify two historical traditions – and by its function as an imaginative assertion of the teleological and continuous nature of history. Figural prophecy puts history into language; it *is* history mediated through language – that is, the "interpretation of one world event by another,"[16] where both are realized textually. The purpose of figural prophecy is to place historical events at the center of man's world, and thus to make the interpretation of history the archetypal act of written expression.[17]

Written language, literary or otherwise, thus becomes, by definition, historically interpretive, at once a key to and source for the understanding of medieval thought. When we realize that history has *become* the text, that real events, as such, are subsumed to the written documents, we can understand that form, for Auerbach, is even more transparent than for Spitzer. No longer metonymic, it has become synecdoche. Auerbach has espoused the concept of participatory perception, basic to medieval historiography, and made it an element of his own critical approach. This explains his disconcerting habit of slipping from a descriptive into a re-creative mode, as he passes from a discussion of a given event suddenly to what would seem to be a "first-hand" account of it. Comments like the following are far from uncommon: ". . . the whole episode lives and breathes; . . . if we read it slowly . . . the two of them seem to stand before us in the flesh."[18]

It is precisely this tendency to focus on individual texts as "events," as references to something else, somewhere else, which some medievalists began to react against about thirty years ago. Spitzer's lyricism, and Auerbach's reactions, seemed to confirm such skeptical observations as

R. G. Collingwood's dictum that "history is nothing but the re-enactment of past thought in the historian's mind."[19] More specifically, they recognized what was apparent to us in reviewing Auerbach's and Spitzer's methodology, that they had little methodological conception of literary form as object, as poeticity. They were at a loss to demonstrate, in A. J. Greimas's terms, how "any poetic object appears at once as the point of convergence of all levels of poetic communication, and as the place were certain poetic utilities are selected while others, excluded."[20] In short, Auerbach and Spitzer failed to describe medieval poetry as a system of poetic communication. They had provided insights into intellectual trends underlying the impulse towards creation – particularly Auerbach's concept of figural interpretation and Curtius' Bible poetics, but they had conflated the description of structures with the substances invested in those structures.[21]

Robert Guiette was one of the first to take the broad hint given by Dante in his reflections on language and consequently to argue that the real basis for dialectic in the medieval lyric lay in the text itself, the text seen as the site of a contest between the poet, his language and the pre-existing elements of the literary tradition. There is, in Guiette, no further talk of going through the text to an ideal referent of which the text is only the external trace. Guiette affirms that:

> For the poets of *langue d'Oïl,* the courtly song is an artistic creation, a rhetorical creation. From all the given elements, they set about making, constructing an "object," a new reality. They are concerned not with a confession, but with a song. The game which lures them is that of "composition:" the setting in place of known elements, the elaboration of a definitive verbal entity, of a text to be sung, of a text that *is* sung.[22]

This manifesto rests on the assertion that in the two thousand or so extant lyrics in *langue d'oïl,* one finds "nothing but tradition and convention."[23] The poeticality of those lyrics, then, must lie in the manipulation of tradition and convention. Since Guiette looked upon tradition and convention as cumulative deposits of poetic language usage over a period of generations, it seemed logical to him to conclude that what was paramount in poetic language was form, form considered as a product of language use according to convention. Rather than being a verbal sign pointing outward to "real" loves, to "real" events, the Old French lyric was a mental fiction, and not "an analysis of the poet's heart." "The artist was not unveiling his passion, but rather his talent."[24]

So conventional a poetry cannot be thought of in terms of units called "poems," each one differentiated from the other. For a century and a half, affirms Guiette, poets virtually sang the same song, endlessly remade, rewritten, recast. Therefore, we must realize that it was not the poem per se that interested them, "but a theme, a series of formulas."[25]

Given this formalist conception of the poem-as-object, it is somewhat

surprising to find Guiette giving so prominent a place in his theory to the idea of poetry as a product of a knowing, known and knowable subject. With Guiette, we are obviously not yet to the point, reached with Zumthor, where it is possible to say, as did Todorov, that "for us, the text composes itself through its author much more than it is written *by him*."[26]

For Guiette, there is still a *trouvère*, a specific individual creator, who sings (invents) his work. This is a point of considerable importance; for as long as the poet is held responsible for his work, it will continue to be situated in a historical moment, however imperfect our knowledge of that moment. There is no denying, however, that Guiette's formalist conception of medieval poetry set real limits to the fantasies which modern scholars could indulge in when evoking the troubadour and his situation. By showing the poet to be constrained by a strict set of pre-existing formulas, that is, a poetic code to be employed according to a set of conventions, Guiette reversed the romantic notion of poetry which had hitherto been applied to medieval lyrics and which held that the subject precedes the object, poet precedes poem. In effect, Guiette said that the formulas preceded the poet, who can only be a poet to the extent that he can master the formulas. One other fertile line of inquiry was opened up by Guiette's "Copernican revolution" of medieval poetics: the essential dominance of synchrony over diachrony implied by his formalist aesthetics. We shall have to return to both of these points, especially since the corrective which Guiette's position represented must, in its turn, be corrected back towards a reintegration of diachrony and synchrony.

But first, let us take note of the extent to which Guiette still valorizes the poetry as a lived experience of the poet. He does not hesitate to speak of the poet's *living* his song. In essence, he has exchanged the older concept of sincerity – meaning that the song is testimony to the veracity of the events depicted – for a concept of the sincerity of the creative act itself. The poet, he says, "thinks his song; . . . what he sings is the need, the desire to sing."[27]

Taking his departure from a melodic phrase – or from a proposition or from a melodic nucleus (*cellule*) – he will compose a succession of sounds which he will ask to manifest his being and his life; but he will not do it primitively, instinctually. He will reveal himself as what he is in reality, a traditional being. His methods will be taken from the tradition, chosen in advance by a fixed convention.[28]

With a finite number of expressive elements – linguistic and musical – at his disposal, the *trouvère*'s artistic goal was to create formal variety, an arrangement not previously constructed. "The poet plays, and his work is an abstraction."[29] Guiette means that the lyric's referential system is a closed one composed of verbal and musical elements which is both actual (the tradition) and virtual (the poems to be created). Each poem poses a formal problem, where *problem* is understood in the mathematical sense.

The intuitive act of the poet begins with his recognition of the expressive potential as yet unrealized in the tradition; this is repeated by the audience which first hears the song and recognizes the problem of formal variation posed and resolved by the song. These givens at once establish the nature of the creative/critical act and control the degree of external references to be admitted into either activity (i.e., the creative and the critical). Access to content, signification, is strictly limited to what can be conveyed through the interplay of formal elements. Finally, the only situational or contextual references valorized are those which relate the poet as maker to the architectonic tradition and the poem as object to a strictly circumscribed synchronic order of other created objects sharing the same aesthetic postulates.

Poet, audience and individual work are thus clearly subordinate to a preexisting structure composed of the living poetic tradition, on the one hand, and the ideal of "formal work," the virtual entity to be realized, on the other. The living poetic tradition provides language which must be learned by poet and audience alike – in a closed formal system the audience must be as well-versed in the code as the poet, or nearly so. The "formal work" is the level of expectation derived from experience with previous works (the tradition), linked to an understanding of the generative "rules of the game," as played by poet and audience.

If, for the sake of clarity, we recast Guiette's theory into a schematic model, the diagram shown in Figure 1 emerges.[30]

Visualized in this manner, Guiette's formalism may be seen as a set of expectations and competencies. The boundary "living poetic tradition" and the field, "poetic language," defines the limits of possibility for the poet and audience, both of whom exercise their creative/critical activity within the limits imposed by the concept of the formal work as potential.

What is striking in this model is the evident dominance of synchrony over diachrony. The formal nature of the tradition assures its synchronous character, necessarily rendering it conservative, resistant to change. It

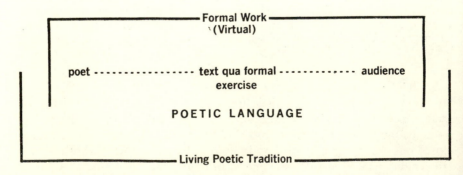

Figure 1. Representation of Guiette's model

could hardly be otherwise, given the fact that so much depends upon the expectations and acquired competencies of poet and audience. And yet, there must have been something else at work to have rendered the tradition homogeneous to the point where medieval poets preferred to be like their contemporaries, rather than different from them, seeking to create poetic objects as alike as possible. Or, to ask the same question another way, what led Guiette and his successors to select the synchronous nature of medieval poetry as one of the basic elements of aesthetic sensibility?

The answer lies in the prominence accorded the concept of poetic language in Diagram 1. The concern with form as self-referential object led Guiette and his successors, notably Roger Dragonetti, to study the rhetorical treatises of the period, and particularly Dante's *De Vulgari Eloquentia*. The concept of poetic language recovered from Dante's treatise has been one of the most authoritative articles of medieval literary theory during the past two decades. Paradoxically, it has also done much to distract attention away from the concerns of historic distance which had so fascinated Auerbach, Spitzer and Curtius.

In a long study of Dante's famous treatise, Roger Dragonetti easily demonstrated the extent to which Dante's view of poetic language was architectonic.[31] Already at the end of the thirteenth century, Dante had perceived that the existence of poetic language as form and potential controlled the relationship between poet and work.[32] As for the nature of the preexistent poetic language, its chief quality was that of *convenance*, that is, "proportion," or "suitableness." It is a balanced combination of music and rhetoric, "a language in which all parts communicate among themselves proportionately."[33] It is a language of harmonious bonds, to the point where the idea of harmony dominates the verbal constructions, as well as the musical composition. In fact, as Dragonetti points out, "harmonious bond" is so basic to Dante's conception of the poetic act that *ligare* becomes synonomous with "compose."

The poet's role was not that of an inventor of language, but rather of a discoverer, an unveiler. The words used to designate the creative act in the vernacular, from the earliest troubadours through Dante, were not Romance variants of the Latin *inventio* or *inventire*, but *trobar*, *trouver*, *trovare*. Dragonetti suggests that, for Dante, this meant something more specific than simply "retrouver"; it meant "entering into the conception of the 'logos.' "[34] The "logos," in Dante, is a spiritual force, the "act or form which produces communication and . . . the willing of its own realization."[35] Language, as potential, not only has a formal set of norms ready to be actuated, it is also invested with a spiritual value, a law of order which the poet must apprehend, in addition to the poetic technique, if he hopes to realize his work in all its potential.

What is this law? Dante has shown it to be "order" in the two senses of the term: Beauty and *injunction*, principle of union and of obligation. The *logos*, in effect, is not only the illuminator of things and the regulating center

which orchestrates the creation of languages, it is also the rallying point of a nation, the sign of its existence, because it unites spiritually all those who reach a common understanding by means of its mystery, and which enjoins them to be what they must as a human being and as an Italian.[36]

The poet, in Dante's view, must strive to achieve the idea of *convenance*,[37] for his success will be judged by the degree of *convenance* found in his work, that is, in the literary form. *Convenance* thus establishes a circularity of poetic language, linking theory and praxis. It is the ideal to be achieved in the act of poetic composition, when the latter is construed as the bringing together of like elements, which are then combined (*ligare*) in an harmonious modulation. But *convenance* is also the critical measure against which the completed work will be judged. As presented by Dragonetti, it may therefore be said to suggest something akin to the idea of "literarity" adumbrated by the Russian Formalists in the early twenties. This concept holds that one does not measure literary discourse in terms of other kinds of discourse, but rather against itself, in terms of its own demands. Or, as Tzvetan Todorov has said, "One does not study the work itself so much as the potentialities of literary discourse which made it possible."[38]

We are now in a position to understand why the recent studies of medieval rhetorical treatises have so successfully emphasized the synchronous nature of poetic language. Viewed from the perspective of modern linguistics, medieval rhetorical treatises appear to correspond, at important points, with modern theories. Todorov exemplifies this when he says that rhetorical treatises "shared at least several concepts in common with modern structural linguistics: They were synchronic, rather than diachronic, in orientation and were concerned with semantics."[39]

Without debating the justice of this evaluation, it is possible to question the usefulness of Dante's poetics as a critical basis for describing the poetics of a tradition that antedates him by two hundred years. The best rhetorical treatises, such as the *Leys d'amors* (c. 1330), or Dante's own (c. 1303), were produced after the tradition on which they were based had ceased to be the force it once had been. In retrospect, distinctions become levelled; it is easy to look at a tradition that has ceased to be viable as though it were a complete, homogeneous entity. This is especially true when the treatises are encyclopedic in nature, undertaking to analyze and reproduce a whole tradition. What Dante and the author of the *Leys d'amor* had in common with modern students of the poetic tradition of the twelfth century is that they, too, were situated beyond that tradition in time. Their view of it was axiological, just as ours is, and the norms they applied in their studies were those of their own world and time, in the same way that ours are drawn from the world around us.

With Dragonetti, as with Guiette, the achievement of establishing the medieval tradition as formalist and synchronous – a contribution of which the importance cannot be underestimated – remains incomplete to the ex-

tent that they could not provide a satisfactory means of resolving the subject-object problem. Dante's treatise makes it abundantly clear that the role of the poet-as-subject is crucial, especially in the quasi-spiritual dimension he assigns to it. However one chooses to interpret this, it is obvious that, for Dante, the intervention of the poet at a specific moment and with a definite purpose is a continuous and determining part of the poetic tradition. The synchronous line must therefore be seen to be intersected regularly by events which can only be called "historical," in the sense that they are successive in time and meant to relate the poetic tradition to the world of "real" events.

Dante himself, in the *Divine Comedy*, creates what amounts to a "literary history" of medieval poetry with an axiological orientation that clearly valorizes the role of poet-in-the-world. Inherent in his view is the notion of literary change evolving towards more sophisticated use of poetic language as an instrument of consciousness, of identity with time and place. It is, after all, not Guilhem IX, traditionally considered as the first troubadour, but Arnaut Daniel, one of the later troubadours, whom Dante called "the best craftsman of the mother tongue" (il miglior fabbro del parlar materno). That Dante also conceives of the poet-as-subject's playing a role in the intersection of the work with the historical moment may be seen from his treatment of poets in the *Divine Comedy*. Take, for example, the punishment of another troubadour, Bertran de Born, whose satires were conceived as having had a deleterious effect upon the political life of his times. Obviously, the subjective impact of the poet upon even the preexisting tradition was thought to be significant. Guiette himself, as we saw, could not abandon the subjective concept of poetic creation, although his theory had difficulty in making place for this idea.

Building upon the work of Guiette and Dragonetti, Paul Zumthor attempts to create a poetics of medieval poetry which he hopes will resolve the problems we have seen to be inherent in the earlier formalist theories. Drawing upon recent studies of synchronous linguistics, as represented in the work of Hjelmslev, and structural semantics as practiced by Greimas, Zumthor seeks to create a theory of style in medieval poetry which would be free from the creator-oriented assumptions of previous critics.

Zumthor boldly attacks the problem on two related grounds long thought to be unassailable domains of the poet-as-subject. The first is the domain of style, and the second, the notion of text as production of meaning. Both are predicated on Guiette's notions, but Zumthor pushes them much further and systematizes them. He accepts the premise that style "is the very essence of the medieval literary work,"[40] but not the correlative premise that style is a manifestation of an individual, historical, knowing subject, nor that the text is a unique product of the poet's historically situated struggle to make meaning.

By stressing the predominance of collective elements in the medieval

tradition, Zumthor construes poetic language as a system of expression in which the theoretical construct takes precedence over the empirical experience. He writes,

We hardly distinguish the part played by the individual in the formation of the literary work; probably it had little value in the opinion of medieval people. The work is entirely "objectified"; its "subject" (the author's subjectivity) has dissolved in the course of time, not only because it has slipped away, but because in some way the author's individuality was not an essential factor of the work.[41]

But it is not only the importance of the author that Zumthor seeks to minimize. He must downgrade the importance accorded to the work itself as individual manifestation. Hence, the individual work becomes but the trace of a larger structure composed of three historical levels: the tradition, the "work" and the text. Only the last is phenomenal, in the sense that we can actually experience it. The "work" (here seen as something similar to Guiette's notion of the formal "work" as virtual) is "located within a tradition, in which it is deeply rooted and from which it derives its meaning. The tradition constitutes the referent of the work."[42] Tradition, as used here, is not the unified poetic construct which Dante and Dragonetti perceived, but something more akin to Hjelmslev's "norm," that is, a concept that determines "usage and speech," modified by Zumthor for literary purposes into "genre and manifestation." Thus, for Zumthor, there are several traditions corresponding to the kinds of literary production to be explained, such as epic, romance, lyric and so on.

In the epic tradition, for instance, there is the "work," conceived as idea, to which we refer as "la Chanson de Roland." This "work" is "situated outside of and hierarchically above its textual manifestations."[43] That is, we postulate the idea of "la Chanson de Roland" from the existence of a number of individual texts, each purporting to be *La Chanson de Roland.* In other words, the "work" is a unity, a substructure of the tradition, but a superstructure to the individual texts. It follows logically, for Zumthor, that the meaning of the texts, their function, derives not from their individual existence as historical manifestations of a legend cast in different forms, in different places, by different poets. The meaning of the texts stems rather from their relationship to the hierarchical structure, that is, to the "work" and, beyond that, to the "tradition."

This tripartite, hierarchical structure allows Zumthor to concentrate on the modalities of distribution of the elements within "poetic language," rather than on the text-as-creation. He stresses the fact that the medieval poetic tradition generated texts, many texts within a given tradition, all more similar to one another than not. It is important to Zumthor to emphasize the idea of similarity, because similarity suggests a deemphasis of differentiated substance. By downplaying the substance of content, he can more readily devalorize the role of the poet as content producer. The emphasis of literary study may then fall upon the combining of pre-

existent elements, rather than on the generation of new meanings within a text, an emphasis which would call attention to the individual text as signifier.

Like Dragonetti, Zumthor finds the lyric to be the most fertile domain for his theories. He postulates a collective tradition of lyric, a corpus of songs which he calls, drawing upon Dragonetti's terminology, the *grand chant courtois*. This collective tradition is described as "one vast text, both objective and virtual, a universe of reference at once imaginary and verbal which constitutes the commonplace of author and listener alike."[44] Since this vast text was both the tradition and the work, in the sense described above, all individual manifestations, the given songs, must pass through the referent of the collective text. Any attempt to study the interrelationships between individual songs without taking into account the primacy of the vertical axis (i.e., the collective text/individual song) must be doomed to failure, according to this view, since it would violate the basic generative principle. The consequences of this postulate for our traditional notions of stylistic analysis of medieval songs are manifold.

If each song, like each speech act, is generated according to preexisting expressive elements, style cannot be studied otherwise than as a product of a code. The author as encoder combines predetermined expressive elements according to predetermined forms to convey a predetermined set of "messages." The act of combination, the choice of elements and order of their position is seen not as a function of individual will – as Dante thought, as well as Spitzer and Auerbach – but as a function of the encoder's mastery of code. We have, then, a closed system of communication, carefully delimited in time (1100–1250), space (the corpus of texts constituting the *grand chant courtois*) and situation (a homogeneous audience conversant in the code).

Zumthor's idea of code is intended to stress the precast notion of poetic language and to undermine the concept of a creative dialectic between tradition and individual text that was still inherent in Guiette and Dragonetti. By denying the role of a dialectic in the production and communication of literary discourse, Zumthor espouses a position that will lead to an impoverished concept of poetic language.[45] On the one hand, he speaks of *expressive* elements, while on the other, he denied any possibility of deviation, in the sense of the kind of rule violation usually associated with expressivity. He comments:

The medieval work is style. But this word, when applied to the *écriture* of the period, designates less a deviation between the system and the use one makes of it, *than this use itself*, as such. Individual variation resides in the disposition of inherited expressive elements, much more than in the original means that one gives them.[46]

He asserts that the code has built into it a set of principles of variation allowing for the "programming" of different objects. However, the variation in the products will not be meaningful as individual variant, but

rather as an example of the way in which the "program" may be made to produce variation, per se. Thus, it is that expressive elements, the discrete units which constitute the individual object, are not important for the inherent content they express, but for the relationship to a code-usage which they demonstrate. In this way, Zumthor gives us not only a code, the poetic language, but also a finite set of expressive variables which assure that the role of the user will be limited to the exercise of predetermined meanings. For the user – in this case the poet – to depart from the program will be impossible for two reasons: a) he would not have any means of communication at his disposal (there is only one code, not a choice of codes); and (b) his audience – trained only to decode the one code – would not understand him. We may well find ourselves in an analogous position. For the code propounded here by Zumthor does not correspond to the main current of theories of expressivity in language.

Zumthor's explanation of how the code provides variation involves a concept which he has been defining and redefining since the late fifties. It is called "expressive register." Expressive register forms the basis of the "language schema" by which Zumthor identifies all aspects of "the work" which relate to language, as opposed to the "mental schemas," or "forms of imagination," under which nonlinguistic phenomena are systematized. The linguistic schema teaches us that "in romanesque poetry, *topoi*, clichés, key-words, theme-words, formulas . . . all derive their evocative value less from themselves than from the structured groups to which they belong: that is, the registers of expression."[47]

Conceived by Zumthor as an intermediate entity between the individual text and the tradition, register has proved singularly difficult to locate phenomenally for anyone but Zumthor himself.[48] Even his descriptions make it sound elusive; for instance, register "is a diffuse, encompassing signal which does not convert to any one of its constituent elements (e.g., syntax, vocabulary, thematics)."[49] If it is not found in the text, neither is it found in the tradition, for he comments that there may be many registers in a tradition, but no tradition in a register.

Although he does not specifically refer to the British linguist M. A. K. Halliday, Zumthor does utilize the term *register*, which Halliday put forward in the late fifties and early sixties; his use is not dissimilar from that of Halliday. The latter sought to distinguish language variation according to two descriptive concepts: dialect and register. Dialect was conceived as "variety according to the user," while register was "variety according to use."[50] The utility of register in literary study, Halliday thought, lay in its capacity as a device for identifying and describing form-dictated language usage in literary genres. Thus, the kind of language expected in a sonnet will be different from that of an ode or an epic. Nevertheless, if the kind of tone or choice of language is dictated in the first instance by the genre one is writing, the way in which the language is used will be

idiosyncratic. For Halliday, then, register is ultimately an analytical tool for isolating and describing stylistic differences between individual poets. This is definitely *not* what Zumthor intends to convey by the term:

There is a participatory connection between the word and its register, and this connection fills a vital function: it constitutes to the exclusion of all others, *the* signal of poetry. . . . Its signalling function proceeds from its *convenance* . . . that is, its equilibrium and internal harmony. . . . While in modern poetry the connotations of the work permit us to infer that the extra-textual thing called History, those of the *grand chant courtois* refer only to the *text* –which is the register.[51]

It is clear that Zumthor has conceived of a radically synchronic poetic tradition cut off from the usual subjective elements which mark the intersection of poetry and the world. This is all very well for a theoretical construct, but one might well ask how Zumthor envisages the pragmatic realization of so impersonal and ahistoric a poetry at a particular moment by real poets before live audiences. The answer lies in the situational function of the code as conceived by Zumthor:

Medieval poetry is poetry-in-situation: and this situation is inscribed in the code. . . . The relationship between text and listener implies a concrete confrontation: a real dialogue between people able to see and touch one another. Medieval poetics is thus a poetics of effect: It tends to fulfill an expectation, *hic et nunc*, and this expectation carries with it known constants which enter into the game. . . . Instead of an author, he who listens to the text sees a speaker.[52]

These situational aspects are clearly predicated upon a postulated relationship of poet-audience based upon oral communication to a large, undifferentiated mass, the collectivity. The actions of composition and reception are seen as simultaneous, somewhat in the way that the horizontal and vertical axes of *langue/parole* are continuous, simultaneous dimensions of speech activity. Instead of an individual poet creating for individual readers, we find speaker/singers (collective encoders of known material) reciting for listeners who are at once a given audience and a collectivity of decoders, manipulating the same code as the speaker/singer.

We have now two intersecting axes: a horizontal axis representing the author's production of a text and the reader/listener's reception of it. This axis represents the *engagement* of each group with the text. It is intersected by a vertical axis of participation (concrete confrontation). The axes are bounded, on the one hand, by the code which controls the poetic activities and, on the other, by what Zumthor calls the "homogeneous social group." It is the latter that allows for and supports so rigid a code, according to Zumthor, by assuring that audience and poet are identities in a single structure. To postulate a multiplicity of types of senders and receivers would reinforce the notion of dialectic in the poetic process and therefore result in greater variety in the poetic objects created, a situation Zumthor's concept of the *grand chant courtois* attempts to minimize. Dia-

gram 2 therefore represents the "homogeneous social group" as an "hypo-
thetical social group," the more effectively to underline that the identity
of poet/audience is Zumthor's own fiction, necessitated by his desire to
restrict such performative aspects of creative activity as rule violation and
rule maintenance in the normal artistic use of poetic language. The use of
"hypothetical social group" is also intended to underscore the circularity
inherent in his model, that is, the tradition and code as he defines them
generate the social group of receivers: "Socially, the tradition establishes
the community linking the author to his auditors in the text: less by virtue
of an adherence to the text itself, than to a poetic system *which is im-
mutable in its virtuality.*"[53]

The way in which Zumthor posits the self-reflexive code and social
group is graphically displayed in Figure 2.

The "Real World as referent," that is, the world as defined by historiog-
raphy, lies outside the boundaries of the model and therefore must be
bracketed, since Zumthor provides no theory of access to such an exog-
enous referent. He has intentionally failed to provide a way to discover
correspondences between the internal structure and the world. He defends
this position by asserting that the code, the tradition and, through them,
the text create a fictive world, "hermetically sealed off from the world of
experience. . . . Disconnected from daily reality, the listener accom-
plishes a reality transference much more powerful and efficacious than

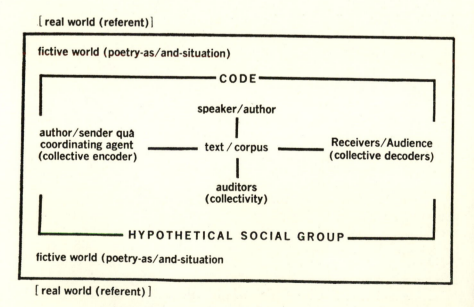

Figure 2. Representation of Zumthor's model

would be possible in a situation of ordinary discourse."[54] Unfortunately, this thesis is totally unsatisfactory.

We can hardly be surprised at this intentional exclusion of meaningful correspondence between the formal internal structure and the referential world; it was already implicit in Guiette. On the other hand, we need not feel particularly satisfied with it, especially since it corresponds neither to the medieval veiwpoint, nor is it required by structuralist poetics. Auerbach and Spitzer were not so far off the mark in trying to relate the inner world of the work to the referential horizon surrounding it – a horizon both diachronic and synchronic. In so doing, they were simply attempting to remain faithful to the stated theories of medieval poetics. The *Leys d'amors* does begin, after all, with a categorical statement of the role of the knowing subject in all poetic creation:

Three things are necessary in any age to create a work: and if any one of them is missing, the work cannot reach completion nor attain perfection. Will is the first thing: it lays the foundation of any work. Knowledge is the second thing: it permits the work to be constructed as it should. Ability is the third thing: it allows the work to be completed. And when ability is wanting, the other elements can be of little avail.[55]

The long *Ensenhamen* ("instruction") of Guiraut de Cabrera, which Martin de Riquer dates between 1150 and 1155, provides specific examples of the kind of will, knowledge and ability a troubadour/jongleur ought to possess. Even at the very beginning of the poetic tradition, in Guilhem IX, we find assertions suggesting a well-developed sense of the subject-object relationship as essential to the poetry.[56]

Zumthor would have little difficulty responding to such examples, and indeed he has addressed a series of articles to the problem of the objectified subject in medieval poetry.[57] To those who do not share his adherence to glossematics, with its devalorization of the content and subject of form and expression, the problem of mediating between internal formal structure and the world it occupies may be soluble by more orthodox structuralist methods.

Before exploring that possibility, a word should be said regarding the approach of Hans Robert Jauss to the same problem. Space constraints do not permit our giving Jauss's aesthetics of reception and impact the attention they merit, but, given Zumthor's awareness of Jauss, and vice-versa, it may be instructive to compare their two models. Jauss, too, believes in the preexistent poetic tradition. For him, however, the interaction of text and audience is a dialectical one in which the historical context of the work "is not a factual series of events which exists apart from the reader."[58] The context develops in the reader's consciousness as a result of his experience with a series of texts. His reading experience develops a set of expectations regarding the nature of a text; this internalized set of expectations then constitutes "a paradigmatic isotopy." This isotopy will

function as a guide in the experience of new texts. It will not – as in the case of Zumthor's code – discourage the assimilation of new forms. The dialectic between past experience and new experience is thus a system of development and correction. "The new text evokes for the reader (listener) the horizon of expectations and rules familiar from earlier texts, which are then varied, corrected, changed or just reproduced."[59]

Proceeding on the theory that "the historical character of literature appears exactly at the intersection of the diachronic and synchronic approaches,"[60] Jauss constructs a model which may be schematized in the following manner. In studying the model,[61] one should bear in mind that the scheme is a cross-section taken from a continuous dialectic. To be totally faithful, the scheme would have to be represented infinitely. It is for this reason that the time symbols indicating succession have been included in Figure 3.

The superiority of Jauss's model over Zumthor's lies in its recognition that genre is a poetic process based on a dialectic in a setting of performance which condenses tradition and historical situation. It requires the interaction of poet and audience in an intersubjective activity with a variety of texts (and genres) over a period of time. The interaction of the poet and audience is never with an individual text or virtual tradition per se, but with texts projected upon a horizon of expectations derived from direct experience with a range of preexistent materials. The effectiveness of this interaction at any moment will depend upon a number of historical contingencies. Thus, the representation of a given work or genre at any moment, or its realization, will be much more varied than Zumthor's model would suggest. These factors are represented by the vertical and horizontal axes of Figure 3. Tradition, work(s), genre(s), his-

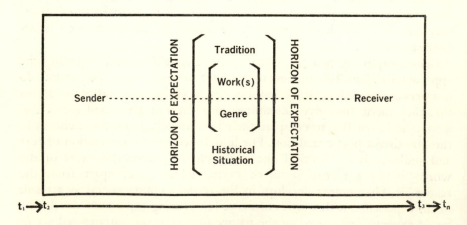

Figure 3. Representation of Jauss's model

torical situation are shown as a vertical axis enclosed by brackets to indicate that they are related elements which affect the activity of poet/audience, which is represented by the horizontal axis. It is the interaction of sender/receiver in the context of the elements comprehended by the vertical axis which creates the horizon of expectations. In Jauss's view, this horizon will, in turn, constrain the kind of rule maintenance or rule violation which determines the nature of the creative activity at a given moment. That activity, in its turn, will depend on another set of perceptions, related to the horizon of expectations and historical situation (but not shown in Figure 3): the dominant concerns to be represented by form in a given historical moment.[62] By these concepts, Jauss brings form into dialectical relationship with the referential world and thus succeeds in reintegrating the processive aspects of medieval poetry into an order which is synchronic and diachronic:

> The principle of an historicisation of the concept of form not only requires that one renounce the substantialist vision of a constant number of qualities which, in their immutability, create a given genre. It is also necessary to jettison the idea of a juxtaposition of genres closed in upon themselves; instead [one must] look for the interrelationships which help them to constitute a literary system at an historically given moment.[63]

Jauss's model makes allowances for the apparently contradictory nature of medieval poetry, at once conservative and innovative, often in the same texts. What one misses in Jauss, however, is a clearcut formulation of the way in which the norms which Jonathan Culler calls "expectations of coherence and expectations of significance"[64] function within the formal poetic object to connote their referent in the experiential world. In other words, since, as we saw, medieval poets claimed to be giving significance to a particular experience, how is this contact with the world signified within a highly formalized system? This question is crucial if we are to understand the motivation for erecting the system of development and correction which constitutes the process of change in the medieval lyric. But even prior to that, our understanding of how meaning was produced and conveyed in the lyric depends, to no little extent, upon the answer to this question.

It may prove a useful response to the problem if we consider a model based upon the most fruitful aspects of the theories studied here. To begin with the elemental object of study, the text, we have seen that almost all of the scholars represented here accept as given the dialectic between generic form and individual manifestation, that is, genre and text. It may be safely asserted that medieval poets and audiences did not see an individual text, but rather a text which, by its very form, projected a relationship to a superstructure called genre. The individual text might realize the generic form, or it might correct it, or negate it, as in the case of Guilhem IX's parodic cansos.[65] At its most basic level, poetic form is

thus a binary structure of discrete elements, the text and a larger unit, the genre. As there can be no text without a genre, and no genre without a text, they stand in reciprocal implicational relationship to one another. Expectations of coherence and totality are predicated upon the perception of the dialectic between the two. Our model, therefore, must show this, less in a hierarchical relationship than in a horizontal sequence of continuous exchange. To think of *one* genre with many texts dependent upon it may be a useful shorthand for literary history, but if taken as a description of the historical reality, it would ignore the dialectical process of continuous exchange which is so important a part of Jauss's theory. Parenthetically, let us note that the reciprocal implicational relationship between genre and text does not preclude comparison of individual texts or genres; it simply recognizes that even when comparing single elements of a relationship, the other will be present by implication and figure in the comparison.

The pair, genre/text, is activated and completed by another binary structure, also dialectical in nature, and also standing in reciprocal implicational relationship: poet/audience. Since poet/audience is called into being by the existence of the poetic object, and vice-versa, they may be seen as interacting through the object. It would be a mistake to view their primary function as purely utilitarian, that is, as sender and receiver of the "poetic message." They interact in a way which determines the nature of the object, as well as what it communicates.

Although the interaction may be said to be initiated by the poet, the audience functions as a developer and corrector of the poet, and vice-versa. It is to be imagined, given the oral nature of the medieval tradition, that the dialectic may often have taken the form of a direct confrontation. This provision for an active subject-object-subject participation in the poetic situation enables us to explain the variety of medieval lyric genres, as well as their subtlety. It also explains the reverse: the similarity of much medieval lyric and its lack of subtlety. The reason for this is not hard to imagine: The greater the multiplicity in the group of senders and receivers, the greater the variation in the production and perception of meaning. This implies not only complex and varied texts clustered at the "high" end of the scale, but also a continuum that goes on down to mediocre texts of minimal complexity and maximum alikeness.

What informs, indeed, renders possible, the meaningful interaction of poet/audience with genre/text is the preexistent poetic language as experienced diversely by poets and audiences. In our model, then, emphasis is placed upon the performative, rather than the normative. The active confrontation of poet/audience with the poetic language creates a horizon of expectations, but not in the same way as Jauss's model. Whereas, for Jauss, the horizon of expectation intends the larger structure, the genre,[66] I prefer to relate it to formal meaning production at all levels, even down

to the basic constituents of text – phonics, syntax, vocabulary. In this way the role of rule violation and rule maintenance as differentiating elements in the production of meaning(s) may be exploited to the fullest in the theoretical construct. It is to emphasize form as a dialectic between performance and perception that the horizon of expectations, as shown in Figure 4, constitutes the boundary for those elements of the model related to the self-referential aspects of the poetic object.

Figure 4 illustrates that the concept of "poetic language" on the self-referential side of the scheme, is complemented by a concept of *vraisemblance* to which it is intimately linked. *Vraisemblance* is used here in the sense authorized by Todorov when he writes:

One can speak of the *vraisemblance* of a work in so far as it attempts to make us believe that it conforms to reality and not to its own laws. In other words, the *vraisemblable* is the mask which conceals the text's own laws and which we are supposed to take for a relation with reality.[67]

Vraisemblance belongs, by this definition, to the same kind of internal structure as "poetic language." However, it differs from the latter in pointing outward, beyond the text, to other texts and objects in the world. It is thus a basis for intersubjectivity within the poetic object itself. Without pretending that it is the historical situation internalized in the text, we can argue that it provides "a set towards the world," a ground for opening the text up to the historical and ontological world. This removes, once and for all, any temptation to postulate a totally enclosed structure à la Zumthor. By linking *vraisemblance* with "poetic language," this model stresses the fact that the dialectical tension between the "mimetic" tendency and the tendency toward self-reflexivity can only result

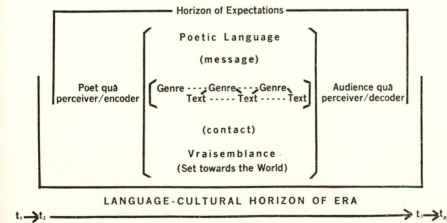

Figure 4. Representation of Nichols's model

in a more complex internal structure of the poetic object. This, in turn, not only contributes to a greater sense of coherence or totality, but creates the potential for a more complex interpretation of the object by the critic. This is desirable if one accepts the Gestaltist premise "that the richest organization compatible with the data is to be preferred."[68]

As Figure 4 shows, *vraisemblance* belongs to that part of the model which is, in Jakobson's terms, "referential," that is, directed towards the context. As adumbrated by Jakobson,[69] and recently recast by Hayden White,[70] the literary statement has two poles, "message" and "contact." The former is self-referential: It is the literary statement considered as *poesis*, that is, calling attention to itself as message. The other pole is the referential side, that is, the literary statement considered "as 'contact' directing attention to the 'phatic' and 'conative' aspects of linguistic behavior which are sources of its *constructive* power."[71] Why does Figure 4 show two elements each on the referential and contact sides of the model, and what is the relationship between them? Briefly, they increase the range and complexity of potential meanings which may be realized in the work. "Message" and "contact" are the basic aspects of opposition which constitute "literary statement." "Poetic language" and *vraisemblance* operate as a kind of superstructure over "message" and "contact," respectively, to produce and convey higher degrees of coherence and signification in the poetic object. All four elements are always present, even in the simplest poetic statement. In a work at the bottom of the scale, however, "message" and "contact" would carry most of the burden, and, even then, minimally. As one climbs higher on the scale of poetic object, the potential of "poetic language" and *vraisemblance*, as described above, would tend to be realized to greater extents. At this level, one would expect not only a more complex work, in terms of the form invested by poetic language, but also a work which, thanks to *vraisemblance*, demonstrated a richer intersubjectivity enabling comparison with other cultural artifacts of the era (intertextuality); in addition, its contacts with the historical situation would be expected to be greater, or at least more obvious.

Restated schematically, the model that emerges from the foregoing description appears in Figure 4. As in Figure 3, the scheme should be taken as a processive phenomenon, unfolding in time, and not as a static grid.

What I have tried to imply by suggesting the possibility of a poetics of historicism may be conveyed, in closing, by referring to Yeats's poem "Among School Children," which ends with the famous line, "How can we know the dancer from the dance?" Paul de Man has recently suggested that the dancer and the dance are *not* the same and that modern literary theory desperately needs *to tell them apart*.[72] That may well be an important aspect of our task, but it does not necessarily follow, as de

Man would seem to imply, that we no longer need "to tell them together" as part of the literary process. That is, after all, the way, or one way, that we experience them in Yeats's poem, in the first place. Recent theories of medieval poetry have tended to concentrate overly much on the "telling apart" of subject and object, poem and process. In so doing, they have minimized the fact that medieval literature has dancers and dances, songs and poets, all functioning within a recoverable cultural horizon. Instead of fragmenting these elements, we should continue to perfect our means of "telling them together."

NOTES

Acknowledgment: I would like to express my gratitude to my friend and colleague, Hoyt Alverson, of the Department of Anthropology, at Dartmouth College, for his critical assistance and guidance in the shaping of the final version of this article.

1. Brian Stock, "The Middle Ages as Subject and Object: Romantic Attitudes and Academic Medievalism," *New Literary History* 5 (Spring 1974), 527–547.
2. Paul Zumthor, "Du nouveau sur la poésie des troubadours et trouvères," *Romanic Review* 66 (1975), p. 86.
3. *Ibid.,* p. 86.
4. Jean Starobinski, "The Meaning of Literary History," *New Literary History* 7 (1975), p. 85.
5. For an interesting and useful formulation of such a continuum, see Hayden White, "The Problem of Change in Literary History," *New Literary History* 7 (1975), p. 101.
6. Leo Spitzer, *Linguistics and Literary History* (Princeton: Princeton University Press, 1948), p. 9.
7. *Ibid.,* p. 19.
8. *Ibid.,* pp. 18–19.
9. *Ibid.,* p. 20.
10. *Ibid.,* p. 27.
11. René Wellek, *Discriminations: Further Concepts of Criticism* (New Haven: Yale University Press, 1970), p. 128.
12. *Ibid.,* p. 129.
13. Erich Auerbach, *Scenes from the Drama of European Literature* (New York: Meridan Books, 1959), pp. 189–90.
14. Erich Auerbach, *Literary Language and its Public in Late Latin Antiquity and in the Middle Ages,* translated by Ralph Manheim (New York: Pantheon, 1965), p. 19.
15. *Ibid.,* p. 6.
16. *Scenes from the Drama,* p. 58.
17. "Besides the opposition between *figura* and fulfillment or truth, there appears another, between *figura* and *historia; historia* or *littera* is the literal sense or the event related; *figura* is the same literal meaning or event in reference to the fulfillment cloaked in it, and this fulfillment itself is *veritas,* so that *figura* becomes a middle term between *littera-historia* and *veritas.*" *Drama,* p. 47.
18. *Literary Language,* p. 110.

19. R. G. Collingwood, *The Idea of History* (Oxford: Oxford University Press, 1956), p. 228.
20. A. J. Greimas, *Du Sens* (Paris: Seuil, 1970), p. 280.
21. *Ibid.*, p. 281.
22. Robert Guiette, *Questions de Littérature* (Ghent: Romanica Gandensia, 1960), p. 13.
23. *Ibid.*, p. 9.
24. *Ibid.*, p. 10–11.
25. *Ibid.*, p. 11.
26. "Les études du style," *Poétique* 2 (1970), p. 225.
27. *Questions*, p. 14.
28. *Ibid.*, p. 14.
29. *Ibid.*, p. 15.
30. All four diagrams are my own representations. They are offered in an attempt to render greater clarity to the descriptions of the models.
31. Roger Dragonetti, *Aux frontières du langage poétique: Etudes sur Dante Mallarmé, Valéry* (Ghent: Romanica Gandensia, 1961).
32. *Ibid.*, p. 55.
33. *Ibid.*, p. 80.
34. *Ibid.*, p. 48.
35. *Ibid.*, p. 51.
36. *Ibid.*, p. 52.
37. *Ibid.*, p. 56.
38. Tzvetan Todorov, *Communications* 8 (1966), p. 125.
39. *Littérature et signification* (Paris: Larousse, 1967), p. 92.
40. Paul Zumthor, "From the Universal to the Particular in Medieval Poetry," *Modern Language Notes* 85 (1970), p. 816.
41. *Ibid.*, p. 817.
42. *Ibid.*, p. 818.
43. *Essai de poétique médiévale* (Paris: Seuil, 1972), p. 73.
44. *Ibid.*, p. 82.
45. Zumthor cannot totally deny this dialectic, but, in passages like the following, he does try to minimize it: La relation traditionnelle est de contiguïté ou de contexte: elle s'établit entre le texte et ceux qui le précédèrent, l'accompagnent et le suivront au sein d'une continuité, en principe, homogène. Elle pose par là une question d'identité: ce qu'un vocabulaire surfait entend par originalité. *Ibid.*, p. 82.
46. Paul Zumthor, *Langue et techniques poétiques à l'époque romane* (Paris: Klincksieck, 1963), p. 126.
47. *Ibid*, p. 121.
48. Stephen G. Nichols, Jr. "Toward an Aesthetic of the Provençal Lyric II: Marcabru's *Dire vos vuoill ses doptansa*," in *Italian Literature: Roots and Branches* (New Haven: Yale University Press, 1976), 15–37.
49. *Essai de poétique médiévale*, p. 232.
50. M. A. K. Halliday, "Descriptive Linguistics in Literary Studies," *English Studies Today*, 3rd Series, ed. G. I. Duthie (Edinburgh: Edinburgh University Press, 1964), pp. 34–35.
51. Paul Zumthor, "Style and Expressive Register in Medieval Poetry," in *Literary Style: A Symposium*, ed. Seymour Chatman (London: Oxford University Press, 1971), pp. 267, 273.
52. *Essai de poétique médiévale*, p. 42.
53. *Ibid.*, p. 76.
54. *Ibid.*, p. 45.

55. *Las Leys d'Amors,* ed. M. Gatien-Arnoult, vol. I (Paris/Toulouse: Bon et Privat, s.d.), p. 2.
56. See the commentaries and introduction in the recent critical edition of Guilhem IX by Nicolo Paserò (Modena: STEM-Mucchi, 1973).
57. See, in particular, Section 3 of Zumthor's most recent book, *Langue, texte, énigme* (Paris: Seuil, 1975).
58. H. R. Jauss, "Literary History as a Challenge to Literary Theory," *New Literary History* 2 (1970–71), p. 11.
59. *Ibid.,* p. 13.
60. *Ibid.,* p. 29.
61. The model is constructed largely from the article already cited and from "Littérature médiévale et théorie des genres," *Poétique* 1 (1970), 79–101.
62. *Ibid.,* p. 95.
63. *Ibid.,* p. 95.
64. See Jonathan Culler, *Structuralist Poetics* (Ithaca: Cornell University Press, 1975), chapter 8.
65. See my article, *"Canso—Conso:* Structures of Parodic Humor in Three Songs of Guilhem IX" in *L'Esprit Créateur* (Spring, 1976).
66. Hans Robert Jauss, *Poetique* 1 (1970), p. 93.
67. Tzvetan Todorov, "Introduction," *Le Vraisemblable, Communications* 11 (1968), pp. 2–3.
68. Cited by Culler, p. 174.
69. Roman Jakobson, "Linguistics and Poetics," in *Style in Language* ed. Thomas Sebeok (Cambridge, Mass.: M. I. T. Press, 1960), 350–377.
70. White, *op. cit.* (n. 5), p. 109.
71. *Ibid.,* p. 109.
72. Paul de Man, "Semiology and Rhetoric," *Diacritics* 3 (1973), 27–33.

Everyman *and the Implications of Bernardine Humanism in the Character "Knowledge"*

THOMAS J. JAMBECK

In his recent essay on the play *Everyman* V. A. Kolve addresses himself to what persists as "one of the most difficult questions in *Everyman* scholarship. Namely, is the character Knowledge to be understood in something like our modern sense of that term [*scientia, intelligentia*]? Or does it stand instead for the even then rarer, and now archaic, medieval sense of 'acknowledge,' naming that part of the sacrament of penance which concerns a full confession of sins?"[1] With few exceptions, most readers subscribe to one of the two general definitions which Kolve succinctly outlines: Those who regard her as *scientia* note the humanistic implications in the "crucial placement of Knowledge . . . as the pivot that turns Everyman toward salvation";[2] those who interpret her as contrition or acknowledgment of one's sins remark the play's emphasis upon the efficacy of the sacraments, particularly the "hous of saluacyon" episode in which Knowledge introduces the hero to "Shryft." However, while either definition satisfies the doctrinal, as well as dramatic interests of the morality when applied to isolated instances of Knowledge's "counseyll," neither is sufficiently inclusive to account for the complex of meanings which the character embodies. For example, Knowledge's ministrations are not confined to the "hous of saluacyon," as well they might be if she is to be narrowly defined as contrition. Thereafter, Knowledge continues to advise Everyman, calling his attention to particulars that are quite outside the province of contrition but which nonetheless bear significantly upon the hero's progress, as, for instance, when she admonishes Everyman to receive the holy sacraments of the Eucharist and extreme unction (lines 706–709) or when she delivers her disquisition on evil priests (751–763). Similarly, to define Knowledge simply in "the modern sense of that term" is to neglect her obvious role in the penitential sequence of the play. Knowledge not only guides Everyman through the rigors imposed by Shryft, but also represents a requisite preliminary in the sacramental ordinance. Clearly, as the playwright is careful to point out, the acknowledgment of one's sins and contrition are dispensations which occur in a precisely delineated chronology, one anticipating the other, indeed imposing the necessary condition for its salutary effect (638–647).

An attractive alternative interpretation of Knowledge is offered by A. C. Cawley in the introduction to his edition of *Everyman*. Defining the ultimate end of human knowledge as the knowledge of God, Cawley cites a fifteenth-century paraphrase of Saint Bernard of Clairvaux's dictum: "ther is non saued/wythoute to haue knowleche of hym self. for of this knowleche groweth humylyte. which is moder of helthe."[3] Although Cawley does not pursue the argument beyond this brief notice, his observation is suggestive on several counts. First, Bernard's theory of knowledge describes a penitential ascesis much like that depicted in the morality, an ascesis which serves to clarify the apparently disparate functions that "knowledge" performs as a counselor to the hero. Too, Bernard's concept of knowledge – especially as it reveals his profound interest in the psychological process by which the soul comes to grapple with the motive principles of human salvation – also serves to unravel several doctrinal puzzles which have occasioned a good deal of theological uneasiness among the readers of the play: that is, the dramatist's insistence upon "Good Dedes" as the regenerative principle of Everyman's salvation; his intimation that the hero, sustained by Knowledge, is the agent of their restitution; and his notion of the role of the four auxiliary advisers – "V. Wyttes," "Beaute," "Strengthe," and "Dyscrecyon" – in the moral play's penitential sequence. That is not to suggest, of course, that the playwright had his Bernard open before him. As has been frequently noted, the influence of Bernardine mystical theology on English morality plays, while considerable, is seldom direct.[4] And this is particularly true in the case of *Everyman*. The lines of influence between the saint and the playwright, crossing as they do some three centuries of popular interpretation and commentary, can hardly be restored with any confidence. Nevertheless, Bernard's theology remains an especially valuable aid to the modern reader of *Everyman* in that it serves as a kind of index to the sensibility, so popular in the later Middle Ages, which informs the doctrinal matrix of the play.

A convenient starting place for a preliminary appraisal of that sensibility is the "hous of saluacyon" episode. Having despaired at the infirmity of his Good Deeds, those acts of charity by which one merits salvation, Everyman is conducted by Knowledge to Shryft, under whose ministrations the hero will receive the "scourge of penaunce" (605). Where, according to the ordinance of the sacrament, we would expect Shryft as the priestly mediator to apply the salutary strokes of the penitential rod, thereby indicating that the hero has received the absolving grace which penance confers, we witness instead a rather curious shift in the sacramental process. Turning to Knowledge for the scourge, Everyman proceeds to flagellate himself, and as he does so, he is gladdened by the appearance of his Good Deeds, once unable to stir, now "hole and sounde,/ Goynge vpryght vpon the grounde" (625–626). The implica-

tion is, of course, that Everyman himself is able to perform the expiatory satisfaction required for his sins, an implication which is corroborated by the subsequent scene. As Everyman rejoins the company of his counselors, having emerged from the "hous of saluacyon," V. Wyttes remarks the hero's transformation: "Peas! For yonder I se Eueryman come,/ Whiche hath made true satysfaccyon" (769–770). V. A. Kolve notes in this instance that V. Wyttes "names the change as though Everyman were its agent; but of course the facts are otherwise. Christ alone could make true satisfaction for sin – He is the great restitution – but it is available to any man through the sacrament of the altar."[5] Similarly, Arnold Williams questions the dramatist's orthodoxy, arguing that according to Catholic theology, man is not saved by good deeds, but by grace: "I have the feeling that all the great historical forms of Christianity agree that, after Adam's fall, man is unable to achieve salvation by his own merits. As a race, man is saved by the sacrifice on the cross – the cycle plays make this point – and as an individual, man is saved by grace earned by this sacrifice – the moral plays make this point."[6] Consequently, Williams concludes that while medieval Christianity does not yield a theology which answers wholly to the *Everyman* penitential sequence, "there is a theology in which man achieves his salvation through his own efforts, aided by knowledge. This is a fundamental Buddhist tenet, and it ought to come as no surprise that the original source of *Everyman* is a Buddhist parable."[7]

One need not go quite so far afield. As Kolve and Williams attest, at the very center of *Everyman*'s doctrinal concern is the generic morality emphasis upon the expiatory action of Calvary as the primary means by which "euery man" might share in the fruits of the Atonement. Thomas F. Van Laan has pointed out in this regard that through his extensive references to the Passion, the dramatist sets Christ's sacrifice and Everyman's progress in a significant thematic parallel: The Christic action – Christ's assumption of human form, his suffering and death, and his subsequent resurrection – "is pertinent to the meaning of *Everyman*, for it alone has made possible the salvation there enacted, and in Christian thought the successful pilgrimage of the individual analogously recreates that action."[8] What has been generally ignored, however, is that the playwright reorders the traditional moral play categories of human salvation in a wholly fresh direction. Implicit in the Christocentric interest of the play is a functional definition of the efficacy of human knowledge as the principal disposition by which man may indeed become an active agent in the work of his own redemption. Aberrant though it may appear, the dramatist's theology hews closely to the theory of satisfaction which arose in the later Middle Ages as an adjunct to the soteriological doctrine of *Christus patiens*, a theory that is largely Bernardine in the intellectual, as well as affective design by which it was known to the *Everyman* audience.

To understand the impact of the Bernardine penitential piety upon the

doctrinal structure of *Everyman* is to appreciate the late-medieval emphasis upon the potentialities of human nature – not only that of Christ, but also that of man himself – as the operative principle in the redemptive process.[9] Unlike the earlier Church Fathers who saw the victory of Calvary in terms of a contest between the divinity of Christ and the diabolical powers, a cosmic drama in which mankind was a "helpless spectator," later commentators on the Atonement locate the Savior's triumph in his suffering humanity and man's hope for salvation in his active participation in that exemplary human nature.[10] Bernard's theory of knowledge reflects this shift in attitude. For Bernard, the Savior's sacrifice not only redeemed man, but also established the pattern of human response by which man could repay the debt incurred by the price of Christ's "infinite love wherewith He gave Himself for our salvation."[11] The very paradigm of human charity, Christ's passion provides for those men "who knew how to love only in a carnal manner," a palpable realization of human perfection which may draw them to a more spiritual love of God himself.[12] That the contemplation of Christ's suffering humanity must appeal, of necessity, to the more physical impulses of human affection is of little concern to Bernard, for the very existence of Christ as man has as a crucial function to portray the potential value of human experience in the plan of salvation.[13] What other reason, Bernard asks, for the ignominious death but that "he wished to partake of the same suffering and temptation and all human miseries except sin . . . in order to learn by his own experience how to commiserate and sympathize with those who are similarly suffering and tempted"?[14] Although Christ as the Word of God knew man's anguish from all eternity, he did not know it by experience and, what is more, could not, without taking on the guise of the servant himself.[15] And this was one of the reasons for the Savior's having abased himself, that he might learn compassion,

not with that pity which he, ever blessed, had from eternity, but with that which he learned through sorrow when in our form. And the labor of love which he began through the former, he consummated in the latter, not because he could not consummate it in the one, but because he could not fulfill our needs without the other.[16]

The implication for mankind is clear: If Christ "made himself wretched . . . in order to learn what he already knew; how much more should you . . . observe what you are, that you are wretched indeed, and so learn to be merciful, a thing you cannot know in any other way."[17] Thus, for Bernard, the ascent to that love which man owes God begins and ends with knowledge: To know yourself is the inception of that wisdom from which charity issues; "to know God is its consummation."[18]

Crucial to Bernard's theory of knowledge, particularly as it bears upon his penitential system, is his perception that between the knowledge of self and that of God there exists an implicit identity.[19] Citing the Scriptural

injunction that man is made *ad imaginem dei*, Bernard explains that since Christ alone is the image of God, it is from him that the soul, made in his image, has its likeness.[20] Accordingly, the mysterious filiation between Christ and the human soul exacts of mankind a terrible personal burden. When the individual conforms his will to that of the Savior, he is capable of participating in the divine eminence which constitutes the soul's "greatness"; to know one's self, that is, to recognize the imprint of Christ in one's soul, is literally to know God, indeed to become like him. But to sin, thereby miring the soul in its fleshly existence, is to obviate man's natural resemblance to God. In his sermon, "De imagine sive Verbo Dei," Bernard recounts the Bible's censure of those who have willfully divested themselves of the image in which they were made:

> *Every man walketh in a vain shew; surely they are disquieted in vain.* Altogether in vain, for it goes on to say: *He heapeth up riches, and knoweth not who shall gather them.* And why is he ignorant, except that he bends down towards things low and earthly, and treasures up for himself nothing but earth? He does not know in the least for whom he is gathering those things which he confides to the earth[21]

Bernard's description of the spiritual myopia which attends man's defection from the will of God calls to mind the opening scene of *Everyman*, where God, decrying mankind's thoughtless abandonment to "wordly ryches," complains that they have lost sight of the very "beynge that I them haue lent" (22–57). For Bernard, like the playwright, the implications of "euery mannes" ignorance are tragically apparent: Deformed by the vicious appetites of a corrupt body, the soul is blinded to its own nature as a "divine analogue," a blindness which severely impairs its ability to recover the resemblance that constitutes its essence.[22]

Blinded as he is by his inordinate love for the "goods" of this world, man is gravely deflected from that charity which constitutes his only hope for salvation. Therefore, the first order of knowledge for one who would recover the path of charity is to know himself and his predilection for cupidity, to recognize, as Everyman himself perceives, "A, Good, thou hast had longe my hertely loue;/ I gaue the that whiche sholde be the Lordes aboue" (457–458). However, as Everyman's progress testifies and Bernard confirms, self-knowledge, while a necessary prerequisite, is inadequate as the efficient cause of satisfaction, for, having judged himself contemptible, the penitent requires of himself the "strictest expiation."[23] Accordingly, between the inception of wisdom and its logical conclusion – the knowledge of God – is an intermediate step without which spiritual advancement is impossible. Hoping for the justice that promises emendation but despairing at their own depravity, "those whom truth has caused to know, and so condemn, themselves," must flee to Christ and embrace the precept which his sacrifice enjoins: *"Blessed are the merciful, for they shall obtain mercy.* And this is the second step of truth, when they

seek it in their neighbors, when they learn others' wants from their own, when they know from their own miseries how to commiserate with others who are miserable."[24] Each individual, recognizing that he is the spiritual heir of Adam, must come to the understanding that his sinful wretchedness is the common legacy of all mankind. To apprehend one's own moral deformity is to know and, consequently, for the contrite Christian, to have compassion for the similar plight of one's neighbors. Moreover, Bernard insists, this knowledge must be eminently compassionate, revealing itself in the works of active charity, or it remains a fatal impediment to salvation:

knowledge stored up in the memory – which is, as it were, the stomach of the soul – unless it has been cooked over the fire of charity and so distributed and disposed amongst our spiritual members – which are our habits and our acts – so that the soul herself derives a goodness of the things she knows – unless this be the case, our knowledge shall be imputed to us as sin. . . .[25]

The second order of knowledge, then, is to understand the intimate rapport which exists between the penitent and his Savior, to apprehend that Christ's resolve to suffer the frailties of human nature obliges man to a certain reciprocity. As the Savior learned mercy through the agonies of His passion, so, too, the penitent, through the knowledge of his own soul's misery, must recreate his Redeemer's act of charity by performing those good works which the sacrifice of Calvary prescribes. Illumined by the wisdom of the Word, the penitent ascends to the final stage of knowledge wherein the soul "*shall know, even as also it is known;* then shall it love even as it is loved, and the Bridegroom shall rejoice over the Bride, because knowledge and love are reciprocal between them."[26]

What is interesting in Bernard's analysis of human knowledge, particularly as it recalls Everyman's progress, is his insistence that self-knowledge is not merely rational cognition.[27] It consists, as well, of an exercise of the will. Animated by the first stirrings of knowledge, the soul turns from the distractions of sense data to examine itself "in the light of truth."[28] For Bernard, the soul's introspection is the prelude to true wisdom, for, having contemplated itself, the soul discovers "how far removed she is from the ideal of perfection."[29] At this juncture, the penitent, chastened by truth, willingly acknowledges his loss of innocence and acquiesces to the purifying emotions of the will – sorrow and penitence. Both dispositions, Bernard maintains, are crucial to spiritual regeneration: sorrow, because it purges the reason of its pride; penitence, because it stimulates the rational faculty to distinguish properly the most expedient course to salvation. Thus, in Bernard's penitential program, self-knowledge represents a tripartite progression: The penitent must have cognition "of what he has done," humility for "what he has deserved," and the intention, born of compunction, to recover "what he has lost."[30] With the cooperation of the will and reason, the penitent ascends to the condition of "free coun-

sel" (*liberum consilium*), that is, "enlightened understanding,"[31] by which the judgment, clearly perceiving and consenting to the good, fervently desires justice and resolves to perform the good works of active charity.

Interestingly enough, it is to Everyman's plea for "counseyll" (516) that Knowledge appears for the first time, her arrival signifying the hero's newfound understanding (524–526). Commenting on Knowledge's entrance, Van Laan notes what has become a commonplace in *Everyman* criticism: "that Knowledge comes from outside Everyman, that she is unexpected, that her entrance is not prepared for – all suggest that Everyman has finally received the grace which he also needs to make his penitence effective, the grace which had always been available but which in his blindness he had been unable to perceive."[32] While Professor Van Laan's observation accurately assesses the transformation of Everyman's "condycyon," a conversion which Knowledge's arrival declares, his reading fails to take into account the theological implications that underpin the dramatic situation. Indeed, that Knowledge is an external force, "unexpected" and "not prepared for," is denied by the action of the play. What is particularly striking in this regard is that the playwright, like Bernard, does not characterize his penitent's acquisition of knowledge as a passive acquiescence to a force imposed from without, but as the logical fruition of an internal probing, a psychologically intelligible ascent through three successive stages of augmented understanding. What is more, each stage adheres exactly to the Bernardine tripartite sequence; and, apparently to underscore the climactic progression of Everyman's growth, each step is dramatically signalled by an impassioned appeal for "counseyll."

Despairing at the flight of Fellowship, Cousin, and Kindred, Everyman turns to Goods, of whom he makes his first explicit request for Counsel: "Come hyder, Good, in al the hast thou may,/ For of counseyll I must desyre the" (339–400). Ironically, it is Goods, the allegorical metaphor of inordinate worldliness, who, in response to the hero's entreaty, echoes God's opening rebuke of Everyman for having "combred" himself with "worldly ryches" (60). Goods confirms Everyman's abased reason ("For bycause on me thou dyd set thy mynde")[33] and his spiritual myopia:

For my loue is contrary to the loue euerlastynge./ But yf thou had me loued moderately durynge,/ As to the poore gyue parte of me,/ Than sholdest thou not in this dolour be.[34]

Thus, he confronts the hero with his prideful ignorance, manifested by Everyman's self-indulgent submission to the transitory "goods" of fleshly gratification. The playwright's selection of Goods's testimony as the antecedent to true knowledge is by no means fortuitous, for in Bernardine terms, the soul's path to enlightenment begins with the promptings of the immediate objects of temporal satisfaction perceived "in the light of

truth."[35] Consequently, Goods's revelation, however malicious his intent, forces Everyman to recognize the onerous nature of his transgression: "I gaue the that whiche sholde be the Lordes aboue" (458). Incipient though it may be, the penitent's awareness signals, according to Bernard, not only the first stage of self-knowledge – the freeing of oneself from the inertia of sin – but also the first stirrings of grace, a spontaneous revivification which does not presuppose any prior merit in the penitent.[36]

So, too, Everyman, discerning the implications of "what he has done," ascends to the second stage of penitence – the dissipation of pride, "the daughter of ignorance of self,"[37] by a humble examination of his own wretchedness:

> For my Goodes sharpely dyd me tell
> That he bryngeth many in to hell.
> Than of my selfe I was ashamed,
> And so I am worthy to be blamed;
> Thus may I well my selfe hate.
> Of whome shall I now counseyll take?
>
> (474–479)

The consequence of his self-examination and subsequent recognition of his need for additional "counseyll" is immediately apparent: Everyman's introspection, his candid assessment of "what he has deserved," enables him for the first time to perceive his soul's corruption, dramatically symbolized by his Good Deeds "so weke/ That she can nother go nor speke" (482–483). The playwright's description of Good Deeds as shackled by the weight of sin (486–488) and, later, his depiction of Everyman's enfeebled "boke of counte" (503–505) follow the Bernardine scheme closely, in that the dramatist couches his representation of the soul's supine condition in the very imagery which Bernard uses to demonstrate the efficacy of this stage of self-knowledge: "for how can she (the soul) help being truly humbled in this true knowledge of herself, when she beholds herself laden with sins, oppressed with the weight of this corruptible body, entangled in worldly cares, polluted with the filth of carnal desires, blind, earthward stooping, feeble . . . ?"[38] But the humility induced by self-contemplation, Bernard continues, is hardly debilitating, for while it reveals the soul's impotence, it also serves to liberate the reason from the corrupting blindness of the flesh. Having recognized the "helplessness of his condition" through the ministrations of humility, the penitent comes to the realization that his only recourse is Christ's mercy: "Turn to me, O lord and deliver my soul: Oh, save me for thy mercy's sake."[39] The appeal for mercy, Bernard observes, anticipates the final stage of self-knowledge in that it is motivated by the fearful understanding that the loss of one's soul is imminent without the intercession of Christ's redemptive power.

Thus, Everyman, disheartened by the "blynde rekenynge" of his soul

and agitated by the urgency of his plight, implores the supernal aid which only Christ's mercy can provide: "Our Lorde Iesus helpe me!/ For one letter here I can not se" (506–507). That Everyman's prayer represents the reversal of his "dystres" is signalled on two contextual levels: dramatically, by his accord, however unwitting, with the salvific *remedium* invoked by God in the opening lines of the play: "I profered the people grete multy-tude of mercy,/ And fewe there be that asketh it hertly" (58–59). And, doctrinally, by his subsequent ascent to the final stage of self-knowledge – the fear of God's justice which, according to Bernard, "is the beginning of salvation quite as much as it is the beginning of wisdom":[40]

> Good Dedes, I praye you helpe me in this nede,
> Or elles I am for euer dampned in dede;
> Therfore helpe me to make rekenynge
> Before the Redemer of all thynge,
> That Kynge is, and was, and euer shall.
>
> (509–513)

Having completed the three preparatory steps to enlightenment, Every-man makes his final appeal for counsel (516), and in response to the hero's heartfelt request, Good Deeds introduces her sister "Called Knowlege, whiche shall with you abyde/ To helpe you to make that dredefull rekenynge" (520–521). Here, the shape of Everyman's dramatic develop-ment and the doctrinal structure coalesce – unlike most other moralities, where the appearance of allegorical personifications never quite coincides with the hero's spiritual progress and where vices and virtues in turn be-devil and redeem a hapless soul who awaits the outcome of a struggle it barely shares in. Knowledge's arrival at this decisive moment is no *deus ex machina* resolution of the hero's "dystres." Hardly "unexpected" or "not prepared for," her entrance symbolizes, indeed dramatically realizes, the fruition of Everyman's frenetic attempt to understand and thereby avoid his impending doom. By embodying the private motions of the hero's conscience, the playwright emphasizes the psychological experi-ence which Everyman and the audience share alike, the mounting recog-nition of the terrible but salutary knowledge that in the economy of salvation one's wilful capitulation to the "Goods" of this world renders his personal account a "blynde rekenynge," and therefore a personal act of satisfaction – the restitution of his Good Deeds – is required to make that "counte full redy."

For Bernard, this juncture in the progress of the soul is crucial, in that having attained to "the knowledge of yourself, that you may fear God," the penitent must discover the subsequent and curative step, to "attain to the knowledge of Him, that you may love Him also. In the one is the beginning of wisdom, in the other is the consummation of it"[41] In his compassionate regard for mankind, Bernard points out, Christ provides every man the means by which he may personally revive those good

works that, on the one hand, promote the penitent's knowledge of God and, on the other, witness his love for the Creator: penance, through which one crucifies himself with the Savior; the Eucharist, by which one incorporates himself with Christ; and alms, "since by the labour of your hands you feed and clothe Jesus Christ in His poor, so that nothing may be wanting to you."[42]

In his "De septem gradibus confessionis," Bernard notes that although self-knowledge conduces one to recognize his own shameful condition, unless he discover in that wisdom the most expedient path to redemption, it remains unprofitable. Having realized the nature of his soul's "dystres," the penitent must take the necessary steps to recover his original innocence by submitting himself to the sacramental renewal of confession: "The first path and the first step in this way is undoubtedly self-knowledge" (*cognitio sui*); the remaining are penitence (*poenitentiae*), sorrow of the heart (*dolor cordis*), confession of the mouth (*confessio oris*), mortification of the body (*maceratio carnis*), purification of one's works (*correctio operis*), and perseverance (*perseverantia*).[43] Thus, Knowledge, her appearance witnessing the fruition of Everyman's self-scrutiny, introduces him to "Confessyon." That the hero is ready to participate in the rigors which attend the expiation of his sins is affirmed by his recapitulation of the threefold ascent to knowledge (*cognitio sui*, *dolor cordis*, and *poenitentiae*) that he has just completed:

> O gloryous fountayne, that all vnclennes doth claryfy,
> Wasshe fro me the spottes of vyce vnclene,
> That on me no synne may be sene.
> I come with Knowlege for my redempcyon,
> Redempte with herte and full contrycyon.
>
> (545–549)

Shryft, who perceives that Everyman is rightly disposed "bycause with Knowlege ye come to me," outlines the remaining steps of the penitential sequence:

> I wyll you comforte as well as I can.
> And a precyous iewell I wyll gyue the,
> Called penaunce, voyder of aduersyte;
> Therwith shall your body chastysed be,
> With abstynence & pesueraunce in Goddes seruyture.
>
> (556–560)

Like Everyman's recitation of the preliminary stages of Bernard's way to confession, those steps which stimulate the inward turning of the will to God, Shryft's program accords point by point with the remaining conditions of the Bernardine taxis, the outward signs of sacramental renewal: Everyman must first mortify his flesh with the rod of "abstynence" (*maceratio carnis*); he must then persevere in "Goddess seruyture" (*per-*

severantia); finally, turning to Knowledge for the "scourge of penaunce," the hero embarks upon the last stage of the penitential program – *correctio operis* – and therein resides the peculiarly Bernardine conception of the penitent's role in the salvific transaction.

Admonishing Knowledge to "kepe hym in this vyage," Shryft reminds Everyman of the enduring reciprocity which penance commemorates:

> Here shall you receyue that scourge of me,
> Whiche is penaunce stronge that ye must endure,
> To remember thy Sauyour was scourged for the
> With sharpe scourges, and suffred it pacyently;
> So must thou or thou scape that paynful pylgrymage.
> (561–565)

In terms of the narrative structure, Shryft's exhortation answers, and thereby resolves, God's opening complaint that "My lowe that I shewed whan I for them dyed/ They forgete clene, and shedynge of my blode rede" (29–30).[44] Doctrinally, Shryft describes the popular medieval conviction that the sacrifice of Calvary, while an historical event, is not circumscribed by space or time. Transcending the perimeters of history, Christ's loving immolation reaches across the ages to engage man spontaneously and personally in the work of the Redemption. In his sermon, "On the Two Visions of God," Bernard notes, for example, that to know and therefore to love God is to share affectively with Him His every torment:

Be like to Him now also whilst you see Him as He has made Himself for your sakes. For if you refuse not to resemble Him even in His humiliation, you have acquired the right to resemble Him in His glory as well. He certainly will never suffer the partners of His sorrow to be excluded from a participation in His triumph.[45]

Consequently, essential to Bernard's program of spiritual progress is the fervent meditation upon Christ's suffering and death as representing not only the "once-for-all" determinant of human salvation, but also an ongoing disposition, a contemporary reality, which serves as an invitation for man to realize that he may participate actively in the process of the Atonement by becoming, in the most literal sense of the word, a "partner" with his Savior in the Redemption: "Is it that we want to share in His joys and to have no part in His sorrows? If that be the case, we prove ourselves unworthy to be His members. For all that He suffers, He suffers for our sake. But if we are unwilling to cooperate with Him in the work of our own salvation, how, I ask, shall we show ourselves his coadjutors?"[46] That the playwright subscribes to the notion of the penitent as "coadjutor" is affirmed in Everyman's subsequent prayer. Echoing the Bernardine sentiment that he will become a "partynere" with Christ in his glory through the "meanes of his passyon," the hero turns to Knowledge for the "scourge of penuance" (602–605), and it is Knowledge who,

as she relinquishes the scourge, identifies the co-agency of Everyman's regeneration: "Thus I bequeth you in the handes of our Sauyour;/ Now may you make your rekenynge sure" (609–610).

That Knowledge should precipitate Everyman's self-mortification coincides precisely with Bernard's conception of the profound relationship which exists between human wisdom and the works of charity in the scheme of salvation. In his *The Mystical Theology of Saint Bernard* Etienne Gilson observes in this connection that, for Bernard, the act of mortification is the process by which we prove "that we are aware of our misery, and pass judgment on ourselves."[47] It gives proof, moreover, that "even in its secret depths the will is now accordant with the divine will; it is thus the concrete expression of an inner communion between our willing and God's willing"[48] By flagellating himself, then, Everyman affirms that he not only recognizes the gravity of his sinfulness but judges it worthy of punishment, indeed judges himself, according to Bernard, "as God judges him . . . inasmuch as he begins to know himself by process of reason as God Himself knows him."[49] However, merely to appraise one's wickedness as deserving of God's justice is not sufficient compensation. The penitent must invite that judgment, initiate it, thereby witnessing his resolve, as Gilson puts it, to go "half way to meet the punishment that he knows he deserves."[50] Thus, Shryft's injunction that Everyman share in Christ's every anguish is no empty bromide of an extravagant piety but a consummately practical expression of the penitent's capacity to collaborate with the Savior in the ransom of his own soul. By identifying his sufferings with those of the Redeemer, by compassionating through his personal trials with the Passion of Christ, Everyman testifies that his will is in accord with God's, that he wills what God wills, and this affinity, according to Bernard, is "spiritual charity itself."[51] It is under the aegis of penance, then, that Everyman gives witness to the second degree of knowledge which directs the penitent to participate in the act of charity and the reparation derived therein by affectively sharing in the loving immolation that the sacrament celebrates. Characteristically, it is Knowledge who announces that Everyman has successfully reestablished in his soul the condition by which it may recover the vigor impaired by the "synne of the flesshe":

> Now, Eueryman, be mery and glad!
> Your Good Dedes cometh now; ye may not be sad.
> Now is your Good Dedes hole and sounde,
> Goynge vpright vpon the grounde.
>
> (623–626)

For Bernard, the soul, enlightened by knowledge and animated by charity, "stands upright . . . because it has been lifted up by the hand of the Word, and set, as it were, upon two feet"[52] But, newly vivified, the soul requires the additional support of certain props without which

it "can neither stand firm in the good to which we have attained, nor rise up towards any fresh good."[53] And the chief among these supports are: *scientia* (the wisdom which is the result of man's wits), *discretionem* (discretion), *virtus* (strength), and *decor* (beauty).[54] The same powers – V. Wyttes, Dyscrecyon, Strengthe, and Beaute – appear in *Everyman* as auxiliary counselors to the hero, an appearance, it should be noted, that has prompted a rather curious ambivalence among the readers of the play. For example, Van Laan has pointed out that while the arrival of the new advisers "visualizes the accomplished purgation of sin and the resulting restoration of natural gifts," they can "ultimately contribute little of value" to Everyman's progress.[55] Similarly, for John Conley, although Dyscrecyon and V. Wyttes provide "some measure of spiritual comfort," that of Strengthe and Beaute is "brief and delusive," all four failing to "comfort Everyman *in extremis*."[56] However, when viewed within Bernard's penitential catechesis, the appearance of these "persones of grete myght" (658) not only constitutes the logical fulfillment of Everyman's potential as the co-agent in the work of his salvation, but also serves to clarify the doctrinal structure which the play to this point has dramatized. As has been frequently noted, the new companions, unlike the first group of friends (Fellowship, Kindred, Cousin, and Goods), are not accidental properties but the "natural powers" of the hero himself, discovered to him only after he has undergone the mortification of penance.[57] That is, having satisfied the requirements of the sacrament, Everyman is proffered the help of those additional counselors who, according to Bernard, confirm the incursion of grace into the penitent's soul and therefore elevate the human condition by augmenting its capacity for those natural endowments which link man's nature with that of Christ – knowledge and charity.

Accordingly, like his counterpart in *Everyman* who promises "aduysement and delyberacyon" (691), Bernard's discretion is also a "moderator and conductor," a "director of the affections," who tempers the novice's fervor for charity by the moderating influence of knowledge:

Where zeal is eager, there discretion, which is the rule of charity by order, is most of all indispensable. Without knowledge zeal is found to be almost less useful and less effectual; and most often it even very dangerous. The more fervent is zeal, the more eager the temper, the more profuse the charity; the more need is there of a watchful knowledge, which moderates zeal, tempers the warmth of the disposition, and regulates the gushings of charity.[58]

Dyscrecyon regulates Everyman's latent impetuosity (My herte is lyght, and shal be euermore;/ Now wyll I smyte faster than I dyde before").[59] Strengthe offers the resiliency calculated to fortify the hero in his struggle for perfection: "and I, Strengthe, wyll by you stande in dystres,/ Though thou wolde in batayle fyght on the grounde" (684–685). Again, it is Bernard's definition of the adviser's special office that places Every-

man's role as "coadjutor" in clearer relief, for the Bernardine notion of
virtus as that power which renders "the soul victorious over itself, and
consequently, invincible by all other adversaries"[60] underscores the sig-
nificant relationship between Strengthe, Knowledge, and Good Dedes in
the morality's thematic structure. Encumbered by the bulk of his own
corruption, the penitent, according to Bernard, is especially vulnerable to
the assaults of three adversaries – the World, the Flesh, and the Devil –
which impel the soul to evil by their wicked suggestions.[61] However,
while the three foes impel the penitent to sin, Bernard argues, they can-
not overthrow him unless, captivated by their wiles, he personally sur-
renders. Consequently, since man is the principal occasion of his own fall,
it is necessary that he arm himself with that "strength, which, as far as in
it lies, directs and rules all things according to reason."[62] Marshalling the
forces of reason against its enemies, the soul acquires the strength of the
Word, who makes "all those whose hope is in Him to be, as it were, all
powerful," and therefore cannot "possibly be either overthrown or
brought into subjection by any open violence, secret guile, or enticing
allurement."[63] Thus, raised up by its ability to assess the nature of its
"dystres," the soul is prevented from falling again by strength. And, in so
far as it witnesses the penitent's firm resolve to bring his will into accord
with that of the Word, strength is nearly analogous to the love of virtue
which is the pinnacle of human wisdom, so that "whatsoever strength la-
boriously prepares, wisdom makes of and enjoys; and that which wisdom
ordains, contemplates, regulates, strength carries into effect."[64]

Once the soul has recovered "stability by the gift of strength," Bernard
observes, and "maturity by that of wisdom, it remains that it should ob-
tain the gift of beauty."[65] At first glance, Bernard's definition of beauty
as that "resemblance to Him" without which the soul "is not able to
please Him who is the fairest among the sons of men" hardly seems con-
sonant with the frivolity of Beaute in *Everyman*, particularly her rather
fickle desertion of the hero as he approaches the grave (794–801). For Ber-
nard, Beaute's defection is by no means inconsistent with her nature, for
of the endowments which God bestows upon man, beauty is a gift of the
body whose term is circumscribed by the very transiency of its agent.
Having recognized that his soul has been salved by the unction which
Christ's merciful love provides, the penitent acknowledges his soul's health
through his external behavior, "providing for things honest not only in
the sight of the Lord, but also in the sight of men."[66] Thus, while beauty
attests to the eternal values of Christ's love, its tenure is necessarily brief,
in that beauty's testimony inheres in the outward reflection of the peni-
tent's inward capacity for virtue: "when, then, all the movements of the
body, all its gestures and habits, are grave, pure, and modest, far removed
from all boldness and licence, from all lightness and luxury, but adapted
to righteousness, and to every duty of piety, then the fairness of the soul
shall be visible"[67] It is not surprising, then, that with the appear-

ance of Beaute and her companions, Everyman resolves to perform the two remaining "Goode Dedes" which, unlike the private expression of charity enjoined by the mortification of "penaunce," give public confirmation of the penitent's desire to love as he himself is loved: almsgiving, through which he may re-act the Savior's compassionate regard for his misery by performing like acts of mercy for his neighbors; and the eucharist, in which he communicates with Christ's Passion, celebrating the "words, 'eat My Flesh' and 'drink My Blood,' as an injunction to participate in His sufferings and imitate the example which He has given us in the flesh."[68] Therefore, heeding the "vertuous monycyon" of his new advisers, Everyman is moved to make his personal testament: "In almes/ halfe my good I wyll gyue with my handes twayne/ In the way of charyte with good entent" (699–700). Thereupon, at the behest of Knowledge and V. Wyttes, the hero determines to visit Preesthode from whom "Fayne wolde I receyue that holy body" (728).

V. Wyttes' advice to the hero in this instance, particularly since he seems to digress from the doctrinal center of the play by his lengthy eulogy of priesthood, has received considerable critical attention and any prolonged discussion here would be redundant. However, one aspect of V. Wyttes' sermon on Preesthode is clarified by Bernard's notion of *scientia* and should be noted briefly. While Good Deeds summons the other advisers, it is Knowledge who introduces V. Wyttes to the hero, and logically so, for as his name indicates and Bernard confirms, V. Wyttes represents the bodily senses, those avenues of knowledge without whose help the soul "could never acquire that science" which should bring the penitent to the knowledge of the Word that he might learn the truth of "His ways."[69] For Bernard, *scientia*, as the product of the five senses, imparts to the penitent that special vision which enables him not only to recognize, but also to practice the good "when it appears." A novice in the ways of God, the penitent, wishing to "do good, but not knowing how," runs the terrible risk of wandering from the path of righteousness, lured by his incapacity to discriminate between that good which liberates the soul and those "goods" of the flesh which imprison it.[70] Thus, as an antidote to Everyman's manifest inability to sort out the ephemeral from the spiritual, V. Wyttes endorses Preesthode, who, according to Bernard, possesses the "senses trained to discern good from evil" and therefore can instruct the soul "in the truths she needs to know."[71] By commending the "lest preest" whose power as the surrogate of Christ on earth is greater than "ony aungell that is in heuen" (736), V. Wyttes offers to Everyman the most expedient access to those *remedia* which constitute the temporal source of man's spiritual solace:

> For of the blessyd sacramentes pure and benygne
> He bereth the keyes, and therof hath the cure
> For mannes redempcyon – it is euer sure –
> Whiche God for our soules medycyne

Gaue vs out of his herte with grete pyne.
Here in this transytory lyfe, for the and me

(716–721)

As the symbols of Christ's suffering humanity and the visible links be-
tween man and his Savior's propitiation, the sacraments, particularly the
Eucharist, give palpable form to the most profound truths of the redemp-
tive mystery. And it is priesthood who is the human steward of those
mysterious but salutary truths. By reenacting sacramentally what took
place historically on Calvary, the priest "bereth the keys" of redemption
which open the way for the penitent not only to fathom the good com-
municated by the Redeemer's sacrifice, but also to share in it by personally
participating in the sacramental renewal of that action. Thus, true to his
nature, V. Wyttes extols the "blessyd sacraments" as the sensible signs
which bring man into direct and intimate contact with the cross of Christ.
Hardly a digression, his sermon gives dramatic voice to the truth which
Everyman has come to know through his own penitential experience, a
truth that is theatrically realized when the hero rejoins the company of
his counselors, having "receyued the sacrament for my redempcyon"
(773):

And now, frendes, let vs go with-out longer respyte.
I thanke God that ye haue taryed so longe.
Now set eche of you on this rodde your honde,
And shortely folowe me.
I go before there I wolde be. God be our gyde!

(776–780)

Now assured that the hero has received the grace which the sacraments
perpetuate and, what is more, that he is willing to cooperate with that
grace by persevering in the good which they commemorate, V. Wyttes
can exclaim with full confidence: "Peas! For yonder I se Eueryman
come,/ Whiche hath made true satysfaccyon" (769–770).

Despite their "vertuous monycyon" and the obvious succor it provides,
the new counselors must desert Everyman when he enters the grave. As
the bodily endowments of the hero, theirs is the temporal solace which,
while it promises a spiritual good, pales in the face of eternity. However,
structurally paralleling as it does the first desertion in which the hero's
friends leave him bereft of worthwhile counsel, forsaken in his "moost
nede" (371), this second defection offers a touchstone by which Every-
man's spiritual progress can be measured. Unlike the earlier desertion,
which is marked by Everyman's frantic despair, the exit of his trusted
companions serves to emphasize the hero's newfound wisdom which each
auxiliary adviser has helped to realize (841–844).

Once ill-equipped to answer Death's summons because of his appalling
ignorance, Everyman now testifies to the depth of his understanding by

becoming himself the spiritual adviser to an audience who has yet to complete its "iornaye" to salvation:

> Take example, all ye that this do here or se,
> How they that I loued best do forsake me,
> Excepte my Good Dedes that bydeth truely.
> (867–869)

For Bernard, the penitent's role as counselor is not only a logical, but an indispensable stage in the ascent to the knowledge of God. In his final sermon on the *Canticles*, "De septem necessitatibus, propter quas anima quaerit Verbum," Bernard summarizes the steps by which the soul seeks the presence of its Savior, a summary that serves as a convenient plot outline of *Everyman* itself:

The soul seeks the Word, and accept His correction with willingness and joy, so that she may obtain enlightenment and the knowledge of Him, that by His support she may attain to virtue, and be reformed according to wisdom, that she may be conformed unto His likeness and rendered by Him fruitful in good works, and finally, may be happy in the enjoyment of His Presence.[72]

Of the seven stages, the penultimate is of particular interest in that Bernard here defines "good works" specifically in terms of the penitent's responsibility to assume his Savior's pastoral function as teacher. Illumined by the merciful knowledge which Christ taught through his own example, the penitent in turn must also generate "new spiritual lives,"[73] to "bring forth souls by preaching."[74] Everyman's personation of Christ's priestly role, according to Bernard, consummates the penitential ascent; for it indicates that the hero has finally arrived at the point in his spiritual progress wherein, purged of the ignorance which obviates the soul's likeness to God, he fervently desires to restore his natural resemblance as the *imago dei* by identifying his every action with that of the Redeemer. With the kind of expert timing and economy which characterizes the entire play, the dramatist drives home the significance of Everyman's new-found identity in the hero's final speech. As he enters the grave, Everyman declares his affinity with Christ, his desire for complete and intimate conformity to the will of his Creator, by intoning those very words which Christ himself uttered at the moment of his death: "*In manus tuas*, of myghtes moost/ For euer, *Commendo spiritum meum* (886–887).

Lest the import of Everyman's dying words escape the audience, the playwright invokes the metaphor so often used by Bernard to define this state of beatific similitude: "that of a soul which God can henceforth seek to make His spouse because He recognizes Himself in it, and because nothing now remains in it to which His love cannot be given."[75] Thus, at the close of the play, an Angel, exalting in the hero's betrothal to Christ, welcomes Everyman's soul: "Come excellente electe spouse to Iesu!" (894).[76]

While the Angel's greeting signals Everyman's salvation, the Doctor's epilogue reasserts the doctrinal premise of the hero's progress to redemption. Addressing the audience who, as the nominal heroes of the play, will themselves be summoned to a "generall rekenynge," the Doctor warns that before the seat of judgment all supports forsake mankind "saue his Good Dedes":

> For after dethe amendes may no man make,
> For than mercy and pyte doth hym forsake.
> If his rekenynge be not clere whan he doth come,
> God wyll saye, "*Ite, maledicti, in ignem eternum.*"
>
> (912–915)

The playwright's emphasis upon the efficacy of the individual's personal "accounte" in the salvific transaction diverges radically from the penitential theology shared by the earlier English moral plays: in *Mankind* and *The Castle of Perseverance*, for example, man is indeed saved by "mercy and pyte" at the last moment and despite his soul's "rekenynge." For the *Everyman* playwright, however, no such facile resolution suffices to explain the fearful eschatological reality of human existence. Confronting the paradoxical nature of the human predicament *vis à vis* the divine economy, an economy in which man, as the agent of his own fall, is rendered helpless, but nonetheless is to be judged finally on the basis of his own actions, the dramatist depicts a penitential ascesis which accommodates the limitations of human nature with man's awesome responsibility as the co-principal of his own conversion. Unlike the other moral plays where the mankind figure is depicted as mired in a kind of spiritual stasis, vexed and redeemed by powers that are ultimately beyond his ken, *Everyman* describes a hero of impressive energy and wit, one who, much like the dramatic heroes of later times, personally explores the recesses of his private conscience to seek out an informing experience which gives shape to his human destiny. While clearly the product of an age which was fond of analyzing the corporate nature of a hapless *Humanum Genus*, *Everyman* is a decidedly atypical product, one which looks forward to a humanism that is implicitly modern. And it is that humanism, particularly its emphasis upon the potential of the individual to reconcile the frailties of his bodily existence with his native aspiration for the eternal, which is Bernard's legacy to the age of *Everyman;* for in his penitential theory of knowledge, affirming as it does the capacity of the penitent not only to apprehend, but also to enact a course of action that will determine his salvation, Bernard rescues human nature from its limbo of passivity and places it squarely at the center of the redemptive mystery.

NOTES

1. "*Everyman* and the Parable of the Talents," *The Medieval Drama*, ed. Sandro Sticca (Albany: State University of New York Press, 1971), rpt. in

Jerome Taylor and Alan H. Nelson, eds., *Medieval English Drama* (Chicago: University of Chicago Press, 1972), p. 325.

2. Edgar T. Schell and J. D. Shuchter, eds., *English Morality Plays and Moral Interludes* (New York: Holt, Rinehart and Winston, 1969), p. 112.

3. *Everyman* (New York: Barnes and Noble, 1961), p. xxii. All references to *Everyman* are to this edition. Hereafter cited as *Everyman.*

4. Edgar T. Schell, "On the Imitation of Life's Pilgrimage in *The Castle of Perserverance,*" *JEGP,* 67 (1968), 235–248. E. N. S. Thompson, *The English Moral Plays* (1910; rpt. New York: AMS Press, 1970), pp. 295–310, 330–339. E. K. Chambers, *English Literature at the Close of the Middle Ages* (1945; Oxford: Clarendon Press, 1964), p. 50. Arnold Williams, *The Drama of Medieval England* (East Lansing: Michigan State University Press, 1961), pp. 142–162. *The Marco Plays,* ed. Mark Eccles, *EETS* No. e.s. 262 (London: Oxford University Press, 1969), pp. xx–xi, 202–16. Robert Potter, *The English Moral Play* (London: Routledge and Kegan Paul, 1975), pp. 19–22.

5. Kolve, 333.

6. "The English Moral Play Before 1500," *Annuale Mediaevale,* 4 (1963), 20.

7. *Ibid.*

8. Thomas F. Van Laan, "*Everyman:* A Structural Analysis," *PMLA,* 78 (1963), 473.

9. Cf., for example, Richard W. Southern, *The Making of the Middle Ages* (New Haven: Yale University Press, 1965), pp. 219–241. Robert D. Marshall, "Dogmatic Formalism to Practical Humanism: Changing Attitudes Towards the Passion of Christ in Medieval English Literature," Diss., University of Wisconsin, 1965, Chs. 1–3.

10. Southern, p. 235.

11. Etienne Gilson, *The Mystical Theology of Saint Bernard* (New York: Sheed and Ward, 1940), p. 36.

12. *St. Bernard's Sermons on the Canticle of Canticles,* trans. by a priest of Mount Melleray (Dublin: Browne and Nolan Ltd., 1920), I, p. 202. Hereafter cited as *Canticles.*

13. Cf., for example, Marshall, Ch. 1.

14. *The Steps of Humility,* trans. by George Bosworth Burch (Notre Dame, Indiana: University of Notre Dame Press, 1963), p. 137. Hereafter cited as *Steps.*

15. Gilson, ch. 3, especially p. 77. Gilson cites by way of example, *De Gradibus Humilitatis:* "non ergo debet absurdum videri si dicitur Christum non quidem aliquid scire coepisse quod aliquando nescierit, scire tamen alio modo misericordiam ab aeterno per divinitatem et aliter id tempore didicisse per carnem." Gilson notes that "it is necessary to emphasize in *didicisse* the force that expresses the value attributed by St. Bernard to experiential knowledge." p. 234, note 100.

16. *Steps,* p. 143.

17. *Ibid.,* p. 147.

18. *Ibid.,* p. 39. *Canticles,* I, p. 441.

19. Etienne Gilson, *The Spirit of Medieval Philosophy* (New York: Charles Scribner's Sons, 1936), p. 290. And, *Canticles,* II, p. 445.

20. *Canticles,* II, pp. 446–447.

21. The translation is that of Samuel J. Eales, *Cantica Canticorum: Eighty-six Sermons on the Song of Solomon* (London: Elliot Stock, 1895), p. 490. Hereafter cited as *Cantica.*

22. *The Spirit of Mediaeval Philosophy*, p. 296.
23. *Steps*, p. 155.
24. *Ibid.*
25. *Canticles*, I, p. 431.
26. *Cantica*, p. 507.
27. *Steps*, p. 55.
28. *Canticles*, I, p. 432.
29. *Ibid.*
30. *Saint Bernard's Sermons for the Seasons and Principal Festivals of the Year*, trans. by a Priest of Mount Melleray (Westminster, Maryland: 1950), III, p. 447.
31. Bernard of Clairvaux, *Concerning Grace and Free Will*, trans. Watkin W. Williams (London: Society for Promoting Christian Knowledge, 1920), p. 20.
32. Van Laan, 470.
33. *Everyman*, p. 13.
34. *Ibid.*
35. *Canticles*, I, pp. 432–433.
36. *Steps*, p. 163: Cf. also, p.52.
37. *Canticles*, I, p. 441.
38. *Canticles*, I, p. 433.
39. *Ibid.*, p. 434; Cf. also p. 451.
40. *Ibid.*, p. 436.
41. *Cantica*, p. 239.
42. *Sermons*, I, p. 153.
43. *Patrologia Cursus Completus: Patrologia Latina*, ed. J. P. Migne (Paris, 1859), Vol. 183, Col. 647ff.
44. I have silently amended Cawley's reading of "Lawe" to "lowe." Cf., for example, his note at p. 29.
45. *Sermons*, II, p. 345.
46. *Ibid.*, p. 68.
47. Gilson, p. 72.
48. *Ibid.*, p. 76.
49. *Ibid.*, p. 73.
50. *Ibid.*
51. *Ibid.*, p. 72.
52. *Cantica*, p. 517.
53. *Ibid.*, p. 520.
54. Cf. Sermons LXXXV and XLIX in *Cantica*, pp. 516–525, and pp. 297–307.
55. Van Laan, p. 472.
56. John Conley, "The Doctrine of Friendship in *Everyman*," *Speculum*, 44 (1969), 381–382.
57. Lawrence V. Ryan, "Doctrine and Dramatic Structure in *Everyman*," *Speculum*, 32 (1957), 730.
58. *Cantica*, pp. 299–300.
59. *Everyman*, p. 19.
60. *Cantica*, p. 519.
61. *Ibid.*, p. 518.
62. *Ibid.*, p. 519.
63. *Ibid.*
64. *Ibid.*, p. 521.
65. *Ibid.*, p. 522.
66. *Ibid.*, p. 523.

67. *Ibid.*, pp. 522–523.
68. *Sermons*, I, p. 150.
69. *Canticles*, I, pp. 32–33.
70. *Cantica*, p. 517.
71. *Ibid.*, pp. 471–473.
72. *Ibid.*, p. 516.
73. *Steps*, p. 110.
74. *Cantica*, p. 524.
75. Gilson, p. 99.
76. Cawley punctuates lines 894: "Come, excellente electe spouse, to Iesu." Cawley's punctuation, however, is largely editorial and ignores an important variant meaning of the line; that is, Everyman is the "spouse to Iesu."

History and Paradigm in the Towneley Cycle

JEANNE S. MARTIN

In a drama created in response to the Corpus Christi feast, two issues suggest themselves as generically fundamental: (1) the way a sequence of plays depicting the history of the world from the Creation to the Last Judgment relates to the feast; and (2) the principle of selection which governs the choice of subjects staged.[1] V. A. Kolve has addressed the first of these issues in a convincing manner pointing to the cycle's celebratory approach to the sacrament as a way of accounting for the "feast and the impulse toward cycle form."[2] But isolating this impulse is only the first step in delineating an internal principle of selection. An analysis of the way in which the Corpus Christi drama "celebrates" the feast limits the range of subject matter to biblical topics but does not explain the choice of one set of biblical subjects over another. Early historians of the medieval stage favored a view that the liturgical calendar provided the basis for the selection of plays in the cycles. This theory, however, posed more problems than it solved. The liturgical calendar not only encompasses a great many subjects which do not appear in any of the cycles, it *begins* with the Advent and subordinates the chronology of Old Testament history to the chronology of Christ's life; the Corpus Christi cycles preserve the historical sequentiality of the Bible. Recent scholarship has proposed a corrective to the liturgical theory and invoked a combination of typological principles and the ages of the world.[3] Erich Auerbach defines typology in the following terms: "Figural interpretation establishes a connection between two events or persons, the first of which signifies not only itself but also the second, while the second encompasses or fulfills the first."[4] To this might be appended the notion of imperfection in the "figure" (an imperfection which becomes perfection in the fulfillment) and of hierarchical progression (Old Testament figures are superseded by the New Testament ones, and those of the New Testament are superseded by the eschaton). The ages of the world is a system of historical division which derives from Genesis and the Matthean Gospel but which was given its first coherent formulation by Augustine in the *City of God*.[5] In this schema, history is divided into seven ages. A major biblical event heralds the beginning of each age, and each age corresponds to one of the

seven days of creation. Adam thus inaugurates the first age, Noah's Flood the second, Abraham the third, David the fourth, the Transmigration into Babylon the fifth, Christ the sixth, and the Doomsday the seventh.[6]

I perceive two weaknesses in this theory. First, it anticipates *most* of the plays in a cycle, but by no means all. And both typology and the seven-ages division encompass or imply material which appears in none of the cycles. In the Towneley Cycle, for instance, the subjects which are not accounted for either through typological correspondences or the system of the seven ages are: the boy in the Killing of Abel play, the Sibyl in the Prophets play, the Caesar Augustus play, the Joseph section in the Annunciation play, the action involving Mak and Gil in the Second Shepherds' play, Herod, and Thomas of India. These subjects comprise no small portion of the cycle.

If one turns to other conspicuous uses of typology in medieval England – the visual arts, religious lyrics, the *Biblia Pauperum*, the *Golden Legend*, the *Speculum humanae salvationis* – one finds a wealth of figures, many of which were at least as popular as those exploited by the cycles. To cite just a few examples; the drunkenness of Noah was a standard figure for the mocking of Christ, Gideon receiving the Angel's message a figure for the Annunciation, Samson and Delilah a figure for Christ's betrayal, and Jonah's three days in the belly of the whale a figure for Christ's descent into Hell and Resurrection.[7] Why are none of these figures ever explored in any of the cycles? The potential for such development certainly existed.[8] All the cycles, for instance, stage both a Noah and a Mocking of Christ play, but the figure of Noah's drunkenness never receives dramatic attention. Similarly, all the cycles stage a Harrowing of Hell play, but none includes a Jonah play. The Towneley Cycle even makes a direct reference to the Jonah-Christ figure in the Thomas of India play, but nothing is done with it, dramatically. The neglect of these common figures, along with the inclusion of non-biblical ones poses questions for which the typological-seven ages theory can offer no answers. In the pages which follow I would like to provide a context that can explain those elements accounted for by the typological-seven ages theory, as well as those which are not.

In the same era in which Augustine was giving intellectual force to typological history, Eusebius of Caesarea was articulating quite another view of Christian history, one which was fundamentally archetypal. Both Augustine and Eusebius formulated their views of history at a period during which the Church was still struggling for survival. The importance of this factor in the formation of their respective positions cannot be over-stressed. For both men, Christianity's relation to the Jews and the Church's relation to the Roman Empire were elements demanding historiographic attention. Augustine dealt with Judaism in the same manner as the early evangelists: Christianity subsumes Judaism. He demonstrated

that Christianity fulfilled the Messianic prophecies and completed the "figures" of the Old Testament, and he addressed the subject of the Church's relation to the Roman Empire in his *City of God*, a work begun in 413, three years after Alaric's sack of Rome. The Visigothic invasion revealed the Empire as susceptible to the same reverses of fortune as other empires, and the advantages of dissociating the Church's claims to validity from the vicissitudes of earthly institutions became obvious. Augustine defines, therefore, two realms of existence: the City of God and the City of Man. Both cities are defined by love, but differing objects of love – self or God – separate the two. By this division Augustine was able to place the Church outside the realm of temporal institutions and thus free it from the bondage of fortune. Participation in the City of God depended on one's spiritual state, not on the particulars of one's earthly involvement.

Eusebius's method of dealing with Judaism and the Roman Empire is radically different. Writing some eighty years before Augustine, Eusebius experienced a world in which the Jews were among Christianity's most hostile persecutors and the Roman Empire lent its support to the Church. The first seven books of Eusebius's *Ecclesiastical History* were published prior to the Edict of 313 which legalized Christianity in the Roman Empire. In these books Eusebius focused on the Church as an historical phenomenon and within a general structure of history. Christianity's relative newness posed problems for its claim to universality. How could an institution which was only some 300 years old claim control over history from the Creation to the end of time? Eusebius solved this problem by locating the roots of Christianity in the pre-Jewish era of the patriarchs (Eusebius regarded the giving of the Mosaic law as the beginning of Jewish [tribal] history). In Chapter 4, Eusebius states:

If the line be traced back from Abraham to the first man, anyone who should describe those who have obtained a good testimony for righteousness as [being] Christian, in fact if not in name, would not shoot wide of the truth. For the name signifies that through the knowledge of Christ and his teaching the Christian man excels in sobriety and righteousness, in control of life and courageous virtue, and in the confession that God over all is but one; and for zeal in all this they were not inferior to us. They had no care for bodily circumcision any more than we, nor for the keeping of Sabbaths any more than we, nor for abstinence from certain foods nor the distinction between others (such as Moses afterwards first began to hand down to their successors) nor for symbolic ceremony any more than Christians care for such things now, but they clearly knew him as the Christ of God, seeing that it has already been demonstrated that he appeared to Abraham, addressed Isaac, spoke to Israel, and conversed with Moses and the later prophets. Whence you would find that those God-loving men obtained even the name of Christ according to the word spoken concerning them, "Touch not my Christs and act not wickedly among my prophets." So that it must clearly be held that the announcement to all the Gentiles, recently made through the teaching of Christ, is the very first and most ancient and antique discovery of true religion by Abraham and those lovers of God who followed him.[9]

In the simplicity and directness of the patriarchs' faith Eusebius finds the same *form* of religion as that made manifest by Christ through His Church. This perception has implications beyond those of typology. As a religion which could trace its origins to the patriarchs, Christianity assumes a history more ancient than that of either the Jews or the pagans.[10]

Underlying Eusebius's attitude toward the patriarchs and the modern church is a perception of history as a struggle between God and the devil. Heresies, for example, are not outgrowths of complex ideological conflicts but are one aspect of Satan's strategy to undermine good.[11] For Eusebius, the struggle between good and evil is fundamental not only to the events which make up the history of the church but to all history since the Fall: Patriarchs and modern Christians, therefore, occupy the same space in a recurring historical structure.

In addition to perceiving history as conforming to one basic pattern, Eusebius believes that the judgments of history mirror divine judgments. In the first section of the *Ecclesiastical History*, he interprets the many calamities which beset the early Church as either tests of commitment or punishment for weakness. Where this element becomes most important, however, is in his treatment of the Roman Empire. Prior to the Edict of Milan, Eusebius regarded the Church as God's exclusive agent in His salvific plan for history. After the Edict of 313, however, he expanded this vision to include Rome. For Eusebius, the Emperor Constantine's conversion was no ordinary event; it was a providential sign that Rome occupied a central position in salvation history. By converting to Christianity, Constantine accomplished both the liberation of the church and the pacification and unification of the Empire. Eusebius found support for interpreting these incidents as signs of Rome's election by discovering the fulfillment of certain Old Testament prophecies and the repetition of crucial patriarchal archetypes in the life of Rome. Constantine is the "last of the patriarchs" and is variously described as the New Abraham, in whom the promise made to Abraham is literally fulfilled, and the New Moses, leader of God's chosen people into a new and promised land.[12] In Eusebius's mature historical vision, then, Rome and the Church, rather than the Old and New Israel, constitute the definitive forces in providential history.[13]

This Eusebian view of history is fundamentally different from Augustine's. History for Augustine is linear, a one-directional, theological process. In the same way that the life of a single man has a fixed beginning and end, history begins with the creation and moves inexorably toward that point at which God's plans for salvation will be fulfilled, the Doomsday. History between Creation and eschaton has a climactic structure, the center of which is Christ's sacrifice. From Augustine's point of view, every event that takes place in time, is a discrete phenomenon

with its own exclusive place in a single continuum. For Eusebius, history is archetypal, a series of recurrent themes and variations on those themes. From the beginning of time, man has experienced history in the same terms: The moral issues which the patriarchs faced differ only in their particulars from those confronted by modern Christians. History, for Eusebius, has a fundamental structure which duplicates itself in successive generations; for Augustine, the historical experience of each generation is unique. Repetitive patterns occupy a central position in Eusebian historiography, whereas, for Augustine, history is cumulative.

Augustine's and Eusebius's respective historical views ultimately exerted very different kinds of influence on the Western tradition. Augustine's position, by removing the center of concern from mundane involvement to moral attitude and choice, finally led to ethics – or in narrative, allegory – rather than to history, *per se*. Eusebius's position, on the other hand, was quintessentially historical in orientation and gave rise to the medieval tradition of national and ecclesiastical histories. In England, Eusebius's influence survived in the works of such historians as Gildas, Bede, Geoffrey of Monmouth, Nicholas Trivet, William of Malmesbury, and Robert Manning of Brunne. Indeed, prior to the evolution of a purely secular historiography in the late fourteenth century, Eusebian structures were distinguishing features of English historiography. It is this tradition which I see as shaping the Middle English cycle plays.[14] In the section which follows I shall analyze the style and structure of the Corpus Christi drama as experiments in Eusebian modes of perception; a final section will summarize the broader implications of this relationship.

By asserting a relationship between the Corpus Christi drama and Eusebian historiography, I do not mean to imply that the cycle plays are primarily concerned with history as a struggle between good and evil. The relationship between the form of the cycle plays and Eusebian historiography is structural, rather than thematic. The Middle English cycle plays, as we shall see, embody an archetypal perception of history but define for themselves the nature of the archetypes.

The most compelling argument for the association between Eusebian historiography and the cycle plays must be the way in which individual plays in a cycle relate to each other paradigmatically, rather than developmentally.[15] The Towneley Cycle (which I will use as representative throughout this essay[16]) begins by establishing two models, both of which address the issue of the relation of the ontological order to its creator. The first angelic speech, that of the Cherubym, glorifies God and in so doing defines a relationship of reciprocity and solidarity:

> Oure lord god in trynyte, 61
> Myrth and lovyng be to the,
> Myrth and lovyng ouer al thyng;

ffor thou has made, with thi bidyng,
Heuen, & erth, and all that is, 65
and giffen vs Ioy that neuer shall mys.
Lord, thou art full mych of myght,
that has maide lucifer so bright;
we loue the, lord, bright ar we,
bot none of vs so bright as he: 70
He may well hight lucifere,
ffor lufly light that he doth bere.
He is so lufly and so bright
It is grete ioy to se that sight;
We lofe the, lord, with all oure thoght, 75
that sich thyng can make of noght.[17]

The most conspicuous stylistic feature of this passage is lexical repetition. "Myrth and lovyng" (l. 62) describe the creation's response to its creator, and then in the next line, describe the creator's response to the creation. In line 64, God "makes" heaven and earth and all that is; at line 68, He "makes" Lucifer; and, He "makes" all from "noght" (l. 76). God "gives" joy to the angels (l. 66) and light to Lucifer (l. 72). The angels receive "joy" from God (l. 66) and feel "joy" when they contemplate Lucifer's splendor (l. 74). God encompasses "all" things (l. 63), makes "all" that is (l. 65), and the angels love God with "all" their thought (l. 75). The phrase "we lofe the, lord" appears twice (ll. 69 & 75), and both times in the same position in the line. Describing both the generative power of God's might and the interaction between God and His creation, repetition, in this passage, functions as a paradigmatic system and thus establishes the unitary nature of the creation. God generates an order in which differentiation exists but is subsumed by sameness or solidarity. The relation of the single comparative construction – that used to describe Lucifer's brightness – to the rest of the passage demonstrates this principle. The Cherubym remark that God has made Lucifer brighter than the other angels – a comparison defined by grammar, the syntagmatic system of linguistic succession. But the system of displacement implicit in the comparative construction is overlaid by a more dominant system, the paradigmatic one. No sooner is Lucifer's brightness mentioned than "brightness" is repeated with reference to the other angels and, as a result, its differentiating power is radically subordinated to a principle of inclusion through repetition. Viewed from the perspective of a paradigmatic order, quantitative brightness distinguishes Lucifer from the other angels; as a quality shared with the other angels, however, Lucifer's brightness invokes a principle of sameness which reverberates with the structures of solidarity that characterize the rest of the passage. The Cherubym feel "joy" in response to God's creation of "heuen, & erth, and all that is." Because Lucifer's brightness is a part of that unity, it too inspires a response of "joy." Through its paradigmatic repetitions, the Cherubym's speech

celebrates solidarity and unity at the expense of differentiation and potential competition.

When Lucifer enters, however, he delivers a speech which is the dialectical antithesis of the Cherubym's.[18] He says:

> Certys, it is a semely sight, 77
> Syn that we ar all angels bright,
> and euer in blis to be;
> If that ye will behold me right, 80
> this mastre longys to me.
> I am so fare and bright,
> of me commys all this light,
> this gam and all this gle;
> Agans my grete myght 85
> may nothyng stand ne be.
>
> And ye well me behold
> I am a thowsand fold
> brighter then is the son;
> my strengthe may not be told, 90
> my myght may no thyng kon;
> In heuen, therfor, wit I wold
> Above me who shuld won.
>
> ffor I am lord of blis,
> ouer all this warld, I-wis, 95
> My myrth is most of all;
> therfor my will is this,
> master ye shall me call.[19]

Lucifer does not celebrate; he argues. Taking as his starting point the Cherubym's remark about brightness, Lucifer constructs a speech in which temporal displacement and differentiation become the chief principle of order. His speech is a series of syllogisms. The first establishes his right to rule: We are all bright angels; all this light comes from me; therefore, if you behold me correctly, I deserve to be master. Within this syllogism the term necessary to complete the logical structure ("of me commys all this light") is withheld until the last possible moment, thus creating a kind of linear "suspense." From this point, Lucifer builds step by step, in a logical progression, to his ultimate conclusion: "I am lord of blis,/ ouer all this world." The structure here is syntagmatic, rather than paradigmatic. Even syllogisms, inherently self-contained structures, require subsequent syllogisms to explain their terms. Repetition, to be sure, occurs in this speech, as in the Cherubym's. But, in this case, what appears as repetition becomes displacement, as the syntactic and semantic functions of the repeated terms undergo progressive changes away from the Cherubym's meaning. The word *all*, for example, appears four times in the passage. The first time it appears, it designates a community: "we ar *all* angels bright." The second and third times, it sets Lucifer apart from that community: "of me commys *all* this light,/this gam and *all* this gle."

Lucifer declares himself the source of his own light; in so doing, he denies his participation in a symmetrical system of reciprocity. The final occurrence of "all" describes Lucifer's domination over the angelic community: "I am lord of blis,/*ouer all* this warld." The sequential nature of this semantic progression is generated by the syllogistic syntax of the passage. Terms such as *since, if,* and *therefore* impose an uncompromising temporal linearity on the passage and subordinate repetition to development. Throughout Lucifer's speech, differentiation implies power and competition. Lucifer perceives his superior brightness as a distinction with temporal and relational consequences: It separates him from the other angels and gives him the right to dominate the heavenly community. Perceiving his position in terms of power, of course, introduces the element of dependence into his relation with the angels, and this, in turn, admits the possibility of challenge. Lucifer's tendency to describe his "mastre" in terms of spatial metaphors reflects the transformation from a community in which differentiation is inconsequential to one in which differentiation implies meaningful competition. Nothing, Lucifer says, can stand "agans" his might, and no one can dwell "above" him. These terms function within a comparative code which also includes such constructions as "I am a thowsand fold/ *brighter then* is the son," and "my myrth is *most of all.*" In each of these instances comparison is interpreted as displacement and thus describes a structure which is fundamentally competitive. The most telling example of the way in which Lucifer consistently substitutes a system of spatial displacement for the Cherubym's system of paradigmatic unity occurs in his use of the word "over": "I am lord of blis,/ ouer all this world." In this context, the word designates the highest position in a hierarchical power structure. In the Cherubym's speech, "over" describes a principle of inclusion. God extends His "myrth and lovyng ouer al thyng" (l. 63). "Over," here, signifies a generative force which creates and sustains a unitary system.

The cycle's beginning offers an objective by which to judge both the Cherubym and Lucifer. God's creation speech:

> Ego sum alpha et o, 1
> I am the first, the last also,
> Oone god in mageste;
> Meruelus, of myght most,
> ffader, & son, & holy goost, 5
> On god in trinyte.
> I am without begynnyng,
> My godhede hath none endyng,
> I am god in trone;
> Oone god in persons thre, 10
> Which may neuer twynnyd be,
> ffor I am god alone.

> All maner thyng is in my thoght,
> Withoutten me ther may be noght,
> ffor al is in my sight; 15
> hit shall be done after my will,
> that I haue thoght I shall fulfill
> And manteyn with my myght.[20]

God has no beginning and will have no ending. He is total being and perfect unity; and He stands "alone" because His nature encompasses everything ("All maner thyng is in my thoght,/Withoutten me ther may be noght") and is indivisible ("My godhede . . . may neuer twynnyd be"). The "all" to which God refers in the last stanza does not indicate something "other" than or "outside" His nature; it is a part of His nature. The relation of "I" to "all" is thus one of synonymity.

When Lucifer attempts to establish his supremacy he echoes God's "I." In his case, however, the personal pronoun does not designate omnipotence, only political dominance. God's "might" is a result of His perfect unity and ability to create. He creates "all"; His authority over "all" is therefore immanent. Lucifer's supremacy, on the other hand, has no generative dimension and is therefore simply "power," the ability to control the behavior of others. As creator, God stands "alone," whereas Lucifer's power exists only in relation to an "other" which it dominates; it is fundamentally contingent. Lucifer is not the "first" and the "last" but the "mastre." His authority is a function of a relationship (master-servant) in which his supremacy requires the recognition of those whom he rules. In the introductory syllogism of his speech Lucifer says: "If that ye will behold me right,/ this mastre longys to me" (ll. 80–81). His position as master is conditional upon a reciprocal action: *If* the other angels perceive his superiority, *then* his supremacy will have definition and functional meaning.

Lucifer posits autonomy, but his assertion is constantly undercut by his inability to define that position without resorting to contingent structures: "*Agans* my grete myght/ may nothyng stand ne be," and "My myrth is *most of all*." Comparative constructions of this kind are conspicuously absent from God's speech because they assume the existence of a second term which is at least potentially competitive, and there can be no real antagonist to God.

The distance between God's kind of supremacy ("might") and Lucifer's ("power") is linguistically focused in the forms of address which each exchanges with other characters in the cycle. R. Brown and A. Gilman have shown in their study of pronouns and social structures that in languages which preserve two singular pronouns of address ("thou" and "you" in early English) there is a correspondence between the use of these pronouns and relationships of power and solidarity.[21] When one

person has power over another (in an alienated sense) the relationship is asymmetrical, creating a "power semantic": The superior use "thou" and receives "you." In what Brown and Gilman call relationships of solidarity, however, where antagonistic or competitive power is non-operative, symmetry of usage governs, and both use "thou."[22] "Power" is not an element in God's relationship to His creation because power is always contingent and God's might is self-contained. Accordingly, when characters such as the Cherubym, Noah, or Abraham address God they always use the pronoun "thou." In terms of power structures, God's relationship to creation is symmetrical, and this fact is affirmed by the consistent exchange within a "solidarity semantic."

"Power," on the other hand, *is* the basis of Lucifer's position, and this is reflected in the way the other angels address him. After Lucifer completes his speech the First Good Angel says to him:

> I rede ye leyfe that vanys royse, 111
> ffor that seyte may non angell seme
> So well as hym that all shall deme.[23] 113

The Good Angel's use of the "power semantic" (ye) follows immediately upon the Cherubym's expression of solidarity with God ("Oure lord god in trynyte,/Myrth and lovyng be to the"). The contrast distinguishes Lucifer's supremacy from God's and emphasizes the contingent nature of Lucifer's position.

The Creation play thus defines a fundamental relationship which subsequent plays repeat, add to, and expand upon. Lucifer's language establishes a paradigm which reappears immediately in the Killing of Abel play. The relationship between Cain and his servant presupposes that differentiation implies displacement.[24] This assumption manifests itself in the form of competition and exploitation. Cain unfairly exploits his servant, and his servant constantly opposes his authority in an effort to gain the "maistry." The result, as with Lucifer, is discord. The simplest attempt at constructive behavior, the plowing of a field or the issuing of a summons, is undermined by the competitive forces set in motion when the master-servant relationship is interpreted as power-based. Cain's resistance to God presents a parallel, but more serious, misapprehension of the implications of differentiation. Abel describes the requirement to tithe as a necessary tribute toward the source of all being, God, and reminds Cain that the Lord "all has sent" and "all the good Thou has in wone/ Of godis grace is bot a lone" (ll. 176 & 116–117). But because Cain applies the standards of contingency to his relation to God, he abuses his position as servant of his Creator in the same way he abuses his position as master of his servant.

Disregard for the function of solidarity relationships generates the central action of the Noah play. When Noah enters his home to announce that the flood is beginning and that the entire family must board the ark, his wife refuses to submit to his authority, and the two come to blows.

So long as this state of affairs persists, progress of any kind is impossible, and God's plan to save the family is impeded. The situation is resolved by the intercession of Noah's sons, who decry their parents' contentious behavior:

> *Primus filius.* A! whi fare ye thus?/ ffader and moder both! 415
> *Secundus filius.* Ye shuld not be so spitus/ standyng in sich a woth.
> *Tericus filius.* Thise ar so hidus/ with many a cold coth.[25] 417

Noah's sons invoke a concept of community – "both" – which reminds the parents of their participation within a community of the family (Noah's response to the rebuke is "*we* will do as ye bid us/ *we* will no more be wroth,/ *Dere barnes!*") and the community of creation. The reminder motivates Noah and his wife to move from a relationship based on power (Lucifer) to one based on solidarity (Cherubym). The transformation is especially evident in Mrs. Noah's speech. In the early scenes of the play, she vilifies Noah at every opportunity (e.g., ll. 375–376). After her sons' reprimand, however, her concern is for the well-being of her family: "So me thought, as I stode/ *we* ar in grete drede;/ Thise wawghes are so wode." Both Noah and his wife begin using the first-person plural pronoun, where before the first-person singular dominated their speech.

The paradigm of differentiation as replacement also structures the roles of Pharaoh, Caesar Augustus, Herod, and Pilate.[26] Each of these characters enters the cycle by making a speech which parallels Lucifer's.[27] The Pharaoh, Caesar, Herod, and Pilate all boast absolute supremacy, but their speeches, like Lucifer's, expose limitation and contingency. "All" Egypt is Pharaoh's, yet his power can be qualified by the complacency and indifference of his subjects:

> All Egypt is myne awne 9
> To leede aftyr my law;
> I Wold my myght Were knawne
> And honoryd, as hyt awe.[28] 12

For the Pharaoh to be accepted in the terms which he proposes, his subjects must acknowledge his superiority, and this confronts him with the limitations of his power. The Pharaoh cannot make his subjects *believe* in his superiority, he can only tyrannize those who refuse to submit to his authority:

> fful low he shall be thrawne 13
> That harkyns not my sawe,
> hanged hy and drawne,
> Therfor no boste ye blaw; 16

The Pharaoh may claim supremacy over all Egypt, but his "lordship" is restricted to a sovereignty based on violent suppression within fixed geographical and temporal boundaries.

Caesar describes a similar situation, in declaring his omnipotence, while revealing his reign to be a function of physical force:

> ffor all is myn that vp standys,
> Castels, towers, townys, and landys,
> To me homage thay bryng; 15
> ffor I may bynd and lowse of band,
> Euery thyng bowys vnto my hand,
> I want none erthly thyng.
>
> I am lord and syr ouer all,
> All bowys to me, both grete and small, 20
> As lord of euery land;
> Is none so comly on to call,
> Whoso this agane says, fowll shall be fall,
> And therto here my hand.[29]

Caesar's assertion at line 20 that he receives homage from "all" is undercut by his provision at line 23 for those who oppose him. Caesar echoes Christ's words to Peter when he claims the power to "bynd and lowse" (Matthew 18:19), but in this case the words conspicuously lack transcendent value; they refer simply to the physical force needed to subdue recalcitrant subjects. Caesar uses the terms "bynd and lowse" to assert the ubiquity of his power. But, by inadvertently alluding to another kind of power, one based on love and inclusion, Caesar merely succeeds in revealing his own limitation. The same relationships govern the speeches of Herod and Pilate. Herod is "Lord of every land," but only because no man "dar" stand against him. And Pilate governs because he eliminates competition as it arises (l. 556). Thus, parallel linguistic and narrative structures establish an archetypal association among Lucifer, Pharaoh, Caesar, Herod, and Pilate and provide a standard by which to judge them.[30]

It is important to keep in mind that in these plays competition is never an operative factor between Lucifer and God. As post-Miltonic readers we might be inclined to see analogies between Lucifer and the unruly subjects who threaten Pharaoh, Caesar, Herod, and Pilate. But the situations are not comparable. God's might comprehends Lucifer's kind of power; Lucifer's cannot limit God's. Lucifer's power has no generative dimension and never transcends the regulative. God's relationship with Lucifer is as symmetrical, in terms of power structures, as His relationship to the Cherubym or Noah. But Lucifer does not perceive it that way, and his failure to do so is the crux of his fall.

The Cherubym's model can be similarly traced throughout the Towneley Cycle.[31] Most of the holy, or righteous, characters in the cycle establish their goodness by affirming a relationship of solidarity and reciprocity with God. Abel refers to his sacrifice as a symbol of his gratitude for divine bounty and acknowledges his dependence on God's creative power:

> God that shope both erth and heuen,
> I pray to the thou here my steven, 175
> And take in thank, if thi will be,
> the tend that I offre here to the;
> ffor I gif it in good entent
> to the, my lord, that all has sent.
> I bren it now, with stedfast thoght, 180
> In worship of hym that all has wrogth.[32]

God, as in the Cherubym's speech, creates "all" ("all has wrogth") and gives "all" ("all has sent"). In return, Abel "gives" his sacrifice and worship. The system that is described is one in which reciprocal actions and the language of repetition affirm solidarity. Noah's first words reflect this attitude; he proclaims God "Maker of all that is" and himself God's faithful "seruant" (ll. 1 & 65). Abraham calls upon the "lord omnipotent" and prays to Him as man's source of "socoure" and "help":

> Adonay, thou god veray, 1
> Thou here vs when we to the call,
> As thou art he that best may,
> Thou are most socoure and help of all;
> Mightfull lord! to the I pray.[33] 5

Reciprocity and solidarity govern this passage as well. Abraham calls to God, and God "hears" man's plea. To man's prayer for help, God responds with "socoure."

The repetition of archetypes creates a structure for the cycle itself which is analogous to the structure of the Cherubym's speech. As a result, the cycle sustains two perspectives: one from within history and one from without. In the first of these, displacement, or sequence, seems to govern; in the latter, displacement is shown to be part of a recurring pattern, and repetitive structures reveal a unitary system.[34] The various correspondences between paradigmatic structural relations and moral categories lead to a further coincidence between the form of the cycle and an archetypal vision of meaning in history. Moreover, the perception of moral truth through the medium of archetypal patterns is possible for characters within the cycle, as well as for the audience. The play of the Flood commences with a monologue in which Noah surveys the course of history from the Creation to his own time. In the progression of historical events Noah perceives a recurring pattern whose implications allow him to comprehend the significance of his own historical moment. The examples of Lucifer and Adam demonstrate that sin does not go without punishment. Mankind at the time in which Noah is living has rejected God and become evil in all its ways (ll. 49–54). Retribution, Noah rightly concludes, must be imminent, and he therefore prays to God to keep him and his family from "velany." Repetitive structures, here, paradigmatic in force, func-

tion as the vehicle of Noah's understanding and lead him to reaffirm his solidarity with God.[35]

Abraham delivers a speech which functions in a similar way.[36] Reviewing previous generations of the earth, he perceives a direct relationship between man's moral state and his temporal prosperity. When man has sinned, as in the case of Adam and Cain, he has been punished; when man has lived a righteous life, as in the case of Noah and Lot, he has been rewarded with mercy. But that is only a partial view. Because of Adam's sin, good men experience only limited mercy. Noah can be saved from the flood and Lot from the destruction of Sodom, but all must finally succumb to death and the punishment of hell. When, Abraham wonders, will man obtain complete mercy; when will he be once again admitted into the kingdom of heaven? Abraham prays to God for mercy of this kind, and his plea initiates an action, the outcome of which is God's promise to "help adam and his kynde":

> I will help adam and his kynde,
> Might I luf and lewte fynd; 50
> Wold thay to me be trew, and blyn
> Of thare pride and of thare syn:
> My seruand I will found & frast,
> Abraham, if he be trast;
> Of certan wise I will hym prouse, 55
> If he to me be trew of louf.[37]

God here employs conditional constructions, but not reflexively as Lucifer does. They do not qualify his own being, only man's fate. Accordingly, as in the Cherubym's speech, conditional contingencies become elements in a larger pattern in which the repetition of "Wold (If) thay (he) to me be trew," reflects the historical recurrence of Adam in Abraham. And, in the case of Noah as well, history, through its paradigmatic structure, provides models that reveal moral truths. The fates of Adam, Cain, Noah, and Lot reveal God's synchronic realization of all history, and this perception leads Abraham to hope for complete mercy. Strengthened by his faith in God's inclusive might, Abraham proves equal to the test imposed on him. By making moral categories available, historical paradigms offer a point of view which transcends the limitations of the particular case – or the particular play. They therefore serve an integral function in both the structure of the cycle and man's historical perception.

The two perspectives created by the individual play (history as displacement) and the cycle as a whole (history as repetition) serve to explain another structure which the cycle develops: the structure of game. History, in the Towneley Cycle, is both a succession of recurrent patterns and a cosmic struggle between Satan-on-Earth and the forces of good. In its temporal manifestation, this struggle assumes the form of a series of moves and countermoves which result (at the Doomsday) in Satan's de-

feat. The Passion plays are central to this development.[38] The staging of Christ's Passion, as V. A. Kolve has pointed out, posed a formal difficulty for the cycle dramatists: how to assign dialogue and personalities to Christ's murderers that could credibly motivate their action without violating Christ's words from the cross that "they know not what they are doing." How can they be both aware and not aware of their actions? The concept of game provided a solution.[39] Game structures govern the action of the Passion plays and function as a means of distancing Christ's tormentors from the murder they perform. Following the capture in the Garden, Caiaphas questions Christ on the charges of pretending to divinity and kingship. Receiving only silence in reply, he invents a game – "King Coppin" – in which Christ's silence becomes a sign of fear which is interpreted as an admission of guilt (ll. 163–171). When Christ is handed over to be scourged, his tormentors revive Caiaphas's game which, by transforming their buffets into playful tests of Christ's ability to "prophecy" (ll. 361–414), becomes a way of abstracting the brutality of their action. The game of King Coppin generates other games, until the torturers are wholly engrossed in game as an end in itself: Christ recedes from their awareness except as an incentive to continue exploring new fictional possibilities. Christ Himself having become a fiction, the torturers "know not what they do" in the non-fictional world.

At the scene of the Crucifixion the torturers propose another game – but one with implications that far exceed those of previous games. The torturers create a fiction in which Christ is a knight about to joust in a tournament and they are His arming servants preparing Him for that end. By elaborating on this fiction, the torturers substitute joust terminology for any direct reference to the task of affixing Christ to the cross and raising the cross to the vertical:

> *iijus tortor.* If thou be kyng we shall thank adyll, 101
> ffor we shall sett the in thy sadyll,
> ffor fallyng be thou bold.
> I hete the well thou bydys a shaft;
> But if thou sytt well thou had better laft 105
> The tales that thou has told.
> *iiijus tortor.* Stand nere, felows, and let se
> how we can hors oure kyng so fre.
> By any craft;
> Stand thou yonder on yond syde, 110
> And we shall se how he can ryde,
> And how to weld a shaft . . .

 . . .

> *Quartus tortor.* let me go therto, if I shall; 197
> I hope that I be the best mershall
> ffor to clynke it right.

> do rase hym vp now when we may, 200
> ffor I hope he & his palfry
> Shall not twyn this nyght.

The language of game distances and insulates the torturers from meaningful activity, and they never confront the result of their action – the desecration of Christ's body – directly. Within their fiction, they do not kill Christ; they help Him achieve a desired end; that is, mounting His horse for battle.

This, of course, reaffirms the central irony on which the play is structured; that literally, as well as metaphorically, the torturers are "ignorant of what they are doing." Christ *is* about to engage in a battle, and his executioners *are* His accomplices. The torturers perceive only a temporal dimension to their game. But another, more important one exists. Christ is about to do battle with Satan and, in a complete inversion of the original joust-game, death *begins*, rather than ends, the contest.[40] At the moment of death Christ descends into Hell, and fiction becomes reality. But the levels of irony do not stop here. When Christ descends into Hell, what appears to be an imminent battle is shown to be no battle at all. Christ's might, like God's in the Creation play, is inclusive and self-sufficient, where Satan's is merely the power of political control. Confrontation, in the sense of contest or contingency, therefore, is never a possibility between Christ and Satan.

The implications of this action reverberate throughout the cycle, and history itself becomes a game which Christ only *appears* to play to win man's salvation. In reality there is no game, because "game" is a contingent structure. This vision of history is implicit in the kind of historiography which descends from Eusebius and which can be inferred at every level from the structure of the Towneley Cycle. Evil, in the cycle plays is not, as for Augustine, simply a perversion or absence of good. It is an active force which seeks to oppose good in the world, and this fact produces an historical structure of conflict-as-game. Lucifer initiates the "game" when he attempts to usurp the heavenly throne (emphasis mine):

> If that ye will behold me right, 80
> this mastre longys to me.
> I am so fare and bright,
> of me commys all this light, 83
> this *gam* and all this gle.

Lucifer's failure to take into account the *quality* of God's "might," as we have already seen, explains his original fall and, as the cycle progresses, leads to his ultimate "historical" defeat. Each time Satan exercises his autonomous power to work evil, his destructiveness is circumscribed by God's inclusive and generative "might." Satan deceives Adam and Eve into disobeying God's command, but the consequences of this fall are eventually subsumed by God's mercy, just as on another occasion, when

Pharaoh works as Satan's agent in victimizing the Jews, he only succeeds in propelling them toward their chosen land and thus the fulfillment of their messianic destiny. Herod and Pilate serve an analogous function in the Passion plays. They both think they are curtailing Christ's power by destroying Him, when actually their actions supply the immediate means of realizing man's salvation.

Viewed from within history, God *appears* to participate in a contingent game which is played for man's soul. But this perspective is shown to be limited. From outside history, God transcends historical contingency, and His might is never less than absolute. History, through its repetitive structure and unity of purpose, corroborates God's statement: "that I haue thoght I shall fulfill/ And manteyn with my myght."

At this point I would like to return to some of the issues which initiated this discussion, namely, the principle of selection which governs the cycle. Most of the dramatic elements which pose problems for the typological-seven ages schema – the boy in the Killing of Abel play, the slapstick domestic comedy between Noah and his wife, Caesar Augustus, the Sibyl, the Joseph section of the Annunciation play, the action involving Mak and Gil in the Second Shepherds' play – are non-biblical in origin but relate to the biblical sections of the drama in ways that can now be traced. First, they expand the range of paradigmatic implication by establishing an affinity between the structure of the experience recorded in the Bible and that which is discovered in secular history. This is an inclusion which finds precedent in Eusebian historiography, but which is not so easily acceptable to theology. In typological historiography the Bible is the central and only relevant historical text. The Bible, moreover, is no ordinary chronicle of the past but a selectively revealed record of God's dealings with man.[41] Because of this uniqueness, the Bible requires the application of special interpretive methods, of which typology is one. Strictly speaking, then, typology is a closed system; it establishes hierarchical correspondences between the Old and the New Testament and between the New Testament and the eschaton. It does not extend to historical events outside the Bible. "Figurae," for Augustine, were the language of God, projected and perfected only *within* the confines of Scripture. Biblical prophecies could either refer to events in the New Testament or in the moral life of man; they could not apply directly to concrete extra-biblical events.

Secular history occupies a different place in Eusebian historiography. Because human experience is perceived as archetypal, *all* history comes under the same category. The Bible thus records only one segment of relevant human history. Biblical history exists on a temporal continuum with the present, and the persistence of biblical patterns and the fulfillment of prophecies can be found in contemporary events. In Eusebius's *Ecclesiastical History*, as I noted earlier, Constantine is called the New Abraham,

and his unification of the Empire and the Church is the literal reassertion of the promise made to the original Abraham.

The perception of history as archetypal in the Towneley Cycle allows for a situation in which biblical material generates non-biblical material. The non-biblical portions of the cycle plays have frequently been discussed as attempts to establish affinities between the fourteenth-century English audience and the religious truth contained in the biblical stories.[42] I would not wish to dispute the accuracy of this observation, but only bring it into sharper focus. The domestic quarrel between Noah and his wife does involve the audience in a more immediate way than would a simple dramatization of the biblical narrative. The same might be said about Cain's relation to his servant, the phenomenon of men "cheating" on their tithes or of Christ's jousting: All are fourteenth-century, rather than Old Testament concerns. But I think the non-biblical sections of the Corpus Christi cycles serve a more integral function than this analysis implies. Through paradigmatic repetition, they establish certain situations and modes of behavior as typical of *all* human experience and provide further opportunities for exploring generalized significance. Noah praises God's infinite mercy when he hears that he and his family will be saved from the flood. Yet, in the ark-building scene, the wonder of his commission recedes before the physical strain of the construction (ll. 261–270). Spirituality does not exempt Noah from the demands of practicality. The world of heavy timbers and long hours of work signify the framework in which he must prove his solidarity with God. This theme recurs again in the Abraham and Isaac play. When God first commands Abraham to travel to the land of Vision and sacrifice his son, Abraham responds with total willingness but perceives a possible conflict between his loyalty to God and his affection toward Isaac (ll. 81–88). What Abraham must discover is that the two loyalties do not conflict but, rather, complement each other. When Abraham explains the nature of his sacrifice to Isaac, Isaac pleads with him for either mercy or explanation. This action focuses for Abrahm the analogy between Isaac's situation and his own.[43] It causes him, in other words, to think paradigmatically. As a result, he commands Isaac to obey him in his role as father and, at the same time, submits himself to God's paternal command. The structure of Abraham's experience provides him with the necessary information to understand, as well as prove his devotion to God.

The Second Shepherds' play provides a final exploration of the way in which man must work *through* his humanity to understand God. At the outset of the play the Three Shepherds complain bitterly and describe a world in which masters abuse their servants, the rich exploit the poor, and wives refuse to obey their husbands. Through the comic action which involves Mak's theft, though, the shepherds discover the need and function of charity. After searching Mak's house for the lamb which they are cer-

tain he has stolen, the shepherds return to their flock. On the way, how-
ever, they are moved by sympathy for Mak's position and decide to re-
turn with nativity gifts for his new son. As a result of this charitable
action, Mak and Gil's deception is discovered, and the shepherds recover
their lamb. But, having once experienced the redemptive possibilities of
charity, the shepherds do not return to their former legalistic position. In-
stead, they waive the penalty which the law prescribes for sheep-theft –
death – and simply punish Mak by tossing him in a blanket. Their action
affirms a sense of community, or solidarity within creation, which con-
trasts with the fragmented and hostile world which they describe at the
outset. In addition, it affords Mak an opportunity to reform and thereby
expand their community. The shepherds discover experientially the truth
which is later announced to them formally by the angel: that charity (i.e.,
Christ) will release man from the bondage of sin (ll. 638–646).

Eusebian historiography provides a model for the presence of non-
biblical material within the salvific structure of history. But the examples
which I have discussed exclude one further category of subject matter;
the Roman Empire. In this category fall the Sibyl, Caesar Augustus,
Herod, and the action involving Christ's torturers. Throughout the cycle
Providence realizes its salvific plan through two major avenues: holy peo-
ple and the Roman Empire. Holy people – Abraham, Noah, Mary and
Elizabeth, the Apostles, John the Baptist – function as God's temporal
agents by aligning their will with His and therefore effecting His plan.
But, as history moves closer to the actual moment of Christ's birth, the
Roman Empire begins to assume a more prominent role. The Sibyl num-
bers among the prophets who announce Christ's advent; Caesar's fears
of a political rival result in the tax which takes Mary and Joseph to Beth-
lehem; Herod's megalomania aids the Magi in fulfillment of the prophecies
which state that the Messiah will be honored by the kings of the earth;
and Rome's imperial representatives (Pilate, Annas, Caiaphas) bring about
Christ's temporal demise, which completes His spiritual victory over Satan.
The perception of Rome as an instrument in salvation history has a cor-
ollary in the historiographic tradition. In contemplating the significance of
past and present history, Eusebius was able to see that God used Rome as
a means of chastizing and strengthening the early Church. Later, when the
Church had stabilized, God transformed the Empire into its earthly pro-
tector and promoter. As either scourge or patron, however, the Church
and the Empire were providentially and historically intertwined. And in
the Towneley Cycle, the instrumental role which Rome fulfills provides
still further evidence of the unity of creation and God's inclusive "might."

The purpose of this discussion has not been to establish a direct relation-
ship of influence between Eusebius and the cycle dramatists. Both Eusebian
and Augustinian structures were available to the fourteenth century in
generalized form: in paradigmatic and typological views of history. What

I have attempted to demonstrate is that, given these two alternative ways of organizing history, the Corpus Christi dramatists chose the former because it provided them with a structure which could encompass both conflict – the fundamental dramatic ingredient – and an affirmation of the unified nature of creation.

NOTES

1. Alan Nelson's *The Medieval English Stage* (Chicago, 1974) challenges many of the accepted theories regarding the origin and staging of the Middle English cycle plays. While Nelson's discussion provides a useful corrective to statements about the socially educative function of the cycles and staging techniques, I do not think it precludes investigations into the structure of the cycles *per se.*
2. V. A. Kolve, *The Play Called Corpus Christi* (Stanford, Calif., 1966), p. 48.
3. Kolve, pp. 57–100; James Earl, "The Shape of Old Testament History in the Towneley Plays," *Studies in Philology*, 69 (1972), pp. 434–452; Rosemary Woolf, *The English Mystery Plays* (Berkeley, Calif., 1972); and Walter E. Meyers, *A Figure Given: Typology in the Wakefield Plays* (Pittsburgh, Pa., 1970). Woolf and Meyers do not invoke the system of the seven ages, although both assert a typological structure. Meyers frequently uses the term "typological" when, in fact, the phenomenon he is describing is "archetypal": for example, "This 'typological' time is a mode of looking at history in which discrete events are ordered, not by their sequential arrangement, but by congruities of pattern." (p. 18).
4. Erich Auerbach, "Figura," trans. Ralph Manheim, in *Scenes from the Drama of European Literature* (Gloucester, Mass., 1973), p. 53.
5. Kolve, p. 89.
6. Kolve, p. 89; also see E. Catherine Dunn, "The Medieval 'Cycle' as History Play: an Approach to the Wakefield Plays," *Studies in the Renaissance*, VII (1960), p. 79.
7. Kolve, p. 86.
8. Kolve poses this question after his analysis of typological correspondences and his inquiry led him to a consideration of the seven-ages schema as a second principle of organization.
9. Eusebius, *The Ecclesiastical History*, trans. Kirsopp Lake, Loeb Classical Library (New York, 1926), Book I, Chapter IV, Sections 5–10, pp. 42–44. I have taken the liberty of repunctuating the first sentence of the translation for purposes of clarity.
10. For a similar analysis, see Robert W. Hanning, *The Vision of History in Early Britain* (New York, 1966), p. 24.
11. Eusebius, Book IV, Chapter VII, Section I, pp. 312–315.
12. Hanning, pp. 29, & 31.
13. Hanning, p. 25.
14. Dunn, p. 80. Ms. Dunn perceives an affinity between the cycle plays and that type of historiography which can be called "universal." She does not, however, equate this tradition, as I do, with the view of history which descends from Eusebius.
15. For a statement of similar position, see Dunn, p. 86.
16. By "representative" I mean typical in terms of subject matter covered, rather than typical in terms of the textual treatment of those subjects. See Earl's article for a discussion of this latter issue.

17. *The Towneley Plays*, ed. George England and Alfred W. Pollard (EETS, es. 71, 1897), p. 3.
18. See Robert W. Hanning, " 'You have begun a parlous pleye': The Nature and Limits of Dramatic Mimesis as a Theme in Four Middle English 'Fall of Lucifer' Cycle Plays," *Comparative Drama*, VIII (1973), pp. 20–50, for an attempt to account for the major elements in Lucifer's speech from a typological point of view. Also see John Gardner, *The Construction of the Wakefield Cycle* (Carbondale, 1974), Chapter 1, pp. 13–22, for an analysis of Lucifer's speech as a parody of God's.
19. *The Towneley Plays*, pp. 3–4.
20. *The Towneley Plays.*, p. 1.
21. R. Brown and A. Gilman, "The Pronouns of Power and Solidarity," *Language and Social Context*, ed. Pier Paolo Giglioli (Baltimore, Md. 1972), pp. 252–282.
22. Brown and Gilman., pp. 254–275.
23. *The Towneley Plays*, p. 4; italics added.
24. See Gardner, Chapter 2, pp. 23–38; Gardner describes a similar phenomenon but does so in terms of relationships based on love and relationships based on obligation.
25. *The Towneley Plays*, p. 35.
26. See Robert A. Brawer, "The Characterization of Pilate in the York Cycle Plays," *Studies in Philology*, 69 (1972), pp. 289–303, for a penetrating discussion of Pilate's function in the York Cycle. Brawer explores the nature and implications of Pilate's "power" and its paradigmatic status within the cycle as a whole.
27. *The Towneley Plays;* Pharaoh, p. 64, ll. 1–24; Caesar, pp. 78–79; ll. 1–24; Herod, pp. 140–141, ll. 1–24; Pilate, p. 222, ll. 560–575.
28. *The Towneley Plays*, p. 64.
29. *The Towneley Plays.*, p. 78–79.
30. See also Gardner, p. 20.
31. *Ibid.*
32. *The Towneley Plays*, p. 14.
33. *The Towneley Plays*, p. 40.
34. Brawer, p. 296; and Jerome Taylor, "The Dramatic Structure of the Middle English Corpus Christi, or Cycle, Plays," *Medieval English Drama, Essays Critical and Contextual*, ed. Jerome Taylor and Alan H. Nelson (Chicago, 1972), pp. 148–156. Taylor argues for a similar structure for the cycle plays when he describes the existence of a sequential progression, the linear causality of the narrative, overlaid with a repetitive pattern of exempla. I am grateful to Professor Taylor for calling this coincidence of interpretation to my attention.
35. For a similar analysis, see Gardner, p. 41.
36. Dunn, p. 83.
37. *The Towneley Plays*, pp. 41–42.
38. Kolve; see entire chapter entitled "The Passion and Resurrection in Play and Game," pp. 175–205, to which this entire section of my discussion is heavily indebted.
39. Kolve, pp. 178–180.
40. Kolve, pp. 192–193.
41. Hanning, *Vision of History*, p. 6.
42. Kolve, Chapter 5, "Medieval Time and English Place," pp. 101–123.
43. See also Gardner, Chapter 4, pp. 49–64, for a related analysis of Abraham's predicament.

William of Malmesbury and the Letters of Alcuin

RODNEY M. THOMSON

In trying to piece together a coherent account of English secular and ecclesiastical history in the century after Bede, William of Malmesbury was forced back upon the *Anglo-Saxon Chronicle*, supplemented by such miscellaneous sources as he could find either in his local library or in the course of his extensive bibliographical travels.[1] Among them, charters and letters occupy an important place, and for a good many of these William is a valuable textual witness. This is true for letters of Aldhelm, Boniface and, to a greater extent than has been realized, of Alcuin.[2]

In the first book of his *Gesta Regum Anglorum* William uses twelve of Alcuin's letters. Five of these reappear in the *Gesta Pontificum*, plus a further four.[3] I propose to study this material with two goals in view: firstly, to identify and describe the manuscript or manuscripts which William used and to assess his contribution to the reconstruction of Alcuin's text; secondly, to analyse and discuss the editorial treatment to which William subjected these letters in the process of incorporating them into his two major historical works.

Long ago Bishop Stubbs stated that William must have used two extant manuscripts of Alcuin's correspondence, British Library Cott. Vesp. A. xiv (Dümmler's A2) and B.L. Cott. Tib. A xv (A1).[4] The A2 was made for Archbishop Wulfstan, perhaps at York;[5] nothing is known of the provenance of A1. Stubbs argued solely on the basis of the particular letters contained in the *Gesta Regum*, some of which are found in no other MSS but A1 and A2. It is odd that he did not take into account the letters in the *Gesta Pontificum* or collate William's extracts with the most recent edition available to him, that of Jaffé and Wattenbach.[6] But even on the basis of which letters are quoted in the *Gesta Regum*, there was no positive reason for supposing William to have known A2, and the suspicion that he did not is confirmed by a scrutiny of the *Gesta Pontificum* letters and a collation of all of them with the *Monumenta* edition. In that edition Emil Dümmler made somewhat desultory use of William's extracts without himself adding anything to Stubbs's argument.

It is true that, of the total of sixteen letters quoted by William in his

two major works, eight are found only in the Cotton MSS.[7] But four of them are found only in A1, and a further three are not in A2; none is found in A2 alone.[8] Moreover, the readings of William's extracts from the ten letters found in *both* A1 and A2 clearly favour a relationship to the first manuscript, rather than the second.[9] If any further proof be wanting that William, if he knew either of these manuscripts at first hand, knew A1 and not A2, it is found in the three non-Alcuinian, papal letters quoted by him in the *Gesta Regum,* for these are otherwise known only from the MS A1.[10] Thus: all of the sixteen Alcuinian letters quoted by William are in A1; four are found nowhere else.

We may take it as established, then, that William did not know A2, but A1 or a manuscript very like it. To establish the precise connection between his exemplar and A1 entails a detailed comparison between the readings of his extracts and of the letters in the Cotton MS. First, a proviso must be made by way of warning. The ways in which William presented the letters vary from a brief summary in his own words to verbatim quotation of the best part of a complete letter. The majority of instances fall somewhere between these extremes, being quotations of reasonable length, verbatim but for some summarization by omission or syntactical compression and for some stylistic "improvements." William's editorial method will be studied in the second part of this paper; here I mention it only to point out that it is a task of some delicacy to recognize and disentangle his elaborate alterations from readings which he must have adopted from his manuscript-source. In general, however, enough of his quotations are given verbatim to enable some precise conclusions to be reached about the manuscript or manuscripts which he used.

Briefly, in the case of extracts from fourteen separate letters, the evidence is either not against or positively in favour of William having copied directly from A1.[11] But there are five cases in which he clearly knew a better text, perhaps the exemplar of A1. As this is a matter of importance, I give the evidence as follows:

Letter 100 (*Gesta Regum* p. 93): religioni Wm.: religione A1; plenam Wm.: post piam A1; Ethelredi Wm.: Aedilfredi A1

Letter 101 (GR pp. 73 and 75; otherwise in A1 only): eram Wm.: *om.* A1; esse Wm.: *om.* A1; de uobis Wm.: uobis A1; missorum Wm.: missurum A1; nece Wm.: neci A1; essem Wm.: esset A1

Letter 128 (*Gesta Pontificum* pp. 18–19): quod si Wm.: si A1*[12]; possit Wm.: posset A1*; ut Wm.: *om.* A1*; resarciatur Wm.A1*: resarcietur A2 *et al.*; coepiscopi Wm.A2 (*after corr.*): coepiscopis A1*; ut fiat Wm.: deliberare A1*: *om. rell.*

Letter 230 (GP pp. 17–18; also in A1 and H): Wm. gives the full *titulus* as in H

Letter 255 (GR p. 86 and GP p. 18; otherwise in A1 only): Audita prosperitate Wm.: Audiatque prosperitatem A1; suscepti Wm.: suscepi A1; (GP) Ethelardo archiepiscopo Wm.: ill. A1; multo Wm.: *om.* A1

It has long been recognized that A1, an extensive corpus of letters (125 of Alcuin, 24 of Dunstan), was transcribed from a group of at least three

smaller collections, plus a scatter of single letters.[13] Now, the letters quoted by William occur in all three main sections of A1. If he knew its exemplar, therefore, that exemplar must have contained virtually all the letters in A1. That would be to put A1 at two removes from the group of separate manuscripts from which its contents derive, an unlikely solution, since some of A1's Dunstanian letters date from the 990s – or not much earlier than the date of the manuscript itself[14] – and since it does not explain why some of William's extracts seem dependent upon A1, while others improve upon it. In fact, it can be shown that William did know A1, and not an exemplar of the whole of it. If we examine the five letters for which his extracts give better readings than A1, it will be seen (using Dümmler's table)[15] that they all come from the third section of that manuscript. We might then conclude that William, besides knowing A1 itself, had access to the exemplar of this section of it only. This would make him an important witness for the text of these five letters.

This hypothesis can be tested by a consideration of two of the three papal letters mentioned earlier.[16] They, too, are found in this last section of A1, from which Stubbs printed them, giving William's variants in his notes. Does William's text suggest that for these letters, also, he used the exemplar of this part of A1, rather than A1 itself? Indeed, this appears to be the case. One of the letters has a very few variants from A1, some of which look like William's habitual "improvements." Two of them, however, correct A1's text.[17] The evidence of the other letter requires more elaborate consideration. Of the many variants in William's version, three are almost certainly interpolations made by him from Glastonbury sources. I shall discuss these later.[18] Six other variants represent improvements on the text of A1; some might be William's work, but some at least seem to reflect a better exemplar. Three others might be William's mistakes, and three are equivocal.[19] Thus, for these two letters and for the five Alcuinian ones just mentioned, William is as important an authority as A1 itself.

I said earlier that the provenance of A1 is at present unknown. Without doubt, the clue to the original home of this important though much damaged manuscript lies in the fullest possible study of its physical disposition and contents. Nevertheless, it may be worthwhile making some provisional deductions as to where William might have found it and the exemplar of its last section. This section contains twenty-two letters of Alcuin, followed by twenty-four concerning Archbishop Dunstan.[20] At first sight it might seem that we have to do with two sections based on two separate exemplars. However, the two sets of letters are united by a common concern, as has long been known.[21] That overriding concern is the affairs of the See of Canterbury. Again, the fact that all of William's extracts from this section, both Alcuinian and tenth-century, have better readings than A1 suggests that he was using a single, earlier manuscript of this complete section. Fairly certainly this exemplar was written at Christ

Church, although whether William found it there is no more than probable. What of A1 itself? The fact that it was copied not long after the latest of the Dunstanian letters again points in the direction of Canterbury.[22] When we add to this the information that William is known to have made extensive use of the Canterbury libraries preparatory to the writing of his two *Gesta,* the evidence that here he found both A1 and the exemplar of its third section seems at least worthy of consideration.[23]

Doubtless, more than one process intervened between William's location of these manuscripts and his copying of extracts from them into the *Gesta Regum* and *Gesta Pontificum,* but it is hard to describe these processes accurately. Leland saw a copy of Alcuin's letters at Malmesbury.[24] By itself, of course, this tells us little, not even whether what he saw was a book dating from William's time. However, elsewhere in his *Collectanea* Leland gives extracts from sixty-five letters of Alcuin and Dunstan, citing a "vetus codex."[25] The letters, their order and readings show that Leland's manuscript was either A1 or a copy; Stubbs assumed the first alternative.[26] This cannot be the case, for Leland's extracts share a handful of readings with William against the Cotton MS.[27] Especially significant are the readings shared by Leland and William for letters found in the third section of A1, and these further support our argument that William knew the exemplar of that portion of it. It is notable, therefore, that the lengthy additions in William's text of the second papal letter mentioned above are not found in Leland's version.[28] In the case of three other variants between William and A1 for this letter, Leland sides twice with William and once with A1.[29] The source of William's additions is, in fact, not hard to find. All of the information in them is found in his own *Antiquities of Glastonbury* and is based upon alleged privileges of King Ine.[30] We shall see below that William felt no compunction about treating his texts in this way.

I conclude that Leland's "vetus codex" is identical with the manuscript of "epistolae Albini" which he found at Malmesbury. This was a transcript of A1 and the exemplar of its last section made by William, into which he had already worked some textual modifications. Thus, consistently with what is otherwise known of his *modus operandi,* William made up his own collection of Alcuin's and Dunstan's letters, extracting from it in his two histories.[31]

William seems to have carried out the preparatory work for the *Gesta Regum* and *Gesta Pontificum* simultaneously. The first edition of the *Gesta Regum* was completed early in 1125, and he then wrote up the *Gesta Pontificum,* finishing the first edition before the end of the same year.[32] I wish firstly to compare the five extracts from letters of Alcuin which occur in both of these works. In two cases the *Gesta Pontificum* passages are somewhat longer than their counterparts in the *Gesta Regum;* in three, the extracts are virtually identical in both works. In one case of the three the *Gesta Regum* extracts are split in two in the *Gesta Pontifi-*

cum, and the halves quoted in entirely different contexts, some fifty pages apart. In another case the *Gesta Pontificum* quotation omits the last clauses given in the *Gesta Regum* version. In the third instance there is exact identity as to the extent of the passage. This would lead to the reasonable presumption that William copied these three quotations into the *Gesta Pontificum* directly from the *Gesta Regum;* but such is not the case, for each *Gesta Pontificum* extract contains readings close to or identical with Alcuin's text, but which William had modified in the *Gesta Regum*.[33] We might then conclude that William went afresh to his complete letter-collection for the *Gesta Pontificum* extracts. But against this would have to be weighed the similarities between the three *Gesta Regum* and *Gesta Pontificum* extracts, both in their extent and in their modifications from Alcuin's text. Two solutions are possible: Either William, in making the *Gesta Pontificum* extracts, referred simultaneously to *both* his Alcuin manuscript and the *Gesta Regum*, or he employed, for both works, a collection of extracts already made by him from the complete manuscript. The second alternative seems to me the more likely, by virtue of its neatness and practicability. One would assume that into this collection of extracts William had already worked some summarization and stylistic improvement, which thus reappear in both of his histories. Here he took these processes further, sometimes in the *Gesta Regum*, sometimes in the *Gesta Pontificum*. If I am right about this, we have a valuable glimpse into the workshop of William as philologist and historian, into the elaborate preparations which must have been necessary for the almost simultaneous, certainly contiguous writing of his two massive works. We are also given an indication of the care which we should expect to find bestowed on his use of such literary evidence. William notoriously rarely quotes verbatim – he admits this himself and justifies the practice on the grounds of concision and stylistic consistency[34] – and he has been stigmatized as careless in the use of his sources.[35] Yet here, at least, he seems to have deliberately shunned the simplest of all possible procedures – simply to recopy his *Gesta Regum* extracts into the later work – in favour of recourse to the primary material. We would do well, on the basis of this hint, to explore all other possibilities before denouncing William as slipshod.

William did not see fit to absorb the information in Alcuin's letters into his own text, as he did, for instance, in the case of Bede; rather, he draws attention to them by introductory and interpretative comment and by quoting from them verbatim and at some length explicitly distinguishes their text from his own. This raises the question of the extent to which William was the slave of his sources. In fact, he was not so mechanically dependent upon their *ipsissima verba* as the preceding remarks might suggest. In most cases William quoted a mere fraction of a lengthy letter. In nearly all instances the quotation is a compact block of text, not a con-

flation of passages from various parts of a letter, although sometimes this is the case.[36] Sometimes the quotation is from the beginning of a letter, but just as often it is from the main body.[37] In one case William quotes verbatim from near each end of a letter, summarizing the intervening contents in his own words.[38] The impression created by these considerations is that William was master of his material, able to select from the raw mass just so much as he found relevant and interesting. This impression is reinforced by a study of the alterations which he made to Alcuin's words. We shall now examine these, keeping in mind two important questions: What were the principles according to which William made these alterations, and did his alterations do violence to Alcuin's text?

In the first place, William made omissions, in the interests of concision, even within the block of material which he quoted, leaving out words, clauses or even whole sentences. Most of what he omitted was rhetorical. Alcuin's biblical apostrophes are a good example; they add nothing to the content or message, and William understandably dropped them. For instance, in the passage which follows, the words in italics were omitted by William:

Laus et gloria *domino* deo *omnipotenti*, qui dies meos in prosperitate bona conseruauit; ut in filii mei karissimi exaltatione gauderem, *et aliquem, ego ultimus aecclesiae uernaculus – eius donante gratia, qui est omnium bonorum largitor – erudirem ex filiis meis*, qui *dignus haberetur dispensator esse misteriorum Christi et* laborare uice mea in aecclesia, ubi ego nutritus et eruditus fueram; et praeesse thesauris sapientiae, in quibus me magister meus dilectus Aelberhtus archiepiscopus heredem reliquit.[39]

The remainder of William's omissions consist of historical information not germane to his theme, such as the internal affairs of the Carolingian Empire or personal messages from Alcuin to his addressees. To present relevant information, shorn of unnecessary (but not all) rhetoric: That, in brief, appears to have been William's aim in making his abridgements. I do not think that there is any case in which his omissions distorted the content or meaning of the passages quoted. This is worthy of note.

But William did not only omit; he wrought changes in syntax, in words and word-order. Some of these were made necessary by his omissions, and they are in support of the same goal: to summarize by pruning Alcuin's rhetoric. But most of William's abbreviation was carried out by simple omission. His alterations were more usually for purely stylistic purposes. It is well known that William was a careful literary craftsman and critic of style.[40] The autograph of his *Gesta Pontificum* shows how he worked over even his final draft, polishing and repolishing with no other end in mind but to achieve the best possible rhetorical effect. He is frequently and explicitly critical of earlier Anglo-Latin writers, even of his patron Aldhelm.[41] Bede is the one exception who calls forth William's warmest and least patronizing praise.[42] By implication, William seems to consider

Alcuin a good stylist, and yet many of his alterations to Alcuin's text can be explained only by dissatisfaction and a desire to improve. Often it is easy to discern the reason for a particular change, but it must be said that in some cases I, at least, cannot tell why William preferred a particular word, expression or word-order to another. A certain proportion of these may, of course, be simple scribal slips.

William's stylistic alterations, I believe, can be seen as attempting to achieve three goals: increased conformity to the ideals of his own time (the ideals associated with monastic *Reimprosa*), a closer approximation to classical canons as he understood them and greater clarity and simplicity. It is arguable that William himself would not have differentiated the first two goals; he saw his own age as recovering the literary ideals of antiquity, and probably thought of his own style as one modelled upon the precepts of the antique grammarians and the great Roman prose-writers known to him – Caesar, Sallust and Cicero.[43] Still, although it is important that this be understood, the differentiation can be made clearly and legitimately.

I deal first with William's attempts to bring Alcuin's prose into conformity with the ideals of early-twelfth-century monastic writing. For instance, in Letter 101 Alcuin has "melius uisum est mihi," which William has changed to "melius mihi uisum est," apparently to achieve greater fluency and sonority from the closer conjunction of the *m*'s and *i*'s, and from the firmer final cadence. In the same letter William, who disliked alliteration as much as Alcuin and his English contemporaries favoured it, changed "peregrinatione permanere" to "peregrinatione remanere." In Letter 17 William reversed "Gildi Brettonum sapientissimi" to "Gilde sapientissimi Britonum" in order to retain the pattern of "Britonum . . . principum . . . episcoporum . . . populi," very much in the fashion of his day. Very similar is his change of "rapinas" to "rapinam," thus adding one more to the series of four nouns ending in "am." In parenthesis, I draw attention to William's substitution of "Gilde" for Alcuin's "Gildi" in the passage quoted above, for this is an alteration which does not properly fall into any of the three classes defined earlier. It might be described as a "philological" change. William obviously thought "Gilde" the proper genitive form of "Gildas," surely following the evidence of other manuscripts, either of Gildas himself or of one of his *vitae*.[44]

William's obviously classicizing alterations are less frequent. In Letter 17 he changed "perdiderunt" to the more poetic and (from a twelfth-century viewpoint) more noticeably classical "perdidere." In this connection another fascinating glimpse of him at work is provided by the autograph of the *Gesta Pontificum*. Alcuin opens Letter 17 with "audiens," plus accusative. William did the same for the extract in his autograph, but later lined it through and substituted the more classical "Cum audissem." This assures us of the deliberateness of what William was about. He also tries,

laudably, to simplify and clarify Alcuin's sometimes tortuous sentence structure. "Striving after effects" was one of William's criticisms of early English writers – "Angli pompatice dictare solent," he said of them on one occasion.[45] By inserting particles, by small omissions and grammatical changes and by toning down needlessly strong words, William aimed at a less stilted effect and greater comprehensibility.

Taking into consideration all of these "improvements," it can still be said that William gives us essentially Alcuin's words and meaning. But there is another, quite different class of alteration, which we may term historical, leading to an altogether different conclusion. There are not many of these, but they are of such a serious nature that I shall discuss them individually.

The easiest to deal with occurs in Letter 16, where Alcuin's "Euboraca ciuitate, in ecclesia beati Petri principis apostolorum, que caput est totius regni" has been changed to "Euboraca ciuitate, que caput totius regni est." The effect is to prevent the legitimate inference being drawn from Alcuin's word-order, that it is the church of York, not York itself, which is "head of the whole realm." William's reproduction in the *Gesta Pontificum* of the notorious "Canterbury forgeries,"[46] his preference for Bede's account of the Wilfrid affair as against Eddi's,[47] his relations with such advocates for Canterbury as Anselm and Eadmer all predisposed him to find this inference repugnant;[48] this, in spite of the fact that Alcuin, if this was his intended meaning, was referring only to Northumbria, not the whole of England. William has at least interpreted Alcuin's meaning, if not altered it altogether. I assume that he was motivated by a prudent consideration of his audience, among whom would surely be the Canterbury monks. If one wished to go further, it would be to say that William himself was to some extent involved and partisan in the great dispute between the two sees.

The next alteration is more problematic. In Letter 114, where Alcuin refers to his master Archbishop Ethelbert (founder of the famous York library), William has substituted "Egbertus" for the "Aelberhtus" of his manuscript. In the extract from Letter 121 which follows 114 in the *Gesta Regum* he inserts the words "Egberti archiepiscopi" after Alcuin's "magistri mei." This is wrong, but it is important to understand, if possible, how William came to make his error. First of all, it must be realized that William was interpreting, not contradicting his source. William always expanded or contracted Anglo-Saxon "ae," which in this case would have given him a choice of "Albertus," "Ethelbertus" or "Egelbertus"; no doubt, he considered these alternatives. Secondly, searching for Alcuin's "magister," he would have had the choice of "Ethelbertus" or "Egbertus," since Alcuin had been taught by both.[49] It is interesting to note that Leland's extract from this letter has "Aelberthus" in the text, the first syllable cancelled by sublinear points and "Eg" written above it.[50] Of

course, this might be due to Leland's having collated his "vetus codex" with a manuscript of the *Gesta Regum;* but I think it more likely that he is faithfully reproducing an emendation already in his exemplar, which I have tried to show was William's personal copy. Thirdly, William had some information about Egbert other than that in Alcuin's letters. He prefaces the extracts from Letters 114 and 121 with these remarks:

Plures post [Paulinum] tantae urbis praesules, simplici episcopatus nomine contenti, nihil altius anhelauerant; at uero Egbertus inthronizatus, animosioris ingenii homo, cogitans quod "sicut superbum est si appetas indebita, ita ignauum si debita negligas," pallium multa throni apostolici appellatione reparauit. Hic, omnium liberalium artium armarium, ut ita dicam, et sacrarium fuit, nobilissimamque bibliothecam Eboraci constituit; cuius rei testem idoneum aduoco Alcwinum, qui . . . in epistola ad Eanbaldum, tertio loco Egberti successorem, ait

In the *Gesta Pontificum,* where this passage and the subsequent extracts are repeated,[51] William adds that Egbert was the brother of King Eadbert of Northumbria; perhaps by simple inadvertence, he calls the king Egbert also. The passage shows that William was unaware of the two Archbishops Eanbald whose reigns were contiguous. He did know of an archbishop between Egbert and Eanbald (I and II conflated), even if he did not know that his name was Ethelbert; he should have known his name and dates, and of the two Eanbalds, since they were recorded in the version of the *Anglo-Saxon Chronicle* which he used.[52] In the *Gesta Pontificum,* however, he calls this man Cena, the name given him in the letters of Boniface.[53] The second conclusion which can be drawn from the above passage is that William did not know of Alcuin's poem in praise of York, or he would have known whom to credit with the foundation of the library.[54] There is, in fact, no positive evidence in his works that William knew any of Alcuin's verse.

The problem then is: Where did William obtain his information about Egbert's relationship with King Eadbert, his assumption of the pallium, his supposed foundation of the York library and reputation for learning? The *Anglo-Saxon Chronicle* could have provided him with the first two items, and if this was his only source, then he has fleshed it out quite creditably on the basis of inference, to arrive at a judgement about Egbert's character and motives. That this archbishop was a learned man and possessor or founder of a good library he could have deduced from the correspondence between him and Boniface[55] – his reference to Archbishop Ethelbert as "Cena" indicates that he was using Boniface's letters at this point. It was presumably on the basis of this information that he credited the origins of the famous library, about which he must have heard at one or more removes from Alcuin's poem, to Egbert. All this led him to reject the testimony of the *Chronicle* and expand the "Aelberhtus" in A1 to "Agelberhtus = Egbertus," rather than to "Ethelbertus."

William's third alteration occurs in the extract from Letter 230 given in the *Gesta Pontificum*.[56] William gives some sentences from the opening paragraph of this long letter, but then occurs a sentence which is not found there. At first sight this looks like a rather careless summary of the rest of the letter, but it is, in fact, an extract from Letter 128, from which a longer passage is quoted earlier in the *Gesta Pontificum*.[57] William, then, has conflated two separate letters, without warning his readers. I assume that he did so deliberately, and the question must then arise, was he justified in so doing?

Letter 230 was written in 801 to Archbishop Aethelheard of Canterbury, who was about to embark on a journey to Rome. The background to this was a letter of King Coenwulf of Mercia to Pope Leo III, seeking the reinstatement of Gregory I's original plan for two English provinces, with the southern see based in London.[58] Letter 128 was written to Aethelheard in 797 consoling him and urging him to repent for the state of the church of Canterbury, "divided asunder not by rational consideration, but by a certain lust for power." This refers to Offa's raising of Lichfield to metropolitan status in 778, a grievance raised by Aethelheard in Rome, where he was confirmed as primate over all the dioceses traditionally subject to his see.[59] At the Council of Cloveshoe in 803 it was declared that Offa had obtained a division of the province by false pretences; Canterbury had its honour restored, and the then archbishop of Lichfield apparently resigned or was demoted.[60]

William introduces the extracts from these letters in the context of his treatment of the succession of the archbishops of York. After introducing Eanbald (he means Eanbald II), he continues:

Ipse est Eanbaldus, qui cum Ethelardo archiepiscopo Cantuariensi mutuis probitatis offitiis inuasionem, quam Offa rex Mertiorum super Cantuariensem ecclesiam fecerat, ad nichilum redegit. Quod Albinus significare uidetur in epistola ad eundem Adelardum, ita dicens: [Letter 230] Audiens salutem et prosperitatem uestram et conuentum cum Eboracensi archiepiscopo filio meo Eanbaldo, satis mihi placuit speranti ex uestre colloquio sanctitatis unitatem sanctae ecclesiae recompaginari, [Letter 128] quae partim discissa est non rationabili consideratione sed quadam potestatis cupiditate.

On the presumption that these letters were the only source for William's preceding interpretative statements, he has again used their skeletal information imaginitively. I think that it can also be said that he was perfectly justified in conflating the two letters, since they relate to the same set of circumstances.

What has this study taught us? Surely a good deal about William's attitude to his sources. It has illustrated the care which he took to make accurate or at least intelligible versions of them – in fact, his text of Alcuin is very faithful, apart from his deliberate alterations. In this connection we have established his importance as a witness for the text of five Alcuinian,

plus two other early letters. At the same time, William was able to accomplish the dangerous task of editing by omission, alteration and conflation without substantially altering the sense of the original. He knew what he wanted his texts to do for him and he was master of their content. On the other hand, he had no compunction about interpreting ambiguities in Alcuin's meaning or in the manuscript-readings, in the light of other historical data available to him. As an attitude to source-material and as a means of using this fragmentary information to construct a coherent account of events, this is impressive, but we have shown that on at least one occasion it got William into trouble. This was because he failed to reconcile his texts and culpably cut the Gordian knot by simply disregarding the testimony of one of them, the *Chronicle*. At this point something should be said of the third papal letter quoted by William and also found only in A1. This is a letter of Pope Sergius to Abbot Ceolfrid of Wearmouth-Jarrow, written about 700.[61] William's text seems to have been copied from A1, where it appears in the first section (that is, part of the manuscript for which William did not have the exemplar), but there is one major variation. Whereas A1 contains an invitation to the abbot to send the "religiosum Dei famulum N. uenerabilis monasterii tui" to Rome, William has "religiosum Dei famulum *Bedam*, uenerabilis monasterii tui *presbyterum*." Bishop Stubbs noted that Bede was not ordained priest until after Sergius's death and that he was not one of the mission of Wearmouth monks who went to Rome in 700 and brought back a papal privilege.[62] Still, he thought it conceivable that the pope, having heard of Bede's learning, may have invited him, "and that the pope's death may have prevented his going." He concluded: "That Malmesbury garbled the letter, as has been supposed, is in the highest degree improbable." Having in mind, however, the way in which William used Alcuin's letters, altering names and conflating passages as he felt necessary, we should be less certain than Stubbs that William was not responsible for the expansion of N. to "Bedam" and the insertion of "presbyterum" in the text of Sergius's letter. Indeed, since he almost certainly copied the letter from A1, it is difficult to account for these variants in any other way.[63]

This important modification is found in two other versions. One is in Cambridge University Library MS Kk.4.6, an extensive miscellany prepared for and annotated by the chronicler John of Worcester, an acquaintance of William's.[64] The text of the *Liber Pontificalis* in it was first associated with William by Levison, and there is now good reason to believe that the Cambridge copy was made from a version modified and interpolated by him.[65] Among the many added texts which point to William's workmanship is Sergius's letter.[66] This part of the Cambridge manuscript was written by a very careless scribe, but once his errors are eliminated, it can be seen that this copy of the letter is derived from A1, except that it shares two variant readings with William, including the

reference to Bede.[67] The other version is an extract in Leland's *Collectanea*, made from his "vetus codex" of Alcuin's and Dunstan's letters.[68] This, too, derives from A1, but has the same two agreements with William found in the Cambridge manuscript. My conclusion is that both Leland's and the Cambridge text derive from A1, via William's complete transcript of it and its partial exemplar, and that in this transcript William had already made his major alteration.

"Garbling," however, would be the wrong word to describe what William actually did. I would hope that this study has to some extent exonerated William from charges of dishonesty or carelessness. Just as he felt free to "improve" Alcuin's style, so he felt justified in interpreting (rather than altering) his information. So here: "N." cried out for expansion. Whom else but Bede would the pope single out among the monks of Wearmouth-Jarrow for a special invitation to Rome? Although William overplayed his hand by the insertion of "presbyterum," he may, for ought we know, have been right in his interpretation. William demands, not our blame, but our understanding; our task is not to judge his use of sources against twentieth-century ideals but to understand his vision of history.

NOTES

1. The most comprehensive account of William's sources is still that by William Stubbs in his edition of William's *Gesta Regum* (Rolls Series, 2 vols., London, 1887–9), II, pp. xv–xxxviii. For William's readings and travels in general, see R. M. Thomson, "The Reading of William of Malmesbury," *Revue Bénédictine*, 85 (1975), pp. 362–402.

2. On William's use of Boniface and Aldhelm see Thomson, *op. cit.*, p. 368 and nn. William's extracts from Alcuin's letters were noted and sometimes collated by E. Dümmler, *Alcuini Epistolae* (*Mon. Germ. Hist., Epist.*, IV, Berlin, 1894).

3. In the *Gesta Regum* (citing by page from vol. I): p. 68 – Dümmler no. 114, p. 167; *ibid.* – no. 121, p. 177; p. 73 – no. 19, p. 55; *ibid.* – no. 43, p. 89; *ibid.* – no. 101, p. 147; *ibid.* – no. 16, pp. 42–3; pp. 73–4 – no. 122, p. 180; p. 74 – no. 17, p. 47; p. 75 – no. 8, p. 33; *ibid.* – no. 101, again p. 147; p. 82 – no. 230, p. 375; p. 86 – no. 255, p. 412; p. 92 – no. 7, p. 32; p. 93 – no. 100, pp. 145–6; in the *Gesta Pontificum*, ed. N. E. S. A. Hamilton (Rolls Series, London, 1870, cited by page): p. 17 – no. 230, again p. 374; p. 18 – no. 255, again pp. 412–3; p. 19 – no. 128, p. 190; p. 209 – no. 16, again p. 43; p. 246 – no. 121, again p. 177; *ibid.* – no. 114, again p. 167; p. 247 – no. 230, again p. 374; pp. 255–6 – no. 31, p. 72; pp. 256–7 – no. 273, p. 431; pp. 267–8 – no. 20, pp. 57–8; p. 268 – no. 16, again pp. 42–3.

4. *Gesta Regum* (GR) II, pp. xxvii–xxviii.

5. N. R. Ker, "The Handwriting of Archbishop Wulfstan," *England before the Conquest; Studies in primary sources presented to Dorothy Whitelock*, ed. P. Clemoes and K. Hughes (Cambridge, 1971), pp. 326–7, 316.

6. Since Dümmler's edition was not completed when Stubbs wrote, he used the edition begun by Jaffé and completed by Wattenbach and Dümmler,

Monumenta Alcuiniana, Bibliothecae Rerum Germanicarum, VI (Berlin, 1873), pp. 132–897. Hamilton cites from the edition of Froben (1777) in the *Gesta Pontificum* (GP).

7. Nos. 7, 8, 16, 100, 101, 122, 255, 273.
8. Only in A1: nos. 100, 101, 122, 255; in A1 and other MSS but not in A2: nos. 31, 121, 230.
9. No. 7 (GR, I, p. 92): Fresonum Wm. A1: Frisonum A2; irruit Wm. A1: inruit A2; subegit sue dicioni Wm. A1: suae subegit dicioni A2; irruerunt Wm. A1: inruerunt A2; dissensionis Wm. A1: disentionis A2; Carolum Wm. A1: Korolum A2; mittendos Wm. A1: mittendas A2. No. 8 (GR, I, p. 75): maiestatem Wm. A1: magestatem A2. No. 16 (GR, I, p. 73): Eboraco Wm.: Eboraca A1: Euboracia A2. No. 20 (GP, p. 267): episcopo Wm. A1: epīs A2; Alcuinus Wm. A1*: Alchuine A2; dominus Wm. A1*: domnus A2. No. 114 (GR, I, p. 68): exaltatione Wm. A1: exultatione A2. For letters used by William and also contained in A2, I have compared Dümmler's edition with that of C. Chase, *Two Alcuin Letter-Books* (Toronto, 1975).
10. GR, I, pp. 62–3, printed in C. Haddan and W. Stubbs, *Councils and Ecclesiastical Documents,* III (Oxford, 1871), pp. 248–50; GR, I, pp. 172–3, 191–3, printed by Stubbs in his *Memorials of St. Dunstan* (Roll Series, London, 1874), pp. 396–7, 397–8.
11. See note 9 above. In addition, see: No. 17 (GR, I, p. 74): accidit partibus Wm. A1 *et al.:* acc. in part. QTS1; trecentis Wm.A2K1Q: tricentis A1 *et al.;* quadraginta Wm.S1AKQ: quinquaginta *rell.;* Britonum Wm.AQ: Brettonum *rell.;* Britones Wm.AQ: Brettones *rell.;* dignatus Wm.K2: dignata *rell.* No. 19 (GR, I, p. 73): Wiorenses Wm.: *cf.* A; sequi Wm.AKD: sequere TQS1; discant nunc Wm.A: discunt T: discant *rell.;* Bedam Wm.: Baedam A1TK1S1D: Boedam A2: Bedan Q: Bedum K2; habet Wm.KTQ: habeat A: habent S1D. No. 20 (GP, pp. 267–8): Higbaldo Wm.A: hugibaldo S1; episcopo Wm.A1*S*: epīs A2; Alchuinus Wm.: Alcuinus A1*: Alchuine A2S1; dominus Wm.A1*: domnus A2S1; eum Wm.A2S1: illum A1*. No.121 (GR, I, p. 68): desunt A1*TK2: detis K1: date Wm.; libellos Wm.K1: libelli A1*TK2; industriam Wm.A1*TK1: industria K2; Eboraca Wm.A1*: Euboraca *rell.;* emissiones Wm.A1*K1: emissionis TK2. No. 122 (GR, I, pp. 73–4): no significant variants.
12. A1* was the siglum used by Dümmler for Thomas Gale's transcript of A1 (Cambridge, Trinity Coll. MS o.10.16), used to supplement those portions of A1 made illegible by damage from the 1731 fire.
13. Dümmler, *op. cit.,* pp. 10–11, citing T. Sickel, *Alcuinstudien,* I, *Wiener Sitzungsberichte,* 79 (1875).
14. On the date of A1 see Ker, *op. cit.,* p. 316, who describes it as having been a new book when Wulfstan used it (*ante* 1023). The latest precisely dateable letter of Dunstan in A1 is of 991. In W. Stubbs, *Memorials of St. Dunstan* (London, 1874), p. 397, no. XXVI.
15. Dümmler, *op. cit.,* pp. 10–11.
16. See above, n. 10; I refer to the second and third documents.
17. GR, I, pp. 191–3: matris nostrae ecclesiae Wm.: nostrae *om.* A1; necnon et Leofstanum Wm.: et *om.* A1; perpetrauerint Wm.: perpetrauerit A1; stabilis Wm.: *om.* A1; uel de inimicis Wm.: de *om.* A1.
18. GR, I, pp. 172–3; Stubbs, *op. cit.,* pp. 396–7. *After* "Glastingaburgh," Wm. *adds* "quae totius Britanniae prima, et ab antiquis primoribus ad proprietatem et tutelam Romani pontificis pertinere dinoscitur"; *after* "uillas," Wm. *adds* "sed et ecclesias de Brente, de Piltune, quas, Ina rege dante

operam, cum aliis ecclesiis quas iuste et canonice possidet, scilicet, Soweie, Stret, Merlinc, Budecale, Sapewice"; *after* "proprietatibus," Wm. *adds* "ecclesiis, capellis."

19. I give the variants here, since Stubbs's collation (*Memorials*, pp. 396–7) is incomplete: propter quod eidem Wm.: p. q. eodem A1; habitationem Wm.: habitatione A1; nocuus Wm.: nociuus A1; cui propinquus Wm.: cum p. A1; a beato Wm.: in b. A1; A1 *adds* "fidelium" *after* "omniumque"; ideo Wm.: ideoque A1; admonemus Wm.: monemus A1; amore Wm.: timore A1; nil de Wm.: nihil ab A1; si haec feceris Wm.: s. h. non feceris A1; proditore Wm.: traditore A1.

20. Dümmler, p. 11, and Stubbs, *op. cit.*, pp. 355ff.

21. Dümmler, p. 11, citing Sickel, *op. cit.*

22. See above, n. 14. I had written this article when I discovered that a Christ Church provenance for A1 is favoured, on similar grounds, by C. Hohler, "Some Service Books of the Later Saxon Church," *Tenth Century Studies*, ed. D. Parsons (London, 1975), p. 74.

23. Thomson, *op. cit.*, p. 392.

24. J. Leland, *Collectanea*, ed. T. Hearne (6 vols., London, 1774), IV, p. 157.

25. *Ibid.*, II, pp. 392–404.

26. Stubbs, *op. cit.*, pp. 366, n. 1, 381, n. 1.

27. Letter No. 17: Gildi A1: Gildae Wm.Le1. No. 100: religione A1: religioni Wm.Le1. No. 101: uobis A1: de uobis Wm.Le1. No. 114: Aelberthus
 Eg
 A1: Egbertus Wm.: Aelberthus Le1. And see below, nn. 28, 29.

28. J. Leland, *op. cit.*, II, p. 404.

29. Propter quod eidem Wm.Le1.: p. q. eodem A1; habitationem Wm.: habitatione A1Le1.; nocuus Wm.Le1.: nociuus A1.

30. J.-P. Migne, *Pat. Lat.* 179, cols. 1705–7; GR, I, pp. 36–9. The privilege given by William *in extenso* is spurious; see P. H. Sawyer, *Anglo-Saxon Charters* (London, 1968), no. 250.

31. William liked to make collections of texts either complete, abridged or summarized; for instance, in B. L. Harl. 3969, which contains his collection of grammatical handbooks, he omitted from his version of Alcuin, *De Orthographia*, what Alcuin had lifted from Bede's work of the same name, also included in William's collection.

32. GR, I, pp. xix–xx, xliv–xlv; in *ibid.*, p. 83, William refers to his forthcoming ecclesiastical history in a way so specific as to suggest that it was already at least at the planning stage. It is now known that work on the GR was well advanced by 1118; on the other hand, the many references in the GP to particular books of the GR show that William had completed GR before the final writing of GP took place.

33. No. 16 (GP, p. 209): populum Wm.Alc.: terram GR. No. 114: eruditus GPA1c.: educatus GR; praeesse GP: et praeesse Alc.: et praeesset GR. No. 121: excellentiae GPA1c.: sapientiae GR.

34. GR, I, p. 2; II, p. xvi.

35. *Ibid.*, II, pp. xxxiii–xxxviii.

36. Cf. no. 20 (GP, pp. 267–8); no. 230 (GP, p. 247).

37. Cf. no. 101 (GR, I, p. 73), no. 17 (*ibid.*, p. 74); no. 128 (GP, p. 19); no. 31 (*ibid*, pp. 255–6).

38. No. 20 (GP, pp. 267–8).

39. No. 114 (GR, I, p. 68).

40. GP, p. 22; GR, I, pp. 1, 121.

41. GP, p. 344, on Aldhelm's sermons.

42. GR, I, pp. 1, 61–7.
43. Thomson, *op. cit.*, pp. 370–3, 379–80, 392 and n. 1.
44. Bede also uses the form "Gildus/Gildi" (*Hist. Eccl.* 1, 22); the alternative "Gildas/Gildae" is given in the title to his *De Excidio*, which William may have known independently of Bede (GR, I, p. 20; Thomson, *op. cit.*, p. 400), and in the *Vitae* by the monk of Ruys and Caradoc; *Gildae De Excidio Britanniae . . .* , ed. H. Williams (*Cymmrodorion Record Series*, 3, pts. 1 and 2 [1900–1]). It is interesting to note that Leland, in his transcript of this letter, has "Gildae" (*Collectanea*, II, p. 399). This suggests that William had already made the alteration in his complete transcript of A1 and its partial exemplar.
45. GP, p. 344.
46. *Ibid.*, pp. 46–62, GR, II, pp. 346–8; R. W. Southern, "The Canterbury Forgeries," *English Historical Review*, 73 (1958), 193–226.
47. GP, pp. 211–44.
48. Thomson, *op. cit.*, pp. 370, 392.
49. C. J. Godfrey, *The Church in Anglo-Saxon England* (Cambridge, 1962), pp. 213–14.
50. *Collectanea*, II, p. 397.
51. GP, p. 246.
52. William used a manuscript of the so-called "E-Type"; Thomson, *op. cit.*, pp. 389–90; D. Whitelock, D. C. Douglas and S. Tucker, *The Anglo-Saxon Chronicle* (London and New Jersey, 1961), pp. 28, 33–4, 37.
53. GP, p. 246.
54. *Mon. Germ. Hist., Poet. Lat. Aev. Car.*, I, ed. E. Dümmler (1881), p. 169ff.
55. M. Tangl, *Die Briefe des heiligen Bonifatius* (Berlin, 1916), nos. 75, 91.
56. GP, pp. 246–7.
57. *Ibid.*, pp. 18–19.
58. Haddan and Stubbs, *Councils*, II, pp. 521–3; GR, I, pp. 86–9.
59. Godfrey, *op. cit.*, pp. 266–7.
60. *Ibid.*, p. 267; Haddan and Stubbs, *op. cit.*, III, pp. 542–44.
61. Godfrey, *op. cit.*, pp. 248–50.
62. GR, I, p. 62, n. 2.
63. The only alternative explanation would be that he collated A1 with another manuscript containing this reading. This is not impossible, but the "presbyterum" suggests that we are dealing with an interpolation based on guesswork, rather than an authoritative reading from an early manuscript.
64. N. R. Ker, "William of Malmesbury's Handwriting," *English Historical Review*, 59 (1944), 375–6; *idem, Medieval Libraries of Great Britain* (London, 2nd ed., 1964), p. 206. Dr Martin Brett, in an unpublished paper which he was kind enough to show me, has demonstrated that John and William knew of each other's work and apparently exchanged notes. Cf. Thomson, *op. cit.*, pp. 393–4.
65. W. Levison, "Aus englischen Bibliotheken, II," *Neues Archiv für deutsche Geschichtskunde*, 35 (1910), 366ff.; Levison realized that this version of the *Liber* was used by William in GR, but thought that he found it, already interpolated, at Canterbury. Dr Brett and myself, working independently, have reached the conclusion that William himself was the interpolator. The matter requires separate consideration.
66. Cambridge University Library, MS. Kk.4.6, ff.270–270v.
67. The other shared reading is: "ut expedire nostrae saluti," Cambr.Wm.: "u. e. saluti nostrae," A1.
68. J. Leland, *op. cit.*, II, pp. 396–7.

The Validity of Boccaccio's Self-Exegesis in His Teseida

ROBERT HOLLANDER

The history of modern critical response to Giovanni Boccaccio's glosses to his own *Teseida* is both curious and revealing.[1] At the turn of the century Paolo Savj-Lopez,[2] having come upon a codex containing these glosses and not believing that they were Boccaccio's own, condescendingly concluded that they were written "by someone who expended great effort to clarify certain episodes of the poem, seeking to find allegories in them."[3] Some thirty years later, Giuseppe Vandelli, whose expertise in such matters was and still is universally recognized, identified a manuscript[4] as being a Boccaccian autograph.[5] Vandelli's labor has, once and for all, legitimized the paternity of the glosses, and there has been not a single instance of anyone, from 1929 to the present, who has even suggested that anyone other than Boccaccio wrote them. Yet perhaps the fact that Boccaccio seems to have modelled his gloss on that of Lactantius Placidus to Statius's *Thebaid*, a copy of which he indeed owned,[6] has led some of those who discuss the glosses to believe that they represent a Boccaccian attempt, spurred by the example of Lactantius, to storm – if not the gate of Heaven – the veiled portico of the university. Perhaps for such cause the self-exegesis of the young Boccaccio[7] is frequently referred to in patronizing terms as being the work of a "neophyte" who seeks only to confirm his own claim to erudition. At any rate, what is most arresting about the current view of the glosses is that their ability to tell us something about the author's intention in his own work is nearly totally discounted or ignored. This "tradition" began with Vandelli himself, who treats those glosses which are most suggestive – the long allegorical commentaries on the Temples of Mars and of Venus – as being indeed extraordinary ("singolarissime" is his form of superlative), but only in the sense that they seem puzzling, inappropriate, forced.[8] And Alberto Limentani, who is the most recent editor of the *Teseida* and its surrounding and interpenetrating *chiose*, is, if anything, even less open to the possibility that these two extended glosses may tell us something important about the poem. His single, eight-line note[9] concerning the glosses to the two Temples refers the reader to Dante's glosses in the *Convivio* (which is assuredly to the point), but says absolutely nothing about either their im-

portance or their applicability to the poem. Perhaps his own earlier judgment, which held that these expositions were to be regarded as "a confused and absurd allegorical analysis,"[10] lies behind his silence here.

One feels uncomfortably on the side of the angels in arguing that, if Boccaccio himself has offered us an interpretive clue as to his purpose in his poem, we should attempt to approach the poem armed with such material. Yet one hastens to add that the current understanding of Boccaccio – and this is far from being a case limited to the *Teseida* – is of such a nature and condition that the side of the angels, even though *their* number be infinite, is surely a minority. Before examining the glosses to the Temples of Mars and of Venus, which do stand out, both with respect to their length and their content, from the rest of the *chiose*, one does well to have some sense of the nature of their marginal companions.[11]

There are some 1,250 *chiose* to the text of the *Teseida*. If we exclude for the time being the two that are of most interest in this investigation, we may observe that Boccaccio's more typical glosses fulfill several categories of function. To begin with the most numerous and least interesting, there are roughly one thousand modest exercises in philology. The vast majority of these do no more than offer the reader a paraphrase of "difficult" words (e.g., *achiva*, "cioè greca" – I, 61, 3) or straighten out the normal indirections of poetic discourse (e.g., *i regni neri* are identified as "l'inferno" – IX, 25, 6). While some glosses of this kind are of tangible assistance to the reader, the majority of them would seem to have little other purpose than to create an atmosphere around the poem, to lend to it the status of "instant classic." And given the tiresome and minimal nature of such interventions, which may serve to make us wonder whether or not Boccaccio might have been pulling our collective leg, it is easy to see why so many margins were allowed to remain blank. Indeed, only Books X and XI fail to show lacunae in the commentator's zeal that last for at least as many as sixty-four lines at a time,[12] and once, in Book III, he is silent at the margin of three hundred and thirty-two consecutive lines, not, we may assume, because he can find nothing to say, but because he has grown weary in his task.

If these thousand marginal notations have little interest for one who would find some indication, in the author's own hand, of his eventual purpose in writing the *Teseida*, a second category of glosses would seem more promising. There are some 225 interventions which reveal Boccaccio's knowledge of the classical world, its myths (ca. 160 entries), its geography (ca. 35), its customs (ca. 30). In the last sub-category, we receive instruction concerning such Greek behavior as the worship of Minerva in Athens (I, 60, 1) the holding of games to honor the gods (I, 60, 5),[13] the setting up of trophies after a victory (II, 10, 3), the uses of the funeral pyre (II, 13, 6), and so on. As for classical geography, we are given the location of Scythia (I, 6, 2), of various Greek islands (I,

40, 3), are told that Athens is situated in Attica (II, 35, 6), that the found-
ers of the Tuscan Pisa came from the homonymous Greek city (VI,
52, 3), and the like. But it is, unsurprisingly enough, classical myth that
receives the largest share of Boccaccio's attention, as he obviously de-
lights in calling our attention to his knowledge of the fables of antiquity.

Boccaccio's epic is far more dependent upon Statius than Virgil (it is
striking that the name Aeneas is not heard once, in either text or com-
mentary), and it is natural that the material for a number of glosses be
drawn from the matter of the *Thebaid*. Yet the vast bulk of the mytho-
graphic material is Ovidian.[14] This is not to claim that Boccaccio was
working from a text of the *Metamorphoses*. In fact, it would seem clearly
not to have been the case, for his summaries of Ovid's tales usually reveal
either more than is present in or too little of the eventual source to be
seen as citations of Ovidian text. Boccaccio would seem rather to have re-
lied upon some compilation(s) of pagan myth. Indeed, although there are
evident borrowings from classical texts in the text of the poem (and for
Boccaccio Dante was a "classical" text),[15] there is only one case in the
chiose of actual reference to an *auctor*, when he reveals that the swiftness
of his character Ida piseo is modelled on that of Virgil's Camilla (VI,
53, 1). This singular admission, which is important in another context as
well,[16] serves to remind us of the vagueness of the form of Boccaccio's
references in all other cases. In the *chiose* a phrase repeated often (more
than thirty times) and in several variants serves also to remind us of the
problem of source. It is frequently Boccaccio's habit to begin his recapitu-
lations of antique tales with some version of the formula "scrivono i poeti
che"[17] A perhaps unintended effect of this generic form of refer-
ence is to make the *chiose* seem to have been cribbed from a compendium
of mythographic material, rather than culled from original sources. While
I am not yet (and may never be) in a position to say exactly what com-
pendium (or compendia) he used for the glosses to the *Teseida*, a more
than likely source is the lost *Liber collectionum* of Paolo da Perugia,
whom he knew in Naples and who also composed a second work known
to Boccaccio (I leave to one side his commentary on Persius), the *Liber
geonologie*, a work which Boccaccio copied into his own compendium
that is known as the *Zibaldone Magliabechiano*. The title of Paolo's work
is enough to indicate that it may have served as one model for Boccaccio's
own encyclopedic *Genealogy of the Gods*.[18]

The *Genealogy* itself provides us with other clues. In Book XV, Chap-
ter 6, Boccaccio defends his modern *auctores*, Andalò del Negro, Dante,
Francesco da Barberino, Barlaam, Paolo da Perugia, Leonzio Pilato, Paolo
dell'Abaco, and Petrarca. In this list Barlaam and Paolo da Perugia are
the only two whom Boccaccio knew in Naples and whom he cites as au-
thorities on myth. But of Barlaam he claims never to have seen any writ-
ten work,[19] and while one should always treat such disclaimers gingerly,

it is true that in the *Genealogy*, where Boccaccio goes painstakingly out of his way to indicate the sources of various opinions concerning the details or interpretations of various pagan myths, Barlaam's name occurs a mere two dozen times.[20]

This is indeed not a large number of citations when we compare the 92 references to Paolo, not to mention the 215 citations of Theodontius, which mysterious *auctor* he found so frequently cited in Paolo's *Collectionum*.[21] This is not the occasion on which to discuss – or even to broach – the "Theodontius problem"; all we need be concerned with is the fact that Boccaccio claims to have received his Theodontius, whoever that mythographer was taken by him to be, from Paolo's book and that he treats him as an earlier authority on whom Paolo himself drew.[22] And again we should turn – if always with caution – to Boccaccio's own words upon the matter, his description of his indebtedness to Paolo da Perugia:

He wrote a huge book which he called *The Collections;* it included much matter on various subjects, but particularly his ingatherings of pagan mythology from Latin authors, together with whatever he could collect on the same subject from the Greeks, probably with Barlaam's help. I shall never hesitate to acknowledge that when still a youngster [*iuvenculus*], long before you [King Hugo] drew my mind to this undertaking, I drank deep of that work, with more appetite than discretion [*ex illo multa avidus potius quam intelligens sumpsi*]. Especially did I prefer all that part set down under the name of Theodontius.[23]

Boccaccio goes on to lament, in the next sentence, the fact that, to the vast detriment of his own book of genealogies, Paolo's shameless wife Biella had, after his death, caused his book to be destroyed.

When he first knew him, Boccaccio concludes, no one was to be compared to Paolo in studies of this sort.[24] How are we to relate the 317 *overt* citations of Paolo's *Collectionum* (the source of Boccaccio's Theodontius, we remember) in the *Genealogy* to the supposed absence of any written text that Boccaccio might have consulted? By comparison, his other modern authorities – and he himself presents to us the names of his "bella scola" of moderns in the *Genealogy*, XV, 6 – are scanted: Andalò del Negro, 14 citations; Dante, 5; Francesco da Barberino, 2; Barlaam, 24; Leonzio Pilato (with whom he had lived for three years and from whom he may be presumed to have collected much information of a mythographic nature), 95; Paolo dell'Abaco, 2; Petrarca, 11. I would suggest that there are only three possibilities which might account for the many citations of the *Collectionum:* (1) Boccaccio had a phenomenal memory; (2) Biella did not destroy the only copy of the work; (3) Boccaccio had made at least a partial copy of the work. It would further seem to me that only the second and third alternatives are serious candidates for our credence, unless we are willing to assume that Boccaccio created a counterfeit version of Paolo's text.

All that we possess of Paolo da Perugia's *Collectionum* (and thus of Theodontius) exists in the pages of Boccaccio's *Genealogy*. One purpose of our inquiry is to determine whether or not the glosses to the *Teseida* reflect acquaintance with the *Collectionum*. The most sensible method of determination calls for a comparison of the citations of Paolo and of Theodontius in the *Genealogy* with the mythographic material found in the margins of the *Teseida*. Even that simple an assignment is not an easy one, however, and I must confess that hours of labor have turned up only a few likely – and far from certain – points of contingency. But we must also try to remember a few important points: (1) Only a small percentage of the *Collectionum* is remembered in the text of the *Genealogy;* (2) not very many of Boccaccio's 160 or so mythographic *chiose* in the *Teseida* will correspond to the vast areas of mythography represented even by as much of the *Collectionum* as is gathered in the *Genealogy;* (3) in matters of mythography sure attributions of sources are very close to impossible, since mythographers, like magpies, are known to feather their nests unashamedly with the treasures of others. With these disclaimers in mind, we may be able to agree that even a few citations of Paolo or of Theodontius might warrant the conclusion that Boccaccio, at least to some degree, drew upon the *Collectionum* in his glosses to the *Teseida*. All that I am currently willing to suggest is that some fourteen passages in the *chiose* would seem to support such a position, while being the first to argue that my findings are tentative, and far from conclusive.[25] Whatever we shall discover to have been Boccaccio's main source of ready-to-use Ovid in his *chiose* to the *Teseida*, at the present time Paolo's *Collectionum* continues to be the most likely source.[26]

In this discussion I have until now omitted from consideration the *auctor* whom many would assume to have been the most likely source to whom Boccaccio would have turned in his *chiose*. It is a fairly frequent gesture to suggest that Boccaccio's desire to gloss his own work derived from his awareness of Lactantius's glosses to the *Thebaid*, especially since he himself eventually owned a copy of the work containing the commentary.[27] Yet no one seems ever to have studied these two commentaries, written some thousand years apart from one another, with a view to determining the influence of the earlier work upon Boccaccio's. And while it seems perfectly reasonable to assert as an hypothesis that – if he knew Lactantius's work before he composed the glosses to the *Teseida* – a commentary on an epic which served as a model for his own effort in the genre might well have turned his thoughts to writing such an accompaniment to his own, there is little or no evidence to suggest that Boccaccio's glosses reflect anything of Lactantius's actual language at all. I render this judgment without claiming to have checked all of the common elements in both texts against one another. But all those which I did examine failed to turn up a single case in which there is a sure example

of Boccaccio's dependence upon Lactantius.[28] The absence of such confirmation is especially striking in Boccaccio's lengthy gloss to the Temple of Mars (VII, 30), since he has taken many of the details for his temple from Statius's description of the Temple of Mars in the *Thebaid* (VII, 34–63), while the gloss itself shows no resemblance to that of Lactantius. Given the importance of the Temple of Mars to the *Teseida*'s major themes, and given the fact of Boccaccio's imitation of Statius,[29] the lack of reference to Lactantius's glosses to that passage in Statius would seem to indicate either that Boccaccio as yet did not know them or that, if he did, he did not find them particularly interesting or useful. It is, as much as we would like to know exactly what cultural apparatus lay under Boccaccio's eyes, more important to understand the force of the gesture he has made by writing a commentary to his own poem than to isolate the sources for that commentary. To herald the rebirth of epic in a modern tongue it was only fitting that the instant classic be born *cum commento*. And it was this gesture which was the likely cause of the glossatorial efforts of two later *chiosatori*,[30] for one wonders whether they would themselves have chosen to take on such a task without the example of a manuscript of the *Teseida*, accompanied by the anonymous leavings of Boccaccio. (One smiles at Boccaccio's little game somewhat sadly: Had he revealed himself publicly as his own glossator his exertions would have seemed the self-loving effort of a nervous father.) Before we turn to the two most important interventions of our commentator, we might reflect a moment upon the nature of other glosses to the *Teseida* which also offer some sense of its author's intentions. There are some twenty passages of this nature,[31] and while most of them are hardly noteworthy (e.g., the explanation at VIII, 3, 1, that, in order to show that the sound of the shock of battle between two warring bands was loud, the author puts forward many examples of loud noises), it is probably important to observe that our commentator feels perfectly at liberty to announce his author's intention.[32] One intervention is especially interesting. As the dying Arcita addresses Teseo, he laments the torment that his unrequited love for Emilia has brought him (XI, 18, 2–6). The commentator clarifies his fairly convoluted expression: "He had not slept with her," he explains, "which act many foolishly consider to be the aim of love."[33] This remark was one of the reasons that Giuseppe Vandelli believed that the glosses were likely to have been the product of Boccaccio's mature years.[34] And while the statement is not couched explicitly as an expression of the author's intention, it serves as such, with its brusque tone and anti-venereal sentiment coming as something of a shock to those readers who like to read the *Teseida* as a work that celebrates carnal passion.

The two glosses which we are about to examine are what most critics would agree might be classified as allegorical in nature. I am less interested in the way in which we should classify them than in what they say about

the *Teseida*. In both form and content they are indeed singular. But this is not to say that some half-dozen other glosses are without an allegorical cast.[35] Two of these are concerned with an allegorical understanding of what Mars represents, and a third prepares us – thus revealing Boccaccio's concern for the program of a critical apparatus in the glosses themselves – for what will at last be revealed in the commentary to the Temple of Mars.

As has frequently been noted, the *Teseida* seems to contain exactly as many lines as does the *Aeneid*.[36] Two young scholars, who have not yet published their findings,[37] have recently been making some rather astonishing discoveries concerning Boccaccio's proclivities for numerology. One aspect of their findings is to show that Boccaccio was intensely aware of the precise mid-point of his fictions. This should not come as a surprise, even if we were to extrapolate only from our earlier awareness of the numerological centering that occurs in Dante's *Vita Nuova* and *Commedia* – and I do not choose to pursue this line of inquiry further, except to suggest that a good deal of medieval literature, which may have not yet been observed in this light, operates on a principle of "significant centering." Whatever the general case, the *Teseida* surely seems to do so. For numerical purposes, the lines of the *Teseida* which "counted" for Boccaccio were those that comprise the actual text of the poem, that is, he excluded his proemial and concluding sonnets and his rubrics from such consideration, as would only seem reasonable. His 9,904 lines are arranged in 1,238 *ottave*. If we take the trouble to account for the distribution of these, we may find the exact numerical center of the work. The twelve books of the poem have the following numbers of *ottave* in them: 138, 99, 85, 91, 105, 71, 145, 131, 83, 113, 91, 86. Book VII, which contains the absolute numerical center of the work (the first six books hold 589 *ottave*, the last six, 649; half of the total number of *ottave* – 1,238 – is 619; thus the center of the work is the thirtieth *ottava* of Book VII), is, by virtue of being the longest book of the twelve, also pointed to as being especially significant and, I would argue, the center of significance for the work.[38] And it is precisely the numerical center of the work that Boccaccio chooses for the first of his two *chiose* "singolarissime," which depends from the thirtieth *ottava* of Book VII. Let us turn to Boccaccio's text.

The abode of Mars is cold and windy (VII, 30), located in a sterile forest (31) that is not unlike the wood of the suicides in *Inferno*, XIII.[39] The temple itself is characterized by hardness (*acciaio, ferro, adamante* – 32). Its personified inhabitants[40] call up feelings of fear and a sense of danger. In short, without the aid of a commentary we might easily understand that one who prays to Mars is hoping for dread things, indeed. But the gloss helps us to grasp more clearly Boccaccio's prescriptive "psychology." There are, he says in the margin, two principal appetites in man, the concupiscible and the irascible.[41] The following text makes the

identical natures of the irascible appetite and the Temple of Mars clear ("il tempio di Marte, cioè questo appetito irascibile"). Such assertions as these leave no doubt as to the negative valence of the Temple of Mars; everything there is described – with a single exception[42] – in terms that make the irascible appetite something to be shunned. The exposition has a moralizing tone throughout, even rising on one occasion to the phrase "divine grace" – the first specifically Christian note in gloss or poem.[43]

If the Temple of Mars seems, in this context, if not in all, to be a vicious place, we might expect to find its antithesis in the Temple of Venus – for such an antithesis is at least as old as the Homer whom Boccaccio had not as yet read – which many of Boccaccio's readers take to be a fine place, indeed. After all, does not Palemon, having prayed to Venus, win Emilia? And the place itself, compared with the Temple of Mars, seems much to be preferred. Her Temple is situated among great shady pines, and the first presence we encounter is that of *Vaghezza* (the natural desire to possess lovely things, as the gloss interprets – VII, 50). In the guiding presence of this eager instinct the reader arrives at the necessary garden, leafy, green, flowery, fountained, and especially abundant in myrtle (51 – the gloss explains that myrtle was, according to the poets, the "albero di Venere, perciò che il suo odore è incitativo molto"); it is full of singing birds, of rabbits, and of other little creatures (52), as well as of the sound of music (53). There we see Cupid making his arrows, which his daughter *Voluttà* tempers for him; with them are *Ozio* and *Memoria*, who help in the tasks of this foundry of Love (54). Let us pause for a moment. This seems a pleasant place indeed. A good deal of the interpretation of that medieval literature which deals with love – one thinks especially of the *Roman de la Rose* – hinges upon the way in which we interpret the venereal *locus amoenus* in its various manifestations. And one must admit that up to here, in Boccaccio's first four *ottave* – if we choose for the moment not to accede to his own gloss – Venus and her Temple seem to offer, if not the summit of earthly bliss, then at least something which is greatly preferable to what is offered by the Temple of Mars. But negative details, which seem so without benefit of gloss, begin to appear. We see *Arti* which have the power to make men do mad things (55, 4–5). And there is *Van Diletto* alone with *Gentilezza* (a suggestive detail, in light of Boccaccio's frequent invectives against claimants of nobility by birth). *Bellezza* passes, admiring herself, in the company of *Piacevolezza* and *Giovanezza;* but here are *folle Ardire, Lusinghe,* and *Ruffiania* (56). At least some of these personifications are distinctly unpleasant, even without reference to Boccaccio's treatment of them in the gloss, which is moralistic and negative.

The temple itself is surrounded by dancing barefoot young men and ladies, while sparrows and doves[44] fly overhead (57); at the entrance are found *madonna Pace, Pazienza, Promesse, Arte* (58); within we find *Sospiri, caldi Disiri, Martiri,*[45] and the cruel, wicked *Gelosia* (59). *Priapo* is

here (60), and trophies: the broken bows of those maidens who once were sworn to Diana, including that of Callisto; and here are Atalanta's apples, and the arms of the other Atalanta (61). And, of course, there are stories painted here of the victories of Venus: Semiramis, Pyramus and Thisbe, Hercules (spinning for Iole), Biblis and Caunus (62).[46] But where is Venus? "In più secreta/parte del tempio si sta a diletto" is Boccaccio's punning answer to our unvoiced question (63). On its way in, Palemon's prayer finds *Ricchezza* guarding the door,[47] and then sees Venus nude upon her great bed (64), her lower parts covered by such thin vestments that she is as though utterly naked (65).[48] Bacchus and Ceres sit at either side of her, and by one hand she holds *Lascivia*, in the other the apple which she was given by Paris when he judged her to be the most beautiful of the three goddesses (66).

The 135 lines may seem artificial and labored, traditional in the worst sense of the word. Yet they are clearly here to reveal to us the nature of the venereal instinct. Whatever we as readers might make of them on our own, Boccaccio has eased our task considerably. The gloss to these 17 *ottave* overpowers the text in the Mondadori edition: *ottave* 50 and 51 – 16 lines of poetry – require 11 pages of text in order to accommodate the nearly 5,000 words of Boccaccio's essay on Venus. It seems absurd that such an obviously important piece of self-exegesis has received so little attention.[49] Yet here we have Boccaccio speaking to us in his own voice – from the grave, as it were – and we do not choose to listen to him.

Looking back to his gloss on the Temple of Mars, Boccaccio makes the following summarizing statement of his role as interpreter: "Dicendo Marte consistere nello appetito irascibile, così Venere nel concupiscibile."[50] It is well to remind the reader of the definition of the *appetito concupiscibile* from his gloss to the Temple of Mars, for it is from this that his discussion of the Temple of Venus depends: The concupiscible appetite is that "by which man desires and is delighted to possess those things which, according as to whether or not his judgment is rational or corrupt, are delightful and pleasing." Whether our judgment is rational or corrupt is, it would seem, of central importance. Our loving or concupiscible selves are free to love either well or badly, either *in bono* or *in malo*. That simple statement is probably a fair one-sentence version of the central notion of Christian morality.[51] Boccaccio's ensuing definition of Venus is likewise double, and comes to the following crucial point:

This Venus is double, since the one may and should be understood as all chaste and proper desires, such as wishing to be married in order to have children, and so on; and of this Venus nothing is said in this passage. The second Venus is that by whose agency any lascivious thing is desired, and this Venus is commonly referred to as the goddess of love; it is her temple and the things which surround it that the author describes in his text.[52]

"E di questa Venere non si parla qui" could serve as a footnote to most of the Venuses whom we meet in Boccaccio's fiction, though surely not

to all of them. It seems clear to me that one of our tasks as readers is to determine which is which and to draw further conclusions as a result of that determination.

While some of the gloss on Venus is taken up with morally unaligned recounting of pagan myth, so much of the text is so pointedly moralizing that its intent is clear. Only a few examples need detain us. *Voluttà* tempers Cupid's arrows in the "fount of our false judgment, when, because of that pleasure which is created by love and hope, we believe that what has pleased us is to be preferred to any other thing, whether worldly or divine."[53] Or take the darkness of the "secret part" of Venus's Temple: "Then [the author] says that this place is dark; and he says this because those who do bad things hate the light." Or his comment on the personification *Lascivia*, who is associated with "kissing, touching, prattling, saying silly things, and the other foolishness which accompanies such behavior." And as for the Judgment of Paris (a parody of sound judgment), the apple which he presents to Venus "signifies the foolish choice of those who prefer such a life to any other."[54] Now all these remarks are nothing short of blasphemy in that religion of love that the "young" Boccaccio was supposed to have been so assiduous in following. The point should require no further belaboring. One thinks of Giuseppe Billanovich's words, however. If the *Corbaccio* is "l'inevitabile, conclusivo *Adversus amorem*,"[55] what, then, is this?

It would be fitting, says Boccaccio, glossing the personifications of *ottave* 55 and 56, to tell how Amore is helped to generate himself in us by these accomplices. But he begs off, claiming that it would be too long a story. Whoever wants to know, he adds, should read Guido Cavalcanti's *Donna mi priega* and the gloss to it made by Maestro Dino del Garbo.[56] We would not have this Latin text except for the copy made of it by Boccaccio himself.[57] Dino begins his commentary by referring to Guido's *canzone* as "Ista cantilena, que tractat de amoris passione . . . ,"[58] and he never loses sight of the carnality of the phenomenon of love as he conceives Guido to have treated it.[59] In A. E. Quaglio's view Boccaccio became deeply involved with Dino's commentary only around 1366, when he made his copy of it. He points out that Boccaccio's later discussions of love in the *Genealogy* and in the *Esposizioni* to *Inferno* V, 100 (as was previously noted by Toynbee, Guerri, and Padoan), clearly reflect Dino's words,[60] but argues that in no work between the *Teseida* and the late works is there reference either to Guido's *canzone* or to Dino's gloss.[61] Vittore Branca, however, points out that there are allusions to and echoes of the *canzone* in the earliest of the *Rime* (IX, XI, XIII, XXIV, and so on), in the *Filostrato* (IX, 5, 6, 7, 8), and in the *Teseida* (X, 55–57).[62] That does not counter all of Quaglio's argument, which may be summarized as follows: Boccaccio refers to the gloss as to a "novità";[63] the references to Guido in several of the *Rime* (which Quaglio believes were

composed at the same time as the *Teseida* or even later) have nothing to do with Dino's gloss, "which remains eccentric to the writer's youthful conception of love, which was courtly/stilnovist, almost Neoplatonic, but always distant from the overly precise, one might say convoluted, philosophical deliberation with which Del Garbo explains Cavalcanti's formulation";[64] and then Quaglio comes to a point that creates some further difficulty – that Boccaccio, even if he did cite Dino's gloss in his own gloss to the *Teseida*, makes no meaningful reference to the matter which it contains.[65] There are two issues here. One is whether or not Boccaccio knew Dino's gloss very well when he cited it; the second is whether or not he agreed or disagreed (or would have agreed or disagreed) with Dino's view of love. The first question is probably not easily resolved. Having mentioned Dino's gloss, Boccaccio gives us a hasty and summary definition of love, one which seems at least closely related to Dino's similar definition: "Questo *amore* è una *passione* nata nell'*anima per alcuna cosa piaciuta* . . ."; ". . . *amor,* ut dictum est, *passio* est quedam *anime* (et passio causatur in anima *ex apprehensione alicuius rei* quam consequitur appetitus)"[66] It seems at least reasonable to believe that Boccaccio had some idea of what Dino thought of love, and that if he cited Dino's commentary as his authority he would not want a reader to come upon divergences between his treatment of love and Dino's. While it may well be true that Boccaccio was not yet as deeply involved with Dino's gloss as he was later to be, Quaglio's second point, that Boccaccio did not agree (or, to be punctilious, would not have agreed) with the attitudes expressed in the gloss, seems dubious: The spirit of the entire gloss is the spirit of Dino's commentary, a biting attack upon those who praise carnal love ("in quibus actibus est furiositas et intemperantia," claims Dino[67]), and Boccaccio's attitude toward love and lovers in the text of the *Teseida*, if stated ironically, rather than openly, as in the gloss to the Temple of Venus, is (or should be) difficult to avoid.

If we have expected to find that the opposition of Mars and Venus will result in the triumph of Venus, we are disappointed by what transpires in the seventh book. The truer opposition in the *deomachia* of that book is between Mars-Venus and Diana. For hers is the culminating temple, which, if it is described in a single line (VII, 72, 1, where it is "mondo," or cleansed, in the Levitical sense), is the *locus* of a better prayer, that of Emilia. Book I of the *Teseida* ended with a marriage, and we may now glimpse some of Boccaccio's intention when we realize that after listening to the four books of agonized expressions of "love" on the part of Palemon and Arcita, it is only here, in Emilia's prayer to Diana, that the marital possibility at last asserts itself: She announces herself ready to be put under Juno's law, if such be the plan of the Fates.[68]

Book XII is nuptial in character, like the end of Book I. Both marriage ceremonies, that of Teseo and Ipolita, and now that of Palemon and

Emilia, take place in a temple. The reader may be puzzled, after what he has learned about the nature of Venus in Book VII, to find that these rites are performed in a Temple of Venus.[69] But if he considers what he has learned in Boccaccio's gloss, that there are *two* Venuses, the difficulty disappears. Each marriage is performed in a Temple of Venus in which the only other deity present is Hymen (I, 134, 7; XII, 49, 3). And here, as in the wedding scene of the *Filocolo* (IV, 160, 1) voices call on Hymen and Juno (XII, 68, 6–8).[70] In all of Boccaccio's vernacular fictions there are traces of this mythology, which pits the two Venuses against one another: the carnal Venus, aided by her destructive son; the celestial Venus, whose adjutants are (surprisingly enough) Diana, Juno, and Hymen. The *Teseida*'s happy matrimonial conclusion, in the traces of the marriage that ended its first book, seems to be intended to serve as a reproof to the mad love experienced and expressed by Palemon and Arcita. Where the latter in fact dies for his lust, the former finds a better and matrimonial frame for his. Under the auspices of the marital Venus he enjoys seven times in one night (XII, 77) what he was ready to die either to have or for not having.

If Boccaccio's intentions, both in text and in margin, seem clearly to be to deride the literary culture of the religion of love, there is at least one moment in the *chiose* which would seem to cast doubt on his seriousness. There are at least five instances in the glosses in which the commentator speaks in the first person.[71] One of these first-person interventions is of particular interest. Describing the tears, sighs, and secret anguish of Palemon and Arcita, the newly awakened lovers of Emilia, Boccaccio's text runs:

> E così sa Amore adoperare
> a cui più per servigio è obligato:
> colui il sa che tal volta fu preso
> da lui e da cota' dolori offeso.

The passage occurs at III, 35, 5–8. In the margin, next to the word *preso*, appears the commentator's rejoinder: "che sono io." What are we to make of this confession of subjection by carnal love? The first problem is to ascertain whether we are to understand that this is "Boccaccio" speaking, or the supposed anonymous scholar who lives in his margins. While there is no ground for a definitive answer to this question, I admit that I prefer the second possibility, not least because the passage is more amusing seen in this way. The second problem concerns the tone of the intervention: Are we to take it seriously, or as a *scherzo?*[72] In order to attempt to answer this question we might attend to the amatory claims made, in the text itself, by our author. The "frame" of the *Teseida*, in its opening and concluding moments, insists upon the amorous source and cause of the work. The author, in his prose dedication of the work to "Fiammetta," begins by remembering his past happiness ("le felicità trapassate") in his present *miseria* (the passage is obviously reflective of Francesca's famous

lament in *Inferno*, V.[78]) His purpose in writing this book, as will be made plain in the concluding words of the *proemio*, is no other than to re-kindle "la spenta fiamma" in his lady, so that she will receive him again in her bed. In short, the *Teseida*, at least insofar as its author would de-scribe its purpose, is a pander, a *Galeotto*.[74] Its announced intention is to win back sexual felicity from a "celestial" being – Boccaccio's inversions of Dante and of Boethius[75] glance out at us from the first page of the dedicatory epistle and should serve to warn us that we should not take the author at his word, since, although he has written a work which cele-brates the marital Venus, he himself is addicted to the carnal goddess. Just as the commentator will own that *he* is "preso d'Amore," the author, in the second line of his proem, admits that he is caught in Love's toils, " . . . nella miseria vedendomi dov'io sono." His "dov'io sono" offers a preparation for the commentator's "che sono io": Each of them is a pris-oner of Love. Thus, despite all of his lengthy ironic attack upon the carnal Venus, our commentator would appear to be, as is our author, sub-ject to Love, even though he, too, should know better.

The major problem attendant upon the use of irony is that once a writer begins to be ironic, it becomes very difficult for his reader to know when (or if) he ever stops. Thus, while I would argue with some convic-tion that we should understand that Boccaccio's version of the religion of love is meant to be taken ironically, I will also admit that his irony may eventually undermine itself.[76] The questions raised by the ironic mode are difficult and troubling, and it was perhaps to some degree in response to the vertiginous nature of the ironic mode that Boccaccio largely turned from it, in his later Latin works and in his commentary on the *Inferno*, toward a Christian humanism that leaves his intentions implacably clear. Nonetheless, whatever the ultimate implications of Boccaccio's ironic treatment of the religion of love in the *opere minori in volgare*, we should first come to see that they all begin with a common tactic: an attack upon the religion of love, which is opposed on two grounds, first, that it is a false religion (as opposed to Christianity), second, that it is a fraudulent religion (since it claims spiritual intentions but reveals an utterly carnal inspiration). Such a view gives birth to a new Boccaccio. In my opinion, he is also a far better one – and here I speak not of his morals, but of his art. The "pagan," youthful Boccaccio is (again in my opinion) a mis-guided artifact of scholarship and a creature for the groundlings, while the ironic master, of whom I have tried to offer some sense in this paper, is perhaps too good for all of us.

NOTES

1. For reviews of the history of the autograph containing the glosses, as well as of the other manuscripts containing them, cf. G. Vandelli, "Un auto-grafo della 'Teseide,'" *Studi di filologia italiana*, II (1929), pp. 5–76, and

the extensive introduction by S. Battaglia to his edition of the work (Florence: Sansoni, 1938). An earlier version of my article was presented as a paper at the Fifty-First Annual Meeting of the Mediaeval Academy of America in New Orleans on 26 March 1976.

2. Paolo Savj-Lopez, "Sulle fonti della 'Teseide,' " *Giornale storico della letteratura italiana*, XXXVI (1900), pp. 57–78.

3. *Ibid.*, p. 78: " . . . vi fu chi volle faticosamente illustrare qualche episodio del poema cercandovi allegorie."

4. The manuscript in question contains both the text of the *Teseida* and the glosses in Boccaccio's own hand: Biblioteca Laurenziana (Firenze), Doni e Acquisti, Ms. 305.

5. Cf. "Un autografo della 'Teseide,' " esp. pp. 5–20.

6. Biblioteca Laurenziana XXXVIII, 6; cf. *Tutte le opere di Giovanni Boccaccio*, gen. ed. V. Branca (Verona: Mondadori, 1964), vol. II, *Teseida*, ed. A. Limentani, p. 886. All subsequent references to text and gloss are to this edition. For the relation of Boccaccio's *chiose* to Lactantius's, see discussion below.

7. The question of the date of composition of the *chiose* has never received major attention, although most scholars seem to assume that they were written shortly after the *Teseida* was completed (e.g., A. E. Quaglio – cf. note 57), and thus sometime soon after 1340. Vandelli stands alone in being troubled enough by the moralistic nature of some of the *chiose* to argue for a much later date (cf. his "Un autografo della 'Teseide,' " p. 70n.). Similarly, cf. his view (*ibid.*, p. 52) that the anti-venereal gloss to X, 18, 2–6 ("non era giaciuto con lei, il che molti stoltamente estimano fine d'amore") "è un'interpretazione che non so se alcun lettore sarebbe mai arrivato a immaginare." In their editions of the *Teseida*, S. Battaglia (Florence: Sansoni, 1938) and A. Roncaglia (Bari: Laterza, 1941) both claim that the glosses derive from the period 1340–50. But Battaglia opts for an early date in the decade ("posteriore, ma non da molto, al 1340," p. xiv), supporting this assertion with the following: "La fisonomia grafica del codice si riconnette al primo periodo dell'attività boccaccesca, e non solo quella che risulta dal testo ma anche quella del commento" – p. cix).

8. "Sulle fonti della 'Teseide,' " pp. 64–65.

9. *Opere*, II, p. 895.

10. A. Limentani, "Tendenze della prosa del Boccaccio ai margini del 'Teseida,' " *GSLI*, CXXXV (1958), p. 542: "una confusa ed assurda analisi allegorica"

11. For another study of Boccaccio's glosses, cf. the first chapter of Piero Boitani's forthcoming monograph concerning the *Teseida* and Chaucer's "Knight's Tale" (Oxford: Blackwell's *Medium Aevum* series), which the author has kindly sent me in typescript.

12. Passages that are unencumbered by commentary for the space of at least eight *ottave* occur as follows: I, 16–39; 42–54; 66–83; 85–101; 103–129; 135-II, 9; II, 37–46; 51–64; III, 45–85; IV, 2–9; 86–V, 9; V, 43–56; 63–87; 100-VI, 13; VII, 13–22; 115–145; VIII, 28–50; 120–131; IX, 48–56; 58–70; 76–83; XII, 43–51.

13. Both these activities are given Florentine counterparts, thus lending credence to the generally accepted view that the *chiose* were written after Boccaccio's return to Florence in 1340. Cf. note 7.

14. An exhaustive list of the Ovidian matter reflected in the glosses would be far too lengthy. What follows is a short list of the longer glosses that descend from Ovid. With one exception (Leander and Hero, from the

Heroides) all the material is to be found – in some form or other – in the *Metamorphoses*. Book I: the Muses (1, 1), Perseus and Medusa (1, 3), Apollo and Daphne (1, 4), Leander and Hero (40, 7), revolt of the giants (59, 3), Hercules and the hydra (84, 2), Medea's attempt to poison Theseus (102, 2), Theseus and the first rape of Helen (130, 7), Cupid's golden and leaden arrows (131, 1); Book II: the underworld (31, 5); Book III: Juno's hatred of Thebans (1, 1), Europa and Jove (5, 1), Jupiter Ammon (5, 8), Aesculapius reviving Hippolytus (25, 2), Apollo as god of medicine (25, 5), Aeolus (27, 2); Book IV: Alcmena, wooed by Jove, gives birth to Hercules (14, 8); Erysichthon [but Diana is substituted for Ceres] (27, 4); Tereus, Philomela, Procne, Itys (51, 1); Book V: Daedalus (17, 3), Latona (30, 3), Typhoeus, Pluto and Proserpina (31, 1), Cadmus and serpent's teeth (57, 1), Actaeon (57, 6), madness of Athamas (57, 7), Niobe (58, 1), Semele (58, 4), Pentheus (58, 5), Book VI: the Myrmidons (15, 4), Leda and Jove, Castor and Pollux (25, 4), Diomedes (of Thrace) killed by Hercules (27, 7), Scylla and Glaucus (28, 6), Evander (35, 1), Io, Jove, Mercury, Juno, Argus (38, 4), Myrrha, Cinyras, Adonis (42, 1), Minos, Scylla, Nisus (50, 5), Asopus, Aegina, Aeacus (60, 2), Narcissus (61, 2); Book VII: Vulcan netting Venus and Mars (25, 3), Hercules and Acheloüs (71, 2); Book VIII: Andromeda and Perseus (102, 5), Orpheus and Eurydice (103, 5); Book IX: Phaeton (31, 4); Book XI: Echo (30, 4), Arachne and Pallas (61, 3), Marsyas (62, 7), twelve labors of Hercules (65, 1).

15. Limentani's notes, *Opere*, II, pp. 886–899, yield the following (probably conservative) totals of attributions: Virgil, 16; Ovid, 6; Statius, 60; Dante, 85.

16. The argument concerning the genuineness of the commentary to the *Elegia di madonna Fiammetta*, is a subject dealt with in my forthcoming monograph, *Boccaccio's Two Venuses* (New York: Columbia University Press, 1977), ch. II, n. 127.

17. This phrase, a commonplace in medieval commentaries on ancient poets, occurs, with variations in word order, at least seventeen times (I, 1, 1 – twice; 41, 1; 131, 1; III, 27, 2; V, 30, 1; 31, 1 – twice; VI, 35, 1; VII, 24, 3; 25, 3; 50, 1 – twice; VIII, 80, 1; IX, 29, 4; X, 32, 2; XI, 63, 3). Other versions of the formula include: "secondo l'antico costume de' componitori" (I, 1, 1), "secondo gli antichi pagani" (I, 1, 3), "scrivono fingendo i poeti" (I, 15, 6; 59, 3), "secondo le fizioni poetiche e gli errori degli antichi" (I, 55, 3), "fu oppinione degli antichi" (II, 31, 5; X, 90, 2; 95, 2), "in tanto che i poeti fingono" (III, 25, 2; IV, 13, 3; VI, 60, 2), "secondo che nelli poetici libri si può vedere" (VI, 38, 2), "secondo l'usanza poetica" (VII, 9, 2), "appo gli antichi" (VII, 50, 1), "dicono i poeti" (VIII, 9, 1), "li Greci finsero" (VIII, 25, 4), "dicono alcuni . . . altri dicono" (XI, 61, 1).

18. The text of Paolo's *Le Geonologie degli uomini e degli dei* is printed in A. Hortis, *Studi sulle opere latine del Boccaccio* (Trieste: Dase, 1879), pp. 525–536; and cf. pp. 537–542 for another such *Genologia*, this one by Franceschino degli Albizzi and Forese dei Donati (not the friend of Dante, but a later Florentine – cf. Hortis, p. 538n.). Since the *Zibaldone Maglia-bechiano* was assembled, according to Macrì Leone, whose hypothesis seems the most likely one to Branca (*Opere*, I, "Profilo biografico," p. 91n.), between 1351 and 1356, one has further tentative evidence that Boccaccio was committed to his own great compendium, the *Genealogie*, at least by the early 1350s. But the fact that what is perhaps his first literary

effort, the *Allegorica Mitologica* (printed in Hortis, pp. 357–361, and also in A. F. Massèra, *Opere latine minori* [Bari: Laterza, 1928, pp. 231–237]), seems to be at least an offshoot of "universal history," moving through time after the Creation with notable stops for Prometheus and Phaeton, would indicate that the *Genealogie* was, in a real sense, Boccaccio's destination from the beginning of his career. C. G. Osgood, *Boccaccio on Poetry* (Indianapolis: Bobbs-Merrill, 1956 [1930]), p. xiii, would locate the inception of work on the *Genealogie* sometime between 1340 and 1350; V. Romano, ed. *Genealogie deorum gentilium libri* (Bari: Laterza, 1951), vol. II, p. 844, would have the work begun in 1350. In some sense we probably ought to think of the glosses to the *Teseida* as the prologue to the greater task and as the first extended labor of *Boccaccius mythographicus*.

19. " . . . non enim opus suum aliquod vidi" – *Genealogie*, ed. Romano, vol. II, p. 761 – XV, 6, 157b.

20. Cf. the most helpful "Indice degli autori e delle fonti," in Vincenzo Romano's text, vol. II, pp. 867–893; further numerical totals of citations also depend upon this source.

21. For Boccaccio's relationship to Paolo da Perugia cf. F. Torraca, "Giovanni Boccaccio a Napoli (1326–1339)," *Archivio storico per le province napoletane*, XXXIX (1914), pp. 229–267.

22. Cf. *Genealogie*, ed. V. Romano, vol. II, p. 649 (XIII, 6, 135a): Boccaccio refers to Aeolus, "quem Theodontius et *post ipsum Paulus* aiunt Iovis fuisse filium . . ." (italics added).

23. *Boccaccio on Poetry*, p. 114; cf. *Genealogie*, vol. II, pp. 761–762 (XV, 6, 157b-c).

24. "Puto igitur eo tempore, quo michi primo cognitus est, neminem illi in talibus equiperandum fuisse" – *ibid.*, p. 762.

25. Possible dependencies are offered as follows (the numbers in parentheses refer first to the page and line in Romano's edition of the *Genealogie*, subsequently to the *locus* of the note in the *Teseida*): Belus, Danaus, Egystus (Paolo: 87, 21–88, 11; I, 7, 1); Agenor as king of Phoenicia (Theodontius and Paolo: 97, 22; III, 5, 1); Climenes and Apollo beget Phaeton (Theodontius: 340, 25–27; III, 16, 3); Alcmena wife of Amphytrion (Paolo: 598, 8; IV, 14, 7); Dionysius a Theban (Theodontius: 42, 25; IV, 15, 1); Iarba son of Garamantis (Theodontius: 522, 23; V, 103, 2); the births of Castor, Pollux, Helen, Clytemnestra (Paolo: 546, 10–14; VI, 25, 4); Cecrops an Athenian king (Theodontius: 283, 24–36; VI, 34, 1); Evander as son of Mercury (Paolo: 620, 3; VI, 38, 1); Dirce turned into a fountain (Theodontius: 165, 31; VI, 59, 1); Callisto (Paolo: 222, 3–8; VII, 50, 1 – p. 467 in Limentani's text); Diana as moon (Theodontius: 236, 7–9; VII, 80, 3); Hebe – note especially the phrases *lactucas agrestes* and *lattughe salvatiche* (Theodontius: 441, 21–442, 1; IX, 29, 4); Castor's relationship to Oebalus (Theodontius: 278, 25–279, 2; XI, 61, 7).

26. The so-called "Third Vatican Mythographer," who is cited as "Albericus" thirty-five times in the *Genealogie*, would seem a plausible candidate. However, comparison of that text and Boccaccio's glosses has not suggested a single sure case of dependency. Cf. G. H. Bode, ed., *Scriptores rerum mythicarum latini tres Romae nuper reperti* (Hildesheim: Georg Olms, 1968 [Celle, 1834]), pp. 152–256. I may also note in this connection that the *Narrationes fabularum ovidianorum*, ed. H. Magnus (Berlin: Weidmann, 1914), which Boccaccio (and many a later scholar) believed to have been written by Lactantius Placidus (Boccaccio refers to the work

three times in the *Genealogie*), seems to have been unknown to him when he wrote the *Teseida* glosses. At any rate, I have been unable to find a single case which even approximates a clear echo.

27. Cf., most recently, A. Limentani, *Opere*, II, p. 886. The edition of Lactantius which I have used is *Commentarii in Statii Thebaida et Commentarium in Achilleida*, ed. R. Jahnke (Leipzig: Teubner, 1898). And cf. Boccaccio's letter to Franceschino dei Bardi, in Neopolitan dialect of 1339, which asks for help in obtaining this text. Some believe the letter to be spurious. For bibliography, cf. Branca, "Profilo biografico," p. 46 and n.

28. This is surely not the case in the *Genealogie*, where Boccaccio refers to the glosses on the *Thebaid* ninety-six times in all.

29. Cf. the fairly obvious resonances of *Thebaid* VII, 34–63, in *Teseida* VII, 30–38 (the Thracian location: *Theb.* VII, 34; *Tes.* VII, 30, 1; the tempestuous weather: *Theb.* VII, 36; *Tes.* VII, 30, 2; the nimbus clouds: *Theb.* VII, 37; *Tes.* VII, 30, 3; the hail: *Theb.* VII, 38; *Tes.* VII, 30, 6; the sterile forest: *Theb.* VII, 40; *Tes.* VII, 31, 1; the iron gates and columns of the temple: *Theb.* VII, 43–44; *Tes.* VII, 32, 6–33, 1; etc.).

30. For descriptions of these two sets of *chiose* to the *Teseida*, the first compiled in the late fourteenth century (only to the first book of the poem), the second in the fifteenth century, cf. E. Levi, "Adriano de' Rossi," *GSLI*, LV (1910), pp. 201–265, esp. 237–249; G. Bertoni, "Pietro Andrea Basso," *GSLI*, LXXVIII (1921), pp. 142–146.

31. Statements – explicit or implied – of the author's intention occur as follows: I, 1, 1; 3, 1; 6, 1; 14, 1; II, 10, 1; III, 5, 1; 5, 8; IV, 1, 2; VII, 27, 3; 29, 1; 29, 4; 79, 5; 91, 4; VIII, 3, 1; 112, 8; IX, 5, 1; X, 18, 2; XI, 24, 1; 60, 6; XII, 86, 7.

32. The easy interchange between Boccaccio's poses as author and as commentator is not limited to this example. A full page of the author's *proemio* is devoted to a summary of the action of the *Teseida* which is very like the summary of Statius's *Thebaid* found in the gloss to II, 10.

33. "Non era giaciuto con lei, il che molti stoltamente estimano fine d'amore."

34. Cf. note 7.

35. Cf. glosses to *Teseida*, I, 15, 6; III, 1, 3 (which is mentioned here only because it prepares the way for the lengthy allegorical gloss on the Temple of Mars which awaits the reader at VII, 30, and shows that Boccaccio senses the importance of what he intends to tell us there); VI, 28, 6 (a euhemeristic unraveling of the *verità nascosa* of the fable of Scylla); VII, 37, 8; XII, 52, 1 (where we are to understand by the sweetness of Amphion's harp, his *cetera*, "la forza della sua eloquenzia" – a version of Dante's similar understanding of Orfeo's *cetera* in *Convivio*, II, i, 3?); XII, 77, 5 (a witty and indelicate explanation of Palemon's ability to make love to Emilia seven times on their wedding night, the cause being his previous abstinence: "perciò che per troppo pescare nell'amoroso fonte sono di tali che se ne scorticano").

36. J. W. Mackail, *The Springs of Helicon* (London/New York: Longmans, Green, 1909), p. 26, was apparently the first to call attention to this relationship between the two epics, claiming that both works contain 9,896 lines. However, either his edition of the *Teseida* omitted an *ottava* or he miscounted, since all recent editions of the *Teseida* contain, in fact, 9,904 lines. Since the difference is the result of a single extra stanza of *ottava rima*, and since the hypothesis is an attractive one (it is just the sort of thing that Boccaccio was likely to have done), one might try to resurrect Mackail's finding by suggesting the following desperate remedies: (1) Boc-

caccio's text of the *Aeneid* may have contained more lines (e.g., the four lines that were frequently printed before *Arma virumque cano* . . .); (2) Boccaccio nodded, somehow miscounting his own *ottave;* (3) Boccaccio wanted to "outdo" Virgil by the length of a single *ottava*. Then again, Boccaccio might never have noticed how many lines the *Aeneid* contained.

37. Victoria Kirkham at the University of Pennsylvania and Janet Smarr at Princeton University. And cf. Cesare Segre, "Strutture e registri nella 'Fiammetta,'" *Strumenti critici*, VI, no. 18 (1972), esp. pp. 141–143.

38. The Temple of Mars is found, of course, in the seventh book of the *Thebaid*. Boccaccio's use of the borrowed temple in his own seventh book is far more elaborate than Statius's, and it leads to the Temple of Venus, which is still more important to Boccaccio and has no counterpart in Statius.

39. For Boccaccio's *nodosi e aspri*, cf. *Inferno*, XIII, 5 and 7.

40. For Boccaccio's use of the text of Statius here, cf. note 29.

41. "Ad intelligenzia della qual cosa è da sapere che in ciascuno uomo sono due principali appetiti, de' quali l'uno si chiama appetito concupiscibile, per lo quale l'uomo disidera e si rallegra d'avere le cose che, secondo il suo giudicio, o ragionevole o corrotto ch'egli sia, sono dilettevoli e piacevoli; l'altro si chiama appetito irascibile, per lo quale l'uomo si turba o che gli sieno tolte o impedite le cose dilettevoli, o perché quelle avere non si possano" (VII, 30, 1 – p. 454). The description of these two appetites probably reflects Aquinas's formulations a century earlier (cf. *Summa Theologica*, I, q. 81, a. 2; I–II, q. 23, a. 1).

42. Boccaccio uses the plural *Ire*, he says, because there is not only vicious, irrational wrath, but another kind which may be rational. Righteous indignation seems to be what he has in mind. This leaves a door open to the necessary positive sense of Mars, such as one finds in Teseo's patron deity in Book I.

43. "E non solamente a questa ostinazione il tetto d'acciaio fa fuggire *la divina grazia* che di sopra viene, cioè il salutevole consiglio della ragione . . ." (VII, 30, 1 – p. 145, italics added).

44. That doves are Venus's birds is a medieval commonplace. And cf. Boccaccio's gloss to VI, 20, 2: ". . . i colombi sono uccelli di Venere"

45. Cf. *Inferno* V, 116–120, Dante's question to Francesca, which uses these three words, so popular as rhyme-words in medieval love poetry.

46. Even the Tisiphone-like Venus of the *Elegia di madonna Fiammetta* warns Fiammetta (I, 17) against the excesses of "abominevole fuoco" like that of Myrrha, Semiramis, Biblis, Caunus, and Cleopatra.

47. One of Boccaccio's recurring mordant criticisms of carnal love and its concomitant "religion" is that only the rich have time for such behavior. Cf. Ovid, *Remedia Amoris*, 746: "Divitiis alitur luxuriosus amor."

48. In Boccaccio's other works Venus's usual iconography is to be partly nude and partly flimsily attired in purple. Here her *veste tanto sottil* have no coloration, but in the gloss she is "in parte nuda e in parte d'una porpora sì sottile coperta . . ." (VII, 50, 1 – p. 471).

49. One of the few scholars to have paid any significant attention to the gloss – if not for the direct study of Boccaccio's poem – is D. W. Robertson, Jr. Cf. *A Preface to Chaucer* (Princeton, N.J.: Princeton University Press, 1962), pp. 106n., 110, 260n., 370, 371.

50. The gloss to *ottave* 50–66 occupies pp. 462–472 of the Mondadori text. Henceforth citations of the gloss will refer only to page number.

51. As a medieval writer, Boccaccio inherited a long Christian tradition of the same things being capable of antithetic valence, either *in bono* or *in malo*.

52. "La quale Venere è doppia, perciò che l'una si può e dee intendere per ciascuno onesto e licito disiderio, sì come è disiderare d'avere moglie per avere figliuoli, e simili a questo; e di questa Venere non si parla qui. La seconda Venere è quella per la quale ogni lascivia è disiderata, e che volgarmente è chiamata dea d'amore; e di questa disegna qui l'autore il tempio e l'altre cose circustanti ad esso, come nel testo appare" (p. 463). Cf. the gloss on *Venere Santissima* from *Le Chiose all' elegia di Madonna Fiammetta* (which most current scholars who deal with the problem conclude to be spurious), ed. A. E. Quaglio (Padua: Cedam, 1957), p. 169: "dui sonno gli ussi [Quaglio: the Rossiano manuscript reads *vissi*] di Venere, cioè Venere licita e Venere illicita. Venere licita è de star lu marito con la sua moglie e però dice santissima; illicita si è de appetere lu marito altra donna che la sua e la donna altro omo che 'l marito." If the orthography and expression are not Boccaccian, the thought is nearly identical to that expressed here. For the medieval tradition of the two Venuses as they are found in the works of Alain de Lille, Bernardus Silvestris, Johannes Scotus Eriugena, and others, cf. R. H. Green, "Alan of Lille's *De planctu Naturae,*" *Speculum*, XXXI (1956), esp. pp. 660–674. Two studies of this important *topos* appeared too late for me to take them into account in this paper: G. D. Economou, "The Two Venuses and Courtly Love," in J. M. Ferrante and G. D. Economou, eds., *In Pursuit of Perfection* (Port Washington, N.Y.: Kennikat Press, 1975), pp. 17–50; E. G. Schreiber, "Venus in the Medieval Mythographic Tradition," *JEGP*, LXXIV (1975), pp. 519–535.

53. ". . . la fonte della nostra falsa estimazione, quando per questa dillettazione, nata d'amore e di speranza, giudichiamo che la cosa piaciuta sia da preporre ad ogni altra cosa o temporale o divina" (p. 465).

54. "Poi dice il luogo essere oscuro; e questo perciò è perché coloro li quali adoperano male, odiano la luce" (p. 471); "la quale lascivia intende essere il basciare, il toccare e il cianciare e 'l motteggiare e l'altre sciocchezze che intorno a ciò si fanno" (p. 471); "vuole dimostrare la stolta elezione di quegli che così fatta vita ad ogni altra prepongono" (p. 472).

55. G. Billanovich, *Restauri boccacceschi* (Rome: Edizioni "Storia e Letteratura," 1945), p. 161.

56. Cf. Guido Cavalcanti, *Rime*, ed. Guido Favati (Milan/Naples: Ricciardi, 1957), pp. 359–378, for the Latin text of Dino's commentary. And cf. p. 348 for bibliographical notices. Cf. also O. Bird, "The Canzone d'Amore of Cavalcanti According to the Commentary of Dino del Garbo," *Mediaeval Studies*, II (1940), pp. 150–203; III (1941), pp. 117–160.

57. Cf. A. E. Quaglio, "Prima fortuna della glossa garbiana a 'Donna me prega' del Cavalcanti," *GSLI*, CXLI (1964), pp. 336–368. The Florentine doctor's Latin was translated into the vernacular by Jacopo Mangiatroia in the late fourteenth century. For the attribution of the manuscript to Boccaccio cf. A. Palescher, *GSLI*, VIII (1886), pp. 364–373; but cf. the firm arguments of M. Barbi, who, in his critical edition of the *Vita Nuova* (Milan: Hoepli, 1907), pp. clxxiv–clxxviii, made the positive identification.

58. I quote from Favati's text, here from p. 359.

59. For example, on Cavalcanti's phrase "fuor di salute," he writes, "Idest: hec passio ponit iudicium [Boccaccio's *giudicio* comes to mind] hominis extra salutem . . ." (p. 368); on "Et non si giri per trovarvi gioco," "Nec etiam aliquis adhereat ei quia credat in ipso inuenire sapientiam multam

uel paucam, quia in ipso nulla est sapientia neque discretio: imo potius quasi ultimo ille qui amat, cum bene est in feruore ipsius, devenit in fatuitatem et insipientiam" (p. 375).

60. "Prima fortuna . . . ," pp. 354–355.
61. *Ibid.*, p. 348.
62. "Profilo biografico," p. 32n.
63. "Prima fortuna . . . ," p. 348.
64. *Ibid.*
65. *Ibid.*, p. 365.
66. Favati, p. 364, italics added in both passages. The *loci* are of some importance, not least because it seems more than likely that Dino's passage reflects the most important single definition of carnal love known to the late Middle Ages, that found in the opening words of the *De amore* of Andreas Capellanus: "Amor est passio quaedam innata procedens ex visione et immoderata cogitatione formae alterius sexus. . . ."
67. Cavalcanti, *Rime.*, p. 372.
68. Boccaccio's gloss reminds the reader that "Giunone è dea de' matrimonii." Cf. the identical glosses to X, 40, 2; XII, 68, 8.
69. *Teseida*, I, 134, 2: "di Citerea il tempio fero aprire"; XII, 48, 7–8: "per che Teseo fece il tempio aprire/di Venere"
70. Juno has, reflecting the mythographic tradition, three main roles in the *Teseida:* She is the opposer of the Thebans (e.g., II, 1, 1; IV, 16, 6; 17, 6; X, 95, 7); the jealous wife of Jove (glosses to V, 58, 4; VI, 38, 4; XI, 30, 4); the goddess of matrimony (VII, 83, 2; X, 40, 2; XII, 68, 4; 75, 7).
71. In three cases the commentator speaks in the first person (in the first two examples "dico" is his locution), in order to emphasize the fact that he is purveying the author's intention: ". . . la principale intenzione dell'autore . . ." (I, 6, 1); ". . . l'autore . . . intende di dimostrare . . ." (II, 10, 1); "come di sopra ho mostrato . . . così l'autore . . ." (XII, 86, 7). In one case, however, and it is singular, the first person serves to unite author and commentator. At III, 27, 1, the text has the phrase "sicule caverne." In the accompanying gloss the commentator explains, "E dico sicule, cioè ciciliane." There are three possibilities here: Boccaccio's editors may be repeating an editorial slip that occurred somewhere along the way in printing *dico* for *dice;* Boccaccio himself may have nodded; Boccaccio may have wittily intended to reveal himself, in this small detail, as the commentator (if this is so, this tiny, unimportant gloss is the only "internal evidence" that links the identity of glossator and author; such a tactic would indeed be "Boccaccian"). The gloss at III, 35, 7, will be discussed shortly.
72. This interpolation on the part of the love-struck commentator has received two very different sorts of treatment. The more usual may be represented by Vandelli ("Un autografo della 'Teseide,'" p. 47), for whom it is "un piccolo sfogo che prorompe dal cuore innamorato del poeta e ch'egli affida a questi fogli scritti da sua mano e destinati forse in un primo tempo alla sua donna, anche se poi ebbero a rimanere, come vedremo, presso di lui." For Limentani, on the other hand (*Opere*, II, p. 891), "Il referimento in chiosa a sue pene d'amore è la punta di maggior civetteria nel fantasioso edificio dell'autobiografia del Boccaccio." Neither of these responses pays heed to the possibility that Boccaccio has invited us to believe that the anonymous commentator, too, is a lover.
73. Cf. *Inferno*, V, 121–123: "Nessun maggior dolore/che ricordarsi del tempo felice/ne la miseria."

74. The fourth chapter of my *Boccaccio's Two Venuses* discusses the pertinence of this motif in all of Boccaccio's vernacular work and finds that in most of them the "author" presents himself as a disappointed lover whose sole purpose it is to regain the affection of his beloved. Such a perception would require that we take the announced authorial purpose in these works ironically, or at least be aware that we must weigh our author's words with care.

75. He refers to her as "più tosto celestiale che umana figura," and then longs for his former (sexual) *consolazione,* going on to curse "la nemica fortuna." The resonances are pretty clearly Boethian and serve to indict the author as a fellow of Palemon and Arcita in the worship of the wrong Venus.

76. This is, as I perceive the matter, the position which informs two important recent studies of the *Decameron* by Giuseppe Mazzotta, "The *Decameron:* The Marginality of Literature," *University of Toronto Quarterly,* XLII (1972), pp. 64–81; "The *Decameron:* The Literal and the Allegorical," *Italian Quarterly,* XVIII (1975), pp. 53–73.

Rhetoric, John Gower, and the Late Medieval Exemplum

KURT O. OLSSON

The wide appeal of the *exemplum* to writers and their public throughout the Middle Ages is a fact acknowledged by most historians of medieval literature, but then relinquished to the historians of popular culture. Although the mode, in its combination of "sentence" and narrative "solas," was respected in the period for its instructive value, it holds little attraction or excitement for modern students of literature because the narrative itself is exceedingly brief, often inhumanly simple, the morality is familiar, and the relationship between the two is unequivocal, even obvious. From earliest antiquity, the *exemplum* was used as a rhetorical figure, and when medieval authors of sermon handbooks or compilations of tales for the use of preachers place it rhetorically, they ground the modern prejudice: it is the means by which abstract ideas are made palatable for *simplices*, a gesture to those who can learn the truths of doctrine or morality only through *visibilia* or the well-told tale. This is Robert Mannyng of Brunne's rationale for translating a French compilation of tales into English: He writes for unlettered folk,

> For many ben of swyche manere,
> þat talys and rymys wyl bleþly here;
> Yn gamys, & festys, & at þe ale,
> Loue men to lestene trotëuale:
> þat may falle ofte to vylanye,
> To dedly synne, or oþer folye;
> For swyche men haue y made þis ryme
> þat þey may weyl dyspende here tyme.[1]

While the *exemplum* can relieve tedium, teach children, fix truths in memory, cause a simple delight, it cannot present an intellectual challenge great enough to warrant more than the momentary attention of the learned – so the argument goes.

This is the implication of a distinction which a medieval author of an *Ars de modo predicandi* makes between it and allegory: A preacher should use both forms, "so that the profundity of the allegory may please the learned and the simplicity of the *exemplum* may edify the ignorant."[2] The assumption of this writer, as well as of modern scholars who follow the

monumental study of the form by Welter, is that the *exemplum* exists for a single purpose: to illustrate a moral doctrine. And among those tales which contain such a double power – a narrative which also refers to something else – it has lost out to the "symbolic mode" of allegory. J. A. Burrow isolates the problem:

In a fiction which merely exemplifies an ethical concept ("patience," "gluttony") or an accepted truth ("Women are fickle," "Radix malorum est cupiditas"), literature condemns itself to an ancillary role The process of metaphorical transfer, or *translatio*, necessary to allegory ensures, we may feel, some degree of imaginative independence in that mode; but in the literal mode of "exemplification," the story may do no more than illustrate slavishly *idées reçues.*[3]

A closer look at the use of the *exemplum* by medieval poets, however, will reveal that it was not limited to a simple relationship between a brief narrative and *idées reçues*. In the *Canterbury Tales* and John Gower's *Confessio Amantis*, the "ensample" becomes a complex form. Even in Gower's early *Mirour de l'Omme*, a work which has its roots in homiletic practice, exemplary narrative is expanded referentially, adapted to four distinct rhetorical fields: In only one of those fields is a moral "sentence" the primary referent. Indeed, it will be helpful to begin our inquiry with this poem, precisely because of its demarcation of exemplary kinds: Gower's work will illustrate how the example, even in a "poetized" homiletic setting, can do more than "prove" a general truth.

Gower's first mode is of the traditional sort. It falls in a vast allegory which constitutes the first segment of the poem, a *conflictus* between the Sins and remedial Virtues. As the *exemplum* is presented in this section, it is closely related to the similitude and the image,[4] forming with these two a class of figures which the handbooks of rhetoric called *homoeosis*, "likeness" or "resemblance." The poet's tale of Ulysses and the Sirens, which in the later *Confessio* is explicitly presented as an "ensample," is thus offered in this work as a similitude: The allegorical deed of the virtue Paour, in relation to the sin of Veine gloire, is likened to the action of Ulysses against the Sirens. One stanza is devoted to the exemplar:

> Uluxes, qant par mer sigla,
> Tout sauf le peril eschapa
> De les Sereines ove leur chant:
> Un bon remedie y ordina,
> Qu'il les orailles estouppa
> Des mariners, q'ils riens oiant
> Y fuissent, mais toutdroit avant
> Leur niefs aloient conduisant,
> Ne destourneront ça ne la;
> Car s'ils en fuissent ascoultant,
> Peris fuissent du maintenant
> Du joye que l'en y chanta.[5]
> (10909–20)

Typically for this part of the *Mirour*, Gower then balances the vehicular stanza with another, offering the parallel of the virtue (10921–32). As Ulysses responds to the attraction of the Sirens, Paour responds to the enticement of Veine gloire: She stops her ears to "flaterie,"

> et si conduit comme sage
> Sa nief toutdroit au sauf rivage,
> U n'est tempeste violente.
> (10930–32)

Unlike things are thus made to correspond exactly in their action, forming a proportion, and the two episodes, parallel in their separate, internal relationships, are made vivid by what ancient rhetoricians called *redditio*, or reciprocal representation: "Such *reciprocal representation* places both subjects of comparison before our very eyes, displaying them side by side."[6]

The second figure, the rhetorical image or *eikon*, is distinct in rhetorical tradition, but in Gower's use it is broadened to resemble the similitude. Defined in the handbooks as a "comparison of one figure with another, implying a certain resemblance between them,"[7] the image, for some rhetoricians, expresses a likeness in appearance, but for others like Cicero it also shows a resemblance in nature.[8] Geoffrey of Vinsauf illustrates the latter usage: "That malignant spirit, the public enemy, with hidden wings flies about man, solicitous to regain what he has lost."[9] Gower also uses the rhetorical image to reveal a hidden design, a nature or a moral disposition, but formally he presents it as a proportion, a similitude. Among the analogies from animal lore scattered throughout his allegory, he thus compares the custom of the osprey, who breaks the bones of its prey by dropping it from a great height onto rocks below, to the practice of the Devil, who "auci par cas semblable," destroys the man he has caused to rise "en vaine gloire surquidable" (1849–72). In the same mode, the poet defines human vice: Malebouche is compared to the dung beetle (2893–904), Hange to the camel (4417–28), and Foldelit to the salamander (9517–28). Action is shown parallel by the device of similitude, making implicit in the result of one deed the consequence of another: the outcome of a grasshopper's "sloth" anticipates the effect of human idleness (5821–44), just as by similitude the action of the osprey captures the Devil's design. The method here, in short, is no different from what it was when the poet fashioned the likeness of Ulysses.

Indeed, if we were to make the relationship between the concrete and the abstract (a moral principle) our sole standard for determining how Gower works with resemblance, all three kinds, the *exemplum* included, could be collapsed into a single mode. The example itself, "the citing of something done or said in the past," with a naming of the agent,[10] would then appear as it is usually understood, an embodied idea, with Gower's added distinction, as in the case of Ulysses, of action shown proportional.

And against the background of the other kinds, it finally would be unique only in a superficial nuance – the definite name.

Before we proceed to a use which distinguishes the *exemplum* from these other figures, we should consider the field common to the three more closely. All three enliven or freshen or clarify an idea, and their power can rest on the fact that in each instance the things compared are unlike. Not only does the collocation please, but it points up an insight otherwise thought impossible. As members of the class *homoeosis*, the three modes are valuable in discovery, as Bede points out in his *Liber de schematibus et tropis*: "*Homoeosis* is a demonstration of what is less familiar by its likeness, which is more familiar."[11] Given this principle, the extrinsic vehicle must be neither obscure nor unknown, and hence the Middle Ages derived its positive judgment of the *exemplum*, "quia familiaris est doctrina exemplaris."[12]

The poet who uses these figures is obligated to show a proportion between unlike things, but *any* phenomenon which is unlike can serve that purpose, provided it can be made "like" and familiar. What is more, when the chosen matter – whether it involves beast lore, a known myth, something fabulous, or a history – is adapted to a single goal such as Gower has selected for this part of the *Mirour*, the demarcation of figures becomes less important than the shared adaptation to that purpose. Here the members of the class *homoeosis* gain their determinacy from the allegory which, in its turn, is the poetic means the author has chosen to express a prudential rule, an expansive vision of the origins and effects of diverse kinds of moral conduct: In this field the *exemplum* does not stand apart.

That placement of the "ensample" among other figures can illumine some of the problems which traditionally arise in discussions of the form. The complaint against Welter's important work is chiefly the breadth of his definition: The *exemplum*, in his use, is too inclusive, drawing into its field all matter "which lends itself to the illustration of a moral."[13] But precisely in relation to his principle – his emphasis on the maker's aim – he follows the apparent confusion of medieval rhetoricians and other *auctores* who superficially distinguished the kinds: Image, similitude, fable or apologue, and *exemplum* can all do the same thing, and consequently we find a writer such as St. Bonaventure arguing that the example "multum valet laïcis," *because* such people delight in "similitudinibus externis."[14]

The function of the *exemplum* in the opening section of Gower's poem also suggests why the form is thought by some to be inferior to allegory: Like certain non-allegorical images which Stephen Manning has isolated in medieval lyrics, *exempla* of Gower's first order "restrict, but they do not simultaneously expand. Rather than being intrinsic to the thought, they merely illustrate it. Once they have served their immediate purpose, they disappear."[15] Allegory, it is thought, expands into diverse meanings: If one assumes, with D. W. Robertson, Jr., that "the function of figurative expres-

sion" is "to encourage the observer to seek an abstract pattern of philo-sophical significance beneath the symbolic configuration,"[16] then the *exemplum,* which is a figurative mode, seems exceedingly limited, for the burden of seeking and finding falls on the maker, not the observer. What this assumes, of course, is a continuum between the *exemplum* and allegory. Both kinds are productive of knowledge, but the referents are more and less explicit, and allegory gives the greater delight because it challenges the acumen of the observer. I shall note other modes of the *exemplum* which do not fit this continuum, but we should observe even within this kind that because the exemplarist will give us an interpretation, there is a capacity in the *exemplum* which may not be available to the allegorist: The author may show disjunction, not conjunction, between the doubled terms; this is not generally a feature of allegory, for if the "other thing meant"[17] is not expressed at all, then it is impossible to conceive of a poet showing unlikeness towards that thing in the only field of evidence we possess, the narrative itself. The expressed doubleness in this exemplary mode, as suggested by the yoking of narrative and *moralitas* in Robert Henryson's *Fables* or Geoffrey Chaucer's "The Clerk's Tale" of patient Griselda, can give us a new dimension of *alieniloquium,* where, precisely because the meaning is expressed, we are not allowed to relinquish the literal text.

I have spoken of consonance or proportion in this exemplary kind, but trends in the history of the *exemplum* call this *consonantia* into question. Frederic Tubach, in a general statement about the medieval progress of the form, notices how, late in the period, the *exemplum* is elaborated toward the verisimilar: Exemplarists leave what he calls the proto-exemplum, where "tangible phenomena are employed only as symbols of man's ac-ceptance or rejection of the ethical precepts which lead to harmony with the divine order," and begin to create an environment in the tale, inessen-tial to the religious point.[18] The form through details becomes a diversion, not essentially instructive; and this means, of course, is disproportion, that the parallel is lost as the thesis recedes. But conceivably this focus on the truthful can also mean that the maker of the example is interested in a "rhet-oric of action" in the broadest sense; he attends to a link – *consonantia* – between the narrative and the auditor, creating a plausible action, one which proves a moral rule to be both experientially true and practicable.

There is another trend in the history of the *exemplum,* quite the oppo-site of this, where disproportionate emphasis falls on the meaning. In a seminal article on what happens to the literal text when a late medieval author chooses to write allegorically, Stanley Kahrl has chosen as his field of evidence the homiletic *exemplum.* Traditionally, he argues, the *exem-plum* was regarded as true, but late in the period there is less concern among some exemplarists for historical "fact": A marvel can serve equally well as a bridge to the higher truth.[19] Such authors, when they write alle-

gorically, are concerned to exclude detail, to be non-specific with their exemplary character, to avoid the realism which G. R. Owst thought dominant in the late homiletic example.[20] Their mode of writing might be seen as part of a larger pattern of a "rhetoric of faith" which finds one of its models in a book like *Barlaam and Joasaph*: Apologues, most often fabulous and without much narrative complexity, sometimes with even less coherence, are made valid and whole at the level of interpretation, all turned to converting Joasaph to the true religion. Indeed, if we were to take Guibert of Nogent as our *auctor*, we might suppose that this rhetoric, as well as this narrative mode, had lost some of its point in the late Middle Ages: "Allegory does little more than build up faith; now, by God's grace, the faith is known to all, and though we ought often to impress it and repeat it to our hearers, we ought no less, indeed much more often, to speak of what will improve their morals."[21] But the point is that this kind of rhetoric co-exists with the other throughout, existing in so popular a work as the relatively late *Gesta Romanorum*. The consonance which emerges in the allegorical example is between the auditor and the higher truths of religion, through "points" of reference in the narrative.

Between these two narrative kinds within the history of the form, Gower's *exemplum* in the first part of the *Mirour* takes its place. The account of Ulysses is brief, manifestly without realistic detail. As a wonder, it would seem to suit the last kind of rhetoric, and yet it is obviously unlike the sort of tale we find in the *Gesta Romanorum*. To be allegorical in a strict sense, Gower would be less concerned with the action, and more with pictorial details like those of Ulysses tied to the mast, the ship, the wax to stop the mariners' ears, or the rock of the Sirens, all to point significance; Christ on the Cross, the Church, the preventive instruction of Scripture, or the Flesh.[22] What makes it possible to see this example as suited to the latter, rather than the former rhetoric, or at least placed on a continuum with the allegorical "ensample," is the clear pointing of an idea: The narrative is directed toward inviolable moral principles, teaching an anticipatory virtue, insight into the motives and effects of action beforehand.

In the parts of the *Mirour* which follow the first, Gower employs a rhetoric of action, and the potential he sees in the *exemplum* is modified accordingly. The second "mirror" of the book concerns justice, and in this section the poet addresses the estates of mankind. When he speaks to the bishop, he draws from Valerius Maximus the tale of Codrus, the "last king" of Athens who hears by prophecy that his people will fall unless he dies to save them:

> Et qant ly Roys oïst ce dire,
> Qu'il l'un des deux estuet eslire,
> Ou d'estre proprement occis,
> Ou souffrir de sa gent occire,

> Mieulx volt son propre corps despire,
> Ainz que ly poeples fuist periz.

. . .

> Pour la salut qe ses soubgitz
> Il souffrist mesmes le martire.
> (19993–98, 20003–04)

In context Gower recalls the self-sacrifice of Christ, draws the contrast to the selfish prelate, and narrates the *exemplum*. This example, extrinsic to the represented issue, does more than freshen or clarify an idea. Part of its distinction is related to the section of the work in which it occurs. Judith, Mordecai, and Elijah in the opening allegory – models of the abstraction Paour – are used to point out the truths which a prudent man must possess: Formally, their function in the conceptual world of *allegoria* is to prove God's rule inviolable. By contrast, in the second mirror a "likeness" is established, not just between the concrete and the abstract, but between concrete things: These things belong to the same (human) class, and the effect of the shown likeness is not speculative – knowing an abstract unknown – but practical. In the exemplar Codrus, Gower embodies an idea (Sacrifice), but he also creates a direct parallel between his exemplars and a specific auditor. Codrus and Christ are juxtaposed with the negligent bishop: All three are leaders able to redeem an endangered people, and the auditor alone has denied his office. If Christ, the prelate's special model, is paradoxically inimitable, what about Codrus? The Athenian king functions as a quasi-historical precedent. By the standard of the argument, he is a lesser figure, a pagan ruler in a secular role, and yet he outstrips the Christian priest in goodness, and Gower in presenting him brings into precise focus an exemplary principle which Gregory the Great illustrates when he discusses Job: "To confound our shamelessness, a Gentile is handed down to be our example, that as he that is set under the Law disdains to pay obedience to the Law, he may at least be roused by comparing himself with him, who without the Law lived as by law."[23] Gower thus ends his tale of Codrus with a powerfully simple question:

> D'un tiel paien qant penseras,
> Responde, Evesque, quoy dirras?
> (20005–06)

Detail is here important because it establishes a parallel, positively with Christ or negatively with the bishop, even because it affirms "unlikeness"; for by making the exemplar a dissimilar character, Gower advances his argument to a point of self-judgment and choice.

This kind of *exemplum* is not a vehicle, but an argument in itself: It, and no abstract "sentence," informs a disposition; the narrative, as a cen-

ter of both pleasure *and* teaching, produces an immediate moral judgment. The correspondence in the tale of Codrus is not wholly contained in the tale itself, for half the parallel inheres in the auditor. Nevertheless, although the complete argument requires an answer to the question – "Quoy dirras?" – the right answer is implied by the narrative.

The precedential mode can work in two directions in relation to an auditor. It can offer a reflection on acts performed, and this is the thrust of Gower's use in imaging justice – a testing of one's unique or proper due. But it can also suggest a course of action for the future. This last, more evident in Gower's later *Confessio*, has a rhetorical past which extends from antiquity. Aristotle included it among modes of induction:

There are two kinds of Example. One kind consists in the use of historical parallel, another in the use of artificial parallel. Artificial parallel takes the form either of comparison or of fable, like Aesop's or the Libyan fables. It would be using historical parallel, if one were to say that we must arm against the Great King and not let him subdue Egypt; for, in a former instance, Darius did not come over till he had got Egypt, but, having got it, he came; and Xerxes, again, did not attack us till he had got it, but having got it, he came; and so this man, too, if he gets it, will come over – therefore he must not be allowed to get it.[24]

The precedential *exemplum* is better known to the medieval period through Quintilian:

It will also be found useful when we are speaking of what is likely to happen to refer to historical parallels: for instance if the orator asserts that Dionysius is asking for a bodyguard that with their armed assistance he may establish himself as tyrant, he may adduce the parallel case of Pisistratus who secured the supreme power by similar means.[25]

As a gloss on Quintilian explains, this kind of exemplary narrative applies what is certain to what is dubious: "Hoc enim manifestum est de Pisistrato, dubium autem erat de Dionysio."[26] While moral allegory and the *exemplum* of Gower's first order adjust the auditor to the ends of life, advising him *in dubijs* by "pointing" a rule which is unchangeable, the literal, quasi-historical parallel stands apart for its immediate rhetorical purpose: A measure of "facts" is found for contingent things; the field is particularized, the mode productive of a choice. Of course, the kind involves variables, not the least of which is the potential for a fiction within a fiction: Peter Alphonsus, in his *Disciplina clericalis*, turns the *exemplum* into a simple trick inside that humorous apologue which was to become the Middle English "Dame Siriþ"; Chaucer uses this kind of *exemplum* in "game" with his Host, who persists in reducing tales to parallels for Goodelief; but the poet also uses it in both "game" and "ernest," as, once again, in the complex tale of the Clerk.

The third mode of the *exemplum* is very much like the second, and it is only suggested by the next part of Gower's *Mirour*, a section which

defines the fortitude embodied in confession.[27] The peculiar argument of the *Mirour* as a whole is such that this section is kept exceedingly brief: While it presents an exemplar, it offers no *exemplum;* the precedents have been set in the second part. Nonetheless, this mirror does suggest another role for the "historical" tale, pointing not to the auditor, but reflexively to the speaker. Again, this kind can be put to humorous use, as when the infamous Chaunticleer in "The Nun's Priest's Tale" reminds himself through "ensample" of the power of dreams, when the poet simultaneously demonstrates how wonderfully ineffectual examples can be, at least so far as chickens are concerned, or when Dorigen in "The Franklin's Tale" hyperbolically and rather inappropriately sets nineteen precedents for a decision – suicide as the only possible course for a noblewoman violated. This kind is suited to ratiocination of various sorts, and it is put to unusual use in Gower's *Confessio,* where the poet offers "ensamples" through Genius which reflect on the character Amans, identified late in the poem as "John Gower."

Finally, the *exemplum* can be turned back on itself, becoming more than an exclusively referential mode. This use is manifest in the special case which ends Gower's *Mirour,* the life of the Virgin and Christ, a tale which is referred to abstract truth, to speaker and auditor, but which is also made to draw these into itself. The biographical sketch is presented as a prayer, the speaker and auditor now collapsed into one exemplar perceiving an action and finding in it how "se refourmera." The narrative itself reveals aspects of temperance, and it is exemplary in the relation of the virtue to the deeds represented, as well as in the relation of both to the external exemplar – the speaker *or* auditor – who is said to lack the "mesure" which a perception of this sacred comedy can produce. The narrative is arranged as a meditation which can reorder "inner sight": The "accepted truth," the auditor, and the speaker are referred to the Truth of the history itself.

Gower's last three exemplary modes depend on the "similitude" of concrete, historical things, and all three are poetically ordered to effect an immediate choice or action in the auditor. It is a curious fact that the homiletic tradition, itself rhetorical, does not tell us much about what I have called a rhetoric of action, though Roger Bacon once said that the most arduous task for the rhetorician is not to build faith or to plead a case in court, but to move a person to do something.[28] Appropriately, however, Bacon called this highest kind of rhetoric "poetic," and it is therefore fitting that we now look at the actional *exemplum* in a context less homiletic, more poetical.

J. A. Burrow has argued that the "prevailing *modus significandi* in Richardian narrative is not allegorical but literal"[29]: It is the mode of exemplification. Normally, he argues, the relation between the narrative and its point is unequivocal, involving a "simple binary system," the clear

example of good or evil. Although Burrow sees in one of Gower's strange collocations of tales an ingeniousness which demands from us "an alertness to context and implication, a readiness to see wit and point in the application,"[30] we are left with questions of how this can be possible in a simple binary system. We can begin to see the challenge of the *exemplum* as we note how variable the congruity of terms can be among the poets: The telling can demand our alertness because the referent – which can be, beyond a specific idea, an auditor or speaker – does not always suit the narrative and because the tale and its referents can both be drawn into a fiction.

In the *Confessio* Gower works between the illustrative and the precedential *exemplum* on various levels. On his large premise that "every man is othres lore" (VIII, 256), he sometimes, inside an *exemplum,* presents a mirror – a tale or an image – which strikes the exemplary character with a likeness. This is what happens in the story of Rosiphelee (IV, 1245–1446), a character who learns to side-step the certain result of her idleness in love by seeing a double resemblance to herself in an envisioned parade of beautiful women who once served Love, accompanied by a horse-knave, a miserable woman, who did not. The heroine, "abaissht" at the sight of these wondrous ladies, hides behind a bough, though she is curious enough to "putte hire hed alitel oute." The fair Rosiphelee is potentially like these women, but she must come to that discovery indirectly: Turning to the horse-knave as a "Suster" and preceptor, she is startled to find that this "wofull womman" who neglected Love is like herself, and her discovery means a conversion:

> "I am riht in the same cas.
> Bot if I live after this day,
> I schal amende it, if I may."
> (1440–42)

In this tale we again encounter the problem of details in exemplary narrative. In two long poetic "delays" (1305–28, 1340–58), the author pictures the wonders of the cavalcade, and we might ask why, for he is an acknowledged master of the plain style, not wont to indulge in *ecphrasis,* to present vast allegorical images, or to add verisimilar detail. Here, as in the whole book, he uses detail to make an action probable: With good reason Rosiphelee is converted, for it is *her* perception which the "delays" represent.

The tale, as precedent and conversion evolve within it, is beautifully told, but another problem arises in relation to its moral point. The narrative seems to demonstrate what happens when a person is so "wantoun" as to neglect Love, or so wise as to choose it. But in relation to Amans, the auditor, it is an impertinence, for he, far from being idle in love, has carried busyness to the point of comic absurdity: "I serve, I bowe, I loke, I loute" (IV, 1169). Why, as exemplary, is the story told at all? Does it

fit a larger truth than that expressed, more important for Amans? These
questions can be answered only by the context of the tale itself, the mir-
ror of other tales, the progress of the shrift, and the end which Genius
envisions for his charge. Other tales offer a clearer parallel for the lover.
The story of Mundus (I, 761–1059), a duke whose love "put reson
aweie," is offered as a mirror for Amans: The poet amplifies the beauties
of the heroine Paulina, for it is the sight of these which drives Mundus
to Ypocrisie and a "vein astat"; the *amplificatio* is especially pertinent to
Genius's pupil, for he has just admitted, in shrift concerning his "wittes,"
a fall into peril through sight. The fact that the priest also concentrates
on Paulina when she "perceives" the deceit and experiences "agonie" as
the victim is appropriate to the parallel being established between the
hypocrite and Amans. The question of this narrative is not really the
quarrel of Love or Amans's "synne" in loving; Mundus's punishment is
in fact mitigated because he is a "worthi knyht" who fell to hypocrisy
through his infatuation. The question is pride, and by the correspondence
between the knight and Amans, Genius is beginning to close avenues to
the lover's success: If Mundus cannot achieve his end through hypocrisy,
neither can Amans.

This is obvious enough to readers of the tale, but how then can the
later "ensample" of Rosiphelee be justified? From the instance of Mundus,
we see that Genius is a rhetorician: He can fashion a tale to suit the oc-
casion and the condition of his pupil. The nature of his argument is such
that he will not isolate a tale so as to posit a rule, fixing it in the auditor's
"memorie" as an absolute: All must be measured and qualified by what
he says when he comes to the final "synne," Amans's loving. The diffi-
culty with Book IV and the tale of Rosiphelee is that they seem to en-
courage Amans in his love. The entire confession, which Gower pre-
sented as an exemplary narrative, clearly involves more than a "simple
binary system" of good and evil if the priest can judge Amans' love as
both good and evil, urging him to it in Book IV and ruling it out of
court in Book VIII. This difficulty resolves itself in the priest's rhetoric
of two laws, those of "kynde" and "reson." It is natural for man to love,
Amans supposes, and the confessor uses "kynde" to dissuade man (and
Amans) from sins like wrath, envy, or sloth: under the rubric of Book IV
(sloth) it is therefore fitting for Genius to urge Amans to persist in his
suit. But in Book VIII the law has changed: the topic of that book is love
"unbesein /Of alle reson" (153–54). Consequently, though in Book IV
Cupid counts idleness toward himself wanton, he does so by the measure
of nature; in the final book of the *Confessio*, Genius by a measure of
reason reverses that judgment, deeming Amans's busyness licentious. The
real precision, coherence, and imaginative power of Gower's work thus
rests on the rhetoric: As the context of argument changes, tales and ideas
assume a new value in the whole, and the result is an integral and more

adequate insight into the complexity of human experience, as well as a fuller grasp of what a "reule" demands.

Gower, of course, is not alone among the Ricardians in presenting a fictional rhetoric. What has always been understood as an important nuance in Chaucer has recently been put in the frame of the "ensample," and this has a bearing on what the two poets share: "The tales as Chaucer adapts them become consistently less neat, less economical, and far less palatable as ethical examples than their sources are – and they succeed with us largely to the extent that they fail their tellers."³¹ Genius is not presented as fallible in his rhetoric, but his tales can succeed with us, not only because they are well-told, but because they sometimes contain "loose ends" – an incomplete "sentence," a paradox, or a curious point in relation to the setting, Amans, or other tales. In Gower's rhetoric, as in Chaucer's, the story often encourages the quest of a truth which is greater than that expressed in the tale itself.

The entire *Confessio* also promotes such a quest. It is an *exemplum* about a character named Amans which Gower fashions for an audience that he has identified in his Prologue: The end of this large exemplary narrative is not to restrict, but to liberate Gower and that audience morally. I shall return to this matter presently, but first it is important to note that the distinction between tale and idea, or Gower's own separation of "lust" and "lore" is difficult to apply to the large "ensample" of the confession, even though J. A. W. Bennett has suggested in an aside that "a Gower . . . like a medieval preacher using *exempla* to stir a torpid audience, keeps 'lust' and 'lore' formally distinct."³² The tales never lack an inner "moralitee," and the precise meaning of "lore" in the *Confessio* is always determined by a context within the large tale, the fictitious shrift. Gower calls himself, as Amans, an exemplar, but the confession is also an entertainment: It gains a peculiar delight because the "moral Gower" has given the role of moralist to another, the fictive Genius; he, the pupil, becomes wary as the doctrine becomes more openly traditional, and he finally charges Genius with trifling – "Mi wo to you is bot a game" (VIII, 2152). But that is precisely the point: It is a "game," and it has taken a confession in eight books for Amans to realize it.

The game of the confession itself has another dimension. The internal rhetoric involving Genius and his charge, the stories and other embodied "truths" is made parallel to a rhetoric involving the poet or "olde Morall Goore" and his audience, the entire confession and the truth it expresses. This relationship is a case of *parabola*, which the ancients exemplified as "quod medicina in corpore, hoc leges in civitate"³³ and which Gower offers as the cure for Amans's sickness, the cure for an illness in the "real" world of Policie. All of the elements at the second level – Gower and his audience, the confession and its earnest "sentence" – are identified in the *littera* of the text, and thus the fiction of the first level finds internal refer-

ents. Manifestly, that fiction is not of sanctity, and it does not express the mystery and Truth which lie at the heart of Christian experience, but while in these ways it is quite distinct from the history which concludes the *Mirour de l'Omme*, it resembles and even surpasses Gower's earlier work in the complex parabolic relation which evolves on the poetic surface.

This is a relationship of "ensample" to referent inside a rhetorical structure. In the role of the unrequited Amans, Gower at the conclusion of his "solemn" confession asks for Venus's grace:

> To grounde I fell upon mi kne,
> And preide hire forto do me grace:
> Sche caste hire chiere upon mi face,
> And as it were halvinge a game
> Sche axeth me what is mi name.
> "Ma dame," I seide, "John Gower."
> "Now John," quod sche
> (VIII, 2316–22)

This humorous scene is matched by another later, where in the role of poet, a renewed moral Gower prays to God – "Uppon my bare knes y preie" (2985) – for the state of England and for a higher love than that which Venus can offer:

> The hyhe god such love ous sende
> Forthwith the remenant of grace;
> So that above in thilke place
> Wher resteth love and alle pes,
> Oure joie mai ben endeles.
> (VIII, 3168–72)

What has brought about this change? During the shrift, Genius has sought to build "reson" in his pupil, often through the instrument of "kynde": But Amans, whose "reson understod him wel," is ruled by nature and will almost to the end. The conversion takes place when the lover appeals his case to Nature, through Cupid and Venus, only to discover or be reminded that he is *senex*, his love "unkynde." In a dream he sees a parade of Elde, Cupid withdraws the "fyri Lancegay," Venus holds up her "wonder Mirour," and Amans at last perceives himself: "Despuiled is the Somerfare" (2856). We know from medieval convention that in dream the soul can be freed from the body, allowed to see "that oure flessh ne hath no myght / To understonde." In dream Amans is released from the dominance of will, and when he awakens he has been transformed. It is perhaps with an appropriate suddenness that the lover sees, becomes morally aged or wise, that conversion, though it can be prepared for, is at the last a gift. And this is important for the effect of the whole *Confessio*. Just as Amans is liberated by a dream, so the audience, in parallel, might be freed by a fiction from what the poet has

called its "malencolie," brought to a readiness to desire and to accept that grace which Gower requests in conclusion.

The allopathic cure for melancholy is, of course, "lust," here the delight in a narrative, the gentle laughter at the exemplary character, but most of all the pleasure in the consonance of the similitude: The audience is "unlike" Amans, but its case has been transferred into a setting which points a likeness. The whole *Confessio* is simultaneously an *ars amatoria*, a king's book, and a moral handbook, and these various elements are given unusual valence as they are turned by the exemplary narrative. The poet has transferred issues into a new jurisdiction, and the *status translationis* means, at last, that the entire work blends the imitative and the doctrinal. The lengthy tale of Amans has its own inner coherence: Though it has referents, though it illustrates "truths" and offers precedents, we impoverish the work and Gower's "moralitee" if we relinquish the "game" of the narrative, for it is the narrative which fashions the morality, "Gower," and the audience.

The nature and magnitude of this tale can remind us that though John Gower, among the great Ricardian poets, is usually thought closest to the homilists in his rhetoric, he is free enough in his poetical art to discover new potential in the *exemplum*. And if this inquiry into one poet's use of the "ensample" cannot reveal all things possible in the form, it can at least remind us not to be sanguine about interpretive approaches which reduce a mode of poetic expression to a power in one dimension.

NOTES

1. *Handlyng Synne*, 45–52, ed. Frederick J. Furnivall, EETS, OS 119 (London, 1901), p. 3.
2. "Secundum erit aliquam dulcem exponere allegoriam et aliquid jocundum enarrare exemplum ut eruditos delectaret allegorie profunditas et simplices edificet exempli levitas et habeant utrique quod secum reportent." Cambridge, University Library, Ms. 1716, Ii 24, f. 333[rb]; cited by J.-Th. Welter, *L'Exemplum dans la littérature religieuse et didactique du moyen âge* (Paris, 1927), p. 77.
3. J. A. Burrow, *Ricardian Poetry: Chaucer, Gower, Langland and the 'Gawain' Poet* (London, 1971), p. 83.
4. For an extended discussion of the similitude, see *Rhetorica ad Herennium*, IV, xlv, 59 to xlviii, 61, ed. Harry Caplan, Loeb Classical Library (London, 1954), pp. 376–83.
5. All Gower quotations are taken from *The Complete Works of John Gower*, ed. G. C. Macaulay, 4 vols. (Oxford, 1899–1902), specifically Vols. I (*Mirour de l'Omme*), II, and III (*Confessio Amantis*). For criticism, see John H. Fisher, *John Gower: Moral Philosopher and Friend of Chaucer* (New York, 1964) and Paul M. Clogan, "From Complaint to Satire: The Art of the *Confessio Amantis*," *Medievalia et Humanistica*, 4 (New York, 1973), pp. 217–22.
6. Quintilian, *Institutio oratoria*, VIII, iii, 79, ed. H. E. Butler, Loeb Classical

Library (London, 1963), III, 255; cf. *Ad Herennium*, IV, xlvii, 60 (Caplan, pp. 380–83).

7. *Ad Herennium*, IV, xlix, 62 (Caplan, p. 385).

8. For example, Cicero: "Imago est oratio demonstrans corporum aut naturarum similitudinem." *De inventione*, I, xxx, 49, ed. H. M. Hubbell, Loeb Classical Library (London, 1960), p. 88.

9. Geoffrey of Vinsauf, *Poetria nova*, 1359–61, trans. Ernest Gallo, *The Poetria Nova and Its Sources in Early Rhetorical Doctrine*, De Proprietatibus Litterarum, Series Maior, 10 (The Hague: Mouton, 1971), p. 87; cf. Edmond Faral, *Les arts poétiques du XIIe et du XIIIe siècle*, Bibliothèque de l'école des hautes études, fasc. 238 (Paris, 1924), p. 238.

10. *Ad Herennium*, IV, xlix, 62 (Caplan, p. 383). In Geoffrey of Vinsauf: "Or I set down an example together with the name of the author who wrote it or of the person who previously performed the exemplary deed" (*Poetria nova*, 1260–62 [Gallo, p. 81; Faral, p. 236]).

11. Carolus Halm, ed., *Rhetores latini minores* (Leipzig, 1863), p. 618.

12. Alain de Lille, *Summa de arte praedicatoria* (PL, 210, col. 114); see also Quintilian, VIII, iii, 73 (Butler, III, 250–53).

13. Frederic C. Tubach, "Exempla in the Decline," *Traditio*, 18 (1962), p. 408.

14. St. Bonaventure, "Ars concionandi," *S. Bonaventurae opera omnia* (Quarracchi, 1901), IX, 18; cited by Welter, p. 74.

15. Stephen Manning, "Analogy and Imagery," ed. Edward Vasta, *Middle English Survey* (Notre Dame, 1968), p. 4.

16. Saint Augustine, *On Christian Doctrine*, trans. D. W. Robertson, Jr., Library of Liberal Arts (New York, 1958), p. xv; cited by Manning, p. 3.

17. Isidore of Seville: "Allegoriae vis gemina est et sub res alias aliud figuraliter indicat." *Etymologiarum*, I, xxxvii, 26, ed. W. M. Lindsay (Oxford, 1911).

18. Tubach, p. 411.

19. Stanley Kahrl, "Allegory in Practice: A Study of Narrative Styles in Medieval Exempla," *MP*, (1965–66), pp. 105–10; see also Judson Boyce Allen, *The Friar as Critic: Literary Attitudes in the Later Middle Ages* (Nashville, 1971), pp. 43–44.

20. This is but part of Owst's large hypothesis that "The pulpit, and not the revival of classical studies, will thus prove itself to be the true parent of a revived literary Realism." G. R. Owst, *Literature and Pulpit in Medieval England* (2nd ed., Oxford, 1961), p. 23.

21. Guibert of Nogent, *Liber quo ordine sermo fieri debet* (PL, 156, col. 26); cited by Beryl Smalley, *The Study of the Bible in the Middle Ages* (Notre Dame, 1964), p. 244.

22. See D. W. Robertson, Jr., *A Preface to Chaucer: Studies in Medieval Perspectives* (Princeton, 1963), p. 143.

23. Gregory the Great, *Morals on the Book of Job*, pref. ii, 4, trans. anonymous, A Library of Fathers (Oxford, 1844), I, 17.

24. Aristotle, *Rhetoric*, II, xx, 2–3 (1393a–b), trans. Richard Claverhouse Jebb (Cambridge, 1909), pp. 110–11.

25. Quintilian, V, xi, 8 (Butler, II, 275, 277).

26. C. Julius Victor, *Ars rhetorica*, vi, 3 (Halm, p. 399).

27. In the opening allegory of the *Mirour* (14593–15096), Gower includes confession among the offices of Science, a daughter of Prouesce (Macaulay, I, 169–75).

28. *Moralis Philosophia*, V, iii, 2, 6–8, ed. Eugenio Massa, Thesaurus Mundi (Zurich, 1953), pp. 254–55.

29. Burrow, p. 82.

30. *Ibid.*, p. 85.
31. Anne Middleton, "The Physician's Tale and Love's Martyrs: 'Ensamples Mo than Ten' in the *Canterbury Tales*," *Chaucer Review*, 8 (1973), p. 15.
32. J. A. W. Bennett, *The Parlement of Foules: An Interpretation* (Oxford, 1957), p. 15.
33. C. Julius Victor, *Ars rhetorica*, vi, 3 (Halm, p. 399).

Erasmi Convivia:

The Banquet Colloquies of Erasmus

LAWRENCE V. RYAN

Of the *Colloquia familiaria* of Desiderius Erasmus, six are in the form of *convivia*, while several others incorporate one feature or another of the literary *symposium*, or *Gastmahl*. The half-dozen which are distinctly of this kind are the *Convivium profanum, Convivium religiosum, Convivium poeticum, Convivium fabulosum, Polydaitia (Dispar convivium)*, and *Nēphalion Symposion*. Although some studies of individual colloquies, and of the collection as a whole, have been written, this particular group has received little attention as a unit. Yet, while each is distinctive in content and form, they share important characteristics and Erasmian religious and humanistic themes; they are, besides, fresh and original examples of an ancient literary type that was widely esteemed and practiced during the Renaissance.[1] The first attempt at a real dialogue to be published by their author, moreover, when the *Colloquia* still consisted primarily of *formulae* for correct Latin speaking, was the *Convivium profanum*, which can justly be regarded as the seed from which the genuine colloquies of the volume later developed. Considering them together also is fitting, since Erasmus boasted in *De utilitate colloquiorum* that "Socrates brought philosophy from heaven to earth; I have brought it even into games, informal conversations, and drinking parties. For the very amusements of Christians ought to have a philosophical flavor."[2]

Yet if in these words, written in defense of his *Senile colloquium*, Erasmus calls certain of his dialogues *compotationes* or *symposia*, they are more properly referred to by the Latin term *convivia*: First, because all except the *Nēphalion Symposion* are so labeled in the early editions and in *De utilitate colloquiorum*;[3] secondly, because, like Cicero and the Italian humanists, their author regarded eating and drinking moderately at table, rather than partaking freely of the festive board and flowing bowl, as the right inspiration to friendship and to congenial and profitable discourse. As Cicero's Cato Maior is made to observe:

For our ancestors rightly named the reclining of friends at the banquet table a "convivium," because it implied a joining together of their lives, more fitly than the Greeks, who called the same thing sometimes a "compotationem" [drinking party], sometimes a "concenationem" [supping together], so that

they seemed to approve most highly what is least important in that sort of affair.[4]

In Renaissance Italy, where a number of *convivia* were written by authors with whose work Erasmus was familiar, the gathering of congenial and learned companions at table came to be regarded as "il simbolo della vita associata."[5] Poggio Bracciolini, in his *Historiae conviviales*, called such occasions "maximum . . . fomentum amicitiae,"[6] while Giovanni Pontano, the influence of whose dialogues is evident in the *Colloquia*, depicts himself and a group of friends in his *Aegidius* as practicing a rather abstemious conviviality while they discuss moral philosophy, philological problems, and the art of writing Christian poetry.[7]

 All of Erasmus's banquet pieces are *convivia* in the sense of Cato's definition and the precedents set for writing them, not only of such ancient authors as Plato, Xenophon, and Plutarch, but also of Italian humanists like Poggio, Pontano, Francesco Filelfo, and Cristoforo Landino.[8] His interlocutors are always temperate, good-humored men who embody their author's own ideals of humane Christian conduct. Elsewhere in the *Colloquia*, in sharp contrast with these exemplary convivialists, one encounters gluttons and rascals who are "potent in potting," beastly within the hostel or at the festive board in manners and conversation. Among such unsavory characters are the "gospel-bearing" boor Polyphemus in *Cyclops* and the toping pilgrims Arnoldus and Cornelius in *De votis temere susceptis*. Both speakers in the latter dialogue are intemperate fools: Arnoldus relates how he slipped into his "rash vow" to go on pilgrimage while carousing with three friends, and the dialogue ends with Cornelius's proposing another drinking-party ("compotatiunculam") where they can tell tall tales about their adventures on the road. (One suspects in this juxtaposition of drinking, lying, and going on pilgrimages a sly authorial comment on the spiritual "inebriety" of trusting in indulgences without an accompanying resolution to lead a sober Christian life.) Nor does Erasmus waste opportunities to associate intemperance with other kinds of reprehensible behavior in the clergy themselves. In *De captandis sacerdotis*, Pamphagus ("gluttonous") is both a foolish benefice-hunter at Rome and a "veterem compotorem" – old drinking companion of the other speaker, Cocles, while in *Ptōchoplousios* ("The Well-off Beggars"), two scoundrelly mendicants, the bountifully provisioned Observant Franciscans Conradus and Bernardinus, put up at a poor inn that is haunted by a surly, hard-drinking local pastor. The opposite vice to excessive belly-cheer also comes under attack, as when in *Opulentia sordida* Erasmus caricatures Venetian frugality in the person of Manutius's father-in-law, Andreas Asulanus, with whom he resided while producing the great Aldine edition of his *Adagia*.

 In the banquet colloquies, on the other hand, the characters invariably uphold the Mean when they forgather; not a single glutton or drunkard appears among them. The notion of a temperate mealtime as an ideal

occasion for pleasant bantering and profitable discourse on learning, the virtues, the true meaning of Christian piety, runs throughout the group from the earliest state of the *Convivium profanum* in the *editio princeps* of 1518 to the last composed of these pieces, the *Nēphalion Symposion* of 1529. As the host Eutrapelus remarks in the *Convivium fabulosum,* "We want this party to be fabulous, not vinolous" (p. 257). The same ideal is suggested, though that colloquy is not itself of the convivial type, in the *Inquisitione de fide* of 1524. This late gesture toward reconciliation with Evangelicals concludes with an agreement between Aulus (Erasmus) and Barbatius (Luther) to share a modest Friday luncheon. That they do and that it is the latter who says, "We'll be so careful of our diet that our minds will be keen for argument" (p. 189), compliments the author's soon-to-be antagonist in the controversy over freedom of the will by placing him among the philosophers and Christian theologians who assemble to feed on wholesome intellectual and spiritual, as well as bodily, meat and drink.[9] Erasmus's own generally abstemious habits, reflected in these dialogues, are known, too, from his letters and other writings. In an epistle of 1522, for instance, he reports that on a certain occasion when the Bishop of Constance wished to honor him with a large banquet, the prelate was advised that the distinguished Netherlander was little given to the pleasures of the table and was averse to "tumultuous feasts." Yet he did enjoy small gatherings where wholesome food and excellent wines were available to spice merry and worthwhile conversation.[10]

These contrasts, then, suggest what Erasmus considered to be an ideal *convivium,* by personal preference, by adherence to literary tradition, and in keeping with his intention of making the *Colloquia* an amusing and pleasant means of instilling proper mores in, as well as teaching correct Latinity to, his readers. He boasts in *De utilitate colloquiorum,* for example, that even "If boys learn nothing else from these but how to talk Latin, how much more praise my labor deserves, for accomplishing this through jokes and entertainment, than is due to men who cram *Mammethrepti, Brachylogi, Catholicons,* and 'forms of signifying' down the wretched youngsters' throats" (p. 631).

His instruction in language and morals through "jokes and entertainment" is, in his opinion, vastly superior to the tedious methods and miserable glossaries employed for such purposes in the grammar schools.[11] To a man of his ideals and personal habits, the classical and humanistic traditions regarding the finest kind of *convivium* were naturally congenial. As Craig R. Thompson has noted, in the *Noctes Atticae* of Aulus Gellius, the *Deipnosophistai* of Athenaeus, and especially the *Moralia* of Plutarch, whom Erasmus venerated for his "Euangelicas cogitationes,"[12] occur various directions for properly arranging a dinner-party. Thus, the appropriately named character Apitius in *Polydaitia* affords the earnestly inquiring Spudus with specific instructions, several of them directly from

Plutarch's *Quaestiones conviviales*, for hosting a successful banquet; in so doing he wins from his friend the admiring compliment, "Truly you're an expert in the art of being a host" (p. 381). This expertise, possessed by the givers of all of Erasmus's literary feasts, is summed up in the dictum with which *Polydaitia* concludes: "Ne quid nimis" – nothing to excess. The dishes should be varied but not lavish, and the drinking moderate. The tales and jests should suit the humors of the company but should be neither scurrilous nor lengthy, lest, as Plutarch had warned, "*tēn aoinon methēn*" – the nonalcoholic intoxication of garrulousness spoil the conversation.[13] The guests should either be seated by lot, or else the host should carefully intersperse those who are "naturally good-humored and talkative" among those less given to speaking (pp. 381–82). Above all, he should not attempt the impossible by inviting a large number to his table and then trying to please everybody; should he do so, his meal may become, unfortunately, a "conuicium . . . non conuiuium" – not a collation but a commotion (p. 379).

The other banquet colloquies adhere to, and even elaborate upon, these sound principles. From the early *Convivium profanum* onward, none of the feasts is marred by commotion or gourmandizing. Christianus, in that piece, does indeed provide the most elaborate spread of any of Erasmus's hosts, but he and his guests, especially the main interlocutor Augustinus, partake of the dishes and the wine with commendable restraint. In the last and shortest of the six to be published, the *Nēphalion Symposion*, only lettuce and pure water are available to the guests at this "wineless drinking party." Instead, the fare is primarily ethical, consisting of anecdotes that illustrate "Christian-like moderation" among the ancient pagans. In the *Convivium religiosum* is served the most temperate, and most pleasing, repast of all, from what the host Eusebius calls "my horn of penury, not plenty" (p. 69). Finally, in the *Convivium poeticum*, the wine is taken diluted, not *merum*, and the foods provided are all simple and natural. The notion, of course, is that drinking and eating lightly of good but not rich or exotic things keep the head clear for both serious discourse and lively play of wit. For as Plutarch had observed, at drinking-parties, "the height of sagacity is to talk philosophy without seeming to do so, and," as in the *Symposium* of Plato, "in jesting to accomplish all that those in earnest could."[14]

Serious discussion mixed with lighthearted banter is, in Erasmus's scheme, the ideal convivial pastime; for him, as for the wisest among the ancients, pleasures of the mind are sweeter than those of the senses. As Plutarch had also remarked, "At parties men of wit and taste hurry at once after dinner to ideas as if to dessert, finding their entertainment in conversation that has little or nothing to do with concerns of the body. . . ."[15] Hence, in all the banquet colloquies Erasmus's speakers engage in discourse that is both pleasurable and profitable; as the character

Levinus notes in concluding the *Convivium fabulosum*, "Nothing is more fun than treating jokes seriously" (p. 266). That is, from amusing tales about virtuous actions of monarchs like Romulus, King Louis XI, and the Emperor Maximilian, one can learn how wise rulers should behave. Augustinus bears out this pleasure-giving rule in the *Convivium profanum* by teaching grammar after dinner through witty little dialogues, each of them a miniature scene from everyday life. On the other hand, the *Convivium religiosum* contains little jesting; there the conversation is, though pleasant enough, soberly instructive, for it centers upon Scriptural exegesis, and the feast is "crowned" with a reading from the Gospels. In the *Convivium poeticum*, one finds a blend of joking and, in the crotchety personality of the host's servant Margareta, even comic drama, with serious philological discussion and the provision of a sound moral lesson for the reader in the contest of extemporizing verses among the guests. Yet, as befits a *symposium*, the game ends on a note of foolery, with the reintroduction of Margareta and the awarding of the prize to the non-poet Crato as the only man present who has got the better in speech of this matchless harridan.

In order that the conversation at a dinner-party may be genuinely literary or philosophical, the number of guests, as Apitius would have it, must indeed be small. In three of the *convivia*, the size of the company is clearly stipulated and the cast of characters organized accordingly. Echoing Plutarch and Aulus Gellius's report of an opinion expressed by Varro, Eusebius in the *Convivium religiosum* specifies that the proper number for an intellectual feast can be no more than nine, equal to that of the Muses.[16] There are also nine speakers in the *Convivium fabulosum*, and in the *Convivium poeticum* one finds the same number of characters, though two of them are Hilarius's servants, Margareta and Mus. In the *Nēphalion Symposion*, where the company becomes ten, the nine guests evidently represent the Muses, while Albertus, the host, is their Apollo. A somewhat more elaborate scheme obtains in the *Convivium profanum*, where three ladies are present, in addition to Christianus and his nine male companions. Though the number seems excessive to one of the other guests, the wit Augustinus justifies it promptly: "Couldn't have happened more suitably. We're a bit wiser than Varro himself, since we've brought three very charming girls; the three Graces, as it were. Then, because it's incredible that Apollo is ever far from the band of nine Muses, we did right to add a tenth guest" (p. 606).

If this conveniently small group is ideal in size for an intellectual feast, the setting, for Erasmus, who shared the humanist belief that the height of living was to be in the countryside among the philosophers, is similarly important. In four of the banquet colloquies, all or part of the dialogue takes place in a garden. The *locus* of the *Nēphalion Symposion* is truly *amoenus*, as pleasant, claim the speakers, as the Fortunate Isles or prelap-

sarian Eden. Attractive outdoor scenes also figure in three other *convivia;* in them are echoed, as in so many Renaissance dialogues, details of Plato's *Phaedrus*, as well as others from his *Symposium*. When Timotheus, for instance, objects in the *Convivium religiosum* that Socrates learned from observing men in cities, whereas fields and trees could teach him nothing, the host Eusebius replies, "But how many things Socrates teaches his Phaedrus in that retreat, and how many does he learn from him in return."[17] The reference is to the charming picture of the two Athenians wading barefoot in the Ilissus and then sheltering from the noonday heat under the famous (and how often transplanted!) plane tree to converse about rhetoric and "winged souls." So, in the *Convivium profanum*, the company strolls in the waning light of evening along the river behind Christianus's garden, after the fashion of Socrates and Phaedrus, while Augustinus instructs them, before they go their individual ways, in some fine points of Latin speaking. In the *Convivium poeticum*, the group retreats for its dessert to the shade of a lime tree, near which there is "a little fountain of water more delicious than any wine" (perhaps an Ilissus in miniature?). They retreat, in fact, from the wrath of Margareta, since the host says, "I'm afraid that if we prolong this discussion she'll upset the table for us, as Xanthippe did for Socrates" (p. 174). Nor is Hilarius's garden only a refuge from his servant-Fury; it furnishes the very subject upon which the diners begin their contest in extemporizing verses using a variety of poetic meters.

While borrowing such Phaedrian settings, as well as certain other features from the Socratic dialogues, in the *Convivium religiosum* Erasmus deals with the three *horti* of Eusebius in a manner that is distinctly his own and makes the setting a place of instruction, as well as for pleasure. In responding to Timotheus's objection against the countryside, Eusebius explains:

Socrates was not altogether wrong if you mean roaming in the fields by yourself. In my opinion, however, Nature is not silent but speaks to us everywhere and teaches the observant man many things if she finds him attentive and receptive. What else does the charming countenance of blooming Nature proclaim than that God the Creator's wisdom is equal to his goodness? (p. 48)

For, in addition to the lessons taught by the paintings on the walls of Eusebius's house – including frescoes of both temperate and voluptuous banquets that admonish the viewer to avoid drunkenness and sensuality – the three successive gardens through which he leads his guests on their way to table are also symbolically instructive.[18] The outer garden of flowers is the least formal and, except at night, is always left open to the public. In its naturalness it suggests another Eden, and it is accessible to persons of whatsoever sort to enjoy its delights. On the door into the courtyard beyond are an image of St. Peter and three evangelical inscriptions urging the visitor to be converted to a religious life. Nearby stands the

figure of Jesus. "I've placed him here, instead of the filthy Priapus," says Eusebius, "as protector not only of my garden but of everything I own; in short, of body and soul alike" (pp. 50–51). There is also a fountain, symbolizing the satisfying waters of Christ's living truth, since from it, "Some even drink, not because of thirst, but of religion" (*ibid.*). From here one enters a second, more cultivated garden of choice, fragrant herbs, each with its particular virtue. This courtyard, besides live plants, contains painted flowers and hedges, in which the skills of man has imitated the handiwork of the Creator. It is an instance of art imitating, or assisting, nature; both come, says the host, from "the goodness of God, who gives all these things for our use and is equally wonderful and kind in everything" (p. 52). The third is at once a domestically useful and botanically experimental garden in which are planted culinary and medicinal herbs, along with a number of exotic trees which Eusebius is endeavoring to domesticate. Beyond stands an aviary, where one may deduce political lessons from observing the natures of the various species of birds: "among some, kinship and mutual affection; among others, irreconcilable enmity" (p. 55). At the end of the orchard is the well-regulated "apum regnum," an apiary in which the host takes much delight. Having completed this guided tour, the guests sit down to their "godly feast"; from viewing Eusebius's gardens and galleries they have seen how nature, art, and religion work in harmony to shape man's moral, aesthetic, and spiritual, as well as to provide for his physical, well-being.

The ambiance portrayed so charmingly in this long introductory passage is not simply an ideal setting for a *convivium;* it is an environment carefully composed for what Erasmus believed to be the finest kind of Christian living. The fullness of life is surely signified by the features of, and by the comments made upon, the house and, particularly, the three gardens. Man, created to enjoy an Eden, because of the Fall must enter into the life of grace through a conversion that turns him inward (into the middle garden) from the confusion of the external world. For only with divine assistance may virtue and art flourish in cooperating with nature to fashion a new earthly paradise where one may become truly human once more. The inner garden, with its well-ordered plots of herbs, its aviary and apiary, becomes a retreat for recovering one's integrity, for discovering by reflection and by observation of these animal societies how to reform, or at least to cope with, the disorder beyond the walls, and for exemplifying in small, through the behavior of the company at the feast itself, what a model Christian *politeia* ought to be.

The *convivia* in general incorporate many of the values implied in the description of Eusebius's surroundings and rendered explicit in the conversation at his table, where the Erasmian design for civilized and pious living is most completely articulated. This exemplary host fares well but not lavishly. When Timotheus observes to him, "You disapprove of

spending too much on churches, and yet you could have built this house for much less," he replies:

Well, I think it's in the modest class. Or call it elegant if you prefer; certainly it's not luxurious, unless I'm mistaken. Mendicants build more splendidly. Yet these gardens of mine, such as they are, pay tax to the needy; and every day I economize in something and deny myself and my family in order to be more bountiful toward the poor. (p. 71)

Like Augustinus in the *Convivium profanum* Eusebius is obviously more concerned with the welfare of his fellow men than with the more showy, and inessential, "observances" of religion. As the temperate Augustinus in the *Convivium profanum* will not dine until he has helped settle a quarrel between his daughter and son-in-law, so Eusebius ever has in mind "Christ's temples," rather than churches built of stone, that is, the poor and those who need moral counsel or spiritual consolation. He eventually excuses himself, in fact, from his own dinner-party because he has several such charitable errands to perform.

His guests, too, stand for that Erasmian Christian *libertas* which prefers the substance of true piety, wherever it be found, to the shadows of "ceremonies" or "Judaic" proscriptions. Again, like Augustinus in the earlier colloquy, one of them advances an argument against heeding iron-bound rules about fasting, "sacrifices," and other "corporeal rites" if in observing them one ignores the needs of one's neighbors.[19] Further, the company will gladly take instruction for righteous living not only from Scripture and the church, but also from non-Christian works of wisdom. Because they are humanists and are at ease in the ancient tongues, they find moral and spiritual guidance in the pagan classics, as well as in the Bible. Because they are Christians, from the moment they encounter the hortatory inscriptions accompanying the figure of St. Peter at the garden gate until the conclusion of their learned exegesis of biblical verses, they are concerned with unraveling the true spiritual sense of the word of God and applying it to their own personal condition. They begin their serious converse by undertaking to expound Proverbs 21:1–3, the passage beginning, "The king's heart is in the hand of the Lord, as the rivers of water"; yet even before their exposition commences Timotheus reminds them that Cicero's *De officiis* is also indispensable reading for whoever would live uprightly (p. 57). The best that natural reason has to offer complements what the Bible reveals. The humanity of the classics, asserts Eusebius, can hardly be labeled "profane," for the ancients' ideals are "so purely and reverently and admirably expressed that I can't help believing their authors' hearts were moved by some divine power. And perhaps the spirit of Christ is more widespread than we understand, and the company of saints includes many not in our calendar" (p. 65).

Socrates is thus not only pagan (despite Nephalius's perhaps too well-known desire to canonize him especially) in this company's litany of

saints. Eusebius believes that Cicero's "pure heart," too, was divinely inspired in his ethical writings; at the end of the banquet, in presenting Uranius with a copy of Plutarch's *Moralia,* he also remarks that "So much piety do I find in them that I think it marvelous such Christian-like notions could have come into a pagan mind" (p. 76). For the conduct of everyday moral and political life, moreover, he regards such authors as guides vastly superior to the contentious Scholastics of recent times:

But when, on the other hand, I read these modern writers on government, economics, or ethics—good Lord, how dull they are by comparison! And what lack of feeling they seem to have for what they write! So that I would much rather let all of Scotus and others of his sort perish than the books of a single Cicero or Plutarch. (p. 65)

In the *Nēphalion Symposion* the list of pagan saints is extended, since the focus of the conversation in this most moral of the *convivia* is entirely upon instances of "Christian" behavior not only by philosophers, but also by rulers such as Aristides and Philip of Macedon, and even by the simple Spartan lass, mentioned by Plutarch, who followed virtue for its own sake instead of for reward. It is most fitting that these classical examples "of moderation and long-suffering" (p. 455) which put to shame by contrast the vengefulness of modern Christians should be the subject of discourse at this "sober banquet," just as it is appropriate that the "Evangelical thoughts" of the noblest pagan moralists be extolled at the "godly feast." In the *Convivium poeticum,* too, this religious and humanistic mixture is centrally present. There the discussion is concerned mainly with prosodic and philological issues in both Christian and classical poetry; the hymns of St. Ambrose and the *Carmina* of Horace and Catullus, alike, occupy the attention of the assembled versifiers. Further, this colloquy demonstrates how much one may derive for upright conduct from a properly managed *convivium;* the guests' poetic variations on the theme, "That man's a fool whose garden blooms with countless delights when his mind is uncultivated by learning and virtue" (p. 174), provide substantial nourishment for the mind and soul after the wants of the body have been cared for.

The anecdotes about Aristides and King Philip in the *Nēphalion Symposion* touch upon some of Erasmus's most serious moral and political concerns in the *convivia;* namely, the qualities and modes of behavior essential in rulers if society is to be well and peacefully governed. Aristides's forbearance after his exile by an ungrateful Athens is contrasted with the current readiness, even of "Dominicans and Franciscans," to avenge injuries. Philip's tempered response to an insult by Demochares, the Athenian ambassador, is praised as an astonishing "example of moderation in a king" (p. 456). Gerardus, who recounts the anecdote, wonders, "Where now by comparison are the monarchs of the world, who think themselves equal to gods and because of a word uttered over the wine stir

up dreadful wars" (p. 457). His words call to mind similar anti-war sentiments already expressed by Erasmus in the *Encomium Moriae*, *Querela pacis*, and *Institutio principis Christiani*.

The main topic in the *Convivium fabulosum*, as in Plutarch's "Banquet of the Seven Sages," is the character and governance of princes; for a king, as leader of his people, should live at the peak of human capacity for good and intelligent behavior. Thus, the interlocutors, though they also regale one another with *facetiae* about contemporary rogues, are rather concerned to tell of Romulus's temperance, of the magnanimous gratitude of Artaxerxes, and especially of the astuteness in reading their subjects' intentions of King Louis XI and the Emperor Maximilian. Louis's generous recompense for small gifts sincerely offered and his shrewd provision of suitable "rewards" for sycophants is illustrated in the anecdote of Conon the peasant's turnip. Since the king had granted this countryman a thousand crowns for his present, a fortune-hunting courtier gave him a fine horse in expectation of some even handsomer return. Louis's response was to bestow upon him the now-shriveled turnip "which had cost him a thousand crowns" (p. 261). In these merry tales, the French monarch comes through as just, perceptive, and gifted with unusual insight into men's hearts. He is, moreover, *eutrapelos*, a *vir facetus*, for the possession of a ready wit is also, as Aristotle had said, a moral virtue, of especial value in one called to rule over others.[20]

In the *Convivium religiosum*, exegesis of the verses from Proverbs about "the king's heart" leads to the most complete exposition of Erasmus's humanistic ideals for monarchs to be found anywhere in the *Colloquia*. That it is to be a major concern of the banqueters is already suggested in the introductory pages as they contemplate the fresco of a basilisk in the host's middle garden. An accompanying inscription has the serpent saying, "Let them hate so long as they fear." When Timotheus calls this "A royal saying, clearly," Eusebius replies, "No, nothing is less royal; the saying of a tyrant, rather" (p. 54). Then, as the group begins to comment on the text from the Old Testament and on the wisdom of Cicero's *De officiis*, Timotheus raises the question whether, if the monarch is answerable to God alone, there is any remedy "against the unbridled fury of wicked kings." Eusebius answers that

The first, perhaps, will be not to receive the lion into the city. Next, by authority of senate, magistrates, and people, to limit his power in such a way that he may not easily break out into tyranny. But the best safeguard of all is to shape his character by sacred teachings while he's still a boy and doesn't realize he's a ruler. Petitions and admonitions help, provided they are polite and temperate. Your last resource is to beseech God to incline the king's heart to conduct worthy of a Christian prince. (p. 58)

The paragraph sums up Erasmus's doubt, well documented elsewhere, that monarchy is, even at best, a desirable form of government, though a *politeia*, or mixed state, might at least hold regal tyranny in check. If

that proves impossible, then proper education may keep the prince on the right course; otherwise, there is no remedy except hope for the influence upon him of divine grace.[21] The true king over Christians, and pattern for their temporal rulers, concludes Eusebius at the end of this exegetical feast, is the Son of God himself: "And all this blessedness we owe to his grace, freely granted us: that instead of having the devil as master, or tyrant, rather, we have Jesus Christ for Lord" (p. 75).

That in these colloquies, and especially in the *Convivium religiosum,* so much attention should have been paid to the qualities desired in kings is in no way surprising. These festive gatherings are themselves images of the sort of well-regulated, harmonious political order that Erasmus longed for, but scarcely expected to effect, in society at large. The *Convivium fabulosum* opens, in fact, with the host making such a comparison by asserting that "It's not right for a feast to be unregulated and lawless, any more than it's proper for a well-constituted state to be without laws and prince" (p. 255). Hence, for this contest in narrating amusing anecdotes about sagacious monarchs, several of the interlocutors are suitably named for the "political" roles they are asked to assume. The host is Polymythus ("Teller of Many Tales"); by lot Eutrapelus ("The Witty Man") is chosen king of the feast; Gelasinus ("Laughter") becomes umpire and judge, while the "urbane" Asteus makes sure that equity is observed and envy avoided by requesting a prize for the teller of the worst, as well as the most amusing anecdote. In the *Convivium religiosum,* everything from the beautifully composed environment to the well-managed dinner-party itself suggests an ideal little *res publica.* Besides Eusebius's concern as host and dispenser of gifts for the spiritual and intellectual, as well as the corporeal well-being of his household and his guests, his charity to neighbors beyond his snug walls is underscored. He guides his companions in their investigation of the qualities desirable in rulers, according to Christian, as well as humanistic, ethical and political ideals. And finally, to emphasize that his *convivium* is a mirror of how men might live together in concord, he points out that, "truly if a meal was something holy to pagans, much more should it be so to Christians, for whom it's an allegory of that sacred last supper which the Lord Jesus took with his disciples" (p. 55).

No other banquet colloquy goes quite so far as this in setting forth Erasmus's standards for humane Christian living. Still, different as they may be in form and may appear to be in purpose, throughout these pleasantly entertaining convivial dialogues may be traced the humanistic reformer's concern for personal temperance, a just and rational political order and mode of behavior in those responsible for its care, and a genuine religious piety based on freedom from onerous regulations and manifesting itself in true concern for the word of Scripture and the welfare of one's neighbor.

At the same time as he uses them to further these ideals for reform,

their author skillfully exploits in his *convivia* a variety of classical types of the *symposia* or closely related literary kinds: the instructions in the *Polydaitia* for planning the most attractive sort of dinner party; the *catena* of lively anecdotes that teach ethical and political lessons in the *Convivium fabulosum* and *Nēphalion Symposion;* the discussion of philosophical or, better, of religious matters in an atmosphere of relaxed ease and good-natured jesting in the *Convivium profanum;* the philological *cum* moral or philosophical banquet in the *Convivium poeticum* and *Convivium religiosum.* Of this special group of colloquies, the most appealing, because they are the most original and artistically accomplished, are these three last named: the "poetic" feast for its creation of the splendid comic character Margareta, the "profane" and "religious" feasts for best exemplifying, through their vividly depicted banqueters with their model behavior and lively conversation, how genuine conviviality can be pious, as well as humane. If, beginning with the extensively revised editions of 1522, Erasmus came to regard his *Colloquia* as teaching the way not merely to correct Latinity, but also to an upright and truly pleasurable manner of living, in none of these dialogues did he succeed better in achieving his aims than in his six *convivia.*[22]

NOTES

1. In her inaugural dissertation, *Die Colloquia Familiaria des Erasmus und Lucian* (Halle, 1927), Martha Heep does single out the six Erasmian *convivia* for a few pages of special comment (pp. 57–61). Her main concern, however, is to demonstrate that they are only slightly indebted to Lucian's dialogues. Since classical times, the *symposion,* or *convivium,* has been a recognized and much-practiced literary genre or sub-genre ideally suited for discussion of an almost infinite variety of topics. Besides Plato, Xenophon, Plutarch, Lucian, Aulus Gellius, and Athenaeus, there are numerous other instances of ancient authors who practiced or commented on this form. During the late Renaissance Johann Wilhelm Stuck compiled *Antiquitatum convivalium libri III* (Zürich, 1582), which contained evidence from some 650 writers of the antique world and "In quibus," as the title-pages goes on to inform the reader, "Hebraeorum, Graecorum, Romanorum aliarumque nationum antiqua conviviarum genera . . . explicantur, & cum iis, quae hodie cum apud Christianos tum apud alias gentes a Christiano nomine alienas in usu sunt, conferentur: multa Grammatica, Physica, Medica, Ethica, Oeconomica, Politica, Philosophica denique atque Historica cognitu iucunda simul & utilia tractantur, etc." For a modern study of the classical tradition, see Josef Martin, *Symposion. Die Geschichte einer literarischen Form.* Studien zur Geschichte und Kultur des Altertums, XVII: 1–2 (Paderborn, 1931; reprinted New York, 1968).
2. *The Colloquies of Erasmus,* trans. Craig R. Thompson (Chicago and London, 1965), p. 630. All ensuing quotations from this edition will be cited simply by page numbers within parentheses following the quoted text. Translations of Latin passages not so cited are my own, and the original source is documented in the footnotes.

3. In the revised *De utilitate colloquiorum* (March, September, 1529), Erasmus refers to the *Polydaitia* by the Latin title *Convivium varium*. For the *Nēphalion Symposion* (literally, "the wineless drinking party") the Greek title was apparently not translated because use of the Latin word *convivium* would have obscured the oxymoron that conveys paradoxically Erasmus's view that sobriety is becoming to a convivial gathering. The *Convivium profanum* was never given an actual title in the earliest printings, but beginning with the expanded edition of March, 1522, it did bear that designation as a running-head.

4. Cicero, *De senectute*, xiii. 45 (translation mine). In "Dialogus in domestico et familiari quorundam amicorum symposio Venetiis habitus," Giannozzo Manetti echoes Cato's observation and, in so doing, reflects a widely held attitude of Quattrocento writers of dialogue: "Convivium latine melius et elegantius a convivendo, quam graece symposium a compotando et combibendo nuncupatus" (quoted from MS. Laur. Plut. XC. sup. 29, fol. 3v, in Francesco Tateo, *Umanesimo etico di Giovanni Pontano* [Lecce, 1972], p. 181, n. 83).

5. Tateo, *ibid.*

6. Poggio, *Opera* (Basel, 1538), p. 35.

7. Giovanni Pontano, *Dialogi: Charon, Antonius, Actius, Aegidius, Asinus* (Florence, 1520), fols. 164r–v, 193r. Pontano also wrote a treatise, *De conviventia*, which was published at Naples in 1498, two decades before the *Colloquia* first appeared in print. The influence of Pontano's dialogues on Erasmus's work has been noted by George Faludy, *Erasmus* (New York, 1970), p. 209; the *Convivium religiosum*, though highly original, does reflect some influence of the *Aegidius*.

8. Filelfo wrote banquet colloquies, which Erasmus's correspondent Johann Kierher published as *Conviviorum libri duo* (Speyer, 1508). Landino's *De vera nobilitate*, though perhaps not known to Erasmus, purports to depict a *convivium* of Lorenzo de' Medici's as a "platonico symposio" (Cristoforo Landino, *De vera nobilitate*, ed. Maria Teresa Liaci [Florence, 1970], p. 32). Erasmus's admired Lorenzo Valla, in his *De voluptate*, curiously provides no likely model for the banquet colloquies. Although one of Valla's dialogues ends with a decorous supper in Antonio Panormita's garden, instead of lively discussions at table, the speeches on the nature of true pleasure are really declamations, seldom interrupted by the other interlocutors. Erasmus, however, would probably have been amused by Antonio's facetious eulogy, in the first part of the volume, of wine as presiding official over all *convivia*, a gift as natural as discourse to human beings, and the causer of all their joys (*De voluptate et vero Bono* [Rome, 1512], fol. XXIIIv).

9. The compliment did not render Luther, at least in his later years, well disposed toward the *Colloquia*. Craig R. Thompson has noted that on his deathbed Luther forbade his sons to read this work of Erasmus (*The Colloquies of Erasmus*, p. 45).

10. "But by a guest he was advised that I am a man of moderate diet, or of none rather; that I abhor tumultuous banquets" (*Opus epistolarum Des. Erasmi Roterodami*, ed. P. S. and H. M. Allen and H. W. Garrod [Oxford, 1906–58], V, 214). For Erasmus's praise of good Burgundy, which he believed helped his gout and was, at it were, a nourishing "mother of mankind," see *ibid.*, p. 215.

11. Near the end of Erasmus's life, a Genoese patrician named Lodovico da Spinula praised him in a letter for the utility of his writings, and particularly for the ease and pleasantness with which readers could learn

both good Latin and sound morals from the *Colloquia* (*Epistolae*, ed. Allen, Allen and Garrod, XI, 116).

12. *The Colloquies of Erasmus*, p. 337. In the *Colloquium religiosum* Eusebius speaks these words concerning the *Moralia* (p. 76). In the prefatory epistle to his own translation of eight of Plutarch's essays (Basel, 1520), Erasmus had also asserted that for teaching good morals he ranked the *Moralia* next only to the Bible: "For after Sacred Scripture I have read nothing more holy than this author."

13. P. 564. The phrase "*tēn aoinon methēn* – the nonalcoholic intoxication" is taken from *Moralia*, 616A.

14. "Whether Philosophy Is a Fitting Topic for Conversation at a Drinking Party," *Quaest. conv.*, I, 1 (*Plutarch's Moralia*, trans. Paul A. Clement and Herbert B. Hoffleit [London and Cambridge, Mass., 1969], VIII, 15).

15. *Quaest. conv.*, V, Preface to Sossius Senecio (*ibid.*, pp. 373–75).

16. "The ninth book of Table-Talk, Sossius Senecio, contains the conversations held at Athens during the festival of the Muses, the reason being that the number nine is peculiarly appropriate to the Muses" (*Quaest. conv.*, IX, Preface, 219). Aulus Gellius cites Varro as having made the following comment on the number of persons appropriate to a dinner-party: "He says that the number of guests should start from the number of the Graces and progress to that of the Muses, that is, begin with three and stop at nine" (*Noctes Atticae*, XIII. 11. 2; translation mine).

17. P. 48. Erasmus more than once imitated the Socrates of the *Phaedrus* in real life, as well as in writing the *Colloquia*. In a letter of 1497, which he composed for his pupil Heinrich Northoff to his brother in Germany, is described a *convivium* in which "After the second course we went out for a short stroll, to the very place where, as Erasmus proceeded to tell us, he had sometimes walked with you when you wandered together, drunk on honey-sweet talk and dodging between the vineyards, while he employed those eloquently persuasive arguments of his to summon you away to a wholehearted love of letters. Do you recognize the spot, Christian? It was there that Erasmus entertained us with a literary recital that was far more elegant even than the supper: he rehearsed so much ancient lore, in so charming a manner, that, to speak for myself, he transported me to the seventh heaven" (*The Correspondence of Erasmus*, trans. R. A. B. Mynors and D. F. S. Thomson [Toronto, 1974], I, pp. 125–26).

18. For a study of Eusebius's villa as an ideal environment for withdrawing from the tumultuous world and for educating one to a moral, Christian way of life, see Wayne A. Rebhorn, "Erasmian Education and the *Convivium Religiosum*," *SP*, LXIX (1972), pp. 143–49. Others who have commented on the symbolical, even allegorical, character of Eusebius's house include M. Wackernagel, "Der ideal Landsitz eines christlichen Humanisten der Renaissancezeit," *Festgabe für Alois Fuchs zum 70 Geburtstage* (Paderborn, 1950), pp. 159–71, and Elsbeth Gutmann, who finds that in the works of art, the inscriptions on the walls, and the gardens, "Überall ist sein gestaltender Geist zu spüren, der jedes Ding prägt und zum Zeichen Gottes erhebt" (*Die Colloquia Familiaria des Erasmus von Rotterdam*, Basler Beiträge zur Geschichtswissenschaft, 111 [Basel/Stuttgart, 1968], p. 160). F. M. Huebner, "Im Garten des Erasmus von Rotterdam," *Neue Schweizer Rundschau* (October, 1954), pp. 352–60, argues that the descriptions in the *Convivium religiosum* recall the actual garden of Erasmus's publisher Johannes Froben at Basel. In a letter to Marcus Laurinus (February 1, 1523), Erasmus had described the instructive paintings in the

house of his friend Botzheim at Constance, which he had visited the pre-
ceding September (*Epistolae*, ed. Allen, V, 212).

19. "I think 'sacrifice' means whatever pertains to corporeal rites and has
some connection with Judaism, such as choice of foods, prescribed dress,
fasting, offering, perfunctory prayers, rest on holy days. Though not to be
omitted entirely in certain seasons, these become displeasing to God if a
person relies on such observances but neglects works of mercy when a
brother's need calls for charity" (p. 61). In the *Convivium profanum*,
Augustinus concludes his attack on superstitious ritualism by saying that if
he were pope, he would encourage everybody to live soberly and not
trouble about strict observance of the fasting regulations; to him, as to his
creator Erasmus, a true piety, instead of merely formal obedience of rules,
would result from this greater Christian liberty (p. 605).

20. *Nicomachean Ethics*, IV. viii. 1128a.

21. Several of the aphorisms, for example, in the opening pages of Erasmus's
Institutio Principis Christiani (1516) seem to be echoed in this passage:

[Where there is some choice, one should seek a person of] a quiet and placid
trend of spirit. Seek rather a nature staid, in no way rash, and not so excitable
that there is danger of his developing into a tyrant under the license of good
fortune and casting aside all regard for advisers and counselors. . . . There is no
choice, however, in the case of hereditary succession of princes. . . . Under that
condition, the chief hope for a good prince is from his education, which should
be especially looked to. In this way the interest in his education will compensate
for the loss of the right of election. . . . That a prince be born of worthy char-
acter we must beseech the gods above; that a prince born of good parts may not
go amiss, or that one of mediocre accomplishments may be bettered through edu-
cation is mainly within our province. . . . There is no better time to shape and
improve a prince than when he does not yet realize himself a prince.

D. Erasmus (*The Education of a Christian Prince*, trans. Lester K. Born
[New York, 1936], pp. 139–41 *passim*).

22. The title-page of the March, 1522, edition, in which the "moral" dialogues,
including the expanded *Convivium profanum* and the introduction to the
Convivium religiosum, first begin to appear, speaks of the colloquies as
"non tantum ad linguam puerilem expoliendam utiles, uerum etiam ad
vitam instituendam" – useful not only for refining the speech of youth, but
also for instruction in how to live. Although the work continued for gen-
erations to serve effectively as a textbook for teaching conversational Latin,
that the latter purpose came to dominate the *Colloquia* as Erasmus went on
expanding and revising the collection is evident from the fact that, apart
from the *Convivium profanum*, none of the other banquet pieces contains
materials that are simply formulas for varying one's Latin phrasing.

The Narrative Style of
The Man of Law's Tale

PAUL M. CLOGAN

Chaucer's religious romances pose rather difficult problems for the modern reader. The Man of Law's Tale, the Clerk's Tale, the Physician's Tale, and the Second Nun's Tale share, if not a genre, a family resemblance as solidly moral tales of virtuous, wronged women. They have often been grouped together because they treat essentially similar themes, use rime-royal stanzas (with the exception of the Physician's Tale), and exhibit exemplary narrative technique in the *Canterbury Tales*. These pious tales have been termed pathetic and have been excluded from discussions of Chaucer's purely novelistic romances because they lack chivalric conventions and concepts of courtly love.[1] When they are viewed as didactic and moral narratives or as exemplary tales[2] written in the style of a saint's legend, they are found by the modern reader to be unsatisfactory, because they lack organic development, realistic characterization, and apparent descriptive detail and contain a large number of improbabilities and coincidences, as well as a heroine who is neither a tragic, nor a comic figure. Above all, these pathetic tales seem to manifest a lack of subtlety in the handling of character, plot, and style which is taken as wholly unrepresentative of the artistry shown in the other tales. Unlike the pathetic tales which are helped by a congruence of teller with tale, the Man of Law's exceedingly pietistic tale of Constance, the accused queen, seems ill-suited to the materialistic portrait of the narrator in the General Prologue. Moreover, the narrator's elaborate rhetorical flourishes, with embellished apostrophes and epic similes, seem to undercut the sincerity and piety of the tale and to alienate the modern reader.

Yet I believe that the features desired by the modern reader are not present in these pathetic tales, and in particular the Man of Law's Tale (MLT), because their narrative depends less on organic structure to develop the story than on exemplary episodic narrative sequence. The apparent lack of descriptive detail is a deliberate effect of the narrator's primary interest in action and participation, and the mode of presentation and the style of the *persona* of the narrator are deliberate effects of the compositional style of hagiographic romance. This essay will first consider the nature of our genre – the relationship between the romances

and hagiographic legends – and will then point out what the MLT shares with certain saints' Lives and romances. That is, they have a learned narrator-*persona* in full possession of *translatio studii*-type literary technique, as well as what serves to distinguish these structures: Hagiography serves an "external" truth, and romance is turned inward upon itself.

More than fifteen years ago, Max Wehrli[3] pointed out that it is in the saint's Life that spiritual knowledge and dogma are united in a variety of ways with secular, fictional art; as a result, it is a richly diversified subject capable of development and change. Romance, he argued, is a more exclusive genre, inasmuch as its social and artistic character is concerned. Romance, the initial thrust of which is secular and liberating, must indeed come to terms with the demands of Christian faith if it is to be more than mere entertainment. Because medieval writers of romance have universally affirmed this serious intention, the concerns of romance tend to merge with those of hagiography. Thus, hagiography and romance share a good deal of common ground, and the close relationship of the two kinds of *matière* reveals essential tendencies and problems in medieval narrative art. Wehrli based his discussion of the complex relationship between the romances and the hagiographic legends on German sources, but his conclusions regarding the literary symbiosis of the sacred and the profane apply to Western European literature as well.

Recently Ludwig Bieler, writing on the romantic elements in Irish hagiography, extended Hippolyte Delehaye's distinction[4] between *passio*, the life of a martyred saint, and *vita*, the life of a confessor who has undergone persecutions, and suggested that:

It was the official recognition of Christianity in the ancient world, its becoming the religion of the emperors and the ruling classes, that made the "martyr," who had been the Christian hero *par excellence*, give way to the "confessor" (the two words literally mean the same), who is "heroic" in that he displays heroic virtue – not only moral virtue practised in heroic degree (the *virtus heroica* of the schoolmen) but also, and above all, by giving proof of *virtus* in the sense of supernatural power, as a practitioner of "white magic."[5]

Using Charles Plummer's term "religious romance"[6] and Delehaye's term "roman hagiographique,"[7] Bieler proposes that the way by which romance elements entered saints' Lives was "aretalogy":

The term *virtues*, Greek *aretai*, was given by the ancients to the extraordinary and memorable deeds, often miraculous, of gods and heroes, and was taken over by those who wrote about their Christian counterparts. The Greek word *aretalogus*, in a derogatory sense, meaning "teller of tall stories," "a jester," was made a loanword in Latin; the Greek *aretalogia* was, in a neutral sense, introduced as a technical term for the account of the miraculous deeds of a religious hero by Richard Reitzenstein and has become generally accepted. Aretalogy opened the door to the influx of all sorts of secular stories either *in toto* or of selected motifs of pagan or generally superstitious character.[8]

By this method, which has its place in the apocryphal books of the Old and New Testament and in Jewish rabbinical tradition, romance (includ-

ing myth, saga, legend, Märchen, and popular superstition) entered the Lives of saints or hagiographic romance.

By the time the vernacular languages began to emerge in Western Europe, hagiography had already established a long and popular tradition. At the end of the ninth century, six hundred Lives had been written. The rich collection of early Christian saints' legends contain a great variety of styles of presentation, and many of these narratives follow the conventional pattern of romance. Both kinds of writing employ narrative, normally with a single protagonist as hero, and both celebrate an ideal experience, disengaged and disencumbered from the demands of reality. Yet the relationship of these two narrative forms has been somewhat complicated by the influence and imitation of the style and mode of one on the other. M. Dominica Legge points out that the *Voyage of St. Brendan*, the earliest Anglo-Norman text, written in 1106, contains elements which later become characteristic of romances: "Saints' Lives were written as counterblasts to romances and to provide the Laity with more elevating literature."[9] As Derek Pearsall remarks, "the blurring of form which so perplexes the modern scholar, preoccupied with matters of generic definition, is the precise goal of these writers, whether they be entertainers with a touch of piety or hagiographers with an eye for their audience."[10] In the late Middle Ages it is indeed difficult to distinguish clearly between saints' Lives and romances.

This difficulty is the result of the profound influence of vernacular hagiography on other genres. Peter Dembowski notes that

The Lives of Saints and other hagiographic writings have never developed specifically different literary forms of their own. . . . Later, in the thirteenth century – the Golden Age of hagiography in Old French – the hagiographic poems of France (imitated directly in Spain, Portugal, Italy, Germany, and Scandinavia, recomposed and composed in Anglo-French and in English) reflect not only the typical form of verse romances (rhymed octosyllabic couplets), but also, and above all, the prevailing tone of these romances. The elegant preoccupation with details, the desire to "interlace" the narrative gracefully, the desire to appear both new and recognizably traditional are shared by both genres. . . . In its close "coexistence" with the epic and novelistic poems [vernacular hagiography] influenced profoundly the very conception of the hero. Not only Charlemagne, Roland, Oliver, Guillaume d'Orange, but also, later Perceval, Lancelot, Galahad, and others become, so to say, "canonized". . . . What is important here is not the canonization of this or that epic hero in "real life," but the "hagiographization" of the hero in the literary work. The Christianization of vernacular literature meant above all the "hagiographization" of the hero. . . . So powerful was the influence of hagiography in most of the literary genres of the vernacular that it created a real symbiosis of the sacred and profane.[11]

We see this process at work in the MLT, which is a saint's Life in all but final martyrdom and canonization. The mode of presentation and the style of the *persona* of the narrator are deliberate effects of the compositional style of hagiographic romance. What the tale of Constance shares

with certain saints' Lives and romances is a clerkly narrator figure in full possession of *translatio studii*-type literary technique.

Early vernacular epic and hagiography prepare the way for the role of the clerkly narrator figure in the MLT. It is the authenticating voice of the epic narrator in *Beowulf*, as Stanley Greenfield points out, that historicizes or distances the narrative characters and events from his immediate audience's time and way of life and relies on his audience's previous knowledge of the legend. In the *Song of Roland*, at the end of Ms. Digby 23, we find a narrator figure with the clerkly name of Turoldus who comments implicitly and explicitly on the narrative characters and events, uses various learned *topoi*, and capitalizes on his audience's previous knowledge of the legend of Roland. The narrator manipulates his language within the text and uses past and present verb tenses, as well as colloquial diction, to locate the story in the past but emphasize its present meaning and import. Through the poetic device of a clerkly narrator figure, the "truth" of the legend of Roland is expressed and transposed into history. In the Old French *Life of Saint Alexis*, verb tenses are colloquially confused to achieve the same effect as that of the Oxford *Roland*.[12] As in the epic, poetry is put in the service of historical truth, and the saint comes to be an imitator of Christ's incarnation. The hagiographic narrator uses the same techniques as the epic narrator, but with different emphasis. The epic narrator refracts his learning in the poem by implicit means. The presence of the learned narrator in vernacular hagiography is more explicit; the clerkly narrator figure becomes part of the saintly paradigm. His voice is the authority of tradition. He participates in the narrative as he celebrates the ritual performance.

For example, in the legend of St. Mary the Egyptian, to which the Man of Law refers (500–1), Zosimas, the pious monk who finds Mary naked in the desert, is an important character in the story, but he is also clerkly witness to Mary's sanctity. We are fortunate in having recent editions of the various redactions of the legend (in both verse and prose), and we can see how the legend developed and how the vernacular poet treated his materials.[13] In the Latin versions of the legend, Zosimas the philosopher is the main hero and the theme is monastic perfection; the finding of Mary is only an episode, in which she recounts her own story in first-person narrative. In the later vernacular redactions of the life of St. Mary the Egyptian, the clerkly narrator assumes the role created by the original clerk, and he narrates it all, Rutebeuf's redaction of the life of St. Mary the Egyptian actually connects the narrator to Zosimas; they have come to be connected in the literary development of the hagiographic tradition.

The mediating role of the narrator in the MLT is clearly elaborated at the beginning of the work.[14] The curious little prologue concerning poverty and the opening lines of the tale establish the authority of a clerkly narrator in the form of a Man of Law. The first twenty-three lines of the

prologue are a paraphrase of a passage in Pope Innocent III's *De Miseria Humane Conditionis,* a popular moral Latin treatise deploring with great zeal everything mundane. Who but a learned clerk would make use of a solidly moral Latin treatise as a major source for the moralizing in the prologue and tale? The translations are from five different chapters, and two different books in *De Miseria* and account for approximately 50 lines of Chaucer's text. They are skilfully incorporated in the work and serve to introduce and develop the figure of a learned narrator in full possession of *translatio studii*-type literary technique.

In the prologue the clerkly narrator self-consciously creates and manipulates his language in the same manner as in the tale. Involuntary poverty is distinguished from voluntary poverty, which is highly praised in the Wife of Bath's Tale (III, 1177–1206). According to the narrator, involuntary poverty undermines "reverence" and breeds wickedness. Poverty's evil is the erosion of the spirit, but wealth breeds nobility, prudence, and wisdom. While the prologue contrasts the evils of poverty and the joy of wealth, the Tale focuses on the nobility of Constance, the lay saint as imitator of Christ's incarnation. Unlike Pope Innocent, who deplored both poor and rich, the narrator scorns only the poor, in order to contrast the wretchedness of poverty with the joy of wealth. Thus, the clerkly narrator reverses his source of authority and manipulates his language within the prologue.

The prologue, typical of hagiographical narratives, is designed to establish a relationship between the narrator, his audience, and his text. It is he who relates Roman, Syrian, and British antiquity to his own English time. He establishes the perspectives and fits them together closely, in order to engage the audience in the action of the story. His presence in the poem and his use of the first-person narrative technique establishes the community, which is essential to the functioning of the tale. The narrator's "I" is joined to the newly created community which becomes the "we" in the intercession at the end of the tale:

> Now Jhesu Crist, that of his myght may sende
> Joye after wo, governe us in his grace,
> And kepe us alle that been in this place! Amen.
> (1160–2).

Thus, through the clerkly application of poetry, a community is established, a community in which Constantine is *our* Roman emperor (156) and Constance queen of all Europe (161). Past and present coexist in such a manner as to place the story in the past and emphasize its present signification. Constantine, who was actually Emperor not of Rome but of Constantinople in 578 and was succeeded, as in the story, by Maurice in 582, is still with us; he is *our* emperor. The Chaucerian narrator has similar characteristics in many of the tales, yet he assumes different roles in different tales. In the MLT, the Chaucerian narrator endeavors to preserve

his distinct identity as narrator; he is a very clerkish figure, ever commenting on the action with similes, apostrophes, and rhetorical questions. He is very much present, physically, at least in his diction, numerous interventions, and elaborate rhetorical flourishes. His presence and use of the first-person narrative device are essential to his explicit role as officiant. As such, he sings the story, commenting explicitly and implicitly on the narrative characters and events, usually by capitalizing on his public's prior knowledge of the legend. As in epic, poetry is here placed in the service of historical truth. The authenticating voice of the clerkly narrator transposes the latent truth of the legend into history.

At the beginning of the tale, the narrator points out (131) that the work is not of his own making, but rather was "taught" to him years ago by a "merchant." He further reveals (135) that the tale originated with some Syrian "chapmen," who in turn heard it when traveling in Rome (148). Thus, Chaucer overcomes the difficulty of assigning to the Man of Law a tale which, from all appearances, is not well suited to him. Notwithstanding the narrator's claim, Chaucer's primary source is the Anglo-Norman prose *Cronicles* by Nicholas Trevet.[15] The fourteenth century saw a revival of interest in historiography. While clerks and monks wrote chronicles and histories in Latin, secular clerks and lay historians produced famous vernacular chronicles, especially in England. Nicholas Trevet, a Dominican friar who taught at Oxford in the early fourteenth century, was a biblicist, classicist, hebraist, historian, and theologian writing extensively in both Latin and French. His interests in history account for his commentary on Livy, which was much in demand at the papal court at Avignon, for his *Annales* and *Historia*, both written in Latin, and for his *Cronicles*, written in Anglo-Norman prose, a history of the world from Creation down to 1334.[16] The scholarly work of Trevet reflects the contemporary trend of serious interest in ancient histories and antiquities. Trevet's story of Constance, a romantic digression like his Arthurian digression, is noted for its use of hagiographical and pseudo-hagiographical materials, the historical names from the fifth and sixth centuries that he used for his fictional characters, and its inveterate admixture of pagan and Christian elements. Trevet makes no sharp distinction between pagan and Christian texts or pagan and Old Testament history, a characteristic of the medieval encyclopaedic tradition and, in particular, of the Oxford Dominican tradition. In the *Cronicles* Trevet's interpolations of pagan events in his universal history were incorporated to show the clash of pagan and Christian forces for power and dominance, and into this clash he fitted the story of Constance. His account is basically a clerical work, which translates faithfully the composite Byzantine tradition. It is straight narrative; dialogue is used frugally to intensify and illustrate the narrative line. The MLT, in which the narrator is retelling the story, operates quite differently. Trevet records the story; Chaucer reenacts it, thanks to the clerkly narrator.

Many critics of the Tale have commented on the narrator's numerous interventions, apostrophes, similes, comparisons, apologies and defenses, rhetorical questions, and transitional paragraphs; it has recently been argued that these interruptions and rhetorical flourishes serve "to alienate us from the story and to stylize the action. They make us not more but less aware of the reality of the emotions of the protagonist."[17] Yet what many critics seem not to notice is that the presence of a clerkly narrator figure is often manifested by a kind of literary self-consciousness which is typical of many hagiographical works. The narrator's rhetorical devices (*occupatio, exclamatio, interrogatio, sententia, comparatio,* and pathetic prayers delivered by the heroine) are characteristic of many hagiographic structures and, in particular, of female saints' legends.[18] Leo Spitzer (1932), Ernst Curtius (1936), Anna Hatcher (1952), and Erich Auerbach (1953) have demonstrated some of these stylistic techniques in reference to the Old French masterpiece *Saint Alexis.* Auerbach notes that the paratactic structure of *Alexis*

is a string of autonomous, loosely interrelated events, a series of mutually quite independent scenes from the life of a saint, each of which contains an expressive yet simple gesture. . . . It is a cycle of scenes. Each one of these occurrences contains one decisive gesture with only a loose temporal connection with those that follow or precede. Many of them . . . are subdivided into several similar and individually independent pictures. Every picture has as it were a frame of its own.[19]

In this perspective, one can see that the narrative of the MLT is composed of a number of independent scenes or a series of self-contained exemplary episodes that are loosely connected to what follows or precedes but thematically related through the devices of juxtaposition, repetition, and intensification. Unlike Trevet, Chaucer deliberately structured the Tale as an episodic narrative, making each scene a narrative frame or picture, and this structure would be recognized by his audience as characteristic of the genre of saint's legend. For Auerbach, the individual scenes in these paratactic structures assume a symbolic relationship manifesting God's presence on earth through the saint's imitation of Christ's incarnation.

The fourteen apostrophes by the narrator, five by Constance and one by the Constable, as well as the other rhetorical devices, deserve close examination, because they become structural components of the Tale and incidentally are all part of Chaucer's additions to his source that distinguish his tale from that of his contemporary John Gower. Lines 267–315 are a good example of the apostrophic tone of the tale and aesthetic of pathos in the tale. As the fatal day of Constance's departure from Rome arrives, she turns pale in sorrow, knowing that she can no longer delay and well aware that nothing would now alter the destined movement of events. At this point, the narrator intervenes with a transitional passage (267–73) on Constance's forthcoming separation from friends and her

marriage to a husband whom she scarcely knows, except by reputation: "Alas what wonder is it though she wepte" (267). The narrator's intervention prepares the reader for the sea of tears which follows. Constance's farewell to her parents (274–87), which is not in Trevet, is a moving and touching expression of sweet sorrow, as she appeals first to her father, reminding him of his young and tender daughter, and then to her mother, crown and pearl of all her joy, except Christ above. In tears, she bemoans her voyage to a pagan nation and sees herself as a wretched girl and as a thrall disposed of and ruled over by men. Here the narrator intervenes again with an epic simile (288–93) comparing the grief heard at the conquering of Troy, Thebes, and Rome to the "tendre wepyng for pitee" (292) heard in Constance's chamber. This long rhetorical passage is concluded with the narrator's first formal apostrophe, in which he turns away from the generality of listeners to address the cause of the fatal woe and events. The first apostrophe (295–308) of the narrator to the *primum mobile*, whose westward motion resulted in the unfavorable influence of the planet Mars at the time of Constance's marriage, is directly followed by the second apostrophe (309–15) to the rich Emperor of Rome, who had no excuse for not knowing the unfavorable time of Constance's voyage. The stars are condemned for their contrary motions and evil powers, and Constance's father, the rich Emperor, is scolded for his imprudence and ignorance in failing to consult an astrologer concerning the appropriate time for his daughter's voyage.

The narrator's account of the scene in Constance's chamber is obviously pathetic. Instead of threatened incest with a father to beget an heir on his daughter, which was the original cause for the accused queen's flight in various versions of the legend, the Roman Emperor, without consultation, dispatches his beautiful daughter for marriage to the pagan Sultan of Syria, where Constance will be vanquished. The narrator is present to witness the scene for us, and he tells us what they feel. We, the public, are not unmoved by the pathetic scene in the chamber, and in our pity for Constance we come to understand the purport of her holiness: It is made real. Thus, the clerkly narrator employs his learning – that is, his rhetorical skills – in the service of the saintly paradigm. The extraordinary rhetorical display in lines 267–315 serves not only to "intensify" the pathetic scene but to shift the emphasis in the poem from faith in what is being served by poetry to poetic service itself.

The third apostrophe is addressed to the Sultana (358–64), who has just revealed her plans to murder her son, all converted Syrians, and the Roman Christians; in it she is called a vicious, deceiving, hypocritical woman. This apostrophe is directly followed by one addressed to Satan (365–71), who is the ultimate cause of the betrayal of this Christian marriage. The narrator links the Sultana's wickedness and Satan's envy since the day he fell from grace with God by referring to Semiramis, an As-

syrian queen who slaughtered her husband, and to the Edenic serpent, which in medieval iconography had the face of a woman. Both apostrophes are typical invectives against villains – in particular, female villains – and express an emotional response to evil influences in the Tale.

The fifth apostrophe is delivered immediately before the bloody slaughter of the Christians; it is addressed to woe, which always follows bliss (421–7), and emphasizes the moral significance of the action. There are similar moralizations in the Nun's Priest's Tale (vii, 3205), *Troilus* (iv, 836), and *Boece* (ii, pr. 4), as well as *De Miseria Humane Conditionis* (i, 23). Here the narrator combines apostrophe with *sententia* to recall the fickleness of fortune and to intensify the reader's response to the slaying of the blissful Christians. The actual slaying is briefly narrated. The Sultan and Christians are hacked into pieces where they are sitting, and all are stabbed, except Lady Constance, who is hastily cast adrift in a rudderless vessel, exiled from Syria and headed toward Italy again. She is allowed to take a store of treasures, supplies of food, and some necessary garments. At this point, the narrator delivers a brief apostrophe to Constance (446–8) and asks God to guide her helm. This is immediately followed by Constance's prayer to the Cross (451–62), her rich and shining altar. Such prayers were often used as rhetorical devices in saints' legends.

As Constance is left to survive alone on the Grecian seas for three years, there follows a long passage (470–507) in which the narrator answers the objections of skeptics by cataloging God's miracles worked in His people, and thus emphasizing the typological significance of Constance's survival at sea. She is compared to Daniel, Jonah, the Israelites in the Red Sea, and St. Mary the Egyptian. Chaucer, of course, makes frequent use of *comparatio* (*Troilus*, II, 666–85, iii, 491ff, 168f; Knight's Tale 1881ff; Franklin's Tale 1493ff), but here the narrator employs it to anticipate and refute any possible objections to the credibility of his tale and to frame and conclude the episode of Constance's first exile at sea.

During her sojourn in Britain, the narrator again apostrophizes Constance (631–7), who has no champion and cannot defend herself in her trial before King Alla. Her innocence before her accuser cannot be established by ordeal of battle, and only Christ, who bound Satan in hell with chains, shall champion her this day. This trial scene is immediately followed by Constance's prayer to God for help (639–44), which cites Susannah, who was falsely accused, and Mary, daughter of St. Anna, by the epic simile of the famous "Have ye nat seyn somtyme a pale face / Among the press" (645–51), and by another apostrophe to queens and other noble women (652–8) to have compassion on an Emperor's daughter standing alone.

In lines 771–7, the narrator addresses an apostrophe to the drunken

messenger who blabs the secrets to Donegild, the second wicked mother-in-law; she in turn is apostrophized in the following lines (778–84) as a man-shaped monster for her treacherous prying into the exchange of letters. Finally, Constance is briefly addressed (803–5) as she is once again cast adrift in the very ship in which she was found – the result of the prying of old Donegild, who is later slain by her son. Each apostrophe serves to frame the scene and underscore the episodic structure of the tale.

In Part III, there are two apostrophes. The first is addressed to God (907–10) to be mindful of Constance, who, after a five-year exile at sea with her baby, lands near a "hethen castel" and is almost raped aboard her ship by a castle steward, who, thanks to the Blessed Mary, was swept overboard and drowned. This incident leads to yet another moralizing apostrophe which is directed to lechery (925–31) and followed by another series of rhetorical questions (932–45) in which Constance's new strength is compared to David's against Goliath and Judith's against King Holofernes.

What artistic purpose is served by this extremely elaborate rhetorical style or by a heroine who protests too little and a narrator who protests too much? There is little attempt to tighten up the paratactic structure of the tale, and the narrator's elaborate rhetoric actually accentuates this narrative structure and sentimentalizes the drama within each narrative picture. Edward Block argued that Chaucer added many realistic passages and touches to humanize his characters and make them more vivid and lifelike and, at the same time, to make Constance, in particular, more pious and religious than she had been in Trevet. Nevertheless, he concluded that Chaucer's additions and touches created a "lingering air of improbability which permeates the Man of Law's Tale" and militates against credibility of his characters. "In trying to make his characters both more human and more religious Chaucer may have been motivated by what is an irreconcilable dualism of purpose."[20] First, it should be noted that in hagiographic romance the reader or audience is not expected to empathize or identify with the characters or events and is deliberately kept at a distance from the action. Chaucer's narrator is present in the story to *witness* the scene for us, and he tells, rather than shows us what the characters feel. His presence in the narrative and his deliberate manipulation of characters and events stylize emotion and action. The hagiographer is a custodian of a religious tradition, and his purpose is not simply to entertain but to construct, to conserve, and to edify.[21] A. B. Lord, in discussing the continuity in oral verse, writes:

For it is of the "necessary" nature of tradition that it seek and maintain stability, that it preserve itself. And this tenacity springs neither from perverseness nor from abstract principles of absolute art, but from a desperately compelling conviction that what the tradition is preserving is the very means of attaining life and happiness.[22]

The role of the narrator in the MLT is to "create" Constance's real presence in the Canterbury community. He officiates in this poetic ritual through which the essential Christian story is made available to his audience. His role as mediator is the chief effect of the stylistic elaboration of Trevet's chronicle. The audience is always aware of the "story" of Constance being retold by a narrator who is both witness and authority and whose presence in the story is real.

The mediating role of the narrator in the MLT is, in effect, the result of a transformation of hagiographic and romance structures, and in particular of the hagiographer-officiant and poet-romancer.[23] The hagiographic narrators of the twelfth and thirteenth centuries, like their counterparts in the romances, shared a strong belief in poetic learning; and it is this belief in learning, manifested in the use of a learned narrator-*persona*, which reveals some of their common characteristics. The narrators of Chrétien de Troyes, Marie de France, and Wace are learned manipulators of the art of poetry. These narrator figures may be identified with the poet-romancer to the extent that they believed more in how they are participating in the narrative they are telling than in manifesting a belief in their material. But the act of composition for the poet-romancer cannot be bound to mere service to an external myth; in romance narrative, poetry always has precedence. Moreover, irony is frequently prominent in romance but, strictly speaking, not in hagiography. This is what seems to distinguish these two genres: Hagiography serves an "external" truth, and romance is turned inward upon itself. Thus, when we compare and contrast a hagiographic romance like the MLT to a Chaucerian novelistic romance or an Arthurian romance, we note a similar devotion to poetic learning, but we also observe a shift in emphasis: Belief in the myth being served by literature is replaced by poetic service itself. In hagiography, as in epic, poetry serves the myth; the heroes and stories are treated as *real* myth, as the truth. In romance, narrative poetry takes precedence over the myth.

Margaret Schlauch and others have shown how widespread was the cycle of persecuted heroines and the close connection between the MLT and the genre of Greek romance.[24] They both are concerned with exile and reunion; both describe suffering and imprisonment of the innocent and faithful, who are separated from family or one another by accident or design and reunited only after numerous adventures and tribulations. Both contain exiles, reunions, shipwrecks, attacks by brigands and pirates, persecutions, slavery, monsters, and divine commands. In classical romance, the tribulations which separated lovers, the hero and heroine, often featured a quasi-historical setting and contained pathetic laments and improbability of events. The worst tribulations were those provoked by the lovers' exceptional beauty, which aroused the most fearful jealousies and rivalries around them. The literary device of the "recognition scene" at the end of the MLT is very common in Greek romance and in the

cycle of persecuted heroines; it brings together at the end of the story all the scattered members of the family for a general reunion. Constance returns to Rome and is finally reunited with her husband King Alla through the agency of her son Maurice.

"Most of what goes on in the night world of romance," writes Northrop Frye, "is cruelty and horror, yet what is essential is not cruelty as such but the presence of some kind of ritual."[25] The series of demonic ordeals in the MLT, not unlike the ones Frye notes in Greek romance, also has, I believe, "a strong resemblance to those in the decent myths of the Bible." When Chaucer subjects Constance to such tribulations, he deliberately inserts biblical parallels, including the stories of Daniel and the Passion of Christ, as well as Jonah, the Red Sea, David, Susannah and the Virgin Mary, Judith, and others. All the biblical parallels, except those of Susannah and the Virgin Mary, are contained in the clerkly narrator's rhetorical questions (470–504, 932–45). The biblical parallels serve not only to impart a tone of piety and devoutness but also to stress the presence of some kind of ritual which balances and checks the presence of cruelty and horror in the Tale. In commenting on the biblical parallels, the clerkly narrator indicates the importance of his role in the transmission of knowledge.

> God liste to shewe his wonderful myracle
> In hire, for we sholde seen his myghty werkis;
> Crist, which that is to every harm triacle,
> By certeine meenes ofte, as knowen clerkis,
> Dooth thyng for certein ende that ful dark is
> To mannes wit, that for oure ignorance
> Ne konne noght knowe his prudent purveiance.
> (477–83)

Indeed, only clerks know how God works his purposes by miracles, which remain hidden to men who know not the prudence of God's providence. It is the special function of the clerkly narrator to teach the truth to the community of non-clerks or readers, whose duty it is to try to understand and heed his saintly poetry.

The numerous classical allusions and epic similes (to the deaths of Hector, Achilles, Pompey, Julius Caesar, Hercules, Sampson, Turnus, and Socrates; to the triumph of Julius Caesar as told by Lucan; and to the wars of Troy, Thebes, and Rome) serve to impart not only a tone of literary learning but also to manifest the presence of a self-conscious, clerkly narrator; he is both witness to the clerkly tradition (a translator-adaptor) and clerkly preacher, whose role is to comment on and summarize the action of the poem. His witness and authority guarantee the "truth" of the tale. The narrator reminds the community that the fate of the Sultan was already written with stars in the book of the heavens at the time of his birth: "That he for love sholde han his death, alas!" (193.)

The narrator also notes that the death of everyman is written in the stars, if he could read it without dread: "but mennes wittes ben so dulle / That no wight kan wel rede it atte fulle" (202–3). The reference to Lucan, the most rhetorical of Roman poets, is indeed appropriate, because he was admired for his animation and pathos until the middle of the seventeenth century.

Although Chaucer deliberately hagiographized the tale of Constance, the narrative follows the familiar pattern of romances concerning persecuted queens vindicated and restored to happiness. The tale is replete with romance amplifications, learned figures, *oratio erecta*, and references to Latin authorities. As Dieter Mehl writes:

The variety of genres in the *Canterbury Tales* . . . does not only spring from the poet's pleasure in his own narrative art; it is at the same time an expression of his consummate ability in literary parody, in the widest sense of the term. Chaucer did not write romances in the sense that the authors of *Octavian* or even *Kyng Alisaunder* did, he parodied them – not only in *Sir Thopas*, where it seems most obvious, but also in the tales of the Squire, the Franklin, and the Man of Law, parody being here not so much understood as derision, but as exaggerated, brilliantly precise, and detached imitation. The poet seizes on certain characteristic examples from the wealth of formulas and motifs in the romances, such as the miraculous vision, the use of magic or the long-suffering woman, and transforms them by his art, an art that is very different from the spirit of the romances.[26]

The romance form imparts authority to Chaucer's narrator in the MLT, and he uses many clerkly romance contrivances, often reversing them for ironic effect. Steeped in the romance tradition, the clerk poet is neither timid nor modest and utilizes his new romance skills in the reconstruction of hagiographic narrative. The poet-clerk and narrator-*persona* share an identity as close as that we find in *Sir Thopas*. Chaucer always tells romances through the mouth of others – never in his own person. The narrator in *Sir Thopas* parodies romance conventions which were treated in all seriousness by Chaucer in his other works. In the MLT, Chaucer assumes a second-order pilgrim narrator role, and we hear Chaucer's own voice filtering through with delicate ironies. His poetic voice is joined to the hagiographic form, and a personal *translatio* governs his relationship to the romance.

The thirteenth-century search for truth in the literature of imagination and for the authenticity of poetry continued in the fourteenth and fifteenth centuries in England. Attacks on verse narrative and its efficacy as discourse remained strong as prose came to be identified, more and more, with truth.[27] These attacks may account in part for the waning of hagiographic poems and the rise of prose hagiography in the form of prose translations and redactions from Latin and French sources. The new prose hagiography, which was taken to be more authentic, lacks many of the romance devices which contributed to the literary representation of

the myth in hagiographic poems. In addition, the appearance in the thirteenth and fourteenth centuries of compilations, collections, and legendaries of the lives of the saints, written mainly in prose and chiefly following the order of the liturgical year, tended to shorten and condense the narrative form of each Life, abbreviating and eliminating the literary character of the genre. The success of Jacobus de Voragine's *Legenda Aurea*, written in Latin about 1260 and designed as a breviary for the layman, is seen in the numerous translations (in both French and English), adaptations, and elaborations in the fourteenth century. Yet despite the attacks on the authenticity of verse narrative and the rise of prose hagiography (and romance), Chaucer found new ways to serve poetry. He knew that the old forms, as such, were no longer viable, but he had also learned from the old hagiographers and romancers that poetry is clerkliness and the clerk's role is to preserve truth. By transforming the rambling account of Constance in the Anglo-Norman prose chronicle of Trevet, Chaucer renewed traditional procedures and kept poetry alive.

Patterns can be half glimpsed in their form. The use of the rime royal stanza in four of the five saints' Lives is indeed significant.[28] Like Chaucer's prose pieces, these pathetic tales are distinguished by poetic form as well as by content. Although the octosyllabic couplet became the standard verse form for both saints' Lives and romances, there are numerous examples of saints' Lives written in lyric stanzas. Matthew Paris illustrated his saints' Lives with pictures of the saints, arranged in pairs and each accompanied by a lyric stanza.[29] The Life of Thomas Becket by Benet, a monk at St. Albans, is more than 14,000 lines long and written in tail rime stanzas.[30] The lyric stanza, especially in tail rime, became very popular among Middle English romancers in East Anglia and is parodied by Chaucer in *Sir Thopas*. Probably derived from and written in imitation of Latin hymns, the lyric stanza was perhaps used in saints' Lives and romances because they were intended to be chanted in church services or intoned before large audiences in the Hall. There is evidence that some saints' Lives were used as sermons to be read and sung on their feast days.[31]

In the MLT, the rime royal stanza serves the paratactic structure of the tale. The seven-line stanza forms a repetitive, metrical unit which effectively and economically serves the series of narrative frames or pictures in the exemplary life of Constance. The rime royal stanza is a pathetic medium which was first used in English by Chaucer in his "Complaint unto Pity" and "Complaint to his Lady," early lyrics written in the literary form of a complaint, manifesting a concern with metrical technique and experimentation. The use of the lyric stanza in the MLT also serves the lyric narrator-protagonist figure. The lyric ego of the narrator, who experiences the poem for us, is linked to the story he recounts as he practices his poetic craft. In the lyric stanza form, the narrator's lyric

self takes on substance as he recounts the pathetic tale of a wronged woman, an appropriate subject for a lyrically oriented narrator. As a result, the MLT is a highly contrived work, and its complex pattern is manifested in the poetic form, as it is in content. In resuscitating the story of Constance, Chaucer revives the *persona* of a clerkly narrator figure and instills in his narrator a new kind of truth closely linked to lyric modes. Hagiographic romance is renewed with fresh purpose and new unity.

NOTES

1. See, for example, J. Burke Severs, "The Tales of Romance," *A Companion to Chaucer Studies*, ed. Beryl Rowland (Toronto: Oxford University Press, 1968), pp. 229–30. For a recent discussion of some of these tales, see Robert M. Jordan, "The Question of Genre: Five Chaucerian Romances," *Chaucer at Albany*, ed. R. H. Robbins (New York: Burt Franklin & Co., 1975), pp. 77–103.

2. On didactic or exemplary romance as a genre, see H. Schelp, *Exemplarische Romanzen in Mittelenglischen*, Palaestra 246 (Göttingen: Vandenhoeck and Ruprecht, 1967), p. 252. Schelp has shown that the didactic romance is different from the purely narrative poem and must be understood through its exemplary purpose.

3. Max Wehrli, "Roman und Legende im deutschen Hochmittelalter," in *Worte und Werte: Festschrift Bruno Markwardt*, eds. G. Erdmann and A. Eichstaedt (Berlin: de Gruyter, 1961), pp. 428–9; and Wehrli, *Formen mittelalterlicher Erzählung. Aufsätze* (Zurich-Freiburg i. Br., 1969), pp. 155–76. On the genre of hagiography, see René Aigrain, *L'Hagiographie: ses sources, ses methodes, son histoire* (Paris: Bloud & Gay, 1953), pp. 132–76. For a critical review of scholarship on saints' legends by C. Horstmann, B. ten Brink, and G. H. Gerould, see Theodore Wolpers, *Die englischen Heiligenlegenden des Mittelalters* (Tübingen: Max Niemeyer Verlag, 1964) and Charlotte D'Evelyn and Frances A. Foster, "Saints' Legends," *A Manual of the Writings in Middle English 1050–1500*, ed. J. Burke Severs, vol. 2 (Hamden, Connecticut: Archon Books, 1970), pp. 410–81.

4. For the *vita/passio* distinction, see Hippolyte Delehaye, *The Legends of the Saints: An Introduction to Hagiography*, trans. V. M. Crawford (Notre Dame, Ind.: University of Notre Dame Press, 1961), pp. 92–8; and Delehaye, *Sanctus, essai sur le culte des saints dans l'antiquité* (Paris: Société des Bollandistes, 1927).

5. Ludwig Bieler, "Hagiography and Romance in Medieval Ireland," *Medievalia et Humanistica*, New Series 6 (New York: Cambridge University Press, 1975), p. 13.

6. Charles Plummer ed., *Vitae sanctorum Hiberniae* (Oxford, 1910), vol. I, xcv, n. 3.

7. Hippolyte Delehaye, *Les Passions des martyrs et les genres littéraires* (Brussels: Société des Bollandistes, 1921), esp. Ch. IV.

8. Bieler, *op. cit.*, p. 13. On the connection between aretalogy and Christian narrative, see Richard Reitzenstein, *Hellenistische Wunderezählungen* (Leipzig, 1906). On the origin and development of aretalogy, its relationship to Hellenistic romance, and its transformation into Christian legend,

see Moses Hadas, *Hellenistic Culture: Fusion and Diffusion* (New York: Columbia University Press, 1959), pp. 170–81. On the relationship of aretalogy to classical romance, see Rosa Söder, *Die apokryphen Apostelgeschichten und die romanhafte Literatur der Antike*, Würzburger Studien zur Altertumswissenschaft, vol. III (Stuttgart: W. Kohlhammer, 1932).

9. M. Dominica Legge, "Anglo-Norman Hagiography and Romances," *Medievalia et Humanistica*, New Series, 6 (New York: Cambridge University Press, 1975), pp. 41–9; and Legge, *Anglo-Norman Literature and its Background* (Oxford, 1963), pp. 206–42.

10. Derek Pearsall, "John Capgrave's Life of St. Katharine and Popular Romance Style," *Medievalia et Humanistica*, New Series 6 (New York: Cambridge University Press, 1975), p. 121.

11. Peter F. Dembowski, "Literary Problems of Hagiography in Old French," *Medievalia et Humanistica*, New Series 7 (New York: Cambridge University Press, 1976), pp. 119–21.

12. On the style of Old French narrative poetry, see Karl D. Uitti, *Story, Myth, and Celebration in Old French Narrative Poetry 1050–1200* (Princeton: Princeton University Press, 1973), pp. 49–61. I am in general indebted to Uitti's insights for some of my comments on Old French narrative.

13. B. A. Bujila, ed., *Rutebeuf: La Vie de sainte Marie l'Egyptienne* (Ann Arbor, Mich., 1949); E. Faral and J. Bastin, eds., *Oeuvres complètes de Rutebeuf*, vol. II (Paris, 1960), pp. 9–59; P. F. Dembowski, ed., *Le Vie de sainte Marie l'Egyptienne. Versions en ancien et en moyen français* (Paris-Genève: Publications Romanes et Françaises, 1976).

14. All references to the text of the Man of Law's Tale are from *The Works of Geoffrey Chaucer*, ed. F. N. Robinson, 2nd ed. (Boston: Houghton Mifflin, 1957), pp. 62–75.

15. See Robert A. Pratt, "Chaucer and *Les Cronicles* of Nicholas Trevet," *Studies in Language, Literature, and Culture of the Middle Ages and Later*, eds., E. B. Atwood and A. A. Hill (Austin: University of Texas Press, 1969), pp. 303–11; M. D. Legge, *Anglo-Norman Literature*, pp. 298–302; Ruth J. Dean, "The Manuscripts of Nicholas Trevet's Anglo-Norman *Cronicles*," *Medievalia et Humanistica*, fasc. XIV (1962), pp. 95–105; and W. F. Bryan and G. Dempster, eds., *Sources and Analogues of Chaucer's Canterbury Tales* (Chicago: University of Chicago Press, 1941), pp. 155–206. For a possible reference to John of Gaunt's second wife, see Roland M. Smith, "Chaucer's Man of Law's Tale and Constance of Castile," *Journal of English and Germanic Philology*, 48 (1948), 343–51; Edith Rickert, *Chaucer's World*, eds. C. C. Olson and M. M. Crow (New York: Columbia University Press, 1948), p. 325; A. C. Edwards, "Knaresborough Castle and 'The Kynges Modres Court,'" *Philological Quarterly*, 19 (1940), 306–9; and Mary Giffin, *Studies on Chaucer and His Audience* (Quebec: Les Editions l'Eclair, 1956), pp. 79–88 and notes.

16. See Ruth J. Dean, "Nicholas Trevet, Historian," *Medieval Learning and Literature Essays Presented to R. W. Hunt*, ed. J. J. G. Alexander and M. T. Gibson (Oxford, 1976), pp. 328–52. Dean suggests that Trevet had in mind a wider audience for his history than the circle of Princess Mary, because he continued to work on the *Cronicles* after Mary's death (p. 348).

17. Morton W. Bloomfield, "The Man of Law's Tale: A Tragedy of Victimization and a Christian Comedy," *PMLA*, 87 (1972), 384–90. See also Edward A. Block, "Originality, Controlling Purpose, and Craftsmanship in Chaucer's *Man of Law's Tale*," *PMLA*, 68 (1953), 572–616; Bernard I.

Duffy, "The Intention and Art of *The Man of Law's Tale*," *English Literary History*, 14 (1947), 181–93; Paull F. Baum, *"The Man of Law's Tale*," *Modern Language Notes*, 64 (1949), 12–14; John A. Yunck, "Religious Elements in Chaucer's *Man of Law's Tale*," *English Literary History*, 27 (1960), 249–61; Robert E. Lewis, "Chaucer's Artistic Use of Pope Innocent III's *De Miseria Humane Conditionis* in the Man of Law's Prologue and Tale," *PMLA*, 81 (1966), 485–92. All of these articles discuss the effect of Chaucer's additions to his source. Bloomfield's article is concerned with the *persona*-figure of the narrator.

18. See Michael R. Paull, "The Influence of the Saint's Legend Genre in the *Man of Law's Tale*," *Chaucer Review*, 5 (1971), 178–94. See also Paul Strohm, "Passioun, Lyf, Miracle, Legende: Some Generic Terms in Middle English Hagiographical Narrative," *Chaucer Review*, 10 (1975), pp. 62–75, 167–9.

19. Erich Auerbach, *Mimesis: The Representation of Reality in Western Literature*, tr. W. R. Trask (Princeton: Princton University Press, 1953), pp. 114–5.

20. Block, *op. cit.*, p. 616.

21. See Thomas J. Heffernan, "An Analysis of the Narrative Motifs in the Legend of St. Eustace," *Medievalia et Humanistica*, New Series 6 (New York: Cambridge University Press, 1975), pp. 63–89.

22. A. B. Lord, *The Singer of Tales* (Cambridge, Mass.: Harvard Univ. Press, 1960), p. 220.

23. See Uitti, *op cit.*

24. Margaret Schlauch, *Chaucer's Constance and Accused Queens* (New York: New York Univ. Press, 1927); Bryan and Demptster, *op. cit.*, pp. 158–69; Schlauch, *English Medieval Literature and Its Social Foundations* (Warszawa: Panstwowe Wydawnictwo Naukowe, 1956), pp. 264–69.

25. Northrop Frye, *The Secular Scripture: A Study of the Structure of Romance* (Cambridge, Mass.: Harvard University Press, 1976), p. 113.

26. Dieter Mehl, *The Middle English Romances of the Thirteenth and Fourteenth Centuries* (New York: Barnes & Noble, 1969), pp. 255–6.

27. G. Doutrepont, *Les Mises en prose des épopées et des romans chevaleresques du XIV^e au XV^e siècles* (Bruxelles, 1939), pp. 380–413.

28. See also Charles Muscatine, *Chaucer and the French Tradition* (Berkeley: University of California Press, 1957), writes that rime royal in *CT* "is always an implement of seriousness" (p. 192); Robert Payne, *The Key of Remembrance: A Study of Chaucer's Poetics* (New Haven: Yale Univ. Press, 1963), comments that "It would seem, more precisely, that in *CT* it is always an implement of a particularly concentrated artifice of emotion" (p. 165); and Bloomfield, *op. cit.*, notes that "the rime royal stanza is a cutting and periodic verse style; it dismembers the flow of meaning into discrete units" (pp. 388–9).

29. See R. Vaughan, *Matthew Paris* (Cambridge: Cambridge Univ. Press, 1958).

30. *La Vie de Thomas Becket par Beneit*, ed. B. Schlyter (Lund and Copenhagen, 1941).

31. See G. R. Owst, *Literature and Pulpit in Medieval England*, 2nd ed. (Oxford: Blackwell, 1961), p. 123.

Some Recent Works for Palaeographers

M. L. COLKER

Indispensable to palaeographers are illustrated catalogues of manuscripts bearing indications of date and place of origin. Recognizing the need for such catalogues, the first international colloquium on palaeography, held at Paris in 1953, and the international committee on palaeography, instituted in 1957, set into motion the establishment of inventories (with photographs) of all Western dated and localized manuscripts, exclusive of documents, before 1600 A.D.

France, home-country of the proposal, published, between 1959 and 1965, three volumes describing dated and localized manuscripts.[1] Each volume is accompanied by an album of plates. Volume I (1959) deals with Musée Condé and Paris libraries other than the Bibliothèque Nationale; volume II (1962) covers the Bibliothèque Nationale Latin manuscripts 1–8000; and volume V (1965) examines the libraries of eastern France. In 1964 Holland published its first volume, with album, for dated manuscripts in Dutch libraries.[2]

These catalogues and succeeding ones follow much the same pattern. Detailed notices are given for texts that can be exactly, or almost exactly, dated, and an effort is made to present a photograph of each of these texts. Summary descriptions are provided for texts that have vague dating or have dates that are in doubt or rejected. The detailed descriptions normally call attention to the self-numbered and collection, leaves to which the date applies, the date, place or origin, contents, number of leaves, dimensions, number of columns and lines, decoration, watermarks, if any, scribe and recipient if they are known, provenance. Each volume regularly contains bibliography and indices.

More recently, Belgium, France again, Italy, and Austria have contributed to the project, and I shall now survey their achievements in the second half of the 1960s and first half of the 1970s.

In 1968 Belgium produced a volume for manuscripts in its public libraries, like the city libraries of Bruges and Mons and the library of the University of Liège, which bear a date before 1500, that is, from 819 to 1400.[3] A second Belgian volume, appearing in 1972, reported on manuscripts of the Bibliothèque Royale at Brussels which are dated 1401–40.[4] The earlier of these volumes has 217 plates; the later book has 415 plates. Volume I describes in detail 96 manuscripts, and volume II describes in detail 221. Of all these manuscripts only 2 are from before the twelfth century, 5 are of the twelfth century, and 21 are of the thirteenth century (1236–95 A.D.). Volume I contains accounts of manuscripts from such monastic sources as St. Martin's of Tournai and St Peter's of Lobbes. Important manuscripts include Bruges 269, dated 1294–5 and containing *Sermones* and *Distinctiones* of Nicholas de Goran, which were written close to the time of the author (he died *ca.* 1295), and Bibl. Roy. IV 248, a text of the *Sermones* of Nicholas de Dinckelsbühl, apparently finished by a student of his at Vienna just three days after Nicholas died there on 17 March 1433.

The Belgian catalogues do not offer any history of their collections, a real desideratum. Also missing sometimes are identifications of watermarks. Thus, "Les filigranes tendent à confirmer la date" (II, 29 and 48) is unaccompanied even by a reference to C. M. Briquet.[5] At the same time readers may find the diplomatic edition of colophons annoying. Here is a typical specimen (I, 29), showing part of a colophon in Bibl. Roy. 4459–70:

q(u)a(m)obrem p(re)catur l(e)c(t)uros in eo q(uod) dic(er)e ueli(n)t anima ei(us) cu(m) a(n)i(m)ab(us) o(mn)i(u)m fideliu(m) defu(n)c(t)or(um). p(er) [] d(e)i m(isericord)iam. (et) p(er) i(es)u (christ)i sang(ui)nis asp(er)t(i)o(n)em.

There seems little justification for presenting such a broken unreadable text when the abbreviations are ordinary, presenting no problem and when, anyhow, the colophons are reproduced in photographs.

In the same year as Belgium printed its first volume (1968), France issued a catalogue of dated manuscripts in libraries of Burgundy, central and southern France, including an album of 200 plates.[6] These plates exhibit pages dating from before 666/7 to 1596. Represented are 12 pre-twelfth-century manuscripts, 19 of the twelfth century, 29 of the thirteenth century. The manuscripts are in such cities as Dijon (which has about 300 codices from Cîteaux), Autun, Lyons, Grenoble, Avignon, Aix, Montpellier (which has about 60 codices from Clairvaux), Toulouse, and Narbonne. But many books have been removed. Thus, the manuscripts of Cluny and of St. Martial of Limoges are now mostly in the Bibliothèque Nationale, and important manuscripts of Burgundy are in Belgium. Indeed, religious, political, and economic upheavals have caused great dispersals and losses in books for southern France. Virtually nothing remains, for instance, of the Dominican library at Dijon, which had 301 books in 1307.[7] Even so, the volume reports on some remarkable manuscripts, like Avignon 297, containing a *Speculum Sanctorale* partly in the hand of its author Bernardus Guidonis, and Dijon 610, containing an inventory of books of Notre-Dame of Cîteaux. The photographs are normally very clear, except for the partly fuzzy upper illustration of plate XVI, and it is regrettable that the dates were cut off in the lower illustration of plate CV and in the upper illustration of plate CXLI.

Another French catalogue (with album) was published in 1974,[8] as a sequel to the 1962 catalogue for the Bibliothèque Nationale.[9] The newer work describes B.N. lat. manuscripts 8001 to 18613. The 255 plates show pages from about 652 manuscripts ranging from 528 or 550 to 1598 A.D. About 58 of these manuscripts were penned before 1200, about 55 in the twelfth century, about 85 in the thirteenth century. The texts had been in such places as the monasteries of Saint-Germain-des-Prés and Saint-Victor and in the Sorbonne. Among the outstanding manuscripts treated in the volume are the original exemplars of Richerus' *Gesta Senoniensis ecclesiae* (lat. 10016), of Radbertus's *Vita S. Adalhardi* (lat. 18296), and probably of Odo de Vaucemani's *De Gauchero abbate* (lat. 10940).

The regular practice in the French catalogues is to name up to three works in a codex and to restort to "Miscellanea" when a codex has three or more works. But B.N. lat. 15467 is described (p. 429) only as *Biblia*, whereas the plate (LVI) shows the opening of Peter of Poitier's *Compendium historiae in genealogia Christi* ("Considerans hystorie sacre prolixitatem . . .").[10] Despite the substantial girth of the two French catalogues, misprints seem rare, though one instantly catches in the 1968 catalogue "sir Thomas Phillips" for "Sir Thomas Phillipps" (p. xxix n. 2) and in the 1974 catalogue "B. ULLMANN" for "B. ULLMAN" (p. 75).

During the interval between these two catalogues, in 1971, the first Italian effort for the project entered the field. This volume, with album of 213 plates, encompasses 127 codices in the Biblioteca Nazionale Centrale of Rome.[11] The codices extend in time from 825 or 837 to 1596. Twenty-four of the books are of the ninth century, two of the eleventh century, four of the twelfth century, and only five of the thirteenth century. Noticed in the catalogue are texts from Italian centers like Farfa, Nonantola, Venice, Mantua, and Cremona, as well as from abroad, for example, from Spain and France. The catalogue is particularly rich in names of scribes: No fewer than sixty-two copyists (mainly of the fifteenth century) are represented.[12] Apart from the early Nonantola texts (ninth to eleventh centuries), of special interest are three autograph codices of Gregorius Catinensis (Farf. 1, 2, 3).

The catalogue often records and expands abbreviations found in the manuscripts, even when these are standard for the period. So, there seems hardly any point in listing (p. 68) for a text of about 1193 the normal abbreviations for *-bus, -que, omnes, -orum, -tur, tria, uero*. In the case of Vitt. Em. 1016 the catalogue declares (p. 122), "anche la filigrana conferma la datazione," without identifying this watermark.

Austria, too, has become active in cataloguing dated and localized manuscripts, and three volumes are now devoted to such manuscripts in the Nationalbibliothek at Vienna.[13] Each volume is in two parts, providing a book for descriptions and a book for plates. Volume I (1969) deals with manuscripts from 782 or 795 to 1400 A.D.; volume II (1971) with those from 1401 to 1450; volume III (1974) with those from 1451 to 1500. Volume I has 272 photographs, volume II has 517, and volume III has 633. Twenty of the manuscripts are from before the twelfth century, about 12 are of the twelfth century, 20 of the thirteenth century. Codices arrived from such sources as the monasteries of Mondsee, Aggsbach, Maurbach, the University of Vienna, as well as Johannes Sambucus and Prince Eugene of Savoy. A copy of Wolfram von Eschenbach (cod. ser. 2643) had belonged successively to Wenzel I (IV), Frederick III, and Maximilian I. Among the many interesting manuscripts discussed are the psalter, written all in gold around 790 for Pope Hadrian (cod. 1861); Frederick III's autograph prayer book (cod. 2674); and autograph works of Thomas Ebendorter (codd. 3423 and 4044) and of Petrus Zach (cod. 4045).

Sometimes the Austrian catalogue displays inconsistencies that may promote confusion. For example, one and the same author is called Bartholomäus Pisanus (I, 46) and Bartholomeus de S. Concordio (II, 33); and the same work by Alexander de Villa Dei is called *Grammatik* (III, 142) and *Doctrinale Puerorum* (III, 180). "Pseudo-" should have prefixed the name of Boethius in an entry (III, 69) for the *De disciplina scholarium:* Elsewhere, when appropriate, "Pseudo-" is used. Furthermore, it seems wrong to give descriptions and photographs of three manuscripts of Thomas de Hibernia's *Manipulus florum* (I, 38, 41, 42; illusts. 65–7): These texts transmit only the date, 1 July 1306, of the archetype. Likewise, it is obvious that codex 568, containing Walter of Châtillon's *Alexandreis,* cannot have been written in 1175, as stated (I, 27). The illustration (no. 37) leaves no doubt that the text was executed far into the thirteenth century: The note at the end of the poem merely aims to say when the *Alexandreis* had been composed, not when the codex was transcribed. Also, cod. 1028* is dated 1212 in the catalogue on the basis of the note "Scriptum per me fratrem Othmarum. Anno domini 1212" (I, 34; illus. 41), but no remark is made about the note's being in a very different style of handwriting, evidently later than the twelfth-century text that precedes. While the striving for telegraphic brevity in a catalogue is commendable, yet the bare

expression "Initialen" or "Initiale" (e.g. I, 44, 46; II, 34, 138) reveals nothing about the colors or motifs of the initials.

The Austrian catalogue has a fair number of errors in transcription, too, as comparison with the plates discloses: for example (II, 98; illus. 419; cod. 4476) "per me" should be "per"; (II, 101; illus. 14; cod. 4531) "per me fratrum" should be "per me fratrem"; (II, 174; illus. 19; cod. 3994) "nycolay de cotting" should be "nycolay de costing"; (II, 136; illus. 185; cod. 5294) "Jeorgium" should be "Ieorigum"; (I, 20; illus. 95a; cod. 362) "de paupertate sua" should be "de sua pauperie." Besides, p̄ must be rendered *pre*, not *prae*, for the fourteenth century (see, for example, "praedicatorem" at I, 68 [illus. 219], in a text dated 1390, and "praepositi" at I, 29 [illus. 112], in a text of 1343/4).

At first inspection there may seem much similarity between all the volumes of dated manuscripts. But closer investigation manifests differences. Only Belgium offers no history of her manuscript collections. Belgium alone limits herself to dated manuscripts and excludes those that are datable otherwise than by the clear note of the scribe, and Belgium alone gives a diplomatic edition of every colophon. But to her credit, Belgium (alone) provides a chronological arrangement for the descriptions of the manuscripts. France alone offers blank verso pages so that descriptions may be cut out or notes written on the blank sides. Only the Italian catalogue names the scripts and analyzes individual letters and abbreviations, and only this catalogue offers plates always reproducing whole manuscript pages. Both the Belgian and Austrian catalogues, but not the others, aim to give a photograph of each (main) colophon. Unlike the bound plates in the Belgian and Austrian books, the albums of the French and Italian works consist of loose plates. These sheets, a nuisance to handle, are easily disarranged or torn and are a ready prey for theft. It would also have been much better if the French catalogues had used arabic numbers for the plates, instead of such cumbersome roman numerals as CCXXXVIII; the Austrian system of numbering each illustration consecutively by arabic numbers is the best system.

But whatever the flaws, the catalogues are of inestimable value to the palaeographer. And though each catalogue has far fewer dated manuscripts for the period before the fourteenth century than afterward, yet collectively the catalogues offer much valuable material for the pre-fourteenth century, as well as for the later period. For example, awareness of the ex-libris formula of Notre-Dame at Cîteaux[14] may help in new identifications of books from this monastery, and one day readers will have, for many parts of Europe, reconstructions of monastic libraries such as that achieved for Britain by Neil Ker.[15] Some colophons in the catalogues give useful information about medieval and Renaissance people: for example, Carcassone 5 (130) reports that Jacobus Bernardis was "in decretis baccalarius, canonicus ecclesie Carcassone et rector ecclesie parrochialis de Paleiano" in 1472. Other notes, important for information about book-production, tell how long scribes worked on a book (cf. B.N. lat. 8247) or the cost of making it (cf. B.N. lat. 8028). Indeed, much information has been hitherto unavailable: For instance, the earlier Austrian catalogue of Latin manuscripts is outdated and very incomplete, especially in recording dates,[16] and for Latin codices 8823–11503 in the Bibliothèque Nationale there have been only lean lists.[17]

Recently, springing up beside the catalogues of dated manuscripts is the first fascicule (1973), of a series examining the handwriting of the Italian humanists.[18] It is the plan of the new series to provide for each entry in a fascicule a short biography of the humanist concerned, followed by notes on his handwriting and on manuscripts written by him (with extensive bibliography),

and to give, whenever possible, photographs of the different styles of handwriting used by the humanist over his life-span and for different purposes, that is, for books, annotations, letters, and documents.

The first fascicule studies Florentine writing, particularly that of Francesco Petrarca, Giovanni Boccaccio, Coluccio Salutati, Niccolò Niccoli, Poggio Bracciolini, Bartolomeo di Francesco Aragazzi of Montepulciano (secretary to Pope John XXIII, died 1429), Sozomeno of Pistoia (1387–1458, canon of Pistoia), and Giorgio Antonio Vespucci (uncle of Amerigo Vespucci and canon by 1482 of Florence). The book includes helpful lists of manuscripts associated in one way or another with these humanists. Thus, for Poggio are listed manuscripts copied by him, his lost manuscripts, his autograph and non-autograph letters, his efforts in the papal chancery, manuscripts copied by his French scribe.

The new book builds upon the works of such scholars as B. L. Ullman, A. Petrucci, and G. Billanovich but does not hesitate to modify ideas that are thought to be incorrect (see, for example, the corrections on Ullman on pp. 30, n. 9, 37, n. 51–52), and original material is given: Up to now there have apparently been no studies of the handwriting of Sozomeno and G. A. Vespucci, and no examples of Niccoli's formal hand had been known;[19] previously unnoticed documents of importance for Vespucci are printed.[20] From the book it is possible to see something of the development of humanistic script (the supposed contributions to its development by Poggio and Niccoli are left open questions, wisely) and to learn handily about the fate of the libraries of the humanists. Above all, the plates, which proceed from a note of purchase by Petrarch in 1325 (pl. 1) to undated corrections by G. A. Vespucci (pl. 25), and the details about handwritings should facilitate identification of so-far-unattributed manuscripts: The book is a great reference work for handwriting mannerisms, such as Boccaccio's framing catchwords by four dots and long dashes in the late 1340s or early 1350s and Vespucci's usually ending a text with two vertical dots, followed by a bent dash and then in Greek letters "Theo doxa."[21]

It is too bad that the fascicule could not have displayed more photographs of whole manuscript pages. In the effort to put about eight photographs on a page (generally), rather small fragments of the originals are usually shown. Also, every illustration should have been captioned with a reference to the relevant description, in order for the reader to correlate with minimum loss of time the illustrations with the notices. Finally, perhaps a tabular presentation, at least for the palaeographic sections, rather than continuous discourse, would have better enabled the reader to seize the salient palaeographic characteristics.

Anyway, just as there have been significant efforts recently for Latin palaeography, so now, at last, important work for Hebrew palaeography has been undertaken, and the first volume on Hebrew manuscripts conveying indications of date (up to 1540) has appeared, with a concomitant album of 189 loose plates.[22] Much of the information is in both French and Hebrew. Each description, in chronological sequence, is mainly like those of the catalogues of dated manuscripts in Latin script, but because it is very hard to establish a typology for Hebrew script, much more attention is given to physical features than in the other catalogues. And so the catalogue delves into matters like the quality of parchment, color of ink, the quiring, catchwords, prickings, and rulings. The book is enriched with tables for persons and places, for titles of works, for manuscripts by genre, for provenance, for present collections where the manuscripts are found. Every plate shows the full page of a manuscript.

This first volume of the Hebrew series deals only with large manuscripts (over 240 mm. in height) in France and Israel and spans the period from 1207 to 1528. Of 179 codices treated there are 23 of the thirteenth century, 48 of the fourteenth century, and 95 of the fifteenth century. Most of the works were transcribed in Western Europe, especially Spain and Italy, and many of the works, as might be expected, are biblical, talmudic, liturgical, cabbalistic, or medical, and one can see copies of Maimonides, Moses of Coucy, Isaac of Corbeil, David Quimhi, and others represented. The catalogue shows that the wanderings of certain scribes resulted in curious admixtures: Thus, items 83 and 107 have Ashkenazic handwriting but Italian ruling.

The usual close attention to detail in the catalogue arouses admiration. It is all the more surprising, then, to see occasional omissions. These include the failure to date some of the evidences of ownership in B.N. héb. 25 and to identify watermarks throughout. Statements like "filigranes (différents dans la copie de chacun des scribes)" for item 77 and "filigranes différents dans la partie ancienne et la partie récente" for item 121 cry out for elaboration. The quiring, too, is sometimes reported in vague terms, for example, "Quaternions sauf un ternion" (for item 4). Why not set up a conventional collation to show exactly where the ternion occurs? It is also unfortunate that the descriptions, as well as the plates, are on loose sheets and unpaged.

In 1972, the year that the first volume for Hebrew manuscripts came out, an international colloquium on Hebrew palaeography was held in Paris.[23] Very instructive papers were given. Malachi Beit-Arié demonstrated the importance of knowing about the physical features of Hebrew manuscripts for localizing them; Mordechai Glatzer discussed the manufacture of occidental and oriental paper; Gabrielle Sed-Rajna and Thérèse Metzger spoke on decoration in Spanish Hebrew codices (the Hebrew Bibles of Spain are famous for their masoretic ornamentation); and Mendel Metzger explained how decoration can sometimes help and sometimes mislead in dating. The papers, however, were not restricted to the study of Hebrew manuscripts, but much attention was still given to physical features. Thus, Julian Brown tried to cope with the problem about distinguishing between membranes processed in the British Isles and membranes processed on the continent; E. G. Turner investigated the format of early codices; and Jean Vezin was concerned with the different ways that catchwords were written. From the papers and the forthright discussions of them, now in book-form,[24] it is conspicuous that the colloquium was an important vehicle for the exchange of ideas on Hebrew manuscripts, particularly in the continued absence of a journal for Hebrew palaeography like *Scriptorium* for Latin palaeography.

So, in the colloquium papers, as well as in the catalogues of dated Latin (and vernacular) and Hebrew manuscripts and in the study of the writing of the humanists, there is much evidence of vigorous research with beneficial consequences, not only for the palaeographer but also for the cultural historian. May the momentum of this research endure!

NOTES

1. Charles Samaran and Robert Marichal, *Catalogue des manuscrits en écriture latine portant des indications de date, de lieu ou de copiste*, I: *Musée Condé et bibliothèques parisiennes.* Notices établies par Monique Garand et Josette Metman, avec le concours de M.-T. Vernet (Paris, 1959); Samaran and Marichal, *op. cit.,* II: *Bibliothèque Nationale, fonds latin*

(*Nos. 1 à 8.000*). Sous la direction de M.-T. d'Alverny. Notices établies par Monique Garand, Madeleine Mabille et Josette Metman (Paris, 1962); Samaran and Marichal, *op. cit.*, V: *Est de la France*. Notices établies par Monique Garand, Madeleine Mabille et Josette Metman, avec le concours de M.-T. Vernet (Paris, 1965).

2. *Manuscrits datés conservés dans les Pays-bas: Catalogue paléographique des manuscrits en écriture latine portant des indications de date*, I: G. I. Lieftinck, *Les manuscrits d'origine étrangère (816–c. 1550)* (Amsterdam, 1964).

3. *Manuscrits datés conservés en Belgique*, I: *819–1400*. Notices établies sous la direction de François Masai et de Martin Wittek, par Albert Brounts, Pierre Cockshaw, Marguerite Debae, Marianne Dewèvre, *et al.* (Brussels-Ghent: Éditions scientifiques e. Story-Scientia, 1968), 87 pp.

4. *Manuscrits datés conservés en Belgique*, II: *1401–1440, Manuscrits conservés à la Bibliothèque Royale Albert I^{er} Bruxelles*. Notices établies . . . [similar to n. 3], Marguerite Debae, Georges Dogaer, *et al.* (Brussels-Ghent: Éditions scientifiques e. Story-Scientia, 1972), 115 pp.

5. C. M. Briquet, *Les filigranes*, facsimile of 1907 edition with supplementary material, ed. A. Stevenson (Amsterdam, 1968), 4 vols.

6. Samaran and Marichal, *op. cit.*, VI: *Bourgogne, Centre, Sud-Est et Sud-Ouest de la France*. Notices établies par Monique Garand, Madeleine Mabille et Josette Metman (Paris: Éditions du Centre national de la recherche scientifique, 1968), xl, 596 pp.

7. *Ibid.*, p. xi.

8. Samaran and Marichal, *op. cit.*, V: *Bibliothèque Nationale, fonds latin (Nos. 8001 à 18613)*. Sous la direction de M.-T. d'Alverny. Notices établies par Madeleine Mabille, M.-C. Garand, Denis Escudier (Paris: Éditions du Centre national de la recherche scientifique, 1974), xxv, 834 pp.

9. See n. 1.

10. Cf. F. Stegmüller, *Repertorium Biblicum Medii Aevi* IV (Madrid, 1954), no. 6778.

11. *Catalogo dei manoscritti in scrittura latina datati o databili per indicazione di anno, di luogo o di copista*, I: Viviana Jemolo, *Biblioteca Nazionale Centrale di Roma* (Turin: Bottega d'Erasmo, 1971), 166 pp.

12. *Ibid.*, p. 8.

13. *Katalog der datierten Handschriften in lateinischer Schrift in Österreich*: Franz Unterkircher, *Die datierten Handschriften der österreichischen Nationalbibliothek* (Vienna: Verlag der österreichischen Akademie der Wissenschaften), 3 vols. (6 parts): vol. I (1969) has 104 pp.; vol. II (1971), 203 pp.; vol. III (1974), 248 pp.

14. Samaran and Marichal, *op. cit.*, VI, p. 181.

15. N. R. Ker, *Medieval Libraries of Great Britain* (2nd edn., London, 1964).

16. *Tabulae codicum manuscriptorum praeter Graecos et Orientales in Bibliotheca Palatina Vindobonensi Asservatorum* (Vienna, 1864–1899), 10 vols. See Unterkircher, *op. cit.*, I, pt. 1, p. 10.

17. See Samaran and Marichal, *op. cit.*, III, pp. vii–viii.

18. A. C. de la Mare, *The Handwriting of the Italian Humanists*, vol. I, fasc. 1 (Oxford University Press, 1973), 143 pp.

19. *Ibid.*, p. xvii.

20. *Ibid.*, p. xviii.

21. *Ibid.*, pp. 23, 112.

22. *Manuscrits médiévaux en caractères hébraïques portant des indications de date jusqu' à 1540*, I: Colette Sirat and Malachi Beit-Arié, *Bibliothèques de*

France et d'Israël, Manuscrits de grand format. Avec la collaboration de Mordechai Glatzer, Arlette Lipszyc, *et al.*, relevé des notes latines et description des reliures par Annie Genevois et Denis Gid (Paris and Jerusalem: Centre national de la recherche scientifique, Paris, and National Academy of Sciences and Letters, Jerusalem, 1972).

23. The proceedings of the colloquium were published in book-form as *La paléographie hébraïque médiévale. Colloques internationaux du Centre national de la recherche scientifique* (Paris: Éditions du Centre national de la recherche scientifique, 1974), 176 pp., 136 plates.

24. See n. 23.

The Pearl-child:

Topos and Archetype in the Middle English Pearl

ROBERT LEVINE

Occasionally, when a literary critic digs up what he perceives to be a new truth, he inadvertently buries, from his own sight at least, a perfectly useable old truth; in some cases the old truth is more nourishing than the new one. In his application of psychoanalytic commonplaces to the text of the Middle English *Pearl*, Paul Piehler seems to have forgotten the lesson Ernst Curtius taught medievalists many years ago: Rhetorical commonplaces have not only formal, but psychological significance.[1] Piehler's difficulties arise from his response to the unusually wise child-lecturer in Pearl, who had seemed to earlier readers, whose hearts had not been hardened by long acquaintance with allegorical conventions, to be devoid of filial feeling. One of her earliest modern critics, abashed by "her absolute lack of tenderness in her treatment of her father, her coldly stern rebukes, her never-changing austerity," concludes that "The Pearl is, in fact, as purely an allegorical figure as the various other beautiful ladies who before our author's time had appeared in imagination to disconsolate poets for their counsel, comfort, and illumination – Philosophy, Nature, Reason, Holy Church."[2] Not everyone, however, has been willing to accept the child as a purely allegorical creature; P. M. Kean has insisted, "But his Maiden is still of a different kind, since she represents the soul of a person who once lived, and with whom the Dreamer had the special relationship of father to child, not of lover to beloved."[3] Piehler, however, has chosen to explain some of the characteristics of the dreamer's daughter, not on the basis of her literary heritage, nor according to the bonds of kinship, but instead, by an *a posteriori* appeal to late nineteenth- and twentieth-century documents: ". . . a number of characteristics of the child-imago appear to derive not from any of its traditional and public manifestations in myth or literature, but directly from the archetypal sources which manifest themselves solely in private visions and dreams. Such sources can only be tapped in the psychologist's notebooks."[4] He then proceeds to cite an essay by Jung to provide analogies for four characteristics of the pearl-maiden which he finds otherwise unexplainable.

However, in his haste to favor archetypes drawn from non-Western literature over traditional literary sources and analogues, Piehler seems almost perversely to overlook the very strong connection between literary *topoi* and the images of the collective unconscious that Curtius insisted upon twenty-seven years ago. In tracing the *puer senex topos* from Vergil through the seventeenth century, and pausing before proceeding into a discussion of the *puella senex topos* from Pliny to Balzac, Curtius remarks:

Digging somewhat more deeply, we find that in various religions saviors are characterized by the combination of childhood and age. The name Lao-tzu can be translated as "old child." Concerning the birth of the Buddhist saint Tsongkapa . . . we are

told: "When the woman went down to the spring one day to fetch water she saw in the mirror of the water a man's face wonderfully beautiful. While she was lost in contemplation of the image, she bore a strong boy with long hair and a full white beard." Among the Etruscan gods we find Tages, "the miraculous boy with gray hair and the intelligence of old age, who was plowed up out of the ground by a plowman at Tarquinii." From the nature-worship of the pre-Islamic Arabs the fabulous Chydhyr passed into Islam. "Chydhyr is represented as a youth of blooming and imperishable beauty who combines the ornament of old age, a white beard, with his other charms."

The coincidence of testimony of such various origins indicates that we have here an archetype, an image of the collective unconscious in the sense of C. G. Jung. The centuries of late Roman Antiquity and of early Christianity are filled with visions which can often be understood only as projections of the unconscious.[5]

Curtius then proceeds to discuss the *puella senex*, a figure that certainly seems to resemble the Pearl-poet's wise child, and he concludes his remarks on the figure of the old-young woman with a Jungian cadenza:

. . . it is rooted in the deeper strata of the soul. It belongs to the stock of archaic proto-images in the collective unconscious. The attributes of the woman whom we found in Hermas, Claudian, Boethius, Balzac, correspond to the language of dreams. In dreams it can befall that beings of a higher order come to us to encourage, to teach, or to threaten. In dreams such figures can be at once small and large, young and old; they can also simultaneously possess two identities, can simultaneously be known and wholly unknown, so that – in our dream – we understand: This person is really someone else The phenomenon of rejuvenation, which occurs in all the texts we have discussed, symbolizes a regeneration wish of the personality. . . . The connections between the archaic psychological world and literary topics will become clearer when we follow the goddess Natura on her journey through the ages.[6]

The term "collective unconscious" seems to provide Curtius with some further, apparently inter-disciplinary assurance that the correspondences he detects are not merely formal, empty, and trivial. Since the term stimulates him to direct his energies to the appropriate texts, the negative associations of "collective unconscious," and particularly the notion of a racial memory, are present in his text only as potentially unpleasant connotations. Piehler, however, apparently ignoring Curtius's sanction to connect archetypes and *topoi*, has directed his energies to more questionable sources in his attempt to account for what he regards as the unusual qualities of the wise child in *Pearl*.

For Piehler, four of her qualities have analogues "only in the psychologist's notebooks: (1) the roundness of the unifying symbol . . . (2) the quaternary pattern as a form of wholeness . . . (3) the constant transformations of the maiden as pearl, flower, and as jewel . . ." and (4) the wise-child archetype as a uniter of opposites.[7] These qualities, however, are conventionally attributed to figures in many of the texts generally considered to be sources for the tradition in which the Pearl-poet was working. Christ's mother is the chief such figure. If Piehler ignored the correspondence between Mary and the pearl-child, her dreaming father certainly did not; when the child describes herself as God's bride and queen of heaven her father is astonished by what seems to him a blasphemous identity:

"Blysful," quod I, "may þys be trwe?
Dyspleseʒ not if I speke errour.
Art þou þ quene of heveneʒ blwe,
Þat al þys worlde schal do honour?"

> We leven on Marye þat grace of grewe,
> Þat ber a barne of vygyn flour[8]

The child explains to her father that no one can take away Mary's identity, but all in heaven may partake of her glory:

> The court of þe kyndom of God alyue
> Hatȝ a property in hytself beyng:
> Alle þat may þerinne aryue
> Of alle þe reme is quen oþer kyng,
> And never oþer ȝet schal depryue . . .
> (445–449)

Critics, too, have acknowledged the existence of a connection between Mary and the pearl-child. Milton Stern, for example, remarks: "The moment of introduction to the Pearl in her arbor is charged with suggestions of the Virgin and consequently of the Virgin's qualities: faithful chastity, humility, holiness, and servitude as a submissive instrument of God's will. . . ."[9] Wendell Johnson, in discussing the symbolic significance of the pearl, concludes his article with an exhortation:

Further scholarship in the background for this symbolism may augment these levels of meaning and supply a full interpretation – answering the problems of the pearl's possible use to represent the poet's own soul, or the Virgin Mary, or particular qualities – but it must take into account the complete scope of the imagery . . . which makes *The Pearl* a picture of two worlds and the means of transition between them, a vision embracing heaven and earth.[10]

Latin, English, and Italian poetry of the thirteenth and fourteenth centuries provide texts that help to interpret the symbolism upon which Professors Stern, Johnson, and Kean focus their attention; John Hoveden's thirteenth-century hymn contains an ingenious combination of the qualities that puzzled Piehler – a round unifying symbol, a quaternary pattern as a form of wholeness, and symbolic flowers:

> Ut aurora, virgo, progrederis,
> Solem tenens caelum efficeris,
> Paradisus praedigne diceris,
> Dum hunc vitae fructum protuleris.
> Solem verum dum sinu retines,
> Dum regyras, moves et sustines,
> Omni caelo tu terra praemines,
> Centrum sphaeram claudis et retines.
>
> Linearis rectae creatio
> Circulatur et fit perfectio,
> Cum extrema conectit unio
> Tuo, virgo, vernanti gremio.
>
> Artem nosti quadrantem circulum,
> Quem quadrasti carnis quadrangulum
> Sphaerae Dei dans per miraculum
> Sauciatum sanando saeculum.
> Florem foves adulescenta,
> Quo reflorent vetusta saecula,
> Flore fulges, o virgo virgula,
> Te tellurem pingit haec primula.

Sertum tibi facis de lilio,
Quod assumis de sinu proprio,
Quo cum vernas, te lucis legio
Veneratur supplex vestigio.

Sinus tuus fit iam rosarium,
Rosam gignens rosarum omnium[11]

(Virgin, you go forth like the dawn, holding the sun, you bring forth the heavens, you are rightly called a paradisal garden, until you bear the fruit of life. While you hold, rock, and support the true sun in your bosom, you, though earth, surpass all the heavens; you enclose the central sphere. The straight line becomes a circle, figure of perfection, when opposites meet in your verdant bosom. You know the art of squaring the circle; you squared the quadrangle of the flesh with the sphere of God, miraculously curing the wounded world with salvation. A young girl, you cherish the flower by means of which ancient times may reflower. You shine with that flower, O virgin, branch; this first flower adorns you, its earth. You make for yourself a garland of the lily which you take from your own breast; at the sight of you blooming with that lily, the suppliant army of light worships your footsteps. Your bosom has become a rose garden, bearing the rose of all roses.)

That Mary shares, in these stanzas, some of the qualities of the Goddess Natura, as Curtius describes her, provides further support for the hypothesis that *puella senex*, Natura, Mary, and the Pearl-child participate in a common archetype.

Any number of passages from medieval Latin hymns addressed to Mary contain the qualities Piehler finds only in psychologists' notebooks. In Walter Wilburn's elaborate fourteenth-century encomium, Mary is saluted, in the course of 972 lines, as a flower (*rosa suavissima*), as a jewel (*gemma puellaris*, *gemma feminarum*), as the shell in which the pearl is born:

Virgo munda, mundi vita,
Concha, de qua margarita
Pretiosa nascitur,
Miserere tuo servo

(Pure virgin, life of the world, shell, from which the precious pearl is born, pity your servant)

and as the uniter of opposites:

Ave, per quam uniuntur,
Coniugantur, coniuguntur
Virginali fibula
Agnus leo, via finis,
Splendor nubes, numen cinis,
Radius et nebula.[12]

(Hail, you by whose pure clasp the lamb and the lion may be joined, the road and its end, brightness and cloud, divinity and ashes, a ray of sun and fog.)

Roses, lilies, and jewels combine in the following passage from "On God Oreisun of Oure Lefdï":

al þin hird is i-schrud mid hwite ciclatune,
And alle heo beoo ikruned mid guldene krune;
Heo beoo so read so rose, so hwit so þe lilie,
Mid brihte зimstones hore krune is al biset.[13]

The Pearl-child, however, need not have borrowed her qualities exclusively from Mary; she might very well have inherited them from some other visionary figures who appear in earlier medieval and late classical texts. One of these documents is a piece of apocrypha to which Piehler refers six times in *The Visionary Landscape,* and which Curtius calls ". . . the most important document of early Christian vision literature," the *Shepherd of Hermas.*[14] It contains a number of passages that provide characteristics that closely resemble the four characteristics Piehler isolates in the *Pearl.*

For example, one passage in the *Shepherd* links round white stones with purity of heart, virginity, and small children:

De duodecimo vero candido monte tales sunt qui crediderunt: sicut parvi infantes, quibus nulla malita ascendit in corde, nec scierunt quae sit nequitia, sed semper in sinceritate manserunt. (*Sim.* IX, 29)

(And they who believed from the twelfth mountain, which was white, are the following: They are as infant children, in whose heart no evil originates; nor did they know what wickedness is, but always remained as children.)[15]

Elsewhere in the *Shepherd,* a vision is explained in which whiteness, squareness, and purity are fused:

Et quidem lapides albi et *pares in coniunctione sua* (τετράγωνοι in the Greek text), isti sunt apostoli et episcopi et magistri et ministri qui ambulaverunt in castitate et sanctitate dei (*Visio* III.5)

(These square white stones which fitted exactly into each other, are apostles, bishops, teachers, and deacons, who have lived in godly purity[16]

In yet another passage from the *Shepherd,* one of the groups of figures that appear in a series of visions is a quartet (or "quaternary pattern") of virgins:

Et dixi ei: Monstra mihi, domine, nomina virginum harum, vel illarum mulierum quae nigra veste vestitae sunt. et dixit mihi: Audi nomina harum virginum quae sunt potentiores, quaeque stant in angulis portae. haec sunt nomina earum: prima Fides, secunda Abstinentia, tertia Patientia, quarta Magnanimitas.

("Explain to me, sir," I said, "the names of these virgins, and of those women who were clothed in black raiment." "Hear," he said, "the names of the stronger virgins who stood at the corners. The first is Faith, the second Continence, the third Patience, the fourth Magnanimity.")[17]

Four virgins also appear as the artificers who open Alanus de Insulis's *Anticlaudianus,* a work in which Astronomy is represented as a virgin with a sphere in her hand; critics, including Piehler, generally agree that the Pearl-poet may very well have been acquainted with Alanus's poems.[18]

Since the pearl itself is round and white, *prima candidarum gemmarum,* according to Isidore of Seville, it seems a plausible symbol for purity, perfection, and for Mary, as well as for the dreamer's two-year-old child.[19] Although it does not present any obvious qualifications as a symbol for the union of opposites, nevertheless its lexical synonym in classical and medieval Latin was *unio.* Both Isidore and Hrabanus Maurus, in fact, considered *unio* a particularly apt word:

. . . aptum nomen habentes, quod tantum unus, numquam duo vel plures simul reperiantur. Meliores autem candidae margaritae, quam quae flavescunt. Illas enim

juventus aut matutini roris conceptio reddit candidas. Has senectus vel vespertinus aer gignit obscuras. Margaritum mystice significat evangelicam doctrinam sive spem regni coelorum, vel charitatem et dulcedinem coelestis vitae.[20]

(They have an appropriate name, because they are only found alone; two or three are never found together. The white ones are better than the yellow ones. Youth and morning dew makes them bright. Old age and evening air makes them dark. Pearl mystically signifies the teaching of the apostles or hope of the kingdom of heaven, or charity and the sweetness of heavenly life.)

One is mildly tempted to speculate that the proximity of *juventus* and *senectus* in Hrabanus's transcription of Isidore partially stimulated the Pearl-poet to connect the archetype *puella senex* with *margarita*.

Among the conventional epithets for Mary are *margarita, margarita pretiosa,* and *concha margeritifera;*[21] Saint Bernard, or someone very much like him, composed an impressive list of figures for her, including *ipsa tabernaculum Dei, ipsa templum ipsa sol, ipsa luna . . . rosa . . . margarita.* Tabernacles and temples are customarily rectangular, sometimes square; the sun and the moon are invariably round; the flower and the jewel correspond exactly to Piehler's requirements for the third quality; Bernard concludes his paragraph on Mary with a reference to her child, the uniter of opposites: *Deus humilis, et homo sublimis.*[22] Bernard's response to the *Salve Regina,* then, contains all four of the qualities, in relatively close proximity, for which Piehler could find no manifestation in myth or literature.

A passage in praise of virginity in one of Jerome's letters moves from circles to Eve and Mary (notice the appearance of *unio* again, as "union" this time), then on to flowers – both lilies and roses – and then on to a pearl:

Postquam de duritia nationum generati sunt filii Abrahae, coeperunt "sancti lapides volvi super terram." Pertranseunt quippe mundi istius turbines, et in curru Dei, rotarum celeritate volvuntur. Corsuant tunicas, que inconsutam desursum tunicam perdiderunt, quos vagitus delectat infantium, in ipso lucis exordio fletu lugentium quod nati sunt. Eva in paradiso virgo fuit: post pelliceas tunicas, initium sumpsit nuptiarum. Tua regio paradisus est. Serva quod nata es, et dic: "Revertere anima mea in requiem tuam." Et ut scias virginitatem esse naturae, nuptias post delictum: virgo nascitur caro de nuptis, et in fructu reddens, quod in radice perdiderat. "Exiet virga de radice Jesse, et flos de radice ejus ascendet". Virga Mater est Domini, simplex, pura, sincera, nullo extrinsecus germine cohaerente, *et ad similitudinem Dei unione foecunda.* Virgae flos Christus est, dicens. "Ego flos campi, et lilium convallium." Qui et in alio loco," lapis praedicatur abscissus de monte sine manibus," significante Propheta, virginem nasciturum esse de Virgine. Manus quippe accipiuntur pro opere nuptiarum, ut ibi: "Sinistra ejus sup capita meo, et dextera illius amplexabitur me." In hujus sensus congruit voluntatem etiam illud, quod animalia, quae in Arcam Noe bina inducuntur, immunda sunt: impar enim numerus est mundus. Et Moyses et Jesus Nave nudis in sanctam Terram pedibus jubentur incedere. Et discipuli sine calceamentorum onere, et vinculis pellium ad praedicationem novi Evangelii destinantur. Et milites, vestimentis Jesu sorte divisis, caligas non habebant quas tollerent. Nec enim poterat habere Dominus, quod prohibuerat servis.

Laudo nuptias, laudo conjugium, sed quia mihi virgines generant: lego de spinis rosam, de terra aurum, de concha margaritam.

(After sons of Abraham have been begotten from the hardness of the heathen, sacred stones began to roll upon the earth. And they pass through the storms of this world and are whirled in God's car with the speed of its wheels. Let them sew themselves coats who have lost the raiment that was without seam, woven from the top

throughout, those who the wailing of infants delights – a cry at the very outset of life, lamenting that they have been born. Eve was a virgin in Paradise. After the garments of skins her married life began. Paradise is where you belong. Continue as you were born and say: "Turn, O my soul, into thy rest." And that you may know that virginity is natural and that marriage came after the offense: it is virgin flesh that is born of wedlock restoring in the fruit what it had lost in the root. "There shall come forth a rod out of the root of Jesse, and a flower shall rise up out of the root." That rod is the mother of the Lord – simple, pure – having no origin of life from without clinging to its untouched body and, like God Himself, fruitful in unity. The flower of the rod is Christ, who says: "I am the flower of the field and the lily of the valleys." In another passage He is foretold to be "a stone cut out of the mountain without hands," a prophecy signifying that He would be born a virgin of a virgin. ["]Hands["] is, of course, to be understood of the marital act, as in the verse: "His left hand is under my head, and his right hand shall embrace me." That this is the intention of the meaning is shown by the fact that the animals which were led into the ark in pairs are unclean: an unequal number of the clean animals was taken; also from the fact that Moses and Joshua, the son of Nave, are bidden to walk with bare feet upon the holy ground, and the disciples are dispatched to preach the gospel without the weight of shoes and fastenings of leather; that the soldiers who divided the garments of Jesus had no shoes to carry off. For the Lord could not have what He had forbidden His servants.

I praise marriage, I praise wedlock, but I do so because they produce virgins for me. I gather roses from thorns, gold from the earth, the pearl from the shell.)[23]

Jerome, Bernard, Henry Hoveden, Dante, and Walter Wilburn present us, then, with texts in which the four qualities which Piehler isolated appear to form a matrix that only an extreme self-consciousness about jargon would prevent us from calling archetypal.

An article by D. W. Robertson, Jr. provides my final illustration of one of the kinds of reconciliations that the figure of *puella senex* made possible, in this case, for a biblical exegete. Resisting the charge that the Pearl-maiden's assertion, "In eventyde into the vyne I come" (l. 582) is evidence of an heretical perversion of the Parable of the Vineyard, Robertson compares Augustine's reading with that of Bruno Astensis. Augustine assigns particular hours of the day to particular ages:

Tanquam prima hora vocantur, que recentes ab utero matrix incipiunt esse christiani; quasi tertia, pueri; quasi sexta, iuvenes, quasi nona, vergentes in senium; quasi undecima, omino decrepiti: unum tamen vitae aeternum denarium omnes accepturi.

(Those who begin to be Christians soon after emerging from their mother's womb are those called as if at the first hour; those who become Christians as children are called as if at the third hour; those who become Christians as youths are called as if at the sixth hour; those who become Christians when growing old are as if called at the ninth hour; those who become Christians when they are altogether decrepit are as if called at the eleventh hour. But all will receive the same penny of eternal life.)

The Pearl-maiden would then seem to have arrived long after the time assigned to her age-group by Augustine, arriving in fact as *puella* at the time set aside for *senex*.

Bruno Astensis, however, provides an interpretation of the parable that obviates the necessity for fashioning ingenious connections:

Regnum Coelorum, Ecclesia est; paterfamilias, Christus Dominus noster: eius namque familia, et angeli et homines sunt: magna quidem est familia, quia magnus est et pater-

familias. Venit autem iste paterfamilias ut conduceret operarios in vineam suam. Vinea enim Domini Saboath, domus Israel est: vinea, Dei Ecclesia est: extra quam qui laborat, mercedem non recepit: in qua qui laborat, denarium suscipit. Ille enim denarius, remuneratio est aeternae beatitudinis: ideo unus denarius omnibus datur: unus primis, et unus novissimis. Et alii quidem primo mane laborare incipiunt alii vero circa horam tertiam: alii autem circa sextam, et nonam horam: alii quoque circa horam undiciman Primo namque mane in vinea Dei laborare incipiunt, qui a primaeva aetate, id est a pueritia in Ecclesia Dei Domino serviunt: illi autem circa horam tertiam laborare veniunt, qui in adolescentia servire incipiunt: veniunt autem et illi circa sextam et nonam horam, que vel in juventute, vel in senectute, ad poenitentiam convertuntur. Undecima vero hora illa est, quae in qualibet aetate fini approprinquat et morti proxima est. Hanc enim hora non solum juvenes et senes, verum etiam pueri habent.

(The kingdom of Heaven is the Church. The Householder is Christ Our Lord, whose family is made up of both angels and men. It is a great family, for the Householder is great also. That Householder went to hire workers in the vineyard. The vineyard of the Lord of Host is the House of Israel, and the vineyard of God is the Church. He who labors outside it receives no reward, but he who labors within it receives a penny. And that penny is the reward of eternal beatitude. Thus a single penny is given to all, one for the first and one for the last. Some indeed begin to labor early in the morning; others about the third hour, others about the sixth and the ninth hour, others also about the eleventh hour Those who serve from the earliest age, or from childhood, in the church of the Lord are those who begin to labor in the vineyard of God at the first hour of the morning. Those who begin to serve in adolescence are those who come to labor about the third hour. Those who are converted to penance in youth or age are those who come at about the sixth and the ninth hours. But the eleventh hour is the hour at which one of whatever age begins to serve when he approaches his end and is near death. Not only the youthful and the aged, but also even children have this hour.[24]

The pattern Robertson detects adds further support to the assertion that the Pearl-child's qualities derive from qualities traditionally associated with *puella senex, Natura,* Mary, and an impressive list of medieval allegorical women; to "tap her sources," then, one need not resort to psychologists' notebooks, but to Migne, Drèves, and Carleton Brown.

NOTES

1. Paul Piehler, *The Visionary Landscape* (London, 1971), esp. pp. 156ff.; see also my note 5.
2. W. H. Schofield, "The Nature and Fabric of the *Pearl*," *PMLA*, XII (1904), pp. 175, 201.
3. P. M. Kean, *The Pearl: An Interpretation* (New York, 1967), p. 130, n. 6.
4. Piehler, *op. cit.*, p. 156.
5. E. R. Curtius, *European Literature and the Latin Middle Ages* (New York, 1953), p. 101.
6. *Ibid.*, p. 105.
7. Piehler, *op. cit.*, p. 160.
8. *Pearl*, edited by E. V. Gordon (Oxford, 1963), ll. 421–426.
9. Milton Stern, "An Approach to The Pearl," in *The Middle English Pearl*, edited by John Conley (Notre Dame, 1970), p. 76.
10. *Ibid.*, pp. 48–49. See also P. M. Kean, *The Pearl* (New York, 1967), pp. 150ff.

11. Guido Maria Drèves, *Ein Jahrtausend Lateinischer Hymendichtung* (Bologna, 1909), vol. 1, p. 343.

12. Drèves, *Analecta Hymnica*, vol. 50, pp. 631–643. For Mary as gem, flower, and *Natura*, see also *Analecta Hymnica*, vol. 54, p. 357: *Ave gemma pudicitia Surge, surge, propera,/ Fugit hiems, floret vinea . . . ,"* as well as p. 402 of the same volume: *Virgo plena gratia . . . castitatis lilium, Iaspide splendidior . . . Rosa suavissima.*

13. *English Lyrics of the XIIIth Century*, edited by Carleton Brown (Oxford, 1932), p. 4.

14. Curtius, *op. cit.*, p. 103.

15. *Hermae Pastor*, edited by Oscar de Gebhardt and Adolfus Harnack (Leipzig, 1877), p. 255 (Sim. IX, 29); translated by F. Crumbie, in *Ante-Nicene Fathers* (Buffalo, 1855), vol. II, p. 9.

16. *Ibid.*, pp. 39–40 (*Visio* III, 5).

17. *Ibid.*, p. 229 (Sim. IX, 15).

18. For a brief note on *puella senex* in Alanus and in Martianus Capella, see Alain of Lille, *Anticlaudianus*, translated by J. J. Sheridan (Toronto, 1973), pp. 30–31.

19. *Etymologiarum sive Originum Libri XX*, ed. by W. M. Lindsay (Oxford, 1962), XVI, x, 1.

20. *Patrologia Latina*, CXI, col. 472; Hrabanus transcribes Isidore's entry, then adds the allegorical gloss: *Margaritum mystice etc.* See also Kean, *op. cit.*, pp. 143–144 for Roger Bacon's remarks.

21. *Patrologia Latina*, CCXIX, col. 511, et *alibi.*

22. *Patrologia Latina*, CLXXXIV, col. 1069.

23. *Patrologia Latina*, XXII, cols. 406–407; translation by C. C. Mierow, *The Letters of St. Jerome* (London, 1963), vol. I, pp. 151–152.

24. D. W. Robertson, Jr., "The Heresy of the Pearl," in Conley, *op. cit.*, pp. 292–294.

Chaucer Criticism

D . W . R O B E R T S O N , J R .

Aside from a few illustrations, Donald R. Howard's *The Idea of the Canterbury Tales* relies almost exclusively on secondary sources.[1] That is, the author has read a great deal of scholarship and criticism but has done very little original research, displaying only rarely first-hand information about fourteenth-century English society, its intellectual traditions, or its literary conventions. In Chapter I, in fact, he renounces historical interpretation, to concentrate instead on what *The Canterbury Tales,* as he puts it, *is,* and on the "mind" of Chaucer. Nevertheless, he does not hesitate to tell us from time to time what "medievals," as he calls them, thought about things, deriving this information from a selection of secondary materials. At the outset, an analysis of the Ellesmere portrait of Chaucer leads to the conclusion that the disproportionately small horse, and Chaucer's small legs, emphasize the head and torso to show that "the man and the poet loom over the fictional pilgrimage." Thus, as we learn in Chapter II, it is important to know the "idea" Chaucer had in mind when he wrote. The *Tales* reflect the idea of the pilgrimage, which is obvious enough, and they are, moreover, comic. For the idea of comedy Professor Howard uses the fourth-century definition of Evanthius, which he found in Cunliffe (1912). Except for some discussion of Dante, later medieval statements about comedy are disregarded. Comedy is said to imply "espousal of the world," an idea with which John of Salisbury might have agreed, but with the additional idea that this represents an unfortunate subjection to Fortune, or to Providential ill consequences.[2] But in Chaucer, Professor Howard assures us, the morality arises from the *Tales* as a whole, so that the basic idea he had in mind was that of "the book," although he concluded his book with another "book," the Parson's sermon.

The style of the "book" of the *Tales* is discussed in Chapter III, where we learn, without much astonishment, that although Chaucer related events in the past, he often used the present tense to create a sense of immediacy. Another stylistic device described is a "sense of obsolescence," especially in contrasting ideals thought to be characteristic of the past with a more reprehensible present. This is a common device of satirists and moralists, but Professor Howard does not examine events during Chaucer's lifetime to determine whether in this instance there was any basis for Chaucer's attitude. There is a diffuse discussion of irony, but again without any reference to medieval ideas about irony and its techniques. Part of the "idea" of the *Tales* is said to be "the search for the world," whose attractions are vividly revealed, especially in the "ideal" love portrayed in *Troilus*.

The "search" is examined further in Chapter IV on "Memory and Form," where it is described as being carried out on a "pilgrimage through the world," which is a part of the "idea" of the *Tales.* But the pilgrimage is a

memory of past experience, and, in this connection, a rather obscure argument is developed to show that the pilgrims in the General Prologue fall into "mnemonic groups." The author does not seem to be familiar with modern memory systems of the kind used by stage performers and card players. The tales themselves can be thought of as occupying a single day in a "symbolic" sense. But the individual tales "discredit each other." The form of the whole is that of a "memory," here compared, again obscurely, with circular designs like those of the so-called rose windows in cathedrals. This "form," we are told, also has a "structure," described in Chapter V. That is, the tales are arranged in pairs, like the Knight's Tale and the Miller's Tale, the latter discrediting the former, the Miller's Tale and the Reeve's Tale, the latter discrediting the former, and so on. This "binary" arrangement, with its "breaks" between the various fragments or groups, is said to form the basis of an "interlace" structure somewhat like that attributed by Professor Vinaver to certain romances. There follows a rapid and superficial survey of the tales, partly designed to show this structure, concluding with the Manciple's Tale, which leads us back to the General Prologue as we seek to remember the character of the Manciple. Thus, the "interlace" is "circular" before we reach the final "book" of the Parson's Tale. The "themes" said to be the basis for the interlace are things like Fortune, food, money, sex, "quitting," and so on. These are four subjects and a device, not themes. There are actual themes in the tales, like the foolishness of submission to Fortune, the ill effects of Mars and Venus (taken figuratively), the advantages of wise old age and the disadvantages of cultivating the old age of the Pauline Old Man, and so on; but these are disregarded, or even denied. However, we are offered one final analogy for the interlace structure, the labyrinth used for symbolic pilgrimages on cathedral floors. The final chapter discusses two tales of special significance, those of the Pardoner and the Parson, with emphasis on the former, which is treated with passionate expressionism, making it sound a little like a modern horror film with intense psychological realism. In general, the author is stubbornly obtuse to stylistic history and the perspectives it affords. The Parson's Tale is said to shed new light on the previous "book," so that we are forced to reflect once more on the tales we have read.

The above summary is a simplification of a diffuse and often verbose argument that almost continuously adduces complexities. It is designed, as your reviewer understands it, to enable the reader to become vicariously involved in the "book" of the *Tales*, so that reading it becomes an emotional experience somewhat like that provided by a novel, and it will undoubtedly appeal to those who relish experiences of this kind. In the course of the argument there are some dubious statements, some historical and some concerning the text. For example, we are told that chivalry was "obsolescent" and that Chaucer would have thought it to be so. From the perspective of history it is true that chivalric ideals would soon weaken and almost disappear, but Chaucer would not have known this. He and his friends were not familiar with mass warfare. Men like Clanvowe and Stury, not to mention Chaucer himself, would have thought the function of chivalry to be something like that of a modern defense establishment, and although they may well have thought that it had declined in England, they could observe without too much difficulty that it had begun to flourish in France. The Yeoman, who is dressed as a forester, is said to wear a "warlike costume." Although a reeve in the fourteenth century is by definition a manorial servant elected from among customary tenants, we are told that there were "no serfs" among the pilgrims. It is quite possible also to think of the Miller and the Plowman as serfs, remembering that the

social distinction between freemen and serfs was becoming blurred in the late fourteenth century. The Plowman's concern for his neighbors suggests strongly that he was a traditional manorial servant elected from among bondmen, and not a hired worker from outside a manor. If we accept this view, then the Parson, his brother, must have been a man of servile origin freed by his education.

The pilgrims are said to represent a "cross-section" of English society. This commonplace of criticism is true only in a very general way, for there are many gaps in the "cross-section." There are no bishops, abbots, archdeacons, or chaplains, although the last were very numerous and often unruly. There are no great magnates, officials of the royal household (except for Chaucer himself, who is not so identified), obstreperous local lords, like the notorious Lord John Fitzwalter of Essex[3] or the almost indestructible Sir Matthew Gurney of Somerset,[4] no stewards or other members of lay courts, no royal justices, apprentices at law, local lawyers, or filacers, no coroners, borough officials, city apprentices, and so on. Many familiar figures are, in fact, missing, and the problem of why Chaucer selected the groups he did has never been faced squarely; it has simply been obscured by a convenient generalization. The pilgrims are also said to be "types," but if this means that they are "typical," it is an absurdity. Chaucer himself is called a "bourgeois," although as a royal squire with war service he was very clearly a gentleman.[5] He is said to have served as a J. P., as though this were an occupation. It is true that he was named on commissions of the peace, but this does not mean that he ever attended sessions, and if he did they would have not taken much time and would have been remunerative only if he had been unscrupulous, as his Franklin evidently was.

With reference to the text, the "end" sought by Palamon and Arcite in the Knight's Tale is said to be marriage, although neither Palamon's oath to make war on chastity all his life nor Arcite's dedication to wrathful passions sounds much like an anticipation of marriage. In this connection, critics of the tale often pay little attention to the text, which does not fit their theories, and the present discussion is no exception. The miller's daughter in the Reeve's Tale, who "thikke and well ygrowen was, / With kamus nose, and eyen greye as glas, / With buttokes brode, and breestes round and hye," is said not to be "sexually desirable," except perhaps for her hair. The urgent exclamation of Nicholas in the Miller's Tale – "for deerne love of thee, lemman, I spille" – is called "courtly love parlance," although Henry of Lancaster's use of it, as he describes it in his *Les Seyntz Medicines*, can hardly be called "courtly," and similar expressions were doubtless used by persons of all ranks. The Franklin's Tale is treated reasonably, if superficially, but the Franklin himself is described as a "genial country squire," as though he might have just emerged, country-fresh, from the pages of Mr. Fielding. It may be an exaggeration to say with one authority that the sheriff's tourn after 1388 became little more than "an instrument of extortion,"[6] but there is enough truth in it, not to mention, in addition, examples of extortionate sheriffs earlier, like Robert Hacche and William Auncel of Devon,[7] to make our very wealthy and self-indulgent Franklin look more than a little suspicious.

To say that the "form" of *The Canterbury Tales* is a memory is to do little more than to place it in the very large class of narratives in the past tense, and the construct of a circular interlace pattern is not very convincing, in spite of recent tendencies among literary critics to try to make almost any work of literature operate like *Finnegan's Wake:* by "a commodious vicus of recirculation." Before we can talk about form and structure in Chaucer's

work with any real conviction we shall need to devote much study to the history of classical forms in the Middle Ages, frequently transformed into modes, first in Latin literature and then in the various vernaculars. But this kind of study has hardly begun. In the present work Chaucer's wit, humor, and vigor suffer because of a failure to appreciate the specific relevance of what he had to say to fourteenth-century English life. More importantly, although the author does make notable concessions to Chaucer's moral ideals, he does not take them seriously enough to provide the necessary vantage for a humorous stance. Finally, it is unfortunate that Professor Howard did not devote more of his considerable energy and intelligence to primary research. It is to be hoped that university presses will in the future demand more such research, and the intelligent use of it, from their authors and that their assigned readers will be more alert to the need for it. If they do not do so, much Chaucer criticism is likely to remain frothy and insubstantial.

NOTES

1. Donald R. Howard, *The Idea of the Canterbury Tales* (Berkeley: The University of California Press, 1976).
2. *Policraticus*, 3.8, ed. Webb, 1.190–199.
3. See Elizabeth Chapin Furber, *Essex Sessions of the Peace 1351, 1377–79*, Essex Archaeological Society Occasional Publications, 3 (1953), pp. 61–62, 82–90.
4. Isobel D. Thornley and T. F. T. Plucknett, eds., *Year Books of Richard II: 11 Richard II* (Ames Foundation, Cambridge, Mass.: Harvard U. Press, 1937), pp. xiii–xvi and 170–174. In spite of his extortions and other felonies, Gurney was named on commissions of the peace and of oyer and terminer in 1381–85 and on peace commissions again in 1388–92. He became a member of King's Council under Henry IV, and died in 1406 at the age of 97.
5. Cf. N. Denholm-Young, *Country Gentry in the Fourteenth Century* (Oxford, 1969), p. 24. The word *bourgeois*, unless it means simply residents of boroughs and cities, makes little sense in fourteenth-century terms. Many members of the higher nobility had residences in London. London merchants were sometimes knighted, and many more of them would have been knighted if the Crown had had its way.
6. I. S. Leadam and C. S. Baldwin, eds., *Select Cases before the King's Council 1213–1482* (Selden Society, Cambridge, Mass.: Harvard U. Press, 1918), lxxxvi. On sheriffs generally, see lxxxiii–lxxxix.
7. Bertha Haven Putnam, ed., *Proceedings before the Justices of the Peace in the Fourteenth and Fifteenth Centuries* (Ames Foundations, London, 1938). For Hacche, see pp. 63, 73–74, 76–77, 80; for Auncel, pp. 74–75, 77–78. See further, N. Neilson, *Customary Rents in Oxford Studies in Social and Legal History*, II (1912), pp. 140, 147–148; Helen M. Cam, *The Hundred and the Hundred Rolls* (London, 1930), 67–85, 106. For an amusing endorsement of the corruption of sheriffs by local lords, see John Smyth, *The Lives of the Berkeleys* (Bristol and Gloucester Archaeological Society, 1883), I, p. 307.

Books Received

This list was compiled from books received between 16 February 1976 and 8 February 1977. The publishers and the editorial board would appreciate your mentioning *Medievalia et Humanistica* when ordering.

Abailard, Peter. *Sic et Non: A Critical Edition.* Eds. Blanche Boyer and Richard McKeon. Chicago: Univ. of Chicago Press, 1976. Fascicle 1, pp. 98. Fascicle 2, pp. 192. $14.00 ea.

Ahl, Frederick M. *Lucan: An Introduction.* Ithaca: Cornell Univ. Press, 1976. Pp. 379. $19.50.

Allmand, C. T., ed. *War, Literature and Politics in the Late Middle Ages.* New York: Barnes & Noble Books, 1976. Pp. xii, 202. $26.50.

Anderson, Judith H. *The Growth of a Personal Voice:* "Piers Plowman" *and* "The Faerie Queene." New Haven: Yale Univ. Press, 1976. Pp. ix, 240. $15.00.

Armstrong, Edward A. *Saint Francis, Nature Mystic: The Derivation and Significance of the Nature Stories in the Franciscan Legend.* Berkeley: Univ. of California Press, 1976. Pp. 270. $5.95 paper.

Balog, Paul. *Umayyad, Abbasid and Tulunid Glass Weights and Vessel Stamps* (Numismatic Studies 13). New York: American Numismatic Society, 1976. Pp. 322, 55 plates. $45.00.

Barraclough, Geoffrey. *The Crucible of Europe: The Ninth and Tenth Centuries in European History.* Berkeley: Univ. of California Press, 1976. Pp. 180. $6.95 paper.

Beale, Walter H., ed. *Old and Middle English Poetry to 1500: A Guide to Information Sources.* Detroit: Gale Research Company, 1976. Pp. xxiii, 454. $18.00.

Beebe, Ruth Anne. *Sallets, Humbles, and Shrewsbery Cakes: A Collection of Elizabethan Recipes Adapted for the Modern Kitchen.* Boston: David R. Godine, 1976. Pp. xxxii, 92. $12.50.

Bélanger, J. L. Roland. *Damedieus: The Religious Context of the French Epic. The Loherain Cycle Viewed Against Other Early French Epics.* Geneva: Librairie Droz, 1975. Pp. xxviii, 299.

Bergweiler, Ulrike. *Die Allegorie im Werk von Jean Lemaire de Belges.* Geneva: Librairie Droz, 1976. Pp. 242.

Bessinger, Jess B., Jr., and Robert R. Raymo, eds. *Medieval Studies in Honor of Lillian Herlands Hornstein.* New York: New York Univ. Press, 1976. Pp. viii, 225.

Björnbo, Axel Anton. *Die Mathematischen S. Marcohandschriften in Florenz,* ed. by Gian Carlo Garfagnini. Pisa: Domus Galilaeana, 1976. Pp. xviii, 162.

Bodin, Jean. *Colloquium of the Seven About Secrets of the Sublime*. Trans. Marion L. D. Kuntz. Princeton: Princeton Univ. Press, 1975. Pp. lxxxi, 509. $25.00.

Bolgar, R. R., ed. *Classical Influences on European Culture A.D. 1500–1700*. New York: Cambridge Univ. Press, 1976. Pp. xviii, 383. $32.50.

Branca, Vittore. *Boccaccio: The Man and His Works*. Trans. Richard Monges. New York: New York Univ. Press, 1976. Pp. ix, 341. $19.50.

Brooke, C. N., D. E. Luscombe, G. H. Martin, and Dorothy Owen, eds. *Church and Government in the Middle Ages*. New York: Cambridge Univ. Press, 1976. Pp. xv, 312. $32.50.

Chaucer, Geoffrey. *Troilus and Criseyde*. Eds. Donald R. Howard and James Dean. New York: The New American Library, Inc., 1976. Pp. lvi, 327. $1.95 paper.

Cipolla, Carlo M. *Public Health and the Medical Profession in the Renaissance*. New York: Cambridge Univ. Press, 1976. Pp. vii, 136. $14.50.

Clemoes, Peter, ed. *Anglo-Saxon England, 5*. New York: Cambridge Univ. Press, 1976. Pp. x, 320. $27.50.

Constable, Giles. *Medieval Monasticism: A Select Bibliography*. Toronto: Univ. of Toronto Press, 1976. Pp. xx, 171. $6.50.

Davis, Natalie. *Society and Culture in Early Modern France*. Stanford: Stanford Univ. Press, 1975. Pp. xviii, 362, 18 plates. $15.00.

De Gaetano, Armand L. *Giambattista Gelli and the Florentine Academy: The Rebellion Against Latin*. Firenze: Leo S. Olschki Editore, 1975. Pp. 431.

de Mézières, Philippe. *Letter to King Richard II: A Plea Made in 1395 for Peace Between England and France*. Trans. G. W. Coopland. New York: Barnes & Noble Books, 1976. Pp. xxxiv, 152. $30.00.

Dennys, Rodney. *The Heraldic Imagination*. New York: Clarkson N. Potter, Inc., 1975. Pp. 224. $15.00.

Dobson, E. J. *The Origins of Ancrene Wisse*. Oxford: Clarendon Press, 1976. Pp. 441. $37.50.

Dobson, R. B., and J. Taylor. *Rymes of Robyn Hood: An Introduction to the English Outlaw*. Pittsburgh: Univ. of Pittsburgh, 1976. Pp. x, 330. $12.95.

Dols, Michael W. *The Black Death in the Middle East*. Princeton: Princeton Univ. Press, 1977. Pp. xvii, 390. $19.50.

Donaldson, E. Talbot, ed. *Essays and Studies*. Atlantic Highlands, New Jersey: Humanities Press, 1976. Pp. 121. $4.50.

Douglas, David C. *The Norman Fate: 1100–1154*. Berkeley: Univ. of California Press, 1976. Pp. xv, 258, 8 plates, 5 maps. $22.50.

Edwards, Jr., Mark U. *Luther and the False Brethren*. Stanford: Stanford Univ. Press, 1975. Pp. 242. $10.00.

Elbow, Peter. *Oppositions in Chaucer*. Middletown, Conn.: Wesleyan Univ. Press, 1975. Pp. 180. $12.00.

Erasmus, Desiderius. *Collected Works of Erasmus*. Volume 3: *The Correspondence of Erasmus, Letters 298 to 445 (1514 to 1516)*. Trans. R. A. B. Mynors and D. F. S. Thomson, annot. James K. McConica. Toronto: Univ. of Toronto Press, 1976. Pp. xvi, 392. $25.00.

Erickson, Carolly. *The Medieval Vision: Essays in History and Perception*. New York: Oxford Univ. Press, 1976. Pp. 247. $3.00 paper.

Evans, G. B., ed. *Shakespeare: Aspects of Influence*. Cambridge, Mass.: Harvard Univ. Press, 1976. Pp. 211. Cloth $12.50, paper $3.95.

Fairfield, Leslie P. *John Bale: Mythmaker for the English Reformation.* West Lafayette, Ind.: Purdue Univ. Press, 1976. Pp. x, 240. $9.75.

Ferber, Stanley, ed. *Islam and the Medieval West.* Binghamton, N.Y.: Niles & Phipps Lithographers, 1975. Pp. vi, 75. $20.00 paper.

Fish, Stanley E. *John Skelton's Poetry.* Hamden, Conn.: The Shoe String Press, Inc., 1976. Pp. viii, 268. $15.00.

Folda, Jaroslav. *Crusader Manuscript Illumination at Saint-Jean d'Acre, 1275–1291.* Princeton: Princeton Univ. Press, 1976. Pp. xxix, 231, 299 plates. $35.00.

Fowler, David C. *The Bible in Early English Literature.* Seattle: Univ. of Washington Press, 1976. Pp. x, 263. $14.95.

Fricke, Donna G. and Douglas C., eds. *Aeolian Harps: Essays in Honor of Maurice Browning Cramer.* Bowling Green, Ohio: Bowling Green Univ. Press, 1976. Pp. xvi, 293. $15.00.

Frye, Northrop. *The Secular Scripture: A Study of the Structure of Romance.* Cambridge, Mass.: Harvard Univ. Press, 1976. Pp. viii, 199. $8.95.

Gardner, John. *The Poetry of Chaucer.* Carbondale, Ill.: Southern Illinois Univ. Press, 1977. Pp. xxxv, 408. $15.00.

Gentry, Francis G. *Triuwe and Vriunt in the Nibelungenlied.* Atlantic Highlands, N.J.: Humanities Press, 1975. Pp. 94. $12.00 paper.

Graves, Edgar B. *A Bibliography of English History to 1485.* New York: Oxford Univ. Press, 1975. Pp. xxiv, 1103. $52.00.

Griffin, Alice. *Rebels and Lovers: Shakespeare's Young Heroes and Heroines.* New York: New York Univ. Press, 1976. Pp. xxi, 425. $6.95 paper.

Guth, Delloyd J. *Late Medieval England 1377–1485.* New York: Cambridge Univ. Press, 1976. Pp. 143. $9.95.

Hamscher, Albert N. *The Parlement of Paris After the Fronde 1653–1673.* Pittsburgh: Univ. of Pittsburgh Press, 1976. Pp. xxii, 270. $15.95.

Harrison, Kenneth. *The Framework of Anglo-Saxon History to* A.D. *900.* New York: Cambridge Univ. Press, 1976. Pp. vii, 170. $15.95.

Hartung, Albert, ed. *A Manual of the Writings in Middle English 1050–1500,* Vol. 5. Hamden, Conn.: The Shoe String Press, Inc., 1976. Pp. 1742. $25.00.

Harvey, John. *The Black Prince and His Age.* Totowa, N. J.: Rowman and Littlefield, 1976. Pp. 184. $14.50.

Haselbach, Hans, ed. *La Formula Honestae Vitae de Martin de Braga (pseudo-Seneque) traduite et glosée par Jean Courtecuisse (1403).* Berne: Herbert Lang, 1975. Pp. 505, 6 plates.

Hay, Denys. *The Italian Renaissance in its Historical Background.* 2nd Edition. New York: Cambridge Univ. Press, 1976. Pp. xvi, 228. $16.95 hard cover, $4.95 paper.

Hieatt, Constance B., and Sharon Butler. *Pleyn Delit: Medieval Cookery for Modern Cooks.* Toronto: Univ. of Toronto Press, 1976. Pp. xx, 172. $9.95.

Hilton, R. H., ed. *Peasants, Knights and Heretics.* New York: Cambridge Univ. Press, 1976. Pp. vi, 330. $12.95.

Hume, Kathryn. *The Owl and the Nightingale.* Toronto: Toronto Univ. Press, 1975. Pp. xi, 139. $10.95.

Jensen, H. James. *The Muses Concord.* Bloomington: Indiana Univ. Press, 1976. Pp. xv, 259. $12.95.

Kane, George, and E. Talbot Donaldson, eds. *Piers Plowman: The B Version.* London: The Athlone Press, 1975. Pp. vii, 681. $54.00.

Katalog der datierten Handschriften in lateinischer Schrift in Österreich:
Franz Unterkircher, *Die datierten Handschriften der österreichischen
Nationalbibliothek.* Vienna: Verlag der österreichischen Akademie der
Wissenschaften, 3 vols. (6 parts): vol. I (1969), pp. 104. DM 115; vol. II
(1971), pp. 203. DM 150; and vol. III (1974), pp. 248. DM 185.

Kelly, Henry Ansgar. *The Matrimonial Trials of Henry VIII.* Stanford: Stanford University Press, 1976. Pp. 333. $15.00.

Kent, Francis W. *Household and Lineage in Renaissance Florence: The
Family Life of the Capponi, Ginori, and Rucellai.* Princeton: Princeton
Univ. Press, 1977. Pp. xiii, 325. $16.50.

Kieckhefer, Richard. *European Witch Trials: Their Foundations in Popular
and Learned Culture, 1300–1500.* Berkeley: Univ. of California Press,
1976. Pp. 191. $13.50.

Kinnamos, John. *Deeds of John and Manuel Comnenus.* Trans. Charles M.
Brand. New York: Columbia Univ. Press, 1976. Pp. xii, 274. $20.00.

Knowles, David. *Bare Ruined Choirs: The Dissolution of the English Monasteries.* New York: Cambridge Univ. Press, 1976. Pp. 329. $16.95.

Krishna, Valerie, ed. *The Alliterative Morte Arthure.* New York: Burt
Franklin & Co. Inc., 1976. Pp. xiv, 361. $21.50.

Krochalis, Jeanne, and Edward Peters, eds. & trans. *The World of Piers
Plowman.* Philadelphia: Univ. of Pennsylvania Press, 1975. Pp. xxi,
265.

Küng, Hans. *On Being a Christian.* Trans. Edward Quinn. New York:
Doubleday & Co., 1976. Pp. 720. $12.95.

Lanham, Richard A. *The Motives of Eloquence: Literary Rhetoric in the
Renaissance.* New Haven: Yale Univ. Press, 1976. Pp. xi, 234. $12.50.

*La paléographie hébraïque médiévale. Colloques internationaux du Centre
national de la recherche scientifique.* Paris: Éditions du Centre national de
la recherche scientifique, 1974. Pp. 176, 136 plates.

Lebègue, Raymond, ed. *Pieresc: Lettres à Malherbe.* Paris: Éditions du Centre
national de la recherche scientifique, 1976. Pp. 173.

Lehmann, R. P. M. and W. P. *An Introduction to Old Irish.* New York: The
Modern Language Association of America, 1975. Pp. xv, 201.

Lengenfelder, Helga. *Das 'Liet von Troyge' Herborts von Fritzlar.* Berne:
Herbert Lang, 1975. Pp. 136.

Lonnroth, Lars. *Njals Saga: A Critical Introduction.* Berkeley: Univ. of California, 1976. Pp. xi, 275. $15.00.

Mabinogion, trans. Jeffrey Gantz. New York: Penguin Books, 1976. Pp. 311.
$2.95, paper.

Mahoney, Edward P., ed. *Philosophy and Humanism: Renaissance Essays in
Honor of Paul Oskar Kristeller.* New York: Columbia Univ. Press, 1976.
Pp. xxiv, 624. $45.00.

*Manuscrits médiévaux en caractères hébraïques portant des indications de
date jusqu'à 1540.* Tome I: Colette Sirat and Malachi Beit Arié, *Bibliothèques de France et d'Israel, Manuscrits de grand format.* Paris: Centre
national de la recherche scientifique; Jerusalem: National Academy of
Sciences and Letters, 1972. 179 plates.

Marcu, E. D. *Sixteenth-Century Nationalism.* New York: Abaris Books, Inc.,
1976, Pp. 126. $8.50.

McGrath, Daniel F., ed. *Bookman's Price Index.* Detroit: Gale Research
Company, 1976. Vol. 11. Pp. x, 794. $58.00.

McLeod, Enid. *The Order of the Rose. The Life and Ideas of Christine de*

Pizan. Totowa, N.J.: Rowman and Littlefield, 1976. Pp. 185, 8 plates. $13.50.

Morewedge, Rosmarie Thee, ed. *The Role of Woman in the Middle Ages.* Albany: State Univ. of New York Press, 1975. Pp. 195. $12.50.

Morse, Ruth, ed. *St. Erkenwald.* Totowa, N.J.: Rowman and Littlefield, 1975. Pp. 111. $10.00.

Murphy, Thomas P., ed. *The Holy War.* Columbus: Ohio State Univ. Press, 1976. Pp. viii, 214. $15.00.

Nagler, A. M. *The Medieval Religious Stage: Shapes and Phantoms.* New Haven: Yale Univ. Press, 1976. Pp. xii, 108. $12.50.

Narkiss, Bezalel, ed. *Journal of Jewish Art,* Vol. 2. Chicago: Spertus College of Judaica Press, 1975. Pp. 96. $7.00.

Parkes, James. *The Jew in the Medieval Community.* New York: Sepher-Hermon Press, Inc., 1976. Pp. xxii, 440. Cloth $14.95, paper $6.95.

Parsons, David, ed. *Tenth-Century Studies: Essays in Commemoration of the Millennium of the Council of Winchester and Regularis Concordia.* Totowa, N.J.: Rowman and Littlefield, 1976. Pp. 270, 38 plates. $25.00.

Patterson, Linda M. *Troubadours and Eloquence.* Oxford: Oxford Univ. Press, 1975. $25.25.

Penninger, Frieda Elaine, ed. *English Drama to 1660 (Excluding Shakespeare): A Guide to Information Sources.* Detroit: Gale Research Company, 1976. Pp. xix, 370. $18.00.

Place, Edwin B., and Herbert C. Behm, trans., *Amadis of Gaul.* Lexington: Univ. Press of Kentucky, 1976. Pp. 749. $15.00.

Powell, James M., ed. *Medieval Studies: An Introduction.* Syracuse: Syracuse Univ. Press, 1976. Pp. x, 389. $9.95 paper.

Randall, Dale B. J., ed. *Medieval and Renaissance Studies.* Durham, N.C.: Duke Univ. Press, 1976. Pp. ix, 127. $7.50.

Reinke, Edgar C. *The Dialogus of Andreas Meinhardi: A Utopian Description of Wittenberg and Its University, 1508.* Ann Arbor, Mich.: Univ. Microfilms International, 1976. Pp. xi, 411. $20.50.

Robbins, Rossell H., ed. *Chaucer at Albany.* New York: Burt Franklin & Co., Inc. 1975. Pp. 222. $17.95.

Rose, Paul Lawrence. *The Italian Renaissance of Mathematics: Studies on Humanists and Mathematicians from Petrarch to Galileo.* Geneva: Librairie Droz, 1975. Pp. 316.

Rosenthal, Joel T. *Nobles and the Noble Life 1295–1500.* New York: Barnes & Noble Books, 1976. Pp. 207. $15.00.

Rowe, Donald W. *O Love, O Charite! Contraries Harmonized in Chaucer's Troilus.* Carbondale: Southern Illinois Univ. Press, 1976. Pp. 201. $12.50.

Runnalls, Graham A., ed. *Le Cycle de Mystères des Premiers Martyrs.* Geneva: Librairie Droz, 1976. Pp. 206.

Schellhase, Kenneth C. *Tacitus in Renaissance Political Thought.* Chicago: Univ. of Chicago Press, 1976. Pp. xiii, 270. $16.00.

Setz, Wolfram. *Lorenzo Vallas Schrift gegen die Konstantinische Schenkung.* Tubingen: Max Niemeyer Verlag, 1975. Pp. xvii, 247. DM 62.

Seung, T. K. *Cultural Thematics: The Formation of the Faustian Ethos.* New Haven: Yale Univ. Press, 1976. Pp. xviii, 283. $16.50.

Shaheen, Naseeb. *Biblical References in The Faerie Queene.* Memphis, Tenn.: Memphis State Univ. Press, 1976. Pp. vii, 217. $12.50.

Sheridan, Ronald, and Anne Ross. *Gargoyles and Grotesques: Paganism in the Medieval Church.* Boston: New York Graphic Society, 1975. Pp. 127. $14.95.

Shippey, T. A., trans. *Poems of Wisdom and Learning in Old English.* Totowa, N.J.: Rowman and Littlefield, 1976. Pp. 152. $12.50.

Smith, Macklin, *Prudentius' Psychomachia: A Reexamination.* Princeton: Princeton Univ. Press, 1976. Pp. xii, 310. $17.50.

Société Internationale pour l'Étude de la Philosophie Médiévále, ed. *Bulletin de Philosophie Médiévale,* Nos. 16–17. Louvain: Secrétariat de la S.I.E.P.M., 1974–1975. Pp. 234.

Spearing, A. C. *Medieval Dream-Poetry.* New York: Cambridge Univ. Press, 1976. Pp. vii, 236. Cloth $19.50, paper $6.95.

Steinbeck, John. *The Acts of King Arthur and His Noble Knights.* New York: Farrar, Straus and Giroux, 1976. Pp. xiv, 364. $10.00.

Stevens, William O., and Albert S. Cook, eds. *The Anglo-Saxon Cross.* Hamden, Conn.: Archon Books, 1977. Pp. 282. $15.00.

Sylvester, Richard S., ed. *The History of King Richard III and Selections from the English and Latin Poems.* New Haven: Yale Univ. Press, 1976. Pp. xxviii, 168. Cloth $12.50, paper $3.95.

—— and Germain Marc'hadour, eds. *Essential Articles for the Study of Thomas More.* Hamden, Conn.: Archon Books, 1977. Pp. xxiii, 676. $20.00.

Tavoni, M. *Il Discorso Linguistico di Bartolomeo Benvoglienti.* Italy: Pacini Editore, 1975. Pp. 107.

Topsfield. L. T. *Troubadours and Love.* New York: Cambridge Univ. Press, 1975. Pp. 295. $17.95.

Viator: Medieval and Renaissance Studies, Vols. VI–VII. Berkeley: Univ. of California Press, 1975–1976. VI, pp. vi, 401; VII, pp. vi, 455. $15.75 ea.

Walpole, Ronald N. *The Old French Johannes Translation of the Pseudo-Turpin Chronicle: A Critical Edition* and *Supplement.* Berkeley: Univ. of California Press, 1976. *Edition,* pp. xxii, 260. $15.00; *Supplement,* pp. 540 $28.50.

Webster, Charles. *The Great Instauration: Science, Medicine and Reform 1626–1660.* New York: Holmes & Meier Publishers, 1976. Pp. xvi, 630.

Wise, Terence. *Medieval Warfare.* New York: Hastings House, 1976. Pp. xii, 258. $12.95.

Wixom, William D., comp. *Renaissance Bronzes from Ohio Collections.* Kent, Ohio: The Kent State Univ. Press, 1975. Pp. x, 184. $14.95 paper.

Zimmerman, Harold. *Der Canossagang von 1077 Wirkungen und Wirklichkeit.* Mainz: Akademie der Wissenschaften und der Literatur, 1975. Pp. 220.